APPAREL PRODUCT DEVELOPMENT

APPAREL PRODUCT DEVELOPMENT

Second Edition

MAURICE J. JOHNSON

EVELYN C. MOORE

Prentice Hall
Upper Saddle River, New Jersey 07458

Library of Congress Cataloging-in-Publication Data

Johnson, Maurice J., 1949-
 Apparel product development/Maurice J. Johnson, Eveyln C. Moore.—2nd ed.
 p. cm.
 Rev. ed. of: So you want to work in the fashion business?
 ISBN 0-13-025439-8 (pbk.)
 1. Clothing trade—Vocational guidance. I. Moore, Evelyn C., 1951- II. Johnson,
Maurice J., 1949- So you want to work in the fashion business? III. Title.

TT497.J64 2000
746.9'2'023—dc21 00-024612

Publisher: Dave Garza
Acquisitions Editor: Neil Marquardt
Managing Editor: Mary Carnis
**Director of Manufacturing and
 Production:** Bruce Johnson
Production Management: York Production Services
Production Editor: Carol Eckhart
Interior Design: York Production Services
Production Liaison: Adele M. Kupchik
Manufacturing Buyer: Ed O'Dougherty
Creative Director: Marianne Frasco
Cover Design Coordinator: Miguel Ortiz
Editorial Assistant: Susan Kegler
Marketing Manager: Ryan DeGrote
Marketing Assistant: Adam Kloza
Printer/Binder: Banta Company

Prentice-Hall International (UK) Limited, *London*
Prentice-Hall of Australia Pty. Limited, *Sydney*
Prentice-Hall Canada Inc., *Toronto*
Prentice-Hall Hispanoamericana, S.A., *Mexico*
Prentice-Hall of India Private Limited, *New Delhi*
Prentice-Hall of Japan, Inc., *Tokyo*
Prentice-Hall Singapore Pte. Ltd.
Editora Prentice-Hall do Brazil, Ltda., *Rio de Janeiro*

Photography and Artwork Credits

Alan Stuart, Inc, courtesy of, (f11-26) 225, (f11-27) 226, (f12-1, f12-2) 238, (f12-3) 239, (f12-4, f12-5) 240, (f12-6) 241, (f12-11) 244, (f12-12) 245, (f12-20, f12-21) 251. • Allen, Christy, courtesy of, 261. • Carabetta, Philip, 362, 367. • Caramico, Mary Lisa, (f5-4, f5-5) 74, (f5-6, f5-7) 75, (f5-8, f5-9) 76, (f9-1, f9-2, f9-3) 156, (f9-4, f9-5, f9-6) 157, (f9-7, f9-8, f9-9, f9-10) 158, (f9-11, f9-12) 159, (f9-13, f9-14) 160, (f9-15, f9-16, f9-17) 161, (f11-16, f11-17) 218, (f11-18, f11-19) 219, (f11-22, f11-23, f11-24, f11-25) 224, (f11-29, f11-30, f11-31) 231, (f11-32, f11-33, f11-34, f11-35) 232. • Carnegie, Michael, 175, (f11-6) 208, (f11-7) 209, (f11-8) 210, (f11-9) 211, (f11-10) 212, (f11-13) 215, (f14-4) 276. • Chung, Wan Sun, (f3-1) 52, (f3-2) 53, (f11-4) 205, (f11-5) 207. • Color Box, courtesy of, (f7-3) 125. • Coulter, David, cover photograph, color insert (f9-20, f9-21, f9-22, f9-23, f9-24). • Davis, Vicky, courtesy of, 9 • Dayton's, Hudson's, Marshall Field, courtesy of, 46. • Dennis, Pamela, courtesy of, 149, 354. • Dittrich, Al, courtesy of, 359. • Dunn, J. Colin, (f2-5) 33. • Federal Trade Commission, courtesy of, (f16-1) 311. • Gerber Garment Technology, courtesy of, (f15-1) 283, (f15-2) 284, (f15-3) 285, (f15-5) 286, (f15-7) 289, (f15-10) 291, (f15-11, f15-12) 292, (f15-13) 293. • Glist, Alan, courtesy of, 341. • Guta, Izabela, 30. • Hancox, Clara, courtesy of, 59. • Harwood Companies, Inc., courtesy of, 222, (f11-28) 229, (f12-9) 243, (f12-13) 246, (f12-22) 252. • Holt, Cathy, (f1-1) 8. • Ike Behar, Inc, courtesy of, 236, (f12-7, f12-8) 242, (f12-10) 244, (f12-14) 246, (f12-15, f12-16) 248, (f12-17, f12-18) 249, (f12-19) 250. • Image Info, courtesy of, (f15-14) 300, (f15-15) 301. • Johnson, Maurice J., all photos not otherwise credited. • Lectra Systemes, courtesy of, (f15-4) 285, (f15-6) 287, (f15-8, f15-9) 290. • Lee, Eun Ju, 207. • Liss, Steve, courtesy of Malden Mills, (f18-4) 333. • Metz, Cara, courtesy of UNITE, (f18-2) 330. • Miami International Merchandise Mart, courtesy of, (f13-1) 264. • Moore, Zachary, 362, 369. • Noh, Bo Young, (f9-18) 162. • Promostyl, courtesy of, (f7-1) 123, (f7-2) 124. • Sani, Sergio, (f7-4, f7-5) 127. • Scavullo, Francesco, courtesy of Tommy Hilfiger, 5, 354. • Shultz, Bob, courtesy of, 137. • Solero, Irving, courtesy of the Museum at the Fashion Institute of Technology, (f7-8) 141, (f7-9, f7-10) 142. • Suk, Ju Won, (f7-6) 130, (f7-7) 131, (f9-19) 163, (f11-14) 216. • Trudeau-Lopez, Trudi, 179, 191, 195, 199. • Tucker, J. Stan, courtesy of, 140. • U.S. Department of Labor, courtesy of, (f18-1) 329. • Van Blaricum, Jason, (f2-6) 34, 136. • Vogt, Ethan, courtesy of Malden Mills, (f18-3) 333. • Yu, Shirley, (f11-20) 220, (f11-21) 221. • Zucker, Maurice, courtesy of, 128.

10 9 8 7
ISBN: 0-13-025439-8

From Maury Johnson
In Loving Memory of
Marian T. Johnson

From Evelyn Moore
With Love to the Men in My Life…
Jesse, Peter, and Zachary

CONTENTS

PREFACE

FOR STUDENTS AND OTHERS INTERESTED IN FASHION

by Maurice J. Johnson

HERE'S WHAT THIS BOOK IS NOT

- It is not a fashion history book, from Louis XIV to Madonna.
- It is not "How to Design a Pleated and Matched Plaid Skirt."
- It is not an examination of the rise and fall of the U.S. department store.
- It is not a technician's guide to patternmaking, grading, and cutting.

There are several really excellent textbooks that cover the above in great detail. We will give you just enough information on these subjects to interest, not confuse, you.

HERE'S WHAT THIS BOOK IS

- An attempt to give you the real flavor of the garment making industry.
- Hopefully a "reality check" about what a job feels like, especially in wholesale, manufacturing, designing, and private label product development. More jobs of the future, including buying, will require a working knowledge of the technicalities of apparel product development.
- A general but practical "how to" when it comes to developing and producing a line of clothing.

Unit 1 explores the fashion industry today. Potential job seekers must have creativity and talent, and they must also be able to recognize and respond to the wants and needs of customers. How does the industry identify and address different customers?

Unit 2 examines the development of garments by following the process of private label product development, step by step. Our attempt is not just to show you the steps but to show how to do these steps, from the first concept through the retail marketplace. We have beefed up the section on research so that students can easily pursue areas of specific interest. We also let you in on a few of the dark little secrets that exist in the wholesale-retail relationship.

Unit 3 focuses on the scale and future of manufacturing. It is one thing to make one blouse for one season. It is another to do it on the mass scale that is required today. Incredible new developments in computerized designing, patternmaking, and production have already changed the industry radically. What's coming next? What's all this talk about offshore sourcing, and where will goods be manufactured in the 21st century? Will there still be an industry in the United States?

Unit 4 includes some inside tips for your future career. From decades of experience in the industry, we're going to predict where some new opportunities might lie—for your new career or maybe even for your own new business. So that you will also sound like a pro, we have given you a brief glossary of terms that you're going to want to keep. Fashion jobs don't come with interpreters. Finally, we asked some veterans to share their sage advice with you.

This book will give you the big picture with sufficient detail to be able to

- Decide if this field is right for you, with an up-close look at apparel product development
- Put subsequent specialized fashion and garment construction courses into perspective
- Serve as a commonsense (rather than glamorized) foundation for a fashion career
- Help students with the transition from the world of school (known) to the world of business (unknown).

Best of all, this book has not been written by just two people. You'll hear many different voices. We have been honored by support and input from all corners of the industry. Each chapter includes messages from members of the country's largest stores, leading manufacturers, and design teams. These are firms you'll recognize, such as Liz Claiborne, Donna Karan, Tommy Hilfiger, Polo, Pamela Dennis, Saks, and Marshall Field's.

Above all, this book should help all readers (students, industry members, and those simply curious) sense where the intense, creative, and often funny garment business is going in the 21st century, rather than where it has been.

Personal note. My career has taken an interesting turn since the first edition of this textbook, *So You Want to Work in the Fashion Business?* I now teach full-time at New York's Fashion Institute of Technology (FIT), a divi-

sion of the State University of New York. And I'm loving it! Students come to class with such energy and enthusiasm about the future. Their perspective, fashion and otherwise, is eye-opening. Luckily I have been able to teach a range of courses already, and one trend in interest is becoming clear among the merchandising/business students. FIT took a leadership role about ten years ago by creating a course in product development for retailers. This area is enormously popular with the students because it combines the needed math and business skills with the more creative parts of garment styling and development. They love this course, and they love the careers to which it has led!

Based on the fact that many students are expressing interest in this specialty within the merchandising field, and based on the fact that almost all retailers today are involved in private label product development, we have reinforced this perspective in the second edition. This does not mean that it has replaced anything else. On the contrary, we hope we have successfully "back filled" with some of the more basic, fundamental points that will help put product development and all fashion jobs into a clearer perspective.

PREFACE

FOR INSTRUCTORS

by Evelyn C. Moore

Fashion surrounds us and is a part of our lives—in our clothes, in our home, work, or school environments, in our stores, and even in the entertainment world: music, TV, and the big screen. Therefore it is no surprise that each year more students of all ages enroll in fashion programs. Some programs even start as early as high school and serve as a foundation for students to enroll in college programs offering both associate and bachelor degrees in product development/design. It would seem then that the transition to the working world should be logical and easy. We are all surrounded by fashion, we all wear clothing, everyone needs clothing. It must be an easy business to move into—but it is not!

Students quickly discover that the fashion industry is a business, and they must wear many hats to be successful. Not only must they be visionary enough to project fashion trends and styles for consumers up to two years in advance, they must also be able to work effectively in the business world—negotiating prices, construction costs, and deliveries.

Fashion designers/product developers of the 21st century must also design and construct textiles and garments using state-of-the-art computer technology. Today the designer must find the right balance between creativity and technology. Students in the classroom, along with the seasoned veterans in the world of work, are quickly learning that the computer will serve as their primary tool and will help strike the balance to connect the global marketplace of two competitive worlds: design and business. Technology is used to relate, exchange, and change designs, manufacturing procedures, and pricing faster than ever before, providing the technologically savvy with the edge in the marketplace.

Along with technology, they must also learn and understand the economic and political world. A solid understanding of world events will help

product developers clarify how and where products should be manufactured in this marketplace of growing global integration.

Working with industry leaders I learned that as an instructor and mentor to those entering the fashion world, I had the responsibility to teach students how to learn these forecasting twists, technological turns, consumer needs, and manufacturing demands of the fashion business world! The industry echoed a common woe—fashion graduates are often artistically talented, but

- They do not have the foundation to analyze and interpret the trends to make forecasting projections and to market products successfully;
- They do not understand the steps to make work boards, cost sheets, or spec sheets;
- They lack a true understanding of what role technology plays in design, production, and marketing/sales of products;
- They often lack an awareness of the world—of cultures, customs, and even politics—to help them understand why and where products are being produced.

I knew I had a responsibility to help students journey successfully from the classroom to the fashion industry. The journey had to be steady, with stopping points to allow them to gather their skills and abilities and make the transition to the fashion world with a solid business foundation, one built with explanation!

As Maury and I compared notes, sought the advice of other industry leaders, and listened carefully to the fears our students expressed, we knew it was important to write a "how to" book on the business of product development and manufacturing.

We knew the explanation had to be multifaceted so that students could find their own niche. Together we developed a textbook to show students what is *really* going on in the fashion business, in addition to some fundamental skills needed for success in the industry.

We have provided techniques for teaching the "how to" in each chapter. We do not consider these activities an afterthought but rather an integral part of the journey from the classroom to the design room. Over the years, the activities have made a big difference with my students. By guiding students through the steps, they have the opportunity to use trade publications, absorb industry lingo, and develop a solid understanding of what it will take for their designs to end up on the selling floor. There is no reason for a class discussing business to be all lecture. Hands-on has always been the first step to on-the-job training, and what better place to start than in the classroom?

No matter what path they follow in the industry, the process will demonstrate for each student that fashion designers, merchants, sourcers, and product developers (regardless of whether their name is on the label) are indeed visionary business people who forecast trends, produce products, give beauty to our world, and end up with financial success. We hope both you and your students enjoy the journey!

ACKNOWLEDGMENTS

For the second edition we had new help from many directions. Thanks to all of the following.

- The industry people who were so generous again with their time and materials: Britt Bivens, Promostyl; Marni Greenberg, Color Box; Christian Nelson, Image Info.

- Our new "Inside Scoop" people: Christy Allen, Alison Durrant, Bob Shultz. Special thanks to Christy for letting Maury "play" cutter and finisher during the summer of 1998!

- Kim Roy and Judy Smith once again for their new industry insights.

- Faculty and staff at the Fashion Institute of Technology, New York, New York. The Fashion Merchandising Management Department has been wonderfully supportive in total. Special thanks for sharing insights on teaching product development to Aurelie Cavallaro, LaDonna Garrett, John Mincarelli, Robin Sackin, Bob Shultz, Diann Valentini, and (my always supportive office-mate) Jane Werner. We also received tremendous support from the Textile Surface Design Department. Karen Gentile put in a huge effort to coordinate artworks from her students; Eileen Mislove also contributed to that effort. Thanks to Irving Solero for his terrific photography.

- Many people at Pearson Education/Prentice Hall: Neil Marquardt, Elizabeth Sugg, Mary Carnis, Adele Kupchik (for *always* being there!), Mark Cohen (for starting the whole project). Special thanks to Dianne Wooten in Florida who coordinated such a wonderful send-off for the first edition, and to Carol Eckhart.

- On a personal basis: Robert Barker who scanned and designed repeatedly on a moment's notice. And Philip Carabetta who had to live through this *again*!

Again, like last time, we especially acknowledge the *students* who made new contributions to this second edition. Their talent is clearly extraordinary, and we wish them huge success in the future: Wan Sun Chung, Eun Ju Lee, Ju Won Suk, No Bo Young, and Shirley Yu.

Maurice J. Johnson
Evelyn C. Moore

UNIT ONE

THE FASHION WORLD
VERSUS
THE REAL WORLD

CHAPTER ONE

So You Want to Work in the Fashion Business?

The two most important words in the title of this chapter are *work* and *business*. Often, people are drawn to this field because they expect it to be exciting and glamorous. It often is, but it is still a business, and a large one at that! The fashion industry is not a hobby; it is not an ongoing conversation about what people like to wear; and it is not an endless fashion show. What is it? It's a high-energy, fast-paced business that controls billions of dollars of consumer spending around the world. Everyone wears clothing. It is that simple (and big).

The best news from this simple fact is that clothes are here to stay. In music, the World War II generation listened to music on fast-turning records called "78s." The generation growing up in the 1950s had smaller single records called "45s." The baby boomers had larger long-playing albums called "33s." These were quickly replaced by the next generation of technology: 8-track, cassette tapes, then CDs. These will also soon be replaced. But with all this going on, everyone was and still will be wearing clothes. It is a fundamental human need. These clothes may be made via newer technology and in a different corner of the world, but thankfully there will always be a garment business.

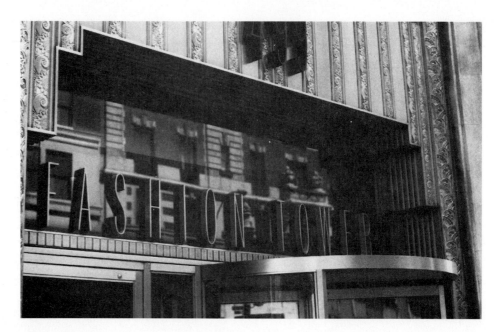

Fashion Tower Building, New York City.

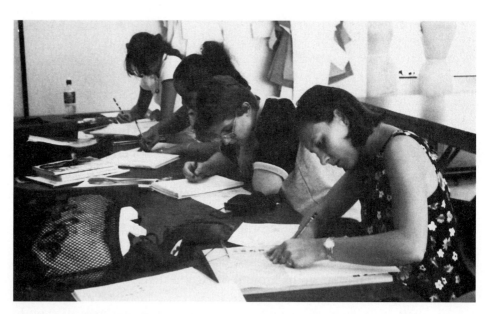

Fashion students learning new skills.

Wendell Watkins, vice president of manufacturing for the Harwood Companies, Inc., says: "Clothing is second only to food as a basic human need. There will always be an apparel industry, which means there will always be opportunities." Students like you, with a keen eye for color and a love of fashion, are looking for opportunities to work in this industry. A fashion student quickly learns that the best designers are also the most visionary business people, who can analyze and interpret business, economic, and consumer trends. They must know how to design, construct, and market fashion products successfully. Just designing is not enough, nor is it the only job.

It is also important for newcomers to realize that fashion is mostly work, just like any other job. Hope Cohen, who has worked at Ann Taylor, Gap, and Polo Ralph Lauren, put it perfectly: "If it wasn't work, they'd call it something else!" So what you will discover is that discipline and dedication pay off in fashion as much as in other fields. There are many job opportunities in the world of fashion, in companies large and small.

How Do You Know If You're Right for the Fashion Industry?

- You like clothes, don't you?
- You follow fashion reports in magazines and on TV?
- People have always told you that you were a great dresser?
- You were the only one in fifth grade to wear black from head to toe?

These all sound like the perfect qualifiers to pursue a career in fashion. They are, in fact, reasons often given by people working in the industry. Well, here's the first shock:

Fashion store mannequin display.

Prada store window.

- You may be a great dresser, but many people are not—and
- They're the ones who are buying the clothes!
- Many American customers unfortunately have limited taste and style (see Figures 1-1 and 1-2). Thankfully, however, there is a whole range of customers with specific ideas and priorities.

The irony of this situation is that anyone who is actually interested in fashion is not a typical customer. As a result, these people tend to be bad "fashion barometers." What they find interesting or new in fashion might be too interesting or too new for most people.

Most customers don't want to look so fashionable that they stand out from the crowd. OK, a tiny few do, but they represent a small number of customers. In fashion theory, these people are often called *innovators*. Those that quickly catch on to what these innovators are wearing are called *early adopters*. Those that pick up a fashion trend just as it is peaking or declining are called *laggards*. "While everyone wants to feel equal, nobody wants to look equal. It's a drive built into our genes. We start separating from the mass by upgrading our appearance—by up-reaching to emulate the standards above where the ranks are thinner and more selective."[1]

But remember: This is a fashion business. To have enough business, you must have many customers. Your chances of landing a job that caters only to the **fashion-forward** innovators are small indeed. Before you panic and say, "But I don't want to design boring clothes!" let's make one point clear: Even though this is work, it is work in which you can and need to use your special taste, creativity, and interests.

Fashion Forward
A person more fashionable than most.

IS THERE A PLACE FOR YOU? CAN YOU FIND CREATIVITY WITHIN LIMITATIONS?

Here's a test to see how you might do in the garment business: What was your reaction in grade school when the teacher gave you two pieces of construction paper, four Popsicle sticks, a ruler, and two rubber bands and said: "Make an airplane out of these"? If you tingled with excitement at the challenge, you will probably do well in the fashion industry. Creativity in the "real world" is as often a matter of finding creative solutions to practical challenges as much as it is a matter of "expressing oneself." The reality of what you can and can't work with should not be viewed as a restriction but as a "dare." You need to see the "possible" rather than the "impossible." The most brilliant achievements are often a matter of making much out of very little.

In garments there are lots of technical limitations—in fabric, in sewing. There are sociological limitations, too—in what "average" people will wear. These limitations become the "rules of the game" for a designer or product manager. Almost always, cost is a major *limiter*. It is easy to make a glamorous gown out of luxurious material that costs $30 per yard, but it takes a lot more skill and ingenuity to make something glamorous out of material that costs $2.50 per yard. But it can be done! The market for $1,000 dresses

FIGURE 1-1 You thought your customer would look like the model in student Cathy Holt's picture.

FIGURE 1–2 But, chances are, she might look more like this!

is far smaller than the market for $59.99 dresses! So, chances are, in your job in the fashion industry, you're going to need this skill and ingenuity.

In menswear, one of the major limiters is what a "guy" will wear. American males tend to be skittish about clothes. They really don't want to stand out from the crowd. Menswear designers and merchants tend to sweat over the smallest details to achieve a balance between "new" and "too new." They have to find the one-millionth new version of a **paisley** pattern, or that just-right color. Designers have found that men can accept one new idea in a garment (maybe color, maybe fabric, maybe a slight **silhouette** change) but not more than one.

In kidswear, the major limiter is usually price. Parents will spend only so much on a garment that will be quickly outgrown. The trick is to find a way to apply the most novelty or "cuteness" for the least amount of labor and materials.

A designer or product manager faces similar tasks and challenges season after season. Those with longevity can devise fresh, original, but still practical solutions year after year. Repeating exactly the same solution each season is as dangerous as being too original each season. Going back to our airplane example: It is a fine line, but if you can make not just one, but two or three different airplanes out of the construction paper and Popsicle sticks, you are really on your way.

Paisley
A classic, rounded, swirling, and highly detailed pattern.

Silhouette
Edges or outline of a garment; also, the model or style.

THE INSIDE SCOOP

VICKY DAVIS

Vicky started her own men's neckwear company in 1969. After the amusing start-up described below, she received the prestigious Coty Award in 1976 and the first Cutty Sark Award in 1979. Two of her largest current accounts are Bloomingdale's and Macy's.

When I started in this business, I was an insecure little lady from Detroit. My husband Larry had won a cruise, so we went to Hudson's Department Store to find appropriate clothes for the cruise and for New York. All men's ties at the time were very narrow, and they looked funny on heavy-set Larry. I decided to make a few wider ties for him.

Through the PTA, I found someone who could sew (I couldn't!) and then located some fabrics at a local fabric store. Well, the 5-inch-wide ties and other novelties that resulted were a big hit on the cruise! People said, "That tie is great! Where did you get it, Bloomingdale's?" Coming from Detroit, I answered, "Bloomingdales...is that a nice store?"

So back home, my PTA partner and I chipped in $23.00 and started our own company! Our first customer was the Claymore Shop in Birmingham, Michigan. They bought two dozen ties and sold them out. Then four dozen, and on and on! Soon, the entire PTA was sewing in my basement! Still shy and insecure, I suddenly found myself driving to places as far away as Grand Rapids, alone!

At first, when a buyer would say "no" to me, I'd go back out to the car and cry. But in a couple of years, I had built up enough confidence to be able to walk in and sell Bloomingdale's and Sak's in New York! Now, if I can do that, anyone can!

THE INSIDE SCOOP

SIMON GRAJ

Simon founded Graj+Gustavsen in 1990 after years in wholesale and retail. The company develops concepts, **brands**, **packaging**, **store design**, and **licensing** ideas for client wholesalers and retailers such as Nordstrom, Discovery Channel, Hickey Freeman, and Gap. In 1997, he teamed up with Spike Lee to form Spike Lee Productions, a new clothing company. We consider him among the most original thinkers in the industry.

Brands
Usually refers to wholesalers' labels that are advertised and widely recognized by consumers.

Packaging
Anything that accompanies a garment when it is presented to the customer: for example, a box, protective bag, or paper hang-tag.

Store Design
The way a store is planned, laid out, and set up.

Licensing
The practice of buying or selling the use of a brand name from one company to another.

On Creativity and Originality

You have to have the courage to go through the void of "not knowing"—and trust that you will know at some point. Don't jump to quick conclusions. If you wait, you will be inspired.

In the flow, accidents occur. And these are the best things! In fact, you go through this whole exercise so you can allow accidents to happen. You can be more original and creative if you are not looking to reinforce what you already know or what someone else already knows. If you are aimed at only the things you already know, you won't allow these accidents to happen.

In the process of observing, you can learn anything you need to know. Designers are reporters. If you lose this fact, you will fail. You'll be locked into too few ideas. You have to see the flux, the panorama. You've got to keep having fresh experiences.

Everyone has a capacity for genius. You just need to give up the things that keep you from experiencing it!

So let's take a look together. As we examine different aspects of the fashion world, you will be hearing from a diverse group of industry members in sections called "The Inside Scoop." Some of these people are famous, some are not. Some run companies, others run sewing machines. But their front-line perspective is important no matter what their (very real) job is. From our classroom experience we know that the first thing you'll want to hear about is the job market. In Chapter 2 we outline many jobs and wonderful opportunities. Then you'll find out where these jobs are going and what you need to learn to get them and then how to find *your* place in the fashion world.

Endnote

1. William A. Rossi, "Fashion Today Gets No Respect," *Footwear News*, December 7, 1998.

HERE'S HOW TO BEGIN . . . CHAPTER 1

It is always fun at the beginning of a course to find out about the person sitting next to you and learn why he or she wants to be in this wonderful, fast-paced, ever-changing industry. Take a moment and get to know the future fashion pros. Together, learn about fashion philosophies, visions, and have some fun at the same time!

The Fashion Quiz

Thinking about your life in general, list three things that you love to do (Dancing? Organizing? Sleeping in?). Then, list three things that you hate to do (Washing dishes? Cleaning your room? Math homework?). We enjoy doing this in class and then suggesting what job in the fashion industry might be a good fit based on these likes and dislikes. (For example, if you really hate math, being a buyer is not a good choice.)

It is also important to keep your list and return to it at the end of the book. See if you can pick where you'd fit into the industry. Or perhaps some of your likes and dislikes will have changed as new opportunities are explained.

Fashion Failures

Most fashion magazines do an annual feature on the "best and worst" of fashion, but obviously that's only once a year. Everyone should bring into class a current magazine and try to find the fashion failures in the issue. It is important to identify the "mistakes" and make sure that you share your reasoning.

Fashion Faux Pas

Oops—we all wear the wrong outfit at the wrong time at least once in our lives. Think over the last few weeks and what you have seen on TV: It could be an outfit shown in a news or entertainment piece that really screamed: "Oops!"

Fashion Fixes

Each of you has said sometime, to someone, "If only that person would dress differently!" Pick a leading national figure, male or female (could be a political figure, an actor or actress, athlete, any celebrity), and write one paragraph about why you think the person's look does not suit his or her image. Then write one paragraph on what you would suggest.

Fashion Firsts

Although you can have a lot of fun laughing at crazy costumes and finding fashion mistakes, take a moment and identify a fashion leader. Again, choose a leading national figure and write one paragraph about why this per-

son makes a strong statement regarding who he or she is and what he or she stands for in appearance. Then identify a fashion leader in your peer group.

HERE'S HOW TO BEGIN . . . COURSE LENGTH PROJECT FOR ENTIRE COURSE: A FASHION BUSINESS JOURNAL

Probably one of the most important keys to success is knowing what is happening in an industry. The fashion industry is all about change—you can be out-of-date in a flash. Before reading further, gather your working tools and supplies. Your first and most important tool will be a fashion business journal. A journal gathers ideas and opinions. Note that a journal is strictly personal: There is no "right" opinion nor is there a "wrong" opinion. This journal will keep you well-versed on the current events of the industry. You will be using this journal throughout the course to help develop your own insight and to analyze and interpret the trends of today and tomorrow.

Fashion Business Journal

Maintain a notebook that is divided into the following three parts.

Part One: "The News": Watching the Trends, Learning the "Lingo," and Identifying Who Is "Growing" and Who Is "Going"

Each week you are to clip the following:

a. One article from the business section of the local newspaper relating to fashion or retailing.
b. One article from *Women's Wear Daily* or *Daily News Record* reflecting an industry activity.
c. One article from a business publication such as *Newsweek* or *Time* relating to retailing.

Write two or three sentences about the content of the article and two or three sentences about how the fashion industry might be affected.

Part Two: "People Watching": Focus on How People Are Responding to Fashion Trends

Every three weeks you are to people-watch. Visit a local mall or shopping area. As you observe the shoppers, make notes about what people are wearing. Compare and contrast, in writing, the leading fashion trends being promoted versus what is actually being worn.

Part Three: "Fashion Influences": A Little of This and a Little of That!

a. Every day you see, hear, or read something that reflects a fashion trend—it could be something you see in a movie or TV show, at a sporting event, or even something being targeted on the news. Maintain a miscellaneous section in your journal and jot down happenings each week that relate to the fashion industry: It could be a reflection from the past, something current, or a feature that you feel will have an impact on fashion's future. For example: Have you seen a fashion trend emerge that is a direct result of a movie that was just released?

b. Sometimes even "unrelated" pictures, ideas, or thoughts influence design. You might be struck by

Paint samples
Photos of places or things
Headlines
Typeface styles
Placemats, napkins, flower petals—who knows?

Good designers and product managers are constantly on the lookout like this. You will be amazed how collecting these ideas will help you remember good design when you need ideas.

Put It All Together

At the end of the course, prepare a two- to three-page synopsis that answers the following questions: If I were a product manager or designer today, what line of apparel would I put together? What is the customer base? (Illustrate with a grid box from Chapter 5.) What kind of store would my line match? What specific fabrics, colors, trims, and styling would I choose? What general marketing strategies would be appropriate for this line?

CHAPTER TWO

SEGMENTS OF THE GARMENT INDUSTRY: WHERE THE JOBS ARE

There are many different opportunities for many different people in the fashion industry. We feel that just about anyone can find a job that is tailored to his or her personal skills and goals. It takes a whole range of skill sets, from creative artists to highly organized number-crunchers, to make any fashion company successful. We are going to provide you with the big picture, a starting point from which to build. This chapter focuses on the gamut of opportunities (and the skills needed) in three different sectors of the garment business:

- Retail
- Wholesale
- Fashion support services

This quick look should help you develop a feeling for the segment or job within the industry that might be the right fit for you. In addition, knowing the breadth of jobs in the industry should help you better understand the industry professionals who are introduced in "The Inside Scoop" sections.

Here is a chart to help you visualize jobs in the three areas and how they interrelate. Simply put, not one of these areas can work successfully without

input from the others. Taking a look at the chart, you might wonder how to know which area is right for you. Let's start by examining each segment.

Retail (Stores)	Wholesale
Sales • Sales associates • Selling specialists	Design • Textile design • Garment design
Store Operations	Merchandising
Merchandising	Production
Fashion Office • Visual display • Special events	Sourcing Sales, Marketing

Support fashion services
Buying offices
Fashion and color services
Fashion promotion and ad agencies

WHERE TO START? RETAIL NEVER FAILS!

If you're not lucky enough to have "connections" to land a job in the fashion industry, the single best way to break in is by getting a sales job in a retail apparel or department store. If you can do this in tandem with study at a fashion institute or technically focused college majoring in design, retail-

Retail Department Store: Lord & Taylor.

Retail Specialty Department Store: Saks Fifth Avenue.

Retail Department Store: Macy's.

Retail Department Store: Dillard's.

Retail Specialty Chain Store: Express.

ing, or business, you will be well on your way. Barbara Dugan, senior vice president of personnel of the Associated Merchandising Corporation, puts it this way: "Focus your energies on related work. Even summer work shows an interviewer that you've thought about the path you'd like to take."

Retailing, by definition, is the sale of goods and services, and even though you may not want to work on the selling floor forever (and your dreams are to be in a designer's studio), it is the best place to start. On the front lines you will encounter many different customer groups and levels of buying power. It is a chance to learn about customers: their wants, needs, habits, and attitudes. The broad variety of retail is also a wonderful advantage when you need to decide which part of the industry is for you: women's, men's, children's, accessories/shoes, home furnishings. Retailing employs more than 20 million Americans—18% of the nation's workforce.[1]

Work experience with an important retail company on your résumé will always serve you well. No matter what end of the industry is your specialty, front-line retail experience will always be viewed as a plus! The sector of the industry with the greatest number of jobs is retail. In fact, retail is one of the largest job markets in the country. For apparel, jobs are available at various retail stores, which you will find outlined in Chapter 6. So if you start as a sales associate, even seasonally or part-time, at a renowned chain such as Federated, May Company, Dillard's, Nordstrom, Dayton-Hudson, or Saks Fifth Avenue, you will have a good learning experience.

Retail Specialty Chain Store: Gap

If department stores are not for you, national specialty chains such as Limited and Gap are also great on your résumé, even if their product lines are a bit more narrow in scope. Either avenue is fine, because both the leading department stores and national specialty stores believe that good training is essential. It's training that you need right now. And the most important qualities that you will need? Enthusiasm and a willingness to learn!

Let's look at three different career paths that you can focus on within retail: sales, store operations, and merchandising (or buying).

Sales

After front-line retail sales experience, many companies will encourage the most promising retail sales associates to concentrate on a specific category or classification of merchandise or even a single designer line. These positions are called *selling specialists*. In this position you become a liaison for the store, the buying office, and the manufacturer. You are responsible for optimizing sales through presentation, promotion, and good customer service. This job involves a keen eye for color and presentation, strong communication skills, and some good merchandising math skills to complete departmental paperwork. Being a selling specialist opens avenues to both merchandising and design, because you usually work directly with the designers and manufacturers.

Store Operations

Some sales employees advance to department manager or group manager. These supervisory jobs are centered around training, educating, and scheduling sales and stock people. Tracking inventories, setting the floor, and managing anything else that makes the branch store run are included in the manager's responsibilities. Store managers are also concerned with personnel, building maintenance, and security. Given that there are now fewer chains of stores but each chain has more branches, it is reasonable that there are more store operations jobs than ever before. Conversely, this means that there are fewer merchandising jobs.

DENNIS ABRAMCZYK

DMM
Divisional merchandise manager. Supervisor of several buyers in a related area, such as all children's wear buyers.

GMM
General merchandise manager. Senior manager, to whom DMMs report, who is responsible for an entire merchandising division of the store, such as all ready-to-wear or all men's and kids.'

Dennis is the senior vice president of Stage Stores in Houston, Texas. Before that he spent 25 years advancing through the ranks of Federated Department Stores (Boston Store) and Carson Pirie Scott. He started right from college on the Federated executive training squad for new graduates in Milwaukee.

I really believe in a career path that gives you both stores and buying office (merchandising) experience. My path was trainee, assistant buyer, branch area manager, buyer, assistant store manager, **DMM**, **GMM**, director of stores, then again GMM. You are much more well rounded after that. You can appreciate what the other half goes through!

Merchandising

Buyer
Retail store employee responsible for purchasing the right merchandise, usually for only one or two departments, for the customers.

Merchandising is the selecting, buying, and distributing of assorted items to various branch stores and coordinating and planning sales and promotions. The career path is generally from assistant buyer to associate buyer to **buyer**. Often, stores will move you back and forth between the merchandising line and the stores line. As you can see from the career described in "The Inside Scoop" for Dennis Abramczyk, you could end up as a manager of many buyers as a divisional merchandise manager, or move all the way into senior management as a general merchandise manager.

Important skills for merchandising are analytical and mathematical skills (generally the use of Excel and/or Lotus). With the entire retail industry computerized, buyers must have excellent spreadsheet math skills. The math required is a version of accounting. *Math is a huge part of the buyer's job.* Aggressive negotiating abilities are also critical. You cannot be shy when you are demanding that a vendor give you markdown money. (Markdown money is money given by the wholesaler to a buyer when that wholesaler's merchandise has not sold as well as expected. The buyer adds this to his or her profit statement to improve it.)

Being a buyer is a tough, demanding job. Hours tend to be long, and the workload is considerable. Buyers are typically responsible for many things over which they have only limited control. There is a high turnover among buyers because either they get promoted or they move to another field, one with a less hectic pace. All buying jobs require similar skills, only the scope changes with the store's size. In small stores, buyers buy many classifications or departments. In large stores, buyers tend to be more specialized.

But what if you find out that you do not want the dollar responsibilities that some of these jobs require—it just isn't you? Yet fashion is in your blood,

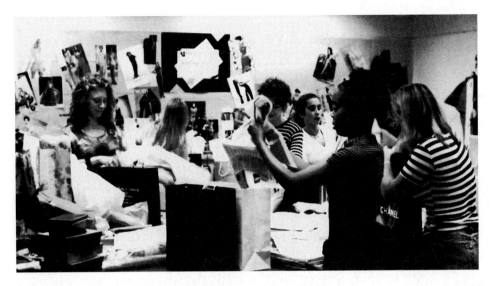

FIGURE 2-1 Display students preparing a window display.

and you have the pulse of knowing the "right" colors, trends, and fashions. You are creative but do not see yourself as a clothing designer. Don't worry, there are still other wonderful opportunities in retail. Success can also be found in the visual and promotion areas.

Visual Display and Promotion

First, take a look at the job of visual display. Figure 2-1 shows students learning display skills in class. Trust us, this is not just changing mannequins. That is only one of many job responsibilities. Visual display coordinators are responsible for setting the entire image of the store: presenting a good floor set, creating exciting visual displays to educate customers, and presenting merchandise physically in ways that will maximize sales. What is a *floor set*? It starts with a floor plan that identifies where racks and merchandise should be placed to create a strong flow of traffic through the store and to present the merchandise most effectively. Often you will hear this called a *plan-o-gram* or *prototype* (Figure 2-2). In fact, because store image and presentation are among the few areas where stores can distinguish themselves from the competition, these areas are growing. The largest retail companies—Federated, Limited, Gap, and Target—have corporate planning offices that prepare plan-o-grams that are implemented nationwide to maintain continuity in presentation.

Visual display and presentation can be a stepping stone for other creative opportunities. With continued success and experience, you might find yourself moving to the store **fashion office** as a fashion coordinator or to the marketing and public relations offices. Here creativity branches out to fashion shows, **trunk shows**, corporate image, and public relations activities involving the local community. These departments act as liaisons between the store and consumers and between the store and its suppliers.

Fashion Office
Store's fashion director and staff.

Trunk Shows
Store events in which a designer or wholesaler will bring an entire collection to show to preferred customers.

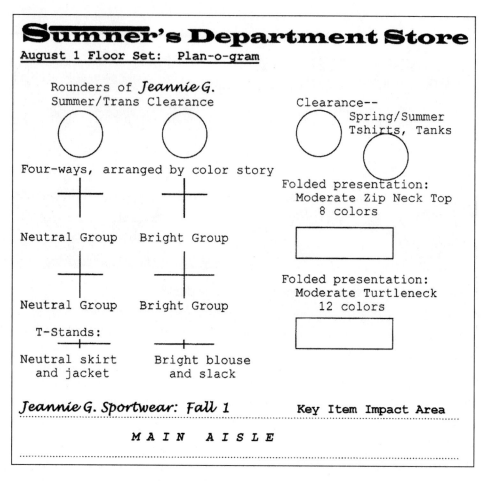

FIGURE 2-2 Plan-o-gram that is used to show each store where merchandise should be placed on the selling floor.

STAY IN RETAIL OR MAYBE TRY WHOLESALE?

Some of you will find that staying in the retail segment of the fashion industry suits you fine. Others might still be anxious to find a place in the design and merchandising world of fashion. If so, start pointing yourself toward that segment of the industry. But even after your (very helpful) experience in retail sales, don't expect to land a job as head designer for Prada—you've still got lots to learn. Nevertheless, that retail background is going to pay off immediately. It will help you land a position on the wholesale side. Here's Zach Solomon, who has been the president of Perry Ellis, Ellen Tracy, and Adrienne Vittadini: "Many wholesalers look to hire people with retail experience for several reasons:

- For their understanding of the buyers with whom they are dealing.
- For their retailer's mentality and math skills.
- For the department store training, which teaches planning and discipline.
- For the ability to visualize stock assortments by store (How is the tops-to-bottoms ratio? Skirts to slacks? etc)."

THE INSIDE SCOOP

KEN MASTER

Ken has held several jobs in the industry, including director of manufacturing for DKNY Men's.

On Persistence and Resourcefulness

After getting my B.A. in economics, I became a project manager for a mechanical construction company for five years in Philadelphia. But then I decided to change career paths and explore the fashion industry. So I got a job at The Cupcake Café at the corner of 39th and 9th on the edge of the garment district in New York City. Every time I gave someone change, I said, "Your change is $12.50, and do you have a position open at your garment business?" Sure enough, someone asked me to come in for an interview!

I ended up at a small **designer firm**, Patricia Clyne, as **assistant production manager**. They were wonderful to me! Being such a small **design house**, I became involved in many jobs, ranging from **cutting**, **sewing**, **patternmaking**, to **shipping**. There were only six of us, so we had to get involved in everything.

From there I went to Bugle Boy (at this interview I stressed that I had a full year and a half of experience). As assistant merchandiser, I learned the import end of manufacturing (10 trips a year to Hong Kong, each trip three to four weeks long!).

After another job in between and yet more experience, I began to network and was hired as corporate production manager at Donna Karan Co.

On your first full-time industry job, even with your retail experience, remember that you probably have less to offer your employer than your employer has to offer you. Stay humble but enthusiastic, positive, and eager. The more a boss sees that an employee is eager and willing, the more that boss will teach and entrust responsibility to that employee.

Remember that you are on your new job to learn, not to run the place. If the job is difficult but you are learning a lot, do your best to tough it out as long as you can. (Being able to handle a difficult situation or a demanding boss is a valuable skill—you will need it again, we promise you.)

Michael McKeithen, **CAD** designer, puts it this way: "Go for the gofer jobs. That's where you will get your initial exposure to the fashion industry. The smaller the company, the better. If you can hang out in one of these jobs, the experience you get will be worth it!"

Student Brent Vandling preparing fabric for draping.

If the situation is really bad or if you stop learning because all you're doing is straightening shelves, move on. Do not allow someone to demean you. If it is not right, it is perfectly OK to move on.

You need a training situation in the wholesale and manufacturing sector that is positive enough so that you can stay long enough to learn and start establishing a résumé with a good amount of time at each employer. May Cygan illustrates the winning attitude: "In this business, you've got to be willing to schlep! I had three other roommates at FIT who thought I was nuts to work two days a week without pay. During market weeks, I even came in on Saturdays. But during this internship, I was exposed to product development and showroom sales. As a result of this experience,

I was able to 'ace' my product development exam, without studying— while my roommates struggled." By the way, May went on to a highly successful product development career at the Associated Merchandising Corporation and at Tommy Hilfiger. Her continued demonstration of willingness paid off.

THE INSIDE SCOOP

ALISON DURRANT

Alison is a product designer for the Associated Merchandising Corporation. Her career path is a good lesson on how to find your way through the volatile fashion industry. Never discouraged when companies disappeared from under her, she alternated between big and small firms, always intent on learning something new.

I received a Fine Arts education in my native England and then went to Syracuse University as an exchange student for painting and drawing. When I was done with school, I moved to New York and got a job as a **fit model** for Leslie Faye because I was a perfect juniors size 7. The job also included duties as a design assistant, which introduced me to the workings of a fashion company: sample rooms, pattern makers, trims, presentation boards.

Fit Model
A person of the exact sample size who is used to try on and fit-test sample garments.

The designer for this division took a new job doing Christy Brinkley for Russ. She brought me along as her assistant, where I started in sweater design. She then moved to a small company on a side street in the garment district, and I came along again. The owner saw that I was eager to learn sweater design, so he sent me to the Far East.

From there I was hired by Henry Grethel as assistant designer for his women's collection. That was great until that division closed. . . but the head designer moved on to another small company, Greg's Sport, and she brought me along. There I was exposed to domestic sweater production since the factories were nearby.

Then, using contacts from my previous job, I was hired back by the parent company of Henry Grethel, Manhattan Industries, as full designer of all women's wovens for John Henry. I spent lots of time learning the specifics of patterns and sample rooms. However, this line was also phased out.

On a blind interview, I got a job as the head designer of the Skyr sweater collection. This meant two trips a year to the Far East, which was another great learning experience. After three years, Skyr closed. However, a friend from Skyr was doing some freelance work and introduced me to the Associated Merchandising Corporation. For six months I did Christmas-motif sweaters for AMC freelance, and then they hired me full time. Thankfully, it's a solid company, and I have been here eight years!

WHOLESALE AND MANUFACTURING

Wholesale
The level of company in the supply chain that produces or contracts for merchandise, which it then sells to retail stores.

Manufacturing
The actual production of garments.

There are several different kinds of jobs in **wholesale** and **manufacturing**, but they are more geographically localized than retail. For wholesale, most are in New York or Los Angeles. Actual garment-sewing manufacturers that are located in the United States tend to be concentrated in the southeast and in Pennsylvania, Texas, Florida, and California. We will now examine in general terms the types of jobs in wholesale.

Garment Design

Flat Patternmaking
Drawing pattern pieces on a flat table.

Computer Patternmaking
Drawing pattern pieces on a computer screen.

Garment Construction
The assembly of a garment; also, the level of quality detail that is included in a garment.

Fabric Construction
Technicalities of thread, yarn size, and machinery used to produce a specific fabric.

Most people have heard of garment design; many mistakenly picture this as the only job in the fashion business. Design involves creativity, including good color and styling sense. But these abilities must be combined with technical skills such as drawing, either **flat** or **computer pattern-making**, and even the fundamentals of garment construction. There is a lot of competition for these plum jobs. Be willing to start with anything remotely related and work up to a design position. The more technical skills you can acquire (**garment construction, fabric construction**), the more successful you will be when you design. "As more and more design work is done on computers, finding designers with the right balance of creative and technical skills is becoming increasingly important. Exceptional creative drawing ability is still my top priority when hiring," said Rebecca Leu, computer-aided design manager for Sears, Roebuck & Co. in Hoffman Estates, Illinois. "Gone are the days when CAD designers simply digitally replicate a hand drawing. Drawing skills are something you can't learn on the job, but you can learn the technical skills. You have to strike the right balance between creative skills and technical skills."[2]

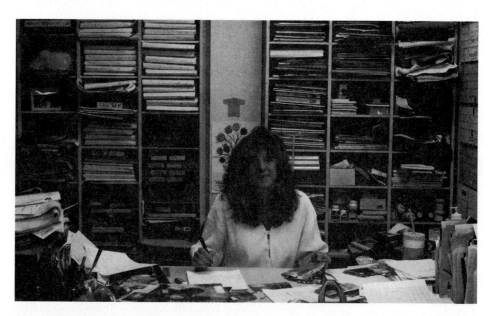

FIGURE 2-3 Designer Valerie Gary of Alan Stuart Menswear. (Yes, this is how a real designer's office looks.)

Designers must have first-rate skills to create, produce, and promote their products (Figure 2-3). But they do have help! A designer's assistant, occasionally an entry-level position, gets exposed to varied tasks. He or she "juggles a roster of jobs, from scouting fabrics, cutting sample garments and sketching models, to running interference between the design studio, where ideas germinate, and the sample room, where they take shape. But the heart of the job is to serve as antennae, picking up design and cultural signals that one's employer may be too busy, or too secluded, to note."[3]

Textile Design

A job in textile design combines pure art (pattern, print design) and technical concerns (printing techniques, weaving techniques). Many companies use freelance help to provide fabric design, particularly prints. There are large print services that show and sell thousands of print designs to mills, wholesalers, product developers, and retailers. The future for originality hinges on exciting fabrications. Many leading designers—Donna Karan, Jhane Barnes, and Pamela Dennis, to name just a few—are concentrating their efforts in textile design to create these new and interesting fabrics.

There are many other technical jobs in the fiber and fabric markets. Usually, this type of technical career starts in a technical or engineering school.

Merchandising

A merchandiser expedites the process of putting together the wholesale or private-label line. Responsibilities include planning styles and inventory quantities, delivery by delivery. Also critical is tracking the status of the line from concept to delivery. The merchandiser works closely with the designer to put the line together and with the production department to get the line made up. This is a real troubleshooting job.

Student Izabela Guta rendering a fabric print.

Original fabric and matching rendering.

Whatever goes wrong becomes the merchandiser's responsibility to fix. You must be able to work with a wide variety of people and to coax and cajole to get things done. This job is interesting because you get involved in all aspects of garment design and production. It also carries tremendous responsibility and can be nerve-wracking. For a merchandiser's job, time spent as a retail buyer is an advantage, because these jobs are somewhat related. Both require strong knowledge of assortment planning and merchandising math.

Production

Production work is mostly technical, with some candidates actually coming up from front-line or supervisory factory jobs. There are also administrative jobs that are concerned with scheduling and tracking. In the production department, people often wear many hats. Being responsible for coordinating fabric delivery to factories, scheduling raw materials for construction, and shipping finished orders to stores takes a great deal of coordination and customer service ability. A thorough knowledge of sewing and other individual production operations pays off here. In addition, this job often has to deal with the complexities of import paperwork and U.S. Customs. The production department controls flow of the product, making sure that there is always enough work (not too much, not too little) and that everyone has the right skills, training, and machinery to construct a garment properly.

Sourcing

If a wholesaler imports a line, the process is slightly different. Often the most interesting fabrics are produced in foreign countries. In addition, most garment production is done in countries with a low cost of labor. Wholesalers hire sourcers to find the new fabrics and to select the right factories for garment making. Overseas contractors must be located (*sourced*) and then controls placed to ensure that production is executed correctly at a long distance. This job requires frequent overseas travel and a sensitivity to cultural differences. Wholesale merchandising is the most direct background for this, in addition to considerable technical knowledge of both garment and fabric construction.

THE INSIDE SCOOP

DIANNE IGE

Dianne has been a buyer for the Boston Store, Milwaukee; a merchandise consultant and product developer for AMC; and head of sales and marketing for Natori. She also worked in wholesale merchandising and sourcing for Polo Ralph Lauren and Gant. She is now director of manufacturing for Talbots.

The number one quality you will need for success in wholesale is flexibility. You also have to be able to see far enough down the road to anticipate changes and potential problems—and then bob and weave to keep things on track. You've got to be proactive rather than reactive. A wholesale merchandising job is very demanding. Don't think people will thank you for keeping up with it through long hours and tremendous effort. That is simply what you are expected to do.

There are many things that come along that you can't control. You should try not to waste negative energy on these situations. Learn from experience, yes—but then let it go. If you can keep a sense of humor about these daily 'disasters,' it will be easier for everyone.

Many newcomers are excited about this opportunity to travel, but remember that you go when and where the job requires, not necessarily when and where *you* want to go. Some positions require that you be away from home as much as six months a year (although three is more common). This takes a toll, so you must realistically assess if your personal obligations will allow this type of commitment. At one time, sourcing was found only in large firms. Today the function is critical in almost every apparel wholesaler and private label retailer.

Sourcing is not a job for beginners. Probably two to three years as a retail buyer and five to eight years as a wholesale merchandiser provide a suitable background.

Sales and Marketing

Sales means selling, and it is part of the overall marketing push that wholesalers undertake to get store buyers to buy their line. Marketing includes market research (consumer and retail), the mission of the firm, and the creation of a need for the products that this firm produces. Specifically for a wholesale sales position, you must have the right personality! There are many strong salespeople in the wholesale markets, and they have spoiled the retail buyers to the point where you're probably going to have to put up with a lot from the buyers, your customers. Buyers are trained to push hard for anything they can get, reasonable or not. You will be on the other side of the table. You must walk away with some profitability left and with that buyer still a customer. This is not always easy.

A sales professional must be "up" every day. You must be pleasant to even the most unpleasant buyer. Salespeople test themselves every day. Unlike many other jobs in fashion, a salesperson does have instant gratification—when an order is placed (or instant rejection when it is not!).

Sales in the Wholesale Market

Showroom Sales
A wholesale sales position based in a showroom (usually New York) to show the line to retailers who visit.

There are two principal roles for wholesale salespeople. You could be on the staff of a designer or manufacturer as a **showroom sales** representative. This means that you are responsible for showing and selling the line in the showroom, which is usually in New York. You work closely with the buying offices, visiting buyers, press, and advertisers. You might also help coordinate fashion events during key market weeks. These representatives often also participate in regional or national trade fairs.

Commission
Percentage of the cost price that a wholesaler gives to the salesperson as payment for having sold merchandise to a retail store.

Another job in sales is that of an *on-the-road representative.* Independent sales reps often work with two or three manufacturers. A rep will cover a geographic territory and show the lines to stores in that territory. Reps make sure that merchandise is delivered and presented well and serve as a liaison between wholesalers and stores. The job of a sales rep is demanding and somewhat unstructured. Reps set their own appointments and keep their own schedules, yet they are responsible to maintain a certain volume of sales. Each manufacturer or designer pays a **commission** to the sales reps for their sales, but the reps often must pay their own business expenses and personal tax liabilities.

What sets a really good salesperson apart is product knowledge. Having been involved in design and/or merchandising is an advantage. Also helpful, again, is that retail experience! Retail buyers (your customers) will feel that you understand them and speak their language if you have been a buyer previously. A salesperson also needs a clear understanding of the retail marketplace. For example, if you sell your line to a discounter, is this going to make it impossible to sell to department stores? Each order that is written often has some sort of repercussion, good or bad. Finally, let's examine a new kind of job that has grown tremendously in the past decade.

Vendor Sales Specialist or Merchandise Coordinator

Vendor sales specialist or merchandise coordinator almost sounds like the selling specialist job we talked about under "Where to Start? Retail Never Fails!" You're right. Many people who want to move into the design field find themselves taking a retail sales path and ending up as a merchandise coordinator for a manufacturer or designer. What's the difference?

Firms including Liz Claiborne, Polo, Ellen Tracy, Donna Karan, and Nike employ specialists who are responsible for a specific geographic territory. Instead of being employees of one store, these specialists work with all the stores in a region to train the sales associates about upcoming deliveries and events. Product knowledge seminars are presented at the onset of the season so that the salespeople will understand the particular vendor's look and quality. Customer loyalty is built through trunk shows and merchandise seminars held for retail consumers.

The latest refinement is the emergence of an independent organization to provide this service to many manufacturers. Merchandising Concepts Group in Philadelphia has been operating since 1995. Nick Eggleston, a principal of the firm, describes the service as "bridging the merchandising service gap between wholesale and retail." This company contracts with several manufacturers. The staff will go into each branch of chains that carries these lines on a prescribed schedule to perform tasks such as straightening that manufacturer's fixtures, putting stock on the floor, conducting special inventories, or providing extra sales help for special promotions. These jobs provide a good introduction to the industry, and they are needed in almost every city in the country.

FASHION SUPPORT SERVICES

The industry giants in retail and wholesale depend on a varied group of independent companies and individuals who can provide fashion and retailing "intelligence." Some companies predict what colors will be popular two years in advance. Some run fashion shows. Some report on the items that have sold well in other stores. These services are of great value to companies that bet millions of dollars each season on the "rightness" of their inventories. They provide some specialized job opportunities that we describe next.

Buying Offices and Retail Private-Label Product Developers

Buying Office
An association of retail stores; used to share and provide several different services to the member stores.

A **buying office** is usually a group of retailers working together under one corporate organization. For example, Burdine's, Rich's, Macy's, and Bloomingdale's are all part of the Federated corporate buying organization. There are also offices such as Atkins (Bon Ton, Elder Beerman) or Doneger (hundreds of accounts) that have member stores but do not own them. Just as there are fewer department store chains, there are now fewer buying offices. We discuss next the two main services provided by buying offices.

Retail Consulting and Direction

The main responsibility of someone in retail consulting and direction is forecasting consumer, fashion, lifestyle, and buying trends. This research enables store buyers to select products that are right for their target market in styling,

THE INSIDE SCOOP

TONYA BOTT

Tonya picked the University of Cincinnati to get her B.A. in fashion design for one major reason: They insisted on a series of co-op jobs as part of the course. She had six different co-ops: Lord & Taylor and Neiman Marcus on the retail selling floor; AMC; assisting with product development; Sarne Handbags doing merchandise **sketching** and **presentation boards**; Edison Brothers working as **MAC illustrator** for labels and **hangtags**; and Mast Industries making size specs. She is now the women's knitwear designer for Gillman Knitwear.

Sketching
Drawing fashion figures or technical renderings of garments.

Presentation Boards
Visual aids such as pictures, drawings, and swatches mounted on foam-core boards to help illustrate a concept or a line.

MAC Illustrator
Artist who works on Apple MAC equipment, preparing graphics or illustrations.

Hangtags
Small paper tags that are attached to garments to communicate information to consumers.

On the Importance of Getting Out in the World

Lord & Taylor was my first co-op job. But I didn't know how to handle the workload. I worked so late every night that they turned out the lights on me. The security guard came around every night to throw me out. I never felt so overwhelmed! I felt a tremendous pressure to prove myself even though I didn't know what I was doing. At least one good thing happened: Because I was trying so hard, a customer went to the personnel office to compliment me on my helpfulness. They gave me an award.

Anyway, from this experience I knew that I didn't want to work in the retail end of the business. But I didn't know what I wanted. When I came to AMC, I knew right away that this was it: product development.

The co-op program was a tremendous learning process. I found out what I did and did not want to do. Then, in trying to land a permanent job, I got no response from résumés and cover letters. But I did call people I had met on co-op, and that's how I got my first job—at AMC!

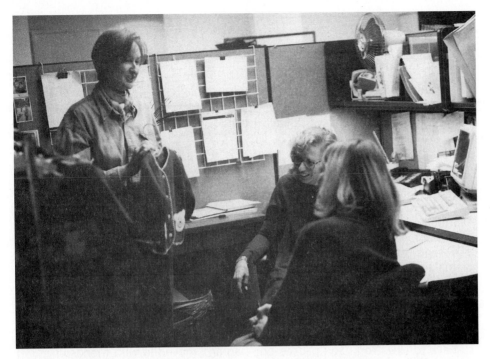

FIGURE 2-4 Tonya Bott and Geri Sussman of Associated Merchandising Corporation (AMC) discuss a proposed children's style.

price, fabrication, and color. The resident buying staff is also responsible for locating new and exciting vendors by constant "shopping" of the wholesale showrooms. They often visit their member stores to be sure they have a clear perception of the stores' profiles and customers. At times they will write "test" orders for stores on new lines, follow-up on buyers' orders, communicate between vendors and stores, and prepare for market weeks. Market weeks are specific periods when wholesalers open their new lines and out-of-town buyers travel to New York to see them. (The dominant office providing retail consulting and direction is Doneger.)

Some store groups have taken this one step further with centralized buying. The corporate (or resident) buyer has the authority to place some (or all) orders for the member stores. Strongly centralized organizations, striving for maximum clout and uniformity, use this technique. (Examples are the May Company and Federated.)

Group Product Development

Group **product development** personnel are responsible for finding, designing, and developing private-label product lines that are in sync with each member store's target market (Figure 2-4). Then they travel worldwide to find manufacturers to produce these products at competitive prices. Needless to say, this is a growing and demanding field. To some extent, stores are becoming their own product developers, thus requiring employees who understand retail, design, *and* sourcing. (Examples are Associated Merchandising Corporation and Mast Industries.)

Product Development
Creating a garment from start to finish. Done by wholesalers and private label staff.

THE INSIDE SCOOP

MAY CYGAN

May studied fashion merchandising at Ursuline College, in Pepper Pike, Ohio. Included in the curriculum was a junior year at the Fashion Institute of Technology (FIT) in New York. She graduated with a B.A. from Ursuline plus an FIT associate degree.

It was the year at FIT that opened my eyes. I was exposed to all parts of the industry (production, buying, fashion design). Two days a week I interned at Joseph and Feiss, a men's clothing maker. (This wouldn't have happened in Cleveland!)

The city intrigued me, but I had to return to Ohio to finish. My first job was for Lerner Stores in East Cleveland, preparing branches for visits by the buyers. When I met the New York buyers, I knew I had to get back to New York. So I packed one bag and moved in with friends in the city. FIT's placement office helped me land a job at Positive Attitude Dresses, as assistant to the merchandiser and designer. It was a great first job—I did presentation boards for salespeople, **swatched spec sheets** for the patternmakers, and was even allowed to order all the buttons and trim.

But I wanted more focus to my career, so I went on an interview for **technical designer** at the Associated Merchandising Corporation, even though I was not really interested in that particular job. But through that interview, I met several people at AMC, and one thing led to another, and I landed a merchandising job in **Infants**.

When I started my fashion study, I had tunnel vision like everyone else. I was sure I only wanted to work in **Juniors** on **7th Avenue**. Well, here I am in Infants, and I love it! My advice? Just try something; it might be great!

For group private-label product development, prior experience is usually also retail buying, but in some cases it can be wholesale merchandising and designing as well. Ironically, with more of the large chains pulling product development back under their corporate wing, there has been a shift, with many of these jobs moving out of New York. Some of the largest current centers follow:

St. Louis, Missouri	May Company
Columbus, Ohio	The Limited
Andover, Massachusetts	Mast Industries (The Limited)
Little Rock, Arkansas	Dillard's
Minneapolis, Minnesota	Target
Dallas, Texas	J.C. Penney

Troy, Michigan K-Mart
Chicago, Illinois Sears
Birmingham, Alabama Saks, Inc.

In the past couple of years, however, this trend has started to reverse it-self: New York is still the fashion center of the United States. As a result, many product development organizations (including San Francisco-based Gap) have established design/product development studios there.

Fashion and Color Services

Fashion and color services tend to be individuals or small companies that sell predictive fashion and/or color information to companies at all levels of the industry. These jobs are real "purist" jobs, and there are few to go around. Current providers include the people who have established themselves through decades of accomplishment as on-target color and trend forecasters. Their credibility is based on their past record of accuracy. This could be an eventual career goal after some years in both retail and wholesale. You need an in-credibly good fashion eye and lots of energy to keep selling yourself over and over. In Chapter 7 we outline some of the companies providing this service.

Fashion Promotion and Ad Agencies

Jobs in fashion promotion and ad agencies are primarily journalism jobs (copy writing) or art jobs (illustration). Remember that most artwork is now

Figure 2-5 Fashion photo by student J. Colin Dunn that captures both age and attitude of the customer.

FIGURE 2-6 Fashion photography class as photographed by student Jason VanBlaricum.

produced on computers. The most common designing programs are Adobe Illustrator and Adobe Photoshop. You must have computer skills—there is no avoiding it.

Another stimulating field is fashion photography (Figure 2-5). You must be a photographer first and foremost—fashion becomes a specialization within that (Figure 2-6). And it is one of the most exciting specializations!

If you have background or training in graphic design, writing, or marketing and want to work in fashion, know that large retailers and wholesalers tend to have some on-staff positions. Most others in the industry will use freelancers or ad agencies for this kind of help. But then there is that one

DINA COLOMBO-ROBINSON

Dina is one of the author's former students at the Art Institute of Ft. Lauderdale. She is the Marketing Director of the DKNY Jeans, Active, Junior, and Life brands.

On Hitting the Glamor Jackpot

I returned to New York after graduating. In my exit interview at the Art Institute, I was told that Donna Karan International occasionally calls for **interns**. After a week home, I called the Donna Karan public relations office and volunteered to intern for them. They needed help because the collection show was just a week away. I really wanted to work in sales, but this opportunity was in publicity. (I got a chance to try sales later and hated it!) Now, I wouldn't leave PR for anything!

In public relations, I work a lot with fashion magazines—advising on samples, working on stories. Fashion editors call, and we decide together what is best for their shoot. DKNY is also very involved in the music industry. Occasionally we would lend clothes to big-name singers. I would review head shots and listen to their music to make sure that everything fits the image of DKNY. I was also involved in dressing celebrities for the Grammys, Tonys, Emmys, and Oscars. At times I've had to fly out to California to meet them. I was invited to the Oscars and went to all the parties afterward!

Internship
Also called cooperative education. Program in which individuals work for a company in the field at a small salary or perhaps no salary to gain firsthand experience.

wonderful job that you never dreamed could be real. (See "The Inside Scoop" for Dina Colombo.)

There is one other specialized area within marketing, show promotion.

Fashion Show Promotion

There are a handful of agencies in New York and Los Angeles that specialize in organizing, publicizing, and mounting fashion shows. The leading firm in New York is KCD. When Marc Jacobs received an influx of operating capital to design the first Louis Vuitton ready-to-wear line, "he said that the extra money was used to hire the efficient powerhouse of production and public relations, KCD, and that for the first time, he wasn't spending hours worrying about staging, models, seating, and lighting".[4] To work in this field, you must be creative, original, flexible, and calm. Being fashionable in appearance also does not hurt.

This chapter has been a snapshot of what the fashion industry can offer you. If you are really interested, you must continue the research. The remainder of the book will give you a more in-depth picture of the expectations and rewards of these jobs. But only you know what is of particular in-

terest to you. You must start by bringing yourself into the industry; uncovering the specifics. What categories are hot? What jobs are available? What types of companies are hiring? What types are not?

Although there are many more, these are three good places to start your research.

- Industry newspapers
 Women's Wear Daily (call 800-289-0273 for a subscription) and *Daily News Record*, menswear version of *Women's Wear Daily* (call 800-360-1700)
 If you are serious about this business, these papers are a must. Everyone in the fashion business reads one or both.
- Books/reports on industry trends
 Standard & Poor's *Industry Surveys* (available at libraries)
 Jobs 98, Kathryn Petras, Simon & Schuster, January 1999
- Internet
 http://www.ceoexpress.com
 Look under industry-specific research, apparel, and retailing.

Now that you've had a look at what opportunities exist, let's move to Chapter 3 to view some of the changes in today's fashion industry and to learn more about the famous names on the garment labels.

Endnotes

1. Anonymous, "Retailing General," Standard & Poor's *Industry Surveys*, October 22, 1998.
2. Kim Ann Zimmerman, "FabriCAD: You Need Both Sides of Brain," *Women's Wear Daily*, July 8, 1998.
3. Ruth La Ferla, "Fashion's Best-Guarded Secret, the Assistant, Emerges," *New York Times*, December 12, 1998.
4. Amy M. Spindler, "Two Take the Money and Produce," *New York Times*, April 9, 1997.
5. Stacy Hirsch, "Job 'Shadowing' Helps Children Discover Different Paths to Success," *New York Times*, May 25, 1997.

HERE'S HOW TO BEGIN . . . CHAPTER 2

Often you will hear people say, "It's not what you know but whom you know," regarding getting a job. This statement has strong merit—and here is an idea of how you can start meeting the right people and not only learn about the industry but also meet the people who are making it happen. Industry leaders call this networking, and without a doubt it is the best way to secure a position in any industry. Develop strong networking skills as you seek part-time jobs or internships and as you grow in your professional ca-

reer. Networking will help guide you to the field that will complement your strengths. It is so disappointing to work at a job that does not allow you to grow creatively and professionally. Networking is also a great way to find out what you like and don't like.

Informational Interviews: This Is Your First Step

How to conduct an informational interview:

a. Ask your instructors, guest speakers, or even people you meet at your current job to suggest someone they might know in a field that interests you or in a field you are learning about.

b. Phone the contact person and ask for a brief meeting to learn about the industry. You are not asking for a job, so these phone calls are easy. Identify who you are, who referred you to the person, and tell him or her that you are simply looking for some advice about the industry.

c. Schedule a brief appointment. Remember that this person is taking time from his or her job responsibilities, so make sure that you are prepared.

d. Arrive on time, appropriately dressed. Make sure that you again emphasize that you are looking for advice and ask if you can take notes. Some suggested questions follow.

1. What are your job responsibilities?
2. With whom do you work or to whom do you report?
3. What are your greatest challenges?
4. How did you start in this field?
5. What suggestions do you have for a newcomer to the industry?
6. Can you recommend any other people with whom I should speak?

e. Keep the meeting brief even if you would love to stay longer. Tell the interviewee how much you respect his or her time and ask if you might return sometime.

f. Write a thank-you note. Make sure you tell the person how much you learned and that you hope to meet again. You never know—that person might be your next boss!

Try to meet at least one new person every quarter. By the time you graduate you will have many new contacts in your field, and with your education you will then be able to say that your first job came from what you know and from whom you met.

As you move through this course, we want you to continue informational interviewing, but we also want to encourage you to become as involved as possible. Take a look at some advice for the near future.

Industry Shadowing: Now It's Time to Learn Some More Details

You're probably wondering what this involvement means. We assure you it does not mean sneaking around—it means having a chance to see the "action." Here are some suggestions on how to arrange a day in the industry.

After you have conducted a couple of informational interviews, you might find yourself wanting to learn more but not quite ready to tie yourself down to an internship or part-time job. One of the greatest opportunities is to shadow someone in the industry for a day. By using the same approach as you did with the informational interviews, call someone whom you have interviewed and ask if you can spend a day observing what happens in the person's office or factory. Many college campuses have faculty employment advisors who can also assist with an appropriate contact. Again, remember to arrive on time and to be dressed appropriately. Make sure that you again emphasize that you are simply there to observe and learn, and ask if you can take notes.

Here's some advice: Stay in the background observing the people and the activity. This is a perfect entry for your fashion journal. Write your thoughts and feelings about the people, the types of jobs, and the atmosphere. What did you like? Even more important, what did you not like? When your day is over, write a thank-you note and point out something specific that you learned. You never know whom that person might be talking to in the industry.

OK, how's this for lucky? The Fresh Air Fund in New York provided a day of garment industry shadowing for their young people—with Tommy Hilfiger himself! They "learned about fabrics, dyes, product quality, and all the different jobs in the fashion industry, like working in retail or accounting, or organizing shows."[5]

Internships: This Is Your Chance to Find Your Niche Before You Look for a Job

Sometimes you will hear people call this on-the-job training and, sometimes, an apprenticeship. No matter what it is called, it can be your key to a future job opportunity. If nothing else, participating in a voluntary internship allows you the opportunity to work in several areas while you discover your niche.

Here are some suggestions about how to arrange an internship: by using your industry contacts, your school placement services, or even through a course requirement, you should dedicate a specific time to learning on-the-job, most often without compensation. Working hand-in-hand with industry professionals, watching the business operations, and helping when needed allow you to find the tempo and creativity that suits you. Volunteer eight hours a week in the industry for about 12 weeks at a time. During that time you will really "see" firsthand what a job or company is like.

Here's some advice: Try to involve yourself in at least three internships during your formal educational training. These will give you an opportunity to explore a few different fields and evaluate which avenue—retail, wholesale, or fashion support—suits you best. In the end you are far better prepared to interview; you not only know what the industry is looking for but your résumé will reflect your intensity and dedication to learning about the fashion industry.

CHAPTER THREE 3

CHANGES IN TODAY'S FASHION INDUSTRY— WHOSE LABEL IS IT ANYWAY?

When most people think about jobs in the fashion industry today, they also think about the

- Many famous designers, brands, and products;
- Names on the labels;
- Stores that sell the merchandise.

Underlying these questions is the issue: *Who actually does the work* in fashion companies? And why do some people get recognition while others do not? More questions such as the following arise:

- Does anyone ever wear the clothing I see at a fashion show or in the fashion magazines?
- How does Tommy Hilfiger have time to design all that merchandise—men's, women's, kids', and even perfume?
- Why do we never see a picture of designer Jennifer Moore?
- Does Michael Jordan really design that Nike merchandise?
- If the Gap has a designer, why isn't he or she famous?

- Is all clothing designed by an actual designer?
- Do I have to be an actual designer if I want to work with styles, colors, and fabrics?

To answer these questions, we will examine the three basic methods by which merchandise is styled, labeled, and marketed. Then we will examine some of the pressure points in the fashion industry that are currently influencing these methods and the jobs that accompany them.

Over the years, consumer lifestyles, attitudes, values, and financial needs have changed, and the apparel industry has changed with them. For centuries, apparel had been used first for practical considerations. Then it became a way to display social status. Today, it is much more an expression of *personal* choice and style. To provide all these choices, the industry has become large and diverse. It is now a global enterprise generating billions of dollars annually and providing millions of jobs. It even affects decisions in international politics.

WHO IS BEHIND THIS CLOTHING BUSINESS?

Just looking at the clothes in your own closet, you can see that there are a huge number of different clothing labels. Clothes are made in every corner of the globe and are available for purchase through thousands of stores and catalogs and over the Internet. Later in Chapters 4 and 5 we will take a close look at clothing consumers and how strongly clothing makers must pay attention to their needs and wants. In Chapter 6, we will examine the many stores that offer clothing to these consumers.

For now, it is important to answer your questions about the labels, companies, and people behind them. This will also provide you with a clearer look at some jobs within the industry. Basically, we're going to be matching the name (or brand, or label, or company) with the type of job that produces this merchandise. We'll also indicate the steps that these companies take to get their clothing to market. What you will quickly learn is that most people in these jobs are not famous! To understand this, we are going to clarify the different types of designing/product development jobs within the three types of clothing labels:

Label type 1. A working designer's own name
Label type 2. A brand or name that is different from those who design the line
 Type 2A: Generic trademark
 Type 2B: Former designer's name
 Type 2C: Licensed name
Label type 3. Private label
 Type 3A: Private-label-only stores
 Type 3B: Private label within department and discount stores

It might sound complicated, but it really is not. You already know all of these labels. You just didn't know *what type* of label they were.

LABEL TYPE 1: A WORKING DESIGNER'S OWN NAME

We'll start here first and give you a flow chart that shows the steps these designers take to create clothing and get it into retail stores for customers. The traditional process involves both a wholesaler and a retailer.

Designers working for the wholesaler create the styles and select the fabrics; the wholesaler's production staff has the clothing made by a production manufacturer; the marketing department attracts retail buyers through selling and advertising; and the customer service department handles follow-up with the buyer. Then a buyer, who is employed by a retail store, selects and buys styles from this wholesaler's line and displays them for sale in the retail store.

The sequence could be viewed this way:

Designer → Fabrics → Production manufacturer →
Marketing (sales, advertising) → Customer service → Retail store

Real designers such as Giorgio Armani, Dolce and Gabbana, Calvin Klein, Betsey Johnson, Anna Sui, Pamela Dennis, and Christy Allen establish the styles for their lines each season. Often they have talented design assistants with whom they work, but these lines are usually designed by the name designers themselves. You might find it interesting that Tommy Hilfiger *does* get involved in every style in his clothing lines. He has a large design staff, but Tommy makes all the final decisions!

Often designer-brand garments are higher priced, giving a fashion-forward consumer good quality with a recognized name. The fashion-forward consumer is a limited market base, but designers recognize that these trendsetters keep their name in the public eye, setting the stage for other, larger groups of customers to buy the designer's secondary lines. For example, a high-end trendsetting customer might buy Donna Karan Collection (those customers include Barbra Streisand, Oprah Winfrey, and Hillary Clinton). Quality is outstanding and the prices steep. So where do most of Karan's sales come from? The lower-priced DKNY line. DKNY is one of the more popular ready-to-wear lines in the market. It has the styling and "attitude" of the collection, but it sells at more affordable prices.

LABEL TYPE 2: A BRAND OR NAME THAT IS DIFFERENT FROM THOSE WHO DESIGN THE LINE

In other types of garment wholesalers, those who are involved in designing the clothing do not have their name on the label. Someone else's name, brand, or trademark appears on the label. But the process still follows the same flow chart as above. There are three different versions of this label type.

Label Type 2A: A Generic Trademark

Brand names such as Nike, Mudd, Esprit, XOXO, Theory, Izod, and Oshkosh are trademarks established by wholesalers that are used to identify their products. Usually there is a whole team of designers and merchandisers that puts the lines together each season. Nike, for example, is still driven by the founder, Phil Knight, who chose to put the name of a Greek god rather than his own name on the label. Nautica is predominantly designed by the founder of that line, David Chu. But Chu felt that the name Nautica better captured the look and feeling of his line.

Label Type 2B: A Former Designer's Name

These brands are the names of real people who are no longer involved in the designing or merchandising of the line. Some names are historical: Levi Strauss invented blue jeans during the 1848 gold rush in California and, in fact, his descendants still own and operate the company. Some names were famous designers in their time, and the name has been continued after their death. These include Christian Dior, Chanel, Lanvin, and even Gianni Versace. These "designer" names are essentially like any other generic brand name—they are styled by others.

Label Type 2C: A Licensed Name

Some working designers license their names to other companies. This means that, in return for a fee, they will give another company the right to put their name on merchandise that the company makes. This will usually be arranged with a company that makes a category of merchandise totally different from what the designer usually makes.

Many designers, including Ralph Lauren, Calvin Klein, and Donna Karan, license their names to other companies. Rather than work in an area where his or her experience is limited, the designer usually directs styling, colors, and quality, but the design team at the licensed company will be responsible to complete the job. For example, Calvin Klein is a sportswear designer, but he licenses an underwear specialist, Warnaco, to make the underwear that is marketed under his name. You see, once a designer establishes a reputation for a certain look and quality of merchandise, that designer has a built-in customer base. In many cases, customers will buy a product with the designer's name on the label *just* because of the name! Some designers are extremely careful about the styling and quality of the merchandise that will be carrying their name; others never see the merchandise. They just see the royalty check. Some "designers" design nothing—they license everything! If you were designing the underwear line, even though Calvin Klein's name is on the label, *your* name would be on the paycheck. But consider *that* status enough!

Some licensing agreements are made with celebrities, not designers. Certain famous people have an image that clothing companies want to associate with their merchandise. These individuals have little to say in the design di-

rection but sometimes get involved in marketing, sales, and advertising components of the traditional flow chart. Michael Jordan certainly does not design the underwear made by Hanes that is sold under his name, but customers eagerly seek it because of his image.

WHAT IS HAPPENING TO LABEL TYPES 1 AND 2 IN TODAY'S FASHION INDUSTRY?

The Best Wholesale Companies (Designer Label and National Brand) Are Getting Bigger

There has been a huge consolidation in the wholesale sector of the apparel industry. Business has gotten more competitive with fewer store chains to whom wholesalers can sell their fashion lines. For the most part, the strongest brands and designer names have grown rapidly; the secondary and tertiary brands have disappeared altogether.

The major channel of distribution for these wholesalers has been department stores. And much of the recent success of department stores has been due to their pursuit of (only) the hottest designer and brand names available in the wholesale market. Fashion in the past decade has been as much "name-driven" as "style-driven." Customers are demanding the right name in the label of the garment. Think of Ralph Lauren, Tommy Hilfiger, Donna Karan, Calvin Klein, Kate Spade. This also means that if a designer or brand is not well-known, stores have little interest in carrying the line.

As part of this partnership, "in-store" retail shops for these super-important wholesalers have become commonplace. This means that sections of each department store are built, decorated, fixtured, and then inventoried to the specifications of the wholesaler. The most common examples are the in-store shops for Polo Ralph Lauren, Tommy Hilfiger, and Nautica. This trend started in men's, so it is not a surprise that these designers also started in men's. The ambiance of the shop is consistent with the *designer's* image and advertising...and not necessarily with the *store's* image and advertising. Sales staff is also specially selected for these shops. The advantage to both wholesaler and retailer is that the special ambiance and display discipline greatly improve sales. Customers do not have to sort through racks of unacceptable merchandise to find what they need. Instead, if they like what Hilfiger makes, they can go to one location and see the newest offering from their favorite designer in an appealing and easy-to-shop arrangement.

The downside to this is that a department store with its row of Polo, Tommy, and Nautica shops tends to look like every other department store. Customers are loyal to the brand; the retail store where they get that brand becomes immaterial. An additional downside for department stores is that these wholesalers are expanding their *own* chains of retail stores—providing even more competition. In the trade, this is known as **dual distribution**. Nevertheless, department stores continue to expand this concept because these important designer brands are the strongest component of their current business.

Dual Distribution
When a wholesaler sells his or her line to retail stores and also sells the same merchandise at his or her own stores.

Liz Claiborne is a dual distribution whole-
saler. The line is sold to department
stores, and it is also sold directly to the
public at Claiborne's *own stores* such as
this one.

The wholesalers who find themselves with such a strong customer fol-
lowing are also expanding their success to new categories of merchandise and
new sub-segments of consumers. Ralph Lauren has successfully expanded into
jeanswear as has Tommy Hilfiger. Lauren has also gone another step by li-
censing the Jones Apparel Group to produce and market a lower-priced misses
sportswear line called Lauren by Ralph Lauren. It, too, has been successful.
The next step was a new line from Jones called Ralph by Ralph Lauren aimed
at the junior customer. Tommy by Tommy Hilfiger, for the same customer,
is also now in stores. In 1999 the Polo Ralph Lauren company also bought
the successful, youth-oriented retail chain Club Monaco to capture yet an-
other segment of the market.

Jones New York's arrangement with Ralph Lauren is just one of several
that Jones has entered recently. Here the trend is for a strong wholesaler, ex-
perienced in design and sourcing, to take on new brand or designer names
to expand its business. Jones' success with Lauren by Ralph Lauren has led
them to arrangements with Nine West (shoes) and Todd Oldham (jeans.) Liz
Claiborne branched out into non-Liz labels a few years ago, producing lines
such as Crazy Horse for J.C. Penney and First Issue for Sears. This division
has become successful lately, as has their arrangement with DKNY to source
and market the DKNY Jeans line. This has led to new agreements with Sigrid
Olsen and Lucky Jeans.

Value Squeeze

The clothing business is also undergoing a "value squeeze." Customers are
simply refusing to pay more for their clothes. Both traditional designers and
nationally renowned brands are grappling with this challenge. As you will see
shortly, the value squeeze is also a main reason why retailers have greatly in-
creased their own private label lines.

Customers today have many alternatives when they are shopping for clothes, in fact *too many*. One of the main factors in their decision is price: which store has the item they want at the best possible price? Wholesalers and retailers alike must constantly find ways to keep prices down without sacrificing quality.

This value squeeze has also forced retailers to put merchandise on sale more frequently than in the past, which has eroded their profit. **Gross margin** for department stores has declined from 36.9% in 1991 to 33.5% in 1996,[1] and the downward trend has continued since. The same trend has also happened in wholesale.

Each step in the process, from acquiring fabric through garment construction and distribution, is being examined for cost savings. Through trial and error, the industry is learning what can and cannot be cut, while still keeping the customer happy with the end product. Dale Nitschke, senior vice president of Dayton's, Hudson's, Marshall Field puts it this way: "It's the supply chain side that will be key to success in the next 20 years. You can still squeeze efficiencies out of it. The person who can deliver the fastest and best will be the winner."

"Best" means best value. If too much quality is taken out of a garment to lower the price, another problem is created. Often it is impossible to tell how a garment will perform until it has been worn and washed several times. Perhaps it shrinks, fades, or loses its shape. Brands and stores that have sold sharply priced but inferior merchandise have often been put out of business. "Best price for acceptable quality" is a fine line for producers and sellers to walk. Yes, fashion is caught in a price squeeze with labor and material costs increasing, but customers still refuse to pay more. As a result, some of the middle people shown in the flow chart are being eliminated.

Gross Margin
The measure of profitability used in the retail industry, generally expressed as a percentage of total department or division sales. It is the portion of total retail sales volume that can be considered as profit (before expenses).

LABEL TYPE 3: PRIVATE LABEL

Private label programs essentially eliminate the role of the wholesaler. Yes, someone still must decide about the styling of the merchandise, but private label lines are usually less daring than designers' lines. Yes, the merchandise still must be produced somewhere. But in private label, these tasks are performed by individuals who work directly for the retail store. They do not need to "sell" their line to the buyer because they are the buyer.

For private label, the number of steps required is fewer than in the traditional process. The work flow then becomes the following:

Product developer/designer → Fabrics → Production manufacturer → Store

Two costly steps have been eliminated from the chart on page 41:

Marketing (sales, advertising) → Customer service

The result of this streamlined process is that money is saved. The private label item can be produced at a lower overall cost than a designer brand or

Reaching new heights.

FIELD
FG
GEAR
Only at Hudson's

A well-developed men's private label program at Dayton's, Hudson's, Marshall Field, three Midwestern department stores owned by the same company.

national brand item of identical quality. The elimination of steps does not mean a lower quality of product. It just means fewer people have to be paid in the process, which lowers the cost. Usually retailers who do private label will pass some of these savings to consumers, offering them sharper values. The retailers will also retain some of the savings as increased profit. Both the consumer and retailer benefit. The wholesaler has been squeezed out! Statistics show that private label programs are now huge. Between specialty chains and department stores, the NPD Research Group estimates that in

Banana Republic would be considered a private-label-only store. Everything in the store carries the Banana Republic label.

1998, private label accounted for 32% of total women's apparel sales in the United States, or $29.3 billion.[2]

The advantages and disadvantages of private label for the retail stores that carry them will be described under "Is Private Label the Perfect Answer for Retailers?"

First, let's examine the two versions of private label: One for stores that only sell their private label merchandise and one for stores that carry designer and national brands in addition to their private label.

Label Type 3A: A Private-Label-Only Store

This category of private label business exploded during the 1990s. Private label retailers are the stores that only carry merchandise with their own label. Usually the name on the door is the same as the one on the clothing. All styles in these stores have been developed and sourced by their own product development teams. Private-label-only stores include some of the most successful specialty chains today:

Gap (including Old Navy, Banana Republic)
Limited (including Express, Structure, Lane Bryant, Lerner)
Intimate Brands (including Victoria's Secret, Bath & Body Works)
Ann Taylor
Abercrombie and Fitch
J. Crew

These stores have raised private brand development to a new level. The unified vision and control of the product, the store environment, and advertising have allowed them to project the strongest "brand" images. The Gap converted their stores to private-label-only in 1991 and never looked back!

Department stores such as J.C. Penney carry both national brands and their own private labels.

Label Type 3B: Private Labels in Department and Discount Stores

Department and discount stores carry designer and national brands, which can be bought at many different stores in a given trading area. But they also carry their own private labels (INC in Macy's, St. John's Bay in J.C. Penney, Faded Glory in Wal-Mart) exclusive to each store. The merchandise carrying these labels can only be bought in the store that owns the label. Product development teams working for stores such as Penney's or Macy's are responsible for creating a store's own private brands. For example, Worthington can only be purchased at the store that developed it, J.C. Penney.

Most department stores are also aggressively pursuing private label to counter the dominance of the most powerful wholesalers' brands such as Tommy Hilfiger, Ralph Lauren, and Jones New York. As these big national brands grow, so do the private label programs to offset them. It is said that the total retail apparel market will grow by about $33 billion from 1999 to 2003 (to $210 billion). Of this $33 billion increase, fully $24 billion will come from private label merchandise.[3]

Here are some familiar private brands:

Saks Fifth Avenue	Real Clothes
	The Works
Federated	INC
	Charter Club
	Jennifer Moore
	Style & Co.
	Clubroom
	Alfani
	Badge
Dayton's, Hudson's, Marshall Field	Field Gear

J.C. Penney	Arizona Jeans
	Worthington
	Hunt Club
	St. John's Bay
Sears	Canyon River Blues
Target	Merona
	Pro Spirit
	Utility
	Gilligan and O'Malley
K-Mart	Jacyln Smith
	Kathy Ireland
	Route 66
	Sesame Street
	Martha Stewart Everyday
Wal-Mart	Kathy Lee
	Faded Glory
	Sasson
	Catalina
Costco	Kirkland

The common assumption in the industry is that department store assortments are approximately 15% to 20% private label. If department store volume is approximately $31 billion,[4] then the private label business in these stores must be between $4.6 and $6.2 billion. Discount store private label business is even larger!

Before reading this chapter, you may have envisioned the only design jobs to be those with your name on the label. But now you can see that a designer label or national brand is a second avenue to travel. Private label's rapid growth is supporting a third avenue as well, full of different jobs, all with direct and exciting contact with merchandise. You don't need to be an actual designer to develop private label merchandise!

IS PRIVATE LABEL THE PERFECT ANSWER FOR RETAILERS?

There are several important reasons why stores have expanded their private label programs, but there are some serious drawbacks as well.

Pros

- **Exclusivity.** This is probably the leading reason given for private label. If no one else carries these items or these (private) brands, you don't have to put yours on sale the minute your competitor does.

Discounters also have their own private labels, such as Faded Glory at Wal-Mart…

…Jaclyn Smith at K-Mart…

…and Merona at Target.

- **Control.** A good brand name has consistent fit and a consistent level of quality so that consumers can count on it season after season. If a store wants to develop a private brand with the same consistency, the best way is the same way a wholesaler does—full product development from beginning to end, as we show in Unit II. The retailer will also be able to control the flow of inventory coming each month under this brand.

- **Profit.** Profitability goes hand-in-hand with exclusivity. If no one else has this item under this brand, the store can get whatever price the market will bear. Also, with the middle people eliminated, the store can take more markup. (See the section in Chapter 10 called *Costing and Pricing: Wholesale Versus Private Label.*) Even with the extra markup, most stores try to position their private label merchandise at least 25% below equivalent branded price points.

However, like everything else, private label also has its drawbacks.

Cons

- **Mistakes.** Oh, the mistakes we've seen buyers make. Until recently, buyers were never expected to be product developers. They were to sit in a showroom and pick their favorites from a line that had been put together by professionals on the wholesale team. Because there is no wholesaler in private label, if the buyer makes a mistake, there is no cushion, no partner, no markdown money from the wholesaler, no returns, no coop advertising dollars. If the goods are wrong for the customer, the buyer has to absorb the entire loss. Remember—the buyer is buying a specification product from a contractor or manufacturer. That means that if the garments come out as specified but look really ugly, that's the buyer's fault (and markdown), not the contractor's.

- **Timing.** Private label ties up funds. Most financial arrangements with contractors require that some funding or financial guarantee (often a **letter of credit**) be posted by the store at the start of the process. This process can take nine months or longer! The store's money is then tied up, which means these funds cannot be used for anything else during that (long) period. When buying from a wholesaler, stores have gotten in the habit of paying for the merchandise well after they've already started selling it. That's a big difference. Yet another risk in buying as much as nine months in advance is that fashion garments have a relatively short selling life. You might buy short skirts when they are hot, only to have them "drop dead" before you can deliver yours!

- **Inexperience.** This is no place for amateurs. As you will see in Unit II, buyers developing private label product must go through the same elaborate, involved and, above all, time-consuming process as would a wholesaler. And this is performed in addition to their normal duties.

Letter of Credit
A legal and binding agreement among (in our case) an importer, that importer's bank, and the local manufacturer. It gives manufacturers full assurance that they will be paid by the bank when they meet the obligation and deliver the merchandise.

It is hard to do both jobs well, especially because customers have learned to reject private brands that do not look as good as national brands.

Who "Creates" Private Label Clothing Lines?

As private label programs grow in size and sophistication, fewer buyers actually develop the lines as an additional job to their usual buying duties. Many department stores now have a separate staff of product managers who

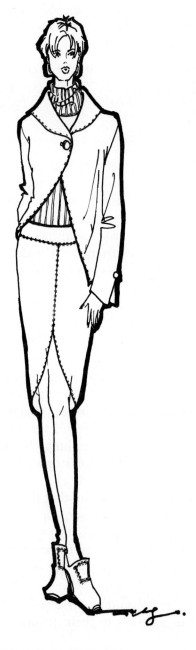

FIGURE 3-1 An actual designer tends to create sketches like this that show a mood or feeling.

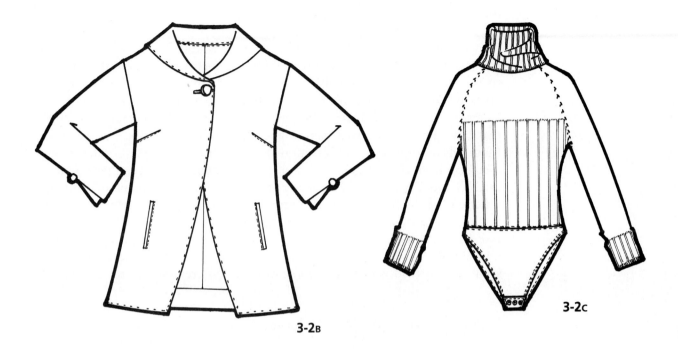

3-2B

3-2C

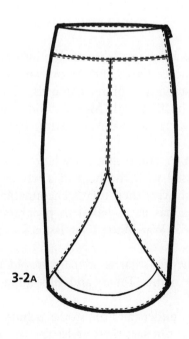

3-2A

FIGURE 3-2 Private label product developers work with technical sketches that show details of each garment. The designer sketch in Figure 3-1 and the flat drawings in Figure 3-2 are of the same outfit and both were done by student Wan Sun Chung.

develop these lines full time, as we indicated in Chapter 2. For example, Federated employs hundreds of people in product development in their New York headquarters. Private label represents 15% of Federated's total sales—more than $2 billion at retail.

Note that *private label product development is not the same as designing!* (See Figures 3-1 and 3-2.) Private label merchandise is usually less original and less daring. Customers will trust designer labels to give them the courage to try something new. Retailers develop only private label items that they know will be big sellers. They cannot afford to experiment with fringe styles. Items in a private label line are often relatively close interpretations of those that have already sold well from higher-priced branded lines. For example, Macy's INC private brand, positioned as better update, would take strong direction from the designer and bridge update vendors such as Prada, Gucci, DKNY, and Calvin Klein (see segmentation definitions in chapter 5). At the other end of the price spectrum, Target's budget update line, Merona, might be influenced by a department store update line such as Liz Claiborne. Private label product development is more creative than simply copying someone else's style, but it is also less original than creating a new style from scratch. This field is open to people of many different skills and talents.

NEWEST TRENDS IN PRIVATE LABEL

As private label programs grow in sophistication, retailers are looking for new ways to make sure their brands look as appealing as both the branded and private label competition. Many department stores are now advertising their labels and establishing in-store shops—effectively making their private labels into private "brands." In a 1998 study, Kurt Salmon Associates found that 67% of consumers believe the quality of a store brand is as good as or better than vendor's brands.[5]

In the past few years, discounters have also learned that instead of making up some generic name (Connections, Cross and Arrow, and so forth) it makes sense to license an already established brand name that has perhaps gone dormant. Target was one of the first with Merona and Gilligan and O'Malley. Others have followed, such as Wal-Mart with Faded Glory, Catalina, and Sasson.

Another arrangement is a hybrid: A brand that is exclusive to one store but that is designed and merchandised with the help of a wholesaler. The first retailer to do this was Nordstrom with their men's Faconnable line. Liz Claiborne's Special Markets Division has exploded with programs such as Crazy Horse for J.C. Penney, Russ for Wal-Mart, First Issue for Sears, and Villager for Kohl's and Mervyn's.

Finally, another variation has emerged that is actually an old idea: Co-branding. Designer name plus store name. Tahari and Bloomingdale's are sharing a joint label.

In this chapter we have helped you understand the stories behind the labels of those clothes in your closet. As you can see, these styles are created in different ways, some of which involve actual designers and others which do not.

Disney's private brand was already a well-known name before the stores were established.

Now that we have explored some of the famous (and not-so-famous) names in fashion, it is time to move on to the most important person in the entire world of fashion. No, neither Giorgio Armani nor Geoffrey Beene. The most important person in the industry is your customer.

Endnotes

1. MOR National Retail Federation, 1998, *Merchandising and Operating Results of Retail Stores.*
2. Sharon Edelstein, "Fueled by Designers, Private Label Moves to a Higher Plateau," *Women's Wear Daily*, March 1, 1999.
3. Anonymous, "Theories of Evolution," *Women's Wear Daily*, May 24, 1999.
4. Arthur Friedman, "Merger Mania," *Women's Wear Daily*, February 9, 1999.
5. Dick Silverman, "More Consumers Hopping on the Brand Wagon," *Daily News Record*, June 8, 1998.

HERE'S HOW TO BEGIN . . . CHAPTER 3

It is important to work with actual products as you compare and contrast designer and national brands with private label names. The best way is in the field. You can even keep your notes in your fashion journal. By the end of the course you will have accumulated some terrific research. Here's some advice on how to stay current.

First

Cut out two or three pictures of designer items from fashion magazines. Choose only the items that are considered a "must" for the season.

Second

Visit your local mall and try to find these items or something comparable by the designer. Take a look at the quality, styling details, and price.

Third

Visit a private-label-only store, a local department store, J.C. Penney or Sears, and a discount store such as Wal-Mart or K-Mart. Find a similar item and compare and contrast. Again look at the quality, styling details, and price. In fact, what styling ideas do you see in the designer-made products that you see in the private label products? Which do you think the consumer will think is the best value and why?

Final Thought

What fabrications and/or styling ideas are in the designer-made products that you feel could be featured in the private label brands to gain even more customer appeal/acceptance?

CHAPTER FOUR

THE CUSTOMER:
DIFFERENT GENERATIONS,
DIFFERENT MOTIVATIONS,
DIFFERENT CLOTHES

So far we've talked mostly about you. You've had a chance to see whether you are a good "fit" for this industry, and you've also had a chance to see how the industry is organized. Before you start carving your niche, think about the people for whom you will be working—no, not your employers. Your customers.

In reality the real employers are your customers. If they like your work, you will move successfully through the fashion business. Take a look at Tommy Hilfiger, Donna Karan, and Ralph Lauren. The consumer made these designers successful simply because he or she has bought and continues to buy their products. The customer has been responsible for the growth of the Limited and GAP organizations. It is the typical consumer who creates the success stories in the fashion industry, not the designer.

Do you remember the typical customer who was profiled in Chapter 1? She wants to look fashionable but not stick out in a crowd. Don't forget her, because you have to satisfy her needs, no matter how old she is or how much money she wants to spend. Before you pick up the sketch pad and start designing or move into the production market or the merchandising arena, let's take a closer look at the customers to whom you can sell and look for ways to identify different consumer groups.

DEMOGRAPHICS AND PSYCHOGRAPHICS

Demographics
The study of measurable population statistics such as births, deaths, geographical locations.

Consumer industries have many different ways to study the people who buy their products. The most common study is **demographics:** Population size, age, education, income, geographical concentration, and so forth. By studying these various characteristics, it is possible to segment the population of the United States into smaller "like" groups. These groups often share purchasing preferences.

For example, geography affects fashion. Northern retailers need to time deliveries of lightweight short-sleeved garments carefully. Too early and they will not sell in the cold weather. Too late, and the demand will soon be ending. In contrast, southern stores might carry these items all year. Conversely, southern stores generally avoid the heaviest-weight merchandise that is carried in the north.

Occupation can also affect fashion purchases. Doctors and lawyers tend to have greater need for tailored career clothing than most blue-collar workers. Ethnic background can also influence the way people shop and what they buy. "Between 1990 and 1996, some 6.1 million immigrants came to the United States. This was the highest six-year total since the turn of the century. The pace of immigration is projected to remain steady through 2050, according to the U.S. Bureau of Census. Together, Asian immigrants and Americans of Asian descent comprise the fastest-growing minority segment in the United States."[1] Surveys also indicate that these populations are concentrated in certain geographic markets. Clearly understanding these differences is important for managers of retail stores so they can stock appropriate merchandise for their particular customers.

As you can see, identifying customer segments requires detailed ongoing research. The most commonly used sources for demographic data are the following:

- U.S. Census Bureau (www.census.gov)
- Fedstats (www.fedstats.gov)
- U.S. Bureau of Labor Statistics (www.bls.gov)

We have also found helpful information from the American Apparel Manufacturers Association (www.americanapparel.org).

Psychographics
The study of personal characteristics such as lifestyles, social standing, interests, values.

Working hand-in-hand with demographics is **psychographics:** The study of more subjective characteristics of people (personalities, attributes, attitudes, interests, preferences). From the study of these characteristics, companies often discover what motivates certain customer groups to buy. For example, prestige or status brands often appeal to consumers' emotions and self-image. These motivators are different from more rational reasons such as durability, comfort, or price.

Using both demographic and psychographic studies, fashion companies can identify consumer groups that will be suitable customers for their specific line of clothing.

CLARA HANCOX

Clara spent 50 years in the menswear industry, predominantly at the *Daily News Record*, the menswear trade daily. She retired as vice president and director of publishing. Clara also worked in marketing, advertising, and merchandising for men's firms such as Cricketeer and was codirector of the Boys' Apparel Manufacturers' Association. She is acknowledged to be the first woman to report on the menswear industry.

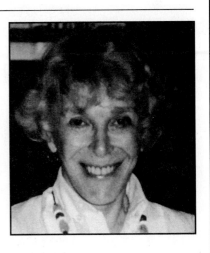

On the Sociology of Fashion

What does a person need to be successful in this business? It might sound strange but you've got to love people! A job in fashion is not like being an engineer, working in a factory with nuts and bolts. Fashion is a people product. How can you design merchandise, romance and sell it if you don't love your customer? And that means having a wide open mind toward your customer as well.

Once, during an interview with Giorgio Armani, I asked him how he knew which way to lead fashion, since he sets the trend for the entire industry. He said, "There is no such thing as a designer who designs from his head. A designer must observe the people in the streets, their attitudes, their behavior in restaurants, at social occasions, and so on. A true designer is one who can read—who can feel his public."

GENERATIONAL MARKETING

American consumers today demand good value along with innovative styling that satisfies their individual needs and matches their individual lifestyle. Product managers and designers looking for acceptance must find the "right" segment of society that will become their loyal customers. Once the consumer has responded, it is the merchant's job to create a long-term demand by providing products every season that are consistent with this customer's needs.

The most common consumer segmentation used in the fashion industry is segmentation by age group. Demographic statistics pinpoint the exact numbers of these customers.

Future Projection of U.S. Population by Age Groups[2] (In Millions of People)

Age group	Year 2000	Year 2005	Change from year 2000	Year 2010	Change from year 2000
Under 5	19.0	19.1	+0.5%	20.0	+5.3%
5–14	40.0	40.1	+0.3%	39.7	−0.8%
15–24	38.1	41.0	+7.6%	42.9	+ 2.6%
25–34	37.2	36.3	−2.4%	38.3	+3.0%
35–44	44.7	42.2	−5.6%	38.5	−13.9%

continued

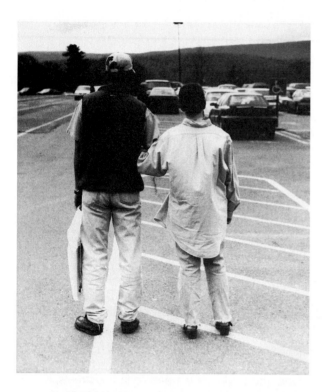

Generation Y shopping

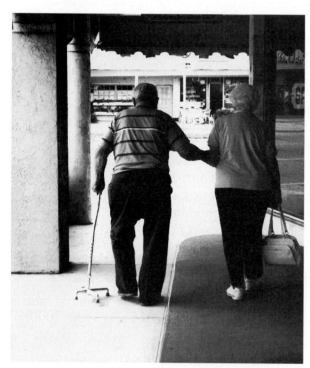

GI generation shopping

Age group	Year 2000	Year 2005	Change from year 2000	Year 2010	Change from year 2000
45–54	37.0	41.5	+12.2%	43.6	+17.8%
55–64	24.0	29.6	+23.3%	35.3	+47.1%
65–74	18.1	18.4	+1.7%	21.1	+17.1%
Over 75	16.6	17.8	+7.2%	18.4	+10.8%

Please note that the largest increases (all measured in millions of people) will be seen in the 15 to 24 age group, and in those older than 45. In fact, by 2010, one-quarter of all Americans will be 55 years or older. This has significant repercussions for all consumer products, including clothing. We will now look beyond the statistics of these groups and focus on their common characteristics and attitudes.

GI Generation (GI is an abbreviation for "Government Issue")

- Born 1912 to 1927.
- Currently this group represents about 6.7% of the U.S. population, 18.5 million people. In fact, the older than 85 age group comprises 3.8 million alone!
- Profile: These men and women were raised to save, save, save and to spend very little! This mature generation, living longer than any generation before, wants value for its money. "Government Issue" was a method of distribution during World War II, this generation's most influential event. Their attitude is that they deserve their Social Security and government benefits. Give them products that are functional and that last but are not expensive. National brands and casual styling are important; designer labels are not.
- Interests: Big Band music, AM radio, group cruises, bingo in retirement homes.
- Notable GIs: Ronald Reagan, Katherine Hepburn, your own great-grandparents!

Remember, these GI Generation customers will still be buying clothes when you get into the industry!

Silencers (post–World War II)

- Born 1928 to 1945.
- Currently this group represents about 15.5% of the U.S. population, 42.8 million people.
- Profile: These men and women save, but they also spend. The younger members of this group actually feel like a "sandwich" generation, taking care of parents and acting as "second" parents to their grandchildren. Much of their spending power is not for themselves but for those

for whom they care. Quality for the price is important to this generation. They want clothes that last without being overpriced.

- Interests: movies, reading, Frank Sinatra and Tony Bennett (for the older Silencers); Sam Cooke and Do-Wop (for the younger Silencers).
- Notable Silencers: George Bush, Jack Nicholson, Gloria Steinem, John Glenn, Tom Brokaw. Believe it or not, Elvis would have been part of this group!

The next generational group is called the Baby Boomers, yet the Baby Boomers really are split in two groups. First there are the older Boomers, affectionately called the Woodstock generation. Then come the younger, more cynical Boomers, who were influenced by Watergate and the hostages in Iran, called the "Zoomers."

Woodstock Baby Boomers

- Born 1946 to 1954.
- Currently this group represents about 12.2% of the U.S. population, 33.9 million people.
- Profile: These men and women typically spend, spend, spend—then borrow and spend more! Because of its sheer size, this generation alone is responsible for more changes in lifestyles and values of Americans than any other. When young they produced the youth culture of the 1960s. When they became parents they produced a "baby boomlet," also called the "echo boom." Vietnam, civil rights, and the women's movement created a lifestyle demanding products on this generation's own terms. Manufacturers and designers were forced to create products, promotions, and selling techniques that spoke directly to this generation. They will not only "leave their mark" on society, but they have flocked together on key fashion statements and brands. They all wore Levi bell bottoms in the 1960s, disco wear in the 1970s, and the status designers in the 1980s. In the 1990s, comfortable dress/casual subbrands such as Slates by Levi were created just for this group. It won't be long before this "graying" group will be ready for retirement. As they strive to build comfortable retirement portfolios, Boomers will find that fashion purchases will have to compete with other priorities.
- Interests: Rock and roll music (Motown, Beatles), dining out, extensive travel, movies, and sports.
- Notable Woodstock Boomers: Bill Clinton, Mick Jagger, Harrison Ford, Jane Fonda.

Zoomer Baby Boomers

- Born 1955 to 1965.
- Currently this group represents about 16.0% of the U.S. population, 44.4 million people.
- Profile: Like their senior Boomers, these men and women also spend, spend, and spend some more! But this younger wing of the Boomer

generation feels somewhat cheated by their older group members. When the national debt got out of hand, savings and loans scandals rocked the United States, and white-collar unemployment soared to record highs, this generational group felt their seniors had squandered things. For many it seemed their responsibility was to "fix" society through self-help and New Age philosophies. But now many in this group are juggling college tuition payments for their children and are beginning to worry about their own upcoming retirement. Yet just like the older Boomers, clothing brands do matter, but their brands have a hipper attitude (Guess, Banana Republic). For these Zoomers, labels such as Banana Republic separate them from the status quo established by their older siblings.

- Interests: rock and roll music (Elton John, U2), dining out, extensive travel, movies, self-help motivators, health food, and personal fitness.
- Notable Zoomer Boomers: Meg Ryan, Tom Hanks, Caroline Kennedy, and maybe even your own parents.

Generation X

- Born 1966 to 1976.
- Currently this group represents about 15% of the U.S. population, 41.4 million people.
- Profile: This generational group is probably the most misunderstood and the most complex. Although criticized for their lack of energy, direction, and purpose, they could be the most self-sufficient generation. These men and women grew up as "latchkey" kids, when their mothers entered the business world. At an early age this generation took care of younger siblings, cooked meals, and took a backseat to their parents' divorces, loss of jobs, and a downsizing economy. As a rebellion against the Boomers, X-ers demanded their own look, one that pushed aside designer labels and focused on finding a more relaxed, "who cares" lifestyle. They have saved very little money. Brand names are not as important as the fashion statement of antistatement. They started as a skeptical, pessimistic consumer group, without brand loyalty, but have since settled into a quiet complacency as jobs and families become dominant in their lives.
- Interests: rap and retro music, Hootie and the Blowfish, coffeehouses, group dating to clubs, movies, and "just hanging out."
- Notable X-ers: Madonna, Courtney Cox, Brad Pitt, and Tom Cruise.

Less Time for Boomers and "X-ers"

Before we continue to the youngest age groups, it is significant to note that recent research has shown that our current core customers, the Boomers and X-ers, are starting to slow in their shopping. For one, time is increasingly precious for those in these age ranges with job and family demands. As we said, Boomers are saving for retirement. X-ers are starting their families and saving for their children's education, be it pre-school or college. Free time

DALE NITSCHKE

Dale is the president of Target Store's new electronic retailing division. Prior to that he was the senior vice president and general merchandise manager at Dayton's, Hudson's, Marshall Field. Based in Minneapolis, Dale's skills propelled him from buyer to DMM to GMM to division president in record time.

On the Importance of Generational Marketing

Every generation wants to have attention paid to it. A retailer definitely wants to know what is really important to their guests [customers], what influences them to buy. So specialized marketing is critical.

It's funny that Tommy Hilfiger is the number one brand for Generation X. His clean, traditional look is counter to everything that Generation X says about itself. But these people still want to be part of a group. Look at Tommy's marketing. It's always a group of people. Generation X says they want to be individuals, but their desire to be part of a group is the same as everyone else's.

is viewed as more valuable than shopping time. Kurt Salmon Associates, an Atlanta-based consulting firm, found that of male and female consumers older than 21, 45% would choose more free time over money.[3] In fact, apparel sales to women in the core 25 to 44 age group dropped 3% between 1996 and 1999.[4] This all adds to another reason why the fashion industry is so excited about the next two generational groups.

Generation Y (sometimes called the Echo Boom)

- Born 1977 to 1987.
- Currently this group represents about 16.0% of the U.S. population, 44.3 million people.
- Profile: The children of the Baby Boomers, this generation is being raised in an economy unlike any before them. It has been unaffected by major wars or military conflicts. These young people are technologically advanced, surrounded with interactive toys, talking learning systems, video technology, Nintendo, Sega, cable TV, and the Internet. Even in their toddler years, they demanded Power Rangers, Nintendo, McDonald's food, and clothing that challenges with "No Fear," "Bad Boy," "Quiksilver," and "Stussy" logos. Rollerblading and skateboarding became the sports for this generation. With TV as a prime source of entertainment, these children are more name conscious, and they have parents who respond to their demands.
- Notable Y-ers: Prince William, Backstreet Boys, Korn

Recently the Y-ers have gone high-profile as the most enticing target group for retailers and other marketers. By 2005, the 15 to 24 age group will have grown by 7.6% in number. Pop culture is once again alive and well with what the *New York Times* calls the "no-complaints generation": "They're smart, ambitious, and uncomplaining."[5] They are busy creating their own world with their own heroes and ideals. Warner Brothers network focuses almost exclusively on this age group with series such as "Buffy the Vampire Slayer" and "Dawson's Creek."

Generation Y may be young, but they already have their own charge cards, bank accounts, and Internet access. Their outlook is optimistic and experimental. Although older customers might be too busy to shop, these kids are not. In a Kurt Salmon survey, 88% of young girls between the ages of 13 and 17 said they loved to shop, making 40% more trips to the malls than did other shoppers.[6]

This group is extremely knowledgeable about brands, products, and fashion (they already know the name "Prada"), but they do not want to be pandered to. Cynical about traditional marketing, the best selling approach is the anti-sell like the Sprite ads, "Image is nothing; thirst is everything. Obey your thirst."

New brand names have become red hot by capturing this generation's relatively sophisticated style cravings: Mudd Jeans, Rampage, Dollhouse, XOXO. Delia's, the catalog company turned retailer, knows how to communicate with this group, and success has followed. They plan to increase their worldwide store count from 2,111 to 5,000.

Other retailers that have their finger on this generation's pulse include American Eagle Outfitters and Pacific Sunwear. Pacific Sunwear plans to expand from its current 342 stores to 700 in 2001. They also recently entered an agreement to produce and distribute Vans apparel, a line geared for hard core board and skate fans known as "shredders."

Ralph Lauren hopes to vault over its dependence on Boomers with the first outside acquisition in its 32-year history: The Club Monaco chain of fashionable but affordable clothes for Generation Y. Companies such as DuPont (who produces and markets Lycra) are probing the psyches of these kids through under-18 consultants.[7]

And how important is this group to the profits of fashion companies? "In 1997 (latest available), the 24.8 million Americans aged 13–19 spent approximately $122 billion at retail, of which 33% was spent on clothing."[8] No one can dispute that these are staggering statistics for a generation that has yet to enter the job market full time.

Generation Z

- Born 1988 to ?? This group will enter its adult years between 2010 and 2015.
- Currently this group represents about 17.7% of the U.S. population, 48.9 million people.
- Profile: We are just starting to learn about this youngest group, but one thing we know already. They are *very* informed. These children did not

just grow up with computers—they grew up with Internet access. Chances are the Internet will be significant in their fashion education as well.

Generation Y companies have already started expanding into clothes for these pre-teens. XOXO (in sizes down to 00), Rampage, and Dollhouse have girls lines. Delia's, Generation Y's catalog of choice, has a new catalog called Dot Dot Dash for Generation Z.

One of the quickest industries to respond to the girls of Generation Z was cosmetics. Bonne Bell is a leader not only with their established Lip Smackers line but also with product offerings for 6- to 12-year-olds such as Cosmic, Bottled Emotion, Flower Buds, and NailGear. In the past years, total sales for Bonne Bell jumped 51% to $64.4 million.[9]

Many products for this young customer feature special tastes and flavors. Club Monaco has scaled-down versions of its sophisticated clothing ready to

IN GREATER DEPTH

LEVI STRAUSS: CAN A BRAND BECOME COOL AGAIN?

Levi Strauss and Company has hit a rough patch. The $6 billion casual apparel maker had been riding high for years as the "coolest" jean brand for the giant Baby Boomer generations. But as one rather harsh magazine article states, "sometime around 1990, a great brand began coming apart at the seams. Levi's market share among males ages 14 to 19 has since dropped in half, it hasn't had a successful new product in years, its advertising campaigns have been failures, its in-store presentations are embarrassing, and its manufacturing costs are bloated."[10] We think that is overstated, but Levi did seem to lose touch with its youngest customers.

Rap music slowly crept into the mainstream during this period, bringing along its baggy, drooping pants. Small companies like JNCO recognized this shift; Levi did not. Levi's retail distribution was 85% in department stores, including J.C. Penney. Not only were these stores "un-hip," they also started competing with Levi with their own private label jeans such as Penney's Arizona, now a $1 billion line.

Suddenly, Levi Strauss became everyone's favorite case study of a company that had lost its cache. Not about to take this lying down, Levi is planning a comeback based on some interesting market insights about Generation Y.

- Micromarketing. Levi realizes that kids don't wear the same brands as their (Baby Boomer) parents. This means totally new brands might be required to make an impression on this new set of customers. They have investigated the possibility of buying an already established Generation Y brand such as Ecko Unlimited. They are also experimenting with a non–Levi-identified subbrand called Red Line.

- Stealth Marketing. Generation Y kids are so savvy about media campaigns that it is almost impossible to advertise a brand into "coolness." Levi is trying a concept called "viral marketing." *Women's Wear Daily* described viral marketing in June 1999: "Rather than hitting consumers over the head with consistent messages in the public eye, they deliberately go underground and create a puzzle for the target market that lives there."[11] The technique involves "wild postings" or unbranded posters put up in urban areas, messages on websites not identified with the brand, and subtle messages on late-night cable stations. These cryptic clues are intended to start word-of-mouth about the brand, allowing new customers to uncover the brand for themselves.

roll out to stores for boys and girls. Many feel this age group has the potential to provide a spending boom in fashion brands and related businesses.

In addition to the differences among the generations, there are also similarities. In fact, there are two subtle lifestyle changes that are affecting all segments of the U.S. consumer base. These changes must also be factored into the thinking and planning of fashion wholesalers and retailers.

CONSUMERS OF ALL AGES HAVE NO TIME TO SHOP!

All Americans are leading increasingly busy lives. Two-income households are the norm, so everyone ends up with less time. One casualty of this time crunch has been shopping time. Survey after survey show that women are not spending as much time shopping as they have in the past. So they are generally spending less money on certain products as well. Apparel is one of the losers. According to Kurt Salmon Associates, 53% of customers surveyed were shopping less than they once did to save time.[12]

Increasingly, shopping trips are planned around convenience: Convenience of parking, of getting in and out, of selection, of paying. Fewer shoppers want to spend the day strolling around large, fancy, and complicated department stores. The formats that score high points for convenience (discounters, specialty chains) are also the formats that are recording the biggest sales increases.

CONSUMERS OF ALL AGES ARE DRESSING MORE CASUALLY

Another pervasive change has happened in the past five years: More work environments are allowing their employees to dress casually. Companies started by encouraging employees to dress down on Fridays as a way to boost morale. Employees liked it so much that dress down is now the norm all week at many companies. This has had a profound effect on the men's tailored business and on women's career clothing.

These consumers are your real employers. We have categorized them by age, but it does not stop there. Other demographic and psychographic factors such as geography, income, attitudes, and common interests also influence buying habits. Each subgroup thinks differently about many things, especially clothes. We will look at some of these other factors in Chapter 5. Bottom line: You cannot create one line that appeals to all groups. But you can create a line that meshes with one group's image and needs. If you can really get into the heads of those specific consumers, you can produce the clothing and products that they will want. This is known as **niche marketing** or **target marketing**. Remember what we said in Chapter 1: Fashion is a business, and to have enough business, you must have many customers. Each generational group is a sufficiently large niche to produce enough customers for success. And in Chapter 5, we will uncover some other viable niche markets.

Niche Marketing, Target Marketing
Strategy of selecting a narrowly defined group of potential customers and styling a line to appeal to their needs and preferences.

Now where does this take you? You're still not ready to make the leap into design and manufacturing, because the next step is very important. Once

you know who the customers are, you must find where they are spending their money and how much they are spending.

Endnotes

1. "Standard and Poor's, Retailing: General," *Industry Surveys*, May 20, 1999.
2. U.S. Bureau of Census, Resident Population of the U.S., Middle Series Projection, 1999.
3. Anonymous, "Clothes Buying Down for Core Females," *Women's Wear Daily*, February 16, 1999.
4. Anonymous, "Clothes Buying Down for Core Females," *Women's Wear Daily*, February 16, 1999.
5. Ian Fisher, "The No Complaints Generation," *New York Times Magazine*, October 5, 1997.
6. Noreen O'Leary, "The Boom Boom Tube," *Adweek*, May 18, 1998.
7. Penelope Green, "Meet Kara and Lynn, 'Mainstream Cool Teens,'" *New York Times*, May 23, 1999.
8. "Standard and Poor's, Retailing: Specialty," *Industry Surveys*, May 22, 1999.
9. Laura Klepacki, "Bonne Bell's Second Life," *Women's Wear Daily*, May 21, 1999.
10. Nina Munk, "How Levi's Trashed a Great American Brand," *Fortune*, April 12, 1999.
11. Kristi Ellis, "'Viral Marketing' Creeps In," *Women's Wear Daily*, June 3, 1999.
12. "Standard & Poor's, Apparel and Footwear," *Industry Surveys*, October 1, 1998.

HERE'S HOW TO BEGIN . . . CHAPTER 4

This chapter has focused on people: Learning their likes and dislikes. If you know your customer, you certainly have a better chance of producing and promoting products that will be sold successfully. One of the best ways to get to know people is right in your own classroom. Don't think meeting new people is the only thing we are talking about. It is also important to learn something new about people we already know. Product managers and manufacturers are always looking for something new that will appeal to their steady customers. In fact, it probably is true that every one of us has turned to a good friend or neighbor and said to them: "I didn't know you liked. . . ." Let's take some time and apply some informational interviewing techniques right in the classroom.

First: Meeting Someone New

Interview someone in your class that you don't know well. Prepare your questions and have the person describe for you his or her likes and dislikes about key topics: School, work, cars, and even hot-point topics such as politics, gun control, and drugs. Based on this information, develop a shopping profile. In other words, decide

1. What types of products would this person like to buy?
2. What is important to this person about the products he or she is purchasing? What is not important?
3. Where do you think this person likes to shop? Try to figure the amount that he or she spends. (Remember, people do not have to pay top dollar for top names anymore.)

Second: Learning Something New About Someone You Already Know

Now, here's the real test. Interview someone you think you know pretty well. Prepare a few questions that deal with the future. You might want to ask what the person would like to be doing in five years. Where he or she would like to live? Ask about something that he or she finds to be annoying and something found to be enjoyable. Really focus your questions on the person's lifestyle. Then, based on what you already know and with this added information, create a customer profile for the types of products that this person would like to buy, and identify the key features for which the person is looking, including price.

Third, Learning About Someone Outside Your Group

Finally, for a real generational approach, interview someone outside your peer group. This is all important, because as you move through Chapter 5 you will learn about fashion taste and price preference and how these factors identify where people shop.

CHAPTER FIVE

HOW MUCH DO CUSTOMERS SPEND AND WHAT SENSE OF STYLE DO THEY HAVE?

We've looked at *one way* the industry segments customers into "like" groups: by generations. Within the industry itself, another segmentation based primarily on price and style has become the most common. These are the market segments you will read about in *Women's Wear Daily* and other trade publications.

Here are the market segments in descending order of price:

- Couture
- Designer or pret-a-porter
- Bridge
- Better and contemporary
- Moderate
- Discounter or budget

Let's take a look at each.

Top End of the Women's Market: Couture, Designer, Bridge

Couture

Couture is the stratosphere of women's apparel. It is custom produced by a handful of designers for a tiny core of elite fashion customers. (Some estimate the total number of couture customers worldwide to be just 2,000!) Designers must be approved by the trade organization, "Chambre Syndicale de la Couture Parisienne," showing that they meet special criteria. There are 18 houses, including Christian Dior, Yves St. Laurent, Givenchy, Chanel, and Christian LaCroix. The runway styles are often extreme, but they influence future fashion styling worldwide. Even though couture dresses can cost as much as $50,000 each, this is not a profit-generating business. Most of these shows are essentially advertising and image building for that designer's lower-priced lines and licensed items.

Couture
Also called "haute couture," an elite group of fashion houses in Paris that custom make clothing for wealthy individual patrons.

Designer-owned specialty store.

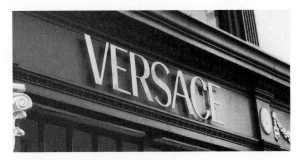

Designer-owned specialty store.

Designer-owned specialty store.

Designer-level department store.

Designer

Pret-a-Porter
Literally "ready-to-wear." A group of high-end fashion designers distinguished from couture because their merchandise is produced in quantities rather than custom made.

Designer or **pret-a-porter** is the next level down in price. These are the commercially produced garments that produce profits for the designers (at least they usually do). Designer shows are held in Paris, London, Milan, and New York and feature all the status designers who have become household names (to those interested in fashion): Armani, Gucci, Prada, Gaultier, Mugler, Kenzo, Donna Karan, Calvin Klein, Ralph Lauren, and Geoffrey Beene.

All fashion students should go out of their way to look at designer garments in person. Stores such as Neiman-Marcus, Saks, and Bergdorf Goodman carry this price level. It is usually a little less intimidating to browse through these departments in a larger store as opposed to a small boutique. Remember that these ensembles can sell for $5,000 and more! The fabrics are superb—very different from the fabrics that are used at lower price points.

Designer is the core of the international fashion scene. The designer runway showings are followed in great detail by all industry members. Their influence is profound. The affluent customer base has been growing worldwide, and the United States is no exception.

Bridge

Bridge collections are the next step down. These are the more "affordably" priced lines, often by the same designers, that are distributed primarily through better department stores such as Macy's, Marshall Field, and Lord & Taylor. These include such lines as Donna Karan's DKNY, Calvin Klein's CK, Anne Klein's A-Line, or exclusively bridge lines such as Ellen Tracy, Tahari, and Dana Buchman.

Better and Below

The next three steps down in price represent huge numbers of customers. They are called better, moderate, and discounter or budget. These three price levels are so large that the market splits each of them more finely. Within each, they identify customers with different senses of style that can be grouped into a taste and price grid.

FIGURE 5-1 Nine-square customer grid.

FIGURE 5-2 Approximate distribution of customers over the nine-square grid. The darker the square, the greater the number of customers.

FIGURE 5-3 Direction in which fashion moves across the nine-square grid.

Please note: We are now using the term "discounter" to identify the budget level of the business. Previously, department stores carried all three price ranges: Better, moderate, and budget. Today, they have largely abandoned the budget price points. Remember that there are vast numbers of people who prefer to pay these lowest prices. This is where the giant discounter chains such as Wal-Mart, Target, and K-Mart have jumped in. They offer clothing at low (budget) prices, and they sell enormous quantities!

PUTTING PEOPLE IN BOXES

With the huge number of customers in these price zones, remember that every person has his or her own personal taste. Mass media and other fashion influences have standardized taste to a degree. The incredibly large and diverse U.S. market is easier to understand by using a grid with two key parameters: price and **taste level**. Before you start examining the charts, let's examine each component.

> Price. How much do people want to pay? High, medium, or low? Or—as stated in the industry—better, moderate, or budget?

> Taste level. What "look" are they searching for? One that identifies their personality? How daring are they in fashion: **Conservative**, **updated**, or **advanced**?

The best way to understand how these customers fit on both scales is to arrange them into boxes forming a grid (Figure 5-1). Most customers will fit into one of the nine squares. Some can also shift between a couple of the

Taste Level
A measure of fashion savvy and awareness; the ability to dress stylishly and appropriately.

Conservative
A customer who is cautious about fashion and who does not want anything too trendy or odd.

Updated
A customer who follows fashion and dresses with an eye to fashion but does not want to appear extreme.

Advanced
A customer who "lives" for fashion and dresses in the latest style no matter how it may look to others.

FIGURE 5-4 Updated customer will wear a top that is only somewhat tight.

FIGURE 5-5 Whereas the advanced customer will wear a top that is quite tight.

squares, depending on time or occasion. For the sake of simplicity, let's assume that any one person fits into just one box. (By the way, where do you fit?)

As you learned in Chapter 1, more customers are at the lower end of the price scale and taste scale. In the industry it is felt that most of the general populace would probably fit in the four lower left squares. (We bet that wasn't where you put yourself.) Again, remember the amount of business that the discounters have at the budget levels. Figure 5-2 shows an approximate visualization of the distribution of numbers of customers. The darker the square, the greater the number of customers. In other words, the bulk of the retail clothing market is either budget/discounter or moderate in price and conservative or updated in taste. Both better price customers and advanced taste customers are a distinct minority. (Is this where you are?) These

FIGURE 5-6 Again, the updated customer will wear only somewhat oversized.

FIGURE 5-7 Whereas the advanced customer will wear very oversized.

minority customers are highly influential, however. They are the trendsetters who will eventually influence even the least sophisticated end of the market.

Through time, fashion tends to filter down our grid in the direction shown in Figure 5-3. As fashion moves down and to the left, it becomes more watered down as well, but there will still be some traceable element of that original fashion vision left.

Let's take a look at Generation Y's favorite wardrobe piece, a crop top. Advanced is the most extreme taste level—if the newest look is tight, advanced is the tightest (Figures 5-4 and 5-5). Similarly if the newest look is oversized, the advanced look is the most oversized (Figures 5-6 and 5-7). It is the same with skirt lengths: Advanced is *whatever length is newest*. If the newest trend is toward short, the advanced customer will probably wear short

FIGURE 5-8 This hem length is about as daring as a conservative customer will want to go.

FIGURE 5-9 Whereas the advanced customer will be comfortable going even shorter.

skirts immediately (Figures 5-8 and 5-9). Can you think of a *current fashion item* and identify its most advanced version? Then try to identify the interpretation of this look for the updated customer and the conservative customer. The same theory applies in jewelry, accessories, shoes, and other non-garment categories. Just for fun, we found some student versions of conservative, updated, and advanced in one of our classes (Figures 5-10 to 5-12). How about your class?

GARMENT CHARACTERISTICS FOR EACH CUSTOMER SEGMENT

Make
Construction of the garment; "full make," for example, has lots of fine details built in.

Garment construction, or **make**, is probably the most important to a conservative customer. They expect to be able to wear the garment quite a long

FIGURE 5-10 Student Josie Miller gives us an example of conservative. Nothing extreme about this outfit…it looks perfectly appropriate and understated.

time, so it must wash well and stay in shape. The customer most concerned with excellent make and excellent quality fabrics would probably be the better conservative customer. She is looking for beautifully finished, timeless garments that display a certain status yet can be worn for a considerable time (Figure 5-13). This is how many picture the wives of most U.S. presidents; however, do not include the late trendsetting Jackie Kennedy here—think more of Nancy Reagan.

Figure 5-11 Student Madelene Semeria could be viewed as updated because of the fit of her outfit (tightish) and the fashionable but not extreme styling of her top (cap sleeves, Y neck).

Cachet
Prestige and special approval.

Conversely, the advanced customer is sometimes more interested in the "look" of the garment rather than the make (although not always, especially at the better end). The style and trend **cachet** is what she wants primarily,

Figure 5-12 Student Mandy Li had this advanced outfit custom made in Hong Kong. The unusual asymmetrical styling, very short skirt, and bold belt set it apart as advanced.

which means that she probably will be moving to a newer look soon (Figure 5-14). Some general guidelines for three of the most contrasting customer types are found in Figure 5-15.

FIGURE 5-13 A better conservative dress.

Figure 5-14 A better advanced dress.

	Conservative	Updated	Advanced
Better			**Look:** could be extreme color, pattern, texture **Fit:** very current, a bit extreme **Performance:** not important, could be handwash or dry clean **Make:** interesting, but less important than the look
Moderate		**Look:** stylish color, pattern, texture **Fit:** stylish but not extreme **Performance:** easy care or somewhat more delicate **Make:** good, serviceable	
Budget/Discounter	**Look:** totally understandable color, pattern, texture; a look that has been around awhile **Fit:** ample, comfortable **Performance:** wash and wear **Make:** sturdy, simple		

Figure 5-15 Garment characteristics for three of the nine customer types.

HOW WHOLESALERS ADDRESS THE CUSTOMER TYPES

We talked about wholesalers in Chapter 2. These are the companies that design and sell lines of clothes to retail stores. They will generally aim their apparel to one segment of customers. Most wholesalers have learned that the best way to market their clothing to appropriate customers is to "position" themselves on this same nine-square grid. If they keep their merchandise consistently positioned as, say, moderate update or better advanced, retailers will know how to handle the merchandise in their stores and customers will understand also.

Note that the "better advanced" square has its own name in the industry. It is called **contemporary**. This is a closely watched and highly influential segment of the market. It also extends downward in price toward moderate in some stores, but for the sake of simplicity we will leave it in the "better advanced" square.

A trap into which some manufacturers and designers fall is to have a line that tries to appeal to too many different customer types simultaneously. Another mistake is to change too quickly among segments. The best brands, those that stay consistently popular over the course of years, are generally those that have stayed true to their customer base in both taste and price. There are some exceptions, such as Ellen Tracy, that have slowly traded up in price or taste, but they are exceptions.

The other tendency is to trade a label down in price and quality, which usually results in an immediate boost in sales as the loyal customer perceives a sudden bargain on their trusted brand. As soon as the customer becomes disappointed with the cheapening of a garment because of a change in fit or fabric, he or she will walk away from that brand. Seventh Avenue is littered with brands that have been ruined in this way.

To help you better understand each segment on the customer grid, we put brands in each box in Figure 5-16. This will give you the "flavor," based

Contemporary
Segment of the ready-to-wear market that features advanced, stylish merchandise usually at better price points.

	Conservative	Updated	Advanced
Better	Ralph Lauren Jones New York	Liz Claiborne Carole Little	(Also known as Contemporary) BCBG Theory Laundry by Shelli Siegel
Moderate	Chaus Lauren by Ralph Lauren Alfred Dunner	Emma James by Claiborne John Paul Richards	ABS
Budget/discounter	Kathie Lee (Wal-Mart)	Russ (Wal-Mart)	

FIGURE 5-16 Women's wear lines for eight of the nine squares on the grid.

on names with which you are probably familiar. Actually, you can split market giants such as Liz Claiborne even further into their sub-brands. For example, Russ, one of Claiborne's special market brands, is distributed in Wal-Mart for the budget/discounter updated customer. Liz's division, Dana Buchman, would go above our chart into the "bridge" price points as described earlier. The reason is that each of these brands can then stay true to its own customer base. In this way, the corporation of all Claiborne brands can cover a diverse market without confusing either their retail stores or their customers.

SIZE AND FIT SEGMENTATION IN WOMEN'S READY-TO-WEAR

People come in all shapes and sizes. That's why clothing also must. The U.S. market, being incredibly diverse, has a wide range of body types and sizes to cover. As the industry started to come to terms with this, it quickly realized that there were millions of customers who had been having trouble finding clothes that fit. These "special sizes" provided more growth during the 1980s and 1990s than the "regular sizes."

A breakdown for women's ready-to-wear sizing follows. Each segment is sized differently and is usually housed in different locations within a department store. In addition, each segment usually requires its own marketing strategy.

THE INSIDE SCOOP

NELIA WATTEN

Nelia started in retail at Bloomingdale's. After stops at Bradlee's and the Madison Avenue shop of Dianne Von Furstenberg, Nelia came to AMC and worked with the fashion "guru" Bernie Ozer. She now develops specialized products for a large American department store chain.

On the Changing Junior Customer

Today's junior customer is more like the junior of the 1960s and 1970s. She wants to be different, have attitude, be a little funky. Ten years ago, the junior and her mother wanted to be "pals." The mother looked like the daughter; the daughter looked like the mother. They both wore leggings and oversized sweaters.

In the 60s and 70s, juniors had more taste, style, and dressing was fun! Then they became serious and everyone looked like everyone else. But in just the last couple of years, every junior looks different again....They are not all in the same "uniform." They want to make their own mark, have their own "website" of fashion. I predict the junior business will get strong again. We always thought juniors was a "size" thing. No. It's a "head" thing. Juniors should be fun, passionate, and outrageous!

Missy or Misses

Missy is the regular fit in ready-to-wear. This is a mature female with an average height of 5 feet 6 to 7 inches. Sizes usually range from 6 to 16.

Petite

The petite customer is similar in build to the missy customer, except that she is generally shorter than 5 feet 4 inches.

Women's (or Large) Sizes

Women's sizes are for larger or more ample customers of more-or-less average height. Sizes range from 14W to 24W. U.S. women, on average, tend to be slightly heavier today than even in the 1960's and 70's. "Delta Burke, who designs a plus-size line that bears her name, said the demand for more fashion has made creating her collection a lot more fun. She added that 'the stores are coming around' to demanding sexier styles."[1]

Juniors

It can be argued that the junior segmentation is based both on size/fit and on "fashion attitude." Juniors are usually young, not-fully-developed females with a slightly higher waistline than that fitted by the comparable missy size. Junior departments in department stores offer sizes 3 to 13, which fit distinctly differently than the fuller missy sizes. In addition, junior departments feature fast, trendy, and usually less expensive clothing. The juniors business turned red hot in the 90s thanks to fast-growing Generation Y. Again there was a fit and look distinction for younger females that fueled the rapid growth of lines such as Mudd, XOXO, Dollhouse, Roxy, Coolwear, Paris Blues, and Tommy Jeans.

OTHER BUSINESSES HAVE THE SAME SEGMENTATION

Even in women's accessories (scarves, jewelry, sunglasses, shoes, bags) and intimate apparel, there are the same grids with equivalent brands. For ex-

	Conservative	Updated	Advanced
Better	Etienne Aigner	Enzo	(Also known as Contemporary) BCBG
Moderate	Dexter	Unisa	
Budget/discounter	Cherokee (Target)	Merona (Target)	

FIGURE 5-17 Shoe lines for seven of the nine squares on the grid.

Men's specialty chain store.

ample, shoe brands are plotted in Figure 5-17. You might not be familiar with all these brands (a shoe expert helped us). It might be interesting to check these names (or other shoe brands) in the mall and put them on your nine-square grid.

IT'S THE SAME IN MEN'S

In menswear the market is more heavily concentrated in conservative and updated. Actually, the foundation of U.S. menswear taste is something called **traditional**, which carries pretty much the same fashion credibility as advanced. Brooks Brothers is probably the best-known traditional men's merchant. Traditional has its own fashion vocabulary that evolves and updates itself by following its own set of rules. The number one rule in traditional menswear is although color and fabric can be quite daring, the model (silhouette) of each garment rarely changes significantly. Think of a button-down shirt: The styling doesn't change, but you've all seen them in surprising colors such as bright purple or coral! This is a typical menswear fashion update.

Traditional
In menswear, the classic button-down, chinos, striped-tie look exemplified by Brooks Brothers or Polo Ralph Lauren.

	Conservative	Updated	Advanced
Better	Polo Nautica	Kenneth Cole Claiborne Perry Ellis	DKNY CK
Moderate	Chaps Levi Arrow	Ron Chereskin Dockers	Guess YMLA
Budget/discounter	Manhattan Route 66 (K-Mart)	Merona (Target)	

FIGURE 5-18 Men's lines for eight of the nine squares on the grid.

The differences between the names on the grid are perhaps more subtle than in women's wear. In men's, fit and comfort still generally outweigh style when it comes to the purchasing decision. As a result, there tend to be fewer new design ideas that men will feel comfortable wearing. Figure 5-18 illustrates some well-known brands on the menswear version of the grid.

Young Men's

Young men's is the menswear equivalent of juniors in women's. It is designed to fit a younger body shape, which can mean baggy if young people are wearing baggy or tight if young people are wearing tight. Often the fit is more extreme than in men's, one way or the other. Young men's is also usually either updated or advanced in taste, not conservative. Just as in juniors, this category is exploding because of the growth of Generation Y. Lines like Ecko, Tommy Jeans, and Fubu cater to this customer.

KIDS ARE A LITTLE LESS COMPLICATED

In children's wear, there tend to be fewer taste-level distinctions. Children's clothes tend to be "cute" rather than fashionable. However, all three price ranges are present, with the better end being popular for gift-giving. Kids' brands are shown in Figure 5-19.

When you get to girl's sizes 7 to 16 and boy's sizes 8 to 20, style does start to become more of an issue, reflective of the trends in junior's and young men's. Here's how Dennis Abramczyk, senior vice president of Stage Stores of Houston, explains it: "Price segmentation also exists in kidswear (budget–moderate–better). But the size of better is very small. In general, price is the key motivator in kid's. There are certain exceptions where a customer is willing to pay a little more, like girl's dresses and special-event dressing. But in general, a customer who wouldn't shop a mass merchant store for herself is very ready to buy her children's clothes there."

So now you know that in addition to the age and generation of the customer, the two parameters of price and taste level are also essential in identifying customers' buying decisions. Now that you also know how the

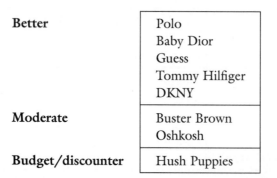

Better	Polo
	Baby Dior
	Guess
	Tommy Hilfiger
	DKNY
Moderate	Buster Brown
	Oshkosh
Budget/discounter	Hush Puppies

FIGURE 5-19 Kid's lines for the three price ranges.

wholesale market segments itself to cater to individual customer groups, let's examine how this affects the retail stores that actually sell this clothing to consumers.

Endnote

1. Anne D'Innocenzio, "Fashion Injection for Plus Sizes," *Women's Wear Daily*, June 19, 1999.

HERE'S HOW TO BEGIN . . . CHAPTER 5

It is time to have some fun and build your own boxes. Write your favorite TV character on a piece of paper. Based on the character being portrayed, briefly list as much of the following information as possible.

Age:
Occupation (on the show):
Favorite hobbies:
Favorite music:
Type of car:
Three words to describe the character:

Now fit the character into one of the boxes on our nine-square grid. Go back and identify the clothing brands the person would probably purchase and then the types of stores in which he or she would shop. As a class, see if you can fill all nine squares of the grid with different TV characters. Then choose both lines and locations that each character would select to fulfill his or her shopping needs.

CHAPTER SIX

6

WHERE ARE CUSTOMERS BUYING THEIR CLOTHES?

As we have seen in Chapter 5, it is important for wholesalers to know *how much* customers want to spend on apparel, and *what level of fashion savvy* they possess. The next step is to find out where they have bought and will buy this merchandise. Successful wholesalers must make sure that their clothing is shown in shopping districts and retail stores that fit with the price and taste level of their line. If the merchandise, store, and customer do not fit, the clothes won't sell! In Chapter 8 we will learn about a test that can be applied to see if all three components fit. First, let's learn about the different places that Americans buy their clothes. (Even though we will start with stores, there are other places as well!)

STORES FOR EVERYONE!

No matter what people want to buy, no matter how much they want to spend, there is a store that will fill their needs. Different categories of clothing stores have evolved since 1818 when the first American store to sell ready-made apparel was founded: Brooks Brothers in New York. Before that, clothes were either homemade or tailor-made.

Specialty chain store.

We will briefly examine the dominant retail categories that carry apparel.

Department stores
Discount stores
Specialty chains
Small specialty stores and boutiques
Designer-owned specialty stores
Off-price stores
Warehouse stores
Factory outlets
Catalogs (direct merchants)
Hybrid stores
Telemarketers
Electronic retailers ("E-tailers")

WHAT DIFFERENTIATES THESE CATEGORIES OF STORES?

Retailers must know who their customers are so that their products and customers match. For wholesalers it is critically important to understand the different types of stores to ensure that the retail store matches the same "grid box" (see Chapter 5) as their line. A manufacturer or designer can have a hot line for the right target customer, but if the line is in the wrong store, it will fail.

Department Stores

Generally, department stores are large emporiums that carry both soft goods (apparel, accessories) and hard goods (home furnishings). They usually offer a broad selection of brand-name and designer-name merchandise, and most have their own private label merchandise as well. They tend to cover multiple price ranges (usually moderate and better) rather than concentrating on

THE INSIDE SCOOP

KIM ROY

A graduate of Skidmore College, Kim worked as a buyer at Abraham & Straus and then in various (and constantly ascending) ready-to-wear positions at AMC, culminating in vice president and GMM. In 1995, she joined the Liz Claiborne organization as vice president of merchandising. One year later she became president of special markets (Emma James for department stores, First Issue for Sears, Russ for Wal-Mart, Crazy Horse for J.C. Penney, Villager for Kohl's and Mervyn's). Each of these lines has been successful in their respective retail stores. In 1999 Kim was given additional responsibility as group president of the Liz Claiborne special markets and accessories divisions.

Each store that we work with markets itself differently. Kohl's, for example, focuses on convenience for their customer: Easy parking, easy for parents to negotiate the aisles with strollers, and so forth.

However, each of these stores wanted a line from us that has current updated styling reflective of the Liz Claiborne company. All customers are more fashion savvy today. If a look is hot, say boatnecks and capri pants, you will find interpretations of this same look in Bergdorf's, Bloomingdale's, and Target. So each line that we developed was inspired by our Liz heritage, but "tweaked" to fit the price points and lifestyle of the consumers shopping these distribution channels.

For J.C. Penney, Crazy Horse is a lifestyle brand with elements of classic sportswear, knit dressing, and denim—all color keyed. This line has been so successful that Penney's awarded us both their "Vendor of the Year" award and their "Precision" award for the best launch of a new line.

For Kohl's, Villager plays a slightly different role: It is the fashion lead-off brand covering looks from career to very casual. This is the best formula for them.

At Sear's, First Issue became the fashion flagship brand. The fashionability of the merchandise plus the credibility of the Liz association has become a magnet to lure customers in from the mall.

Each line has "like" product categories and a similar fashion attitude, but at different levels of sophistication depending on the customer profile of that retailer.

just one price point (for example, just moderate or just better). Customer service (help in selecting merchandise, alterations, and so forth) tends to be a high priority for these stores. In these industry giants you will discover Boomers, Silencers, and GIs shopping next to each other.

In the past, there was a clear distinction between local or regional department stores (for example, Macy's) and national department stores (J.C. Penney, Sears). Today, with consolidations and expansions, this distinction is basically gone: Macy's/Federated is no longer regional, for it has approximately 400 stores in 32 states.

The top four department store chains in descending volume order are Sears, J.C. Penney, Federated (Bloomingdale's, Macy's, Burdine's, Lazarus,

Department store.

Discount store.

Rich's, Bon Marche, Stern's), and May Co. (Robinson-May, Hecht's, Kaufmann's, Strawbridge's, Filene's, Lord & Taylor).

Discount Stores

Discount stores are large-format stores that also offer a wide range of soft goods and hard goods (appliances, hardware, and so forth). However, unlike department stores, they offer no-frills service (essentially self-service) and low prices. These stores operate on lower **mark-ups** than department stores (and in most cases than specialty chains) but make up for this with huge retail volume. In addition, they have such large buying power that they can negotiate very sharp prices from their suppliers.

As a result of this format's dependence on large volumes, it is dominated in the United States by a handful of powerful giants. The number one chain in volume is Wal-Mart, which is also the largest retail organization in the world. The next largest discounters are K-Mart and Target.

All generational groups frequent these stores for specific categories of merchandise. However, when it comes to apparel at discounters, customers still tend to favor basics like underwear, socks, and T-shirts, casual styles such as jeans, or activewear. Many will hesitate to select dressy or better-priced apparel that must be placed in a shopping cart next to the potting soil and potato chips.

Mark-Up
Difference between the retail price and the wholesale cost; always expressed as a percentage of the retail price.

Specialty chain store.

Small specialty boutique.

National Specialty Chain Stores

The main hallmark of specialty chains is that they specialize in a narrower assortment of merchandise than do department stores. They can be very narrow (for example, only sophisticated men's and women's casual apparel at Banana Republic) or they can be somewhat broader (men's, women's, and kid's apparel and accessories; intimate apparel; cosmetics at Gap). In all cases they do *not* cover the wide range of merchandise categories nor the wide range of price points that department stores do. Generation X found its styling at Express and Victoria's Secret. Generation Y is fueling the success of Club Monaco, Delia's, and Pacific Sunwear.

Specialty chain stores might offer strictly branded merchandise (Toys Я Us), strictly private label merchandise (Gap, Abercrombie & Fitch), or a combination of the two (Wet Seal). Customer service levels also tend to be quite high in specialty chain stores, particularly because the stores tend to be smaller than other formats.

A new subcategory of specialty store chain has emerged in the U.S. marketplace in the past 10 years: The category killer. This is a store that stocks an extensive assortment within its target merchandise category. It tends to overwhelm the competing assortments in department stores or in small specialty stores. (They are called "killers" because they often put smaller competitors out of business!) Examples of category killers are Toys Я Us for children's toys, Bed Bath & Beyond for linens and domestics, and Lechter's for housewares. There are few "category killers" in apparel because this market is much more segmented by price and taste level. The closest store to a category killer in men's is Men's Wearhouse, which has become dominant in budget/moderate men's tailored clothing.

The top four specialty chain stores in descending volume order are Limited, Gap, Intimate Brands (Victoria's Secret, Bath and Body Works), and Venator/Foot Locker.

Small Specialty Stores and Boutiques

This is the traditional format of a one- or two-unit privately owned local fashion store or boutique. Whereas this category used to be represented in every

Designer-owned specialty store.

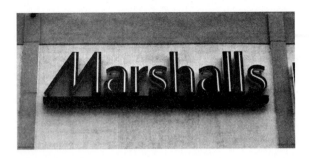

Off-price store.

large and small U.S. city, its numbers have been severely cut by the dominance of the newer, larger national formats listed above. Many of these small stores still exist, mostly if they have an especially unique merchandising perspective. (For example, very advanced fashions for a local student population or better conservative styles for older, affluent suburbanites.)

Designer-Owned Specialty Stores

Designer-owned specialty stores are regular-priced stores that carry only the labels of one designer—owned, operated, and promoted by the design house. These stores enhance a designer's image and generally reflect the most accurate representation of the designer's "vision." Examples are Versace, Prada, Armani, Krizia, and St. John. The Boomers with their newly found affluence in the 1980s established this marketplace. Today this store type survives because of the advanced/better image, and there are a few customers for this merchandise in all generational groups.

Off-Price Stores

Off-price stores have had ups and downs over the past 15 years. The basic premise is that these stores buy merchandise from wholesalers or jobbers who are eager to dispose of it for various reasons (too late in the season, excess inventory, and so forth). Off-price stores, however, are very choosy about such merchandise: Their best success is if the merchandise carries a designer or other highly sought-after label.

Service levels are basically nil: Customers must pick through pipe-racks of rather jumbled merchandise. Concrete floors and little visual merchandising ambiance signal "low prices!" to customers. Many traditional retailers tried this format in the 1980s only to find that the supply of desirable merchandise was too irregular on which to build a large business. As a result, there has been a significant consolidation in this retail format. (Smaller chains have mostly disappeared.) The top retailers in this group are TJX (Marshall's, TJ Maxx) and Ross stores.

Warehouse store.

Warehouse Stores

Warehouse stores are also based on large (national scale) volumes and nonexistent customer service. The stores are giant, the atmosphere is strictly utilitarian, and inventory is stacked on shipping pallets throughout the store. These stores charge an annual membership fee (usually about $25–$35) and allow only members to shop there. What customers find is rock-bottom pricing on a disparate range of goods (grocery is dominant in this format). However, for each item, selection might be limited to just one or two brand names. Apparel is a profitable category for these retailers, but their reputation is usually stronger in grocery, small and medium-size appliances, and automobile care.

Again, based on the scale required to be successful in this format, there are only two giants left in the warehouse category: Costco and Sam's Club (division of Wal-Mart).

Factory Outlets

Factory outlets exploded in the 1980s and are now settling into maturity. Growth is harder to achieve because the entire country is now more or less saturated with outlets.

Wholesalers first used a handful of company-owned outlet stores to dispose of unwanted merchandise outside the trading areas of their regular retail store accounts. However, customers responded so enthusiastically to the deeply discounted brand and designer name merchandise (30–50% off and more) that an entire factory outlet mall industry developed. These malls would feature a row of shops, each owned by a famous brand name or designer (Liz Claiborne, Van Heusen, Polo, and so forth). Demand was so large that these wholesalers had to make merchandise especially for these stores and hire buying/merchandising staffs for them.

Famous department stores (for example, Saks Off Fifth, Neiman Marcus Last Call) also got into the act, opening their own "outlet" stores for clearance merchandise. Customers drove long distances to shop at these (remote)

Factory outlet store.

Hybrid store.

mall locations, so soon there were outlet malls near every major city in the United States. This competition, combined with sometimes inferior "made up" merchandise, has led to stagnation in this category.

Outlet volumes are usually not split from the parent corporations (wholesale or retail), so it is difficult to judge who the top volume producers are. Certainly Polo Ralph Lauren, however, is one of the most dominant. This format appeals to the bargain hunters in each generational group.

Catalogs (Direct Merchants)

Catalogs have been part of the U.S. retail scene since pioneering days: The Sears Roebuck catalog serviced the needs of a population that was widely scattered throughout distant rural areas. The 1970s and 80s saw an explosion of catalogs. But they too became saturated, and consolidation followed in the 1990s. The main drawbacks for catalog shopping of apparel continue to be the customer's inability to feel the fabrics and to be sure of the fit. As a result, catalogs have always had to deal with a high return rate.

Some retailers in other formats have continued their catalog operations (J.C. Penney), whereas others have dropped theirs (Sears). Among the merchants who distribute primarily through catalogs, the largest are Spiegel (including Eddie Bauer) and Lands' End.

Hybrid Stores

Does this mean that one store falls exactly into one and only one definition? Nothing is ever that clear-cut. For example, Saks Fifth Avenue and Neiman Marcus are department stores and also specialty stores. They both cater to a specific target market, with high levels of customer service, but are much bigger than most specialty stores. They could be considered specialty department stores or "limited line" department stores.

The larger the store, the more squares on the grid it will probably cover. However, even in such a case, and much like the wholesaler's sub-brands, stores usually segment into departments that appeal more or less to one box. Department stores have found that putting merchandise of various price

DENNIS ABRAMCZYK

As you heard in Chapter 2, Dennis has a long history at the famous Midwestern department store, Carson Pirie Scott, and is now at Stage Stores, Houston.

> Segmentation is critical to the success of a department store. It creates focus. If you don't have focus in your business, you won't be successful . . . you can't be all things to all people.

> A customer looks for "clarity of offer." If your offering is not clear, you end up with a confusing mix of merchandise that isn't appealing. In addition, you won't have a big enough or broad enough selection at the price level your customer is willing to pay.

> Department stores also need to segment by category of merchandise. For example, designer sportswear lines (where the name and label are very important) are distributed to fewer competitors. That means the department store carrying it will achieve differentiation, which sometimes allows for more price "flexibility." However, on a generic staple category such as turtlenecks or T-shirts, the label is not important to the customer. What they want is their size, reasonable quality, good colors, at a sharp price. And here department stores struggle, because other stores (Target, Kohl's) are better known for sharp prices and good values.

ranges and taste levels side by side on the selling floor is almost always a mistake. Customers get confused and walk away. It is better to group "like" merchandise into separate departments.

Telemarketers

Direct selling from television channels (QVC, Home Shopping Network) caused a huge flurry of activity in the early 1990s. Were traditional stores dead? Would most customers abandon the rigors of a shopping trip and replace them with a TV, a cup of coffee, and their phone?

After all the initial excitement, this retail avenue has settled into a relatively small niche. The usual catalog-type drawbacks of not touching and not trying on are indeed issues for many customers. In addition, this type of show-marketing requires customers to view long selling periods of items that might not be of interest to get to something they really want. Judging from the styles being offered, the GI and Silencer generations seem to be the most responsive.

Electronic Retailers ("E-tailers")

Shopping over the Internet is *the* hot topic in retailing today. Bottom line, investors are eagerly plowing millions of dollars into electronic retailers even though few can produce a profit. The first dominant Internet selling was generated by the book market (amazon.com, barnesandnoble.com). Apparel

e-tailing is still in its infancy, but the first signs of major success appeared in the Fall/Holiday 1999 season.

The Gap seems to have successfully piggybacked its website onto its powerful retail store format. Lands' End (http://www.landsend.com) has also had good results. Being catalog merchants, Lands' End knows how to "talk" to customers using print and pictures. They are using different body-shaped "models" on line to help customers find the correct fit in tricky categories such as swimwear.

Victoria's Secret got a lot of mileage out of a live on-line fashion show. Their site has been heavily visited. Wal-Mart's site is also said to be getting heavy traffic. REI, the outdoor retailer, has been successful in a small way with their website, but it is coming at a higher cost than via their traditional retail stores.

Federated Department Stores is aggressively pursuing their Internet connection through their acquired Fingerhut division. Fingerhut will also be providing order fulfillment services for Wal-Mart. Federated has also purchased an on-line bridal registry.

Other retailers are joining into Internet groups. Fashionmall.com has both retailers and wholesalers listed. Global Sports is the website for four different sports retailers: Athlete's Foot, Jumbo Sports, MC Sports, and Sport Chalet.

Another company, bluefly.com, has been growing rapidly by offering designer goods off-price. However, Bluefly has still not produced a profit.

At this early stage, we guess that the youngest generational groups (X, Y, and Z) will be the most comfortable with purchasing apparel on-line.

WHICH RETAIL FORMAT SELLS THE MOST?

A trade organization, the American Association of Manufacturers of Apparel, estimates that total apparel sales in the United States in 1997 were $170 billion.[1] The following breakdown by type of retail store is generated from their data.

RETAIL SALES OF APPAREL BY MAJOR OUTLETS (IN BILLIONS OF DOLLARS)

	1997 SALES	% OF TOTAL
Discount/outlet stores	$54	32%
Specialty stores	$37	22%
Department stores	$31	18%
Specialty chain stores	$28	16%
Direct mail/catalog	$10	6%
Other	$10	6%
Total	$170	100%

Note that individual specialty stores still rank very high because of their sheer number in the United States. This does not contradict the fact, however, that they are closing at a rate much higher than any other format. These figures will show a huge shift in the next 10 years.

Note that the American Association of Manufacturers of Apparel also breaks this figure down by gender/children's.

RETAIL SALES OF APPAREL BY GENDER/CHILDREN'S (IN BILLIONS OF DOLLARS)

	1997 SALES	% OF TOTAL
Women's apparel	$90	53%
Men's apparel	$51	30%
Children's apparel	$29	17%
Total	$170	100%

HOW DO DESIGNERS AND WHOLESALERS FIT INTO THESE STORES?

Looking back at the market segmentation in Chapter 5, we can line up the most common retail outlets for each price level of business (Figure 6-1). Granted, some of these can be argued, but this does provide an approximate guideline.

Having neatly laid out the categories of stores by price zone, let us quickly acknowledge that there has been a dramatic shift in shopping habits over the past few years. People today, regardless of income, tend to shop just about anywhere. They no longer patronize only one type of store. The same customer might buy a suit at Nordstrom but get her undergarments at K-Mart. This does not mean that Nordstrom and K-Mart are carrying the same price levels or taste levels. But it does mean that it is getting harder to classify customers as strictly one-price-category shoppers. Even New York City has seen the range of retail increase. There were always expensive stores in Manhattan, but mega-discounter K-Mart also moved in during the 1990s.

Even with all these changes, the fundamentals of being a good buyer have never changed. There are certain retailing principles that always lead to success. We thought it would be helpful, because we are examining the different store categories, to listen to a retail industry veteran's common-sense approach to buying. These basics, unfortunately, seem to be getting lost in today's world (see "The Inside Scoop" for Ted Shapiro, p100.).

Now let's bring ourselves up-to-date on some of the latest developments in U.S. retail stores. This dynamic field is changing rapidly. If you are considering a job in retail, you should know what is happening to this end of the industry.

PRICE LEVEL	CATEGORIES OF STORES
Couture	Custom-made clothing that is not sold in stores; customers are fitted directly in the designer's studios
Designer	Designer-owned specialty stores Fine department stores Small specialty stores and boutiques
Bridge	Department stores Small specialty stores and boutiques
Better and contemporary	Department stores Specialty chains Small specialty stores and boutiques Off-price stores Factory outlets
Moderate	Department stores Specialty chains Small specialty stores and boutiques Off-price stores Factory outlets Catalogs (direct merchants) Telemarketers Electronic retailers
Budget/discounter	Discount stores Specialty chains Off-price stores Warehouse stores

FIGURE 6-1 Where different price levels of apparel are sold.

THE BIGGEST STORES ARE GETTING BIGGER STILL

Not too many years ago, every community had its own local department store plus an array of "mom and pop" specialty stores. Sure there were also the mass merchants such as Sears, J.C. Penney, and Montgomery Ward, but even they carried special items for each local audience. Now the smaller operators are mostly dropping out thanks to mergers and acquisitions, leaving only the strongest national retailers who keep getting bigger. Consumers today have more shopping options than in the past. In fact, they have too many! The amount of retail space per person has risen 36% between 1986 and 1998 to an incredible 20 square feet of selling space for every man, woman, and child in the United States. Over the same period, the sales per square foot has fallen 16% in inflation-adjusted dollars.[2]

TED SHAPIRO

Another of those famous Abraham & Straus (A&S) trainees, Ted rose in his career to be merchandise manager in the Budget Store. A&S in those days was known as the best-run store in its aggressively competitive marketplace. After A&S, he went to Gertz Department Stores and then to AMC as divisional vice president of menswear.

On Knowing Some of the Often-Forgotten Basics of the Business

"Day-to-day rightness" is what a good buyer should aim for. At every point in time, you need to have the "customer preference" items, in all sizes and colors. A "customer preference" item is hot, timely, and semi-fashion; and it's also usually seasonal in nature. The "Member's Only" jacket was a perfect example. Customer preference items usually have their day…and then they either become a basic or they get phased out completely. They are different from basic-basics such as socks and underwear, for example.

Overbuy and overemphasize these customer preference items. If you think you can sell 50, buy 75. You'll figure out how to sell them! Put these customer preference items out at a reasonable price every day. They'll sell. And hopefully you can find one in each classification to lead the department.

Next you've got to learn to buy "narrow and deep." Some buyers overassort [buy little bits of many styles] because they think it is safer to have a little of everything. This is wrong. It just leads to markdowns. One style of 100 pieces is easier to sell than 10 styles of 10 pieces—because on the one style, you will at least have a full color and size assortment to offer. And the more times you reorder, the more correct your inventory will be.

Consider these facts:

- Of the total apparel industry's retail sales, the top 10 retail chains (J.C. Penney, Wal-Mart, Target, K-Mart, May Company, Federated, Sears, Limited, Dillard's, and Gap) captured 47% of the entire business in 1998. As recently as 1990, these stores had captured only 35% of the total;[3]

- In 1997 there were more than 15,000 retail bankruptcies;[4]

- Twenty years ago, Wal-Mart was a factor only in limited markets in the southern United States. In 1999, Wal-Mart was the largest retail organization in the world with 3,400 Wal-Mart discount stores, 500 Sam's Club warehouse stores, and more than 500 supercenters that include groceries. In one year, Wal-Mart has sold over $500 worth of goods for every single American.[5] Wal-Mart intends to become a global retail brand and has opened stores in China, Germany, the United Kingdom, and Korea in addition to joint ventures in Mexico and Brazil;

Department store.

- The Gap's phenomenal success across all formats (Gap, Banana Republic, Old Navy) is fueling aggressive growth plans. In 1999 alone, more than 500 new stores were being added and 100 stores expanded, and advertising expenditures were budgeted at a whopping $550 million.[6]

The largest retailers in each format enjoy several advantages:

- Their huge buying power gives them an extreme advantage in price: Wholesalers and manufacturers must strain to meet the prices demanded by these mega-retailers;

- Their volume allows them to stay up-to-date in information systems, which has proven to be a huge benefit. Large retailers can demand that their suppliers connect to their own computer systems to speed the replenishment process;

- Their volume and geographical spread allow them to advertise more effectively. Generic television advertisements featuring Wal-Mart's roll-back of prices create a clear and motivating image in consumers' minds. Old Navy can create its own demand through item advertising (for example, board shorts and tech vests).

Most industry observers feel that there is still more consolidation ahead. Many believe that in the near future we will have four or five department store chains, two or three discounters, and about two dozen specialty chains. These retailers will span the entire country. Even 15 years ago, few would have predicted that the chains of Federated (Bloomingdale's, Lazarus, Rich's), Allied (Stern's, Bon Marche), and Macy's would be merged into one nationwide mega-company! Even country boundaries no longer contain retailers, as we have seen in the case of Wal-Mart. The Swedish furniture chain IKEA has stores in virtually every part of the globe.

What in the World Is This Leading to?

Everything in life is cyclical. We feel that as soon as the retail market is dominated almost totally by a handful of huge stores, the time will be exactly right

for small companies to pop up with an original concept, or with an offering needed in just a small local area, or that find some other niche. For example, Claire's found an unserved customer with their catalog and stores full of fun accessories for girls between 9 and 18. There will always be room for a fresh retail concept. We will explore some of these options in Chapter 19.

Dale Nitschke, president of Target's e-tail venture, put it this way: "On a grand scale, it's true that the big will get bigger. Stockholders will continue to want a return on their investment. And technology is becoming so important—and expensive—that only the big guys will be able to afford it. Still, there is room for smaller players to survive and succeed. Guests [customers] are always looking for unique fashion and a personal touch. The 'Big Guys' struggle to deliver that."

OK, So What Does All This Mean?

Let's take a look at where you are now. In Unit I, you have learned that a career in the fashion field is filled with multiple avenues and opportunities. But as in any other field, things are changing rapidly.

- Wholesalers (designers, merchandisers) must keep a sharp focus on the consumer segment that is their customer base. And in more cases, they might have to create different lines under different names or brands to appeal to more than one customer segment.
- Retailers also must be in close contact with the people who shop in their stores. With the growth of private label, this becomes doubly important. What do these customers want in styling, color, price? Recently, we can add brand or designer name to the list of things those customers are seeking. Even discounters must offer status names such as Martha Stewart.
- Fashion students must understand what produces business (and lots of it!).

Here's your bottom line:

- Yes, you like clothes;
- You follow the fashion reports in the newspaper;
- You are a good dresser;
- Now you know that designers and product managers can find success creating garments for a wide variety of design firms, national labels, and private labels, big and small;
- You also know that your real employer is the customer, who either buys your ideas and makes you a success—or rejects your ideas and shoots you down.

You also know that you still have much to learn before you take the world by storm. In Unit II you will learn *exactly how product managers and wholesalers create garments* that appeal to the target customer, at the right price, at the right time, and in the right store. Hold on, because it isn't as easy as you might think.

Endnotes

1. http://www.americanapparel.org/gen_info_stats_home.htm, accessed May 19,1999.
2. "Standard & Poor's, Apparel and Footwear," *Industry Surveys*, October 1, 1998.
3. Anonymous, "NPD: Dept. Stores Taking a Bigger Slice of Apparel Pie," *Women's Wear Daily*, April 30, 1999.
4. Philip Black, *The Apparel Strategist*, March 99.
5. Ibid.
6. Anonymous, "Gap's $1B Budget to Fund Growth, Ads," *Women's Wear Daily*, April 6. 1999.

HERE'S HOW TO BEGIN . . . CHAPTER 6

Match Game

Now that you know the different types of customers, different price levels of business, and stores that sell apparel, it is time to put it together. The best way is to look at the stores themselves. Can you see the match among customer, wholesaler (and/or private brand), and store? Here is an exercise to help structure that information for you.

Pick a store, and then select a department within it.

If you pick a large store such as a department, discount, or off-price store, you will need to narrow your focus to one or two departments. For example, if you select Macy's, then zero in on just moderate misses casual sportswear, men's better sportswear, or girls 7–14, for example. The same applies if you select other large stores such as Wal-Mart, Target, Marshall's, Sears, or J.C. Penney. (For the purposes of this project, *do not select a private-label-only store* such as Gap, Old Navy, Limited Express, and so forth. We will be looking for all the labels that stores carry, and, as you know, these stores carry only their own label.)

Once you have selected your store and department(s), answer the following questions.

1. Name of store:
2. Name of department(s):
3. How would you describe the customers shopping in this department?
4. Where would you position them on the nine-square grid?

5. Do the store and department fit into the same square in terms of overall price, atmosphere, and display? If yes, describe how these elements match the consumer base. If no, what does not fit, and why do you feel that way?

6. List five of the labels that you find in this department (include a private label too, and please note that it is a private label). For each label, look at the prices, colors, and styles of the garments. Does each one fit with the customer in this department and with the store in total? Does each label also fit into the same grid square? What is it about the garments that tells you this?

UNIT TWO

2

THE PRODUCT DEVELOPMENT PROCESS

CHAPTER SEVEN

RESEARCH: PUTTING OUT FASHION "FEELERS"

No matter where you are working in the fashion industry, you must have a vision for the future that is firmly rooted in the past. Everyone in the industry starts after some type of research. Research can help you with the past, present, and future. Reliable information becomes the starting point to the following:

- Reflect on past successes and failures,
- Measure current customers' wants and needs,
- Balance future challenges and changes.

From that point, a sensible plan can be set in motion for upcoming seasons. Future planning is often termed *forecasting*. To forecast effectively you must first understand what you are researching and why. These issues of *what* and *why* are generally followed by the question of *where* to start. From that point, you must make sense of the data and use it correctly to develop and promote products successfully in the marketplace.

In Chapters 3–6 we focused on the connections among products and consumers and stores. More than likely, you feel a sense of relief because you know "That's how it all fits together!" However, along with the relief

you are probably feeling some frustration and may be wondering, "Just *how* am I supposed to know all of that?" This chapter is going to show you the steps to take:

- *Why* the data are important;
- *What* you should research;
- *Where* you should look;
- *How* you should begin.

You too will be able to make well-defined decisions as you design/develop products by learning to analyze and interpret the strengths, weaknesses, needs, and opportunities of the following:

- Economic trends;
- Industry trends and key companies involved with textiles, apparel, technology, and retail;
- Consumer groups;
- Lifestyle trends;
- Fashion trends—from both the wholesale and retail perspectives.

As you work with research sources, you will see how the labels we discussed in Chapter 3 evolved, how the customer groups we identified in Chapter 4 have been determined, and how their attitudes served as a foundation for the purchasing decisions reflected in Chapters 5 and 6. You will also quickly see how these researching skills will help you tremendously as you look back to job opportunities mentioned in Chapter 2.

Is this a lot to learn? Well, you might surprise yourself at what you already know. If you have been developing a journal as you are working through this book, you are already involved in the research process. Your personal curiosity is uncovering articles about buying habits, fashion trends, and store news. That information alone will serve as a wonderful foundation for your own designs.

Actually you are doing more than researching. You are also developing an excellent habit of gathering information. Someday you might work for a firm that does not have the latest computers or the largest marketing/sales staff. Those may be variables that are unequal and that you cannot change. But no one person or company can have more information than another. Ultimately that information which will help you forecast cutting edge fashion may be the most important ingredient for success. Dig in and learn as much as you can about *why* you should research, *what* you should research, and *where* you should look. And we will be right there to help you at the end of the chapter with some advice on *how* you should begin. First we'll start with the economy.

ECONOMIC TRENDS

Why You Should Research—Economic Trends

Every day our lives, our ability to buy a home or car, to apply for school loans, to get a raise, and even to buy something from the local department

store is affected by the health of the economy. We are not just talking about economic health of the local business community but the economic health of the world. We know that which happens around the world can certainly affect our daily habits and purchases.

Economic research defines consumer confidence and consumer buying power. From that you can further research how industries are growing based on consumer needs and demands. In the fashion market, the health of the textile, manufacturing, and retailing industries must be measured before designers and product managers make decisions on what to manufacture and sell. Beyond our personal dollar-and-cent involvement with budgets and checkbooks, it is important to become familiar with shifting stock markets, consumer confidence, and capital investments. All these affect job market opportunities based on the long- and short-term outlooks of economies worldwide.

Yes, the fashion business is affected as much as any other business by the larger economic and consumer trends—maybe more. In uncertain economic times, new clothes become a purchase that can be postponed. (In the industry, some say that women stop buying for their husbands immediately when the economy falters and only if the economy really turns bad do they stop buying for themselves!) When the economy is good, opulent fashion often sells. The 1980s saw the explosion of the **Italian designer business**, for instance. People had a lot of money to spend, and the expensive fabrics and fine tailoring used by Italian designers provided a new and glamorous fashion look for U.S. customers. When the economy is difficult, everyone in the business works to reduce prices. Sharp-value merchants such as Gap, particularly with their Old Navy stores, often flourish under such circumstances. Unemployment and inflation rates affect consumer confidence, which in turn affect clothing sales. "One reason Old Navy is making money in this competitive market is that its stores are not in malls. One of the more obvious ways Old Navy keeps prices down is using less expensive fabrics and fewer details. Old Navy is also less strict when it comes to consistency in colors and sizes of its merchandise. Because Old Navy merchandise does not carry the

Italian Designer Business
High end of the fashion trade conducted by designers such as Armani, Missoni, Krizia, and Prada.

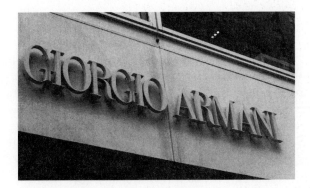

Armani is part of the Italian designer business.

Sharp-value merchants such as Old Navy flourish during difficult times.

same hefty markups as Gap and Banana Republic clothing, robust sales volume is the name of the game".[1]

You have also learned that, with powerful national chains setting up more retail stores, consumers have an overabundance of places to buy clothes. This means that retail purchases are spread over many comparable players. As a result, in the past 10 years or so, we have rarely seen the big positive increases in business during the "good times" that were common previously.

As recently as the 1970s, department stores could "hit on" a hot item and sell tens of thousands of units in a matter of weeks, because they were the only ones to have this item. Now the same item can probably be found in any department store, and there might be other versions in the national specialty chains and discounters as well. There might still be tens of thousands of units sold but no longer just in the one lucky store that discovered it!

What You Should Research—Economic Trends

You now have a good idea *why* you need to research, but you may not know what you are looking for. As merchants, you will be looking for economic signals to support decisions about:

- How much people can afford to pay;
- Where you should make your products;
- Where you should sell your products.

Your research may deal with such topics as:

- Cost of living;
- Employment versus unemployment;
- Education levels;
- Housing starts;
- Interest and inflation rates.

Keep an open mind as you read about these topics; they might lead to other studies that measure economies in other countries. Remember, apparel product development and manufacturing is a *global* industry, as is its customer base.

Where You Should Look—Economic Trends

Finding the best sources can often be daunting. In fact most people feel with the invasion of the Internet into their homes that they are overwhelmed and can lapse into information overload. You don't have time for information overload, so let's look at some sources that will help you work smart, not hard. The most important thing is to use an assortment of materials to get an "overall" viewpoint. Remember, not all data can be found on the Internet, and even if some cyber information is found it is *not* always available for free! The virtual library cannot always be the *only* tool. So make it a habit to visit your local library and keep reading the newspapers and publications.

As you search, do not pass immediate judgement on the information you find. You may be looking for a specific fact and not find it. Instead the information you find may be valuable later. Sometimes you will stumble on information that serves no immediate answer for you. Actually, you can almost divide data into two categories: Information that you need to know and information that is nice to know. Believe it or not, the "nice to know" often gives you an idea about a better concept, so don't throw away that article or picture, just store it for use later.

Economic research can be hard to assimilate, so we're not going to suggest highly statistical sources. Instead we indicate some user-friendly sources to learn about the economy worldwide.

WHAT DO YOU WANT TO KNOW?	SOME SUGGESTIONS WHERE TO LOOK
International trends/worldwide competitiveness rankings. Countries for expanded market base.	World Trade Center with offices around the world offers outstanding information and is easily accessed at http://iserve.wtca.org, or World Economic Forum at http://www.weforum.org
Local or national quality of life and/or cost of living. Information about unemployment (rankings), population growth (rankings), figures for manufacturing, as well as service industry and wholesale and retail trade.	*American Business Climate & Economic Profiles*, published by Gale Research, Local newspapers such as *Crain's Chicago Business*, *South Florida Business Journal*.
International, national, and local economic spending.	*Survey of Buying Power* Leading newspapers such as *Wall Street Journal*, always a trusted, easy-to-read source of national and international economic information (subscribe at http://interactive.wsj.com). Also check consumer magazines such as *Business Week*, *Newsweek*, *Time*, or *Fortune*. Visit their websites directly or use www.ceoexpress.com and link to business magazines, business news, or international news.

INDUSTRY TRENDS

Why You Should Research—Industry Trends

Often the most valuable information you will uncover will surface when you are conducting industry research. In this market, effective research will cover textiles, apparel, technology, and retail trends. As you focus on the economic, technological, and consumer conditions that drive an industry, you will see how those factors contribute to the continued health and stability of the best businesses in the industry.

What You Should Research—Industry Trends

A good industry analysis will give you a chance to look at your industry from an insider's point of view. Good research will give you a stronger definition of your industry and then help you answer questions such as the following:

- What are the characteristics of the products or services offered by this industry?
- What are the sales trends in this industry?
- What are the technological trends in this industry?
- What are the job opportunities in this industry?
- What training is needed for success in this industry, both now and in the future?
- What role does this industry play in the local, state, domestic, or international economy?
- What phase is represented by this industry in the business life cycle—emerging, growing, stable, or declining?
- What are the leading companies in the industry? How would you categorize the company(ies) in question? For example, does the firm you are researching fit into the textile industry or the apparel industry?
- What are the industry organizations and/or affiliations?
- What are the trade publications in this industry?
- What kinds of government regulations are affecting the industry and why?

Answering questions like these certainly can help you make some good decisions about the skills and training you need for a career path. With these data you can look deeper into the industries and identify the top firms and factors that contribute to their strength and position in the marketplace. It will also help you to determine the opportunities for opening new businesses or for expanding into the global marketplace.

Where You Should Look—Industry Trends

Often when conducting industry research you may be asked for a SIC code. SIC stands for "standard industrial classification" and is used to group similar industries. These codes, which have recently been finely tuned by the North American Industry Classification System (NAICS), are generally needed when searching electronic databases for up-to-date industry information. Before you begin researching a particular industry, first identify the SIC. The easiest way is by using http://www.ceoexpress.com (which we really consider our online "one-stop shopping" site). From there move to the SEC category and link right into NAICS/SIC codes. If you prefer, simply link directly into http://www.naics.com/search.htm.

WHAT DO YOU WANT TO KNOW?	SOME SUGGESTIONS WHERE TO LOOK
An up-to-date snapshot of an industry, supported by numerous statistics and charts along with projections of trends in that particular industry.	Standard & Poor's industry surveys. Even though some of this information is available on-line, the most detailed can only be found in the library or through a paid subscription. It is a must, providing rich comparative company analyses and useful glossaries and industry data. Link through http://www.ceoexpress.com or access directly at http://www.standardandpoors.com
Career and industry forecasts, regionally and nationally for a wide range of industries including fashion and technology (yes, you must know how computers will affect your field). Information on web resources, salary figures, skills required, industry publications, lists of major companies within the industry, lists of regional business directories, and addresses for government employment offices.	*Jobs '98* by Kathryn Petras, George Ross, Ross Petras (contributor), George Petras (contributor) (published by Simon and Schuster).
A comprehensive reference about hundreds of different occupations, including opportunities, qualifications, salaries, working conditions, and career advances.	*Occupational Outlook Handbook* (published by U.S. Department of Labor), which can be found in libraries, bookstores, and on-line at http://stats.bls.gov/ocohome.htm
Information presenting statistics and fairly current information for 137 industry groups representing approximately 3,500 companies. Data on such topics as key business ratios, earnings per share, book value/share, and industry rankings (e.g., ranking specific companies within an industrial group). Industry rankings are measured by criteria such as revenues, profit margins, net incomes, and price/earning ratios.	*Moody's Industry Review* (published by Moody's Investors Service) with a helpful glossary in the front, this resource can be understood by the lay person. Data are also available at http://www.moodys.com
General industry outlook for women's and children's.	*Women's Wear Daily*, backbone of the industry, published by Fairchild Publications 7 West 34th Street New York NY 10001 212-630-4230 800-289-0273 http://www.wwd.com
Information on manufacturers, including market weeks, apparel marts, trade associations, and individual wholesalers' profiles.	*WWD Buyer's Guide*, also published by Fairchild Publications (see previous entry for address) 212-630-4000

WHAT DO YOU WANT TO KNOW?	**SOME SUGGESTIONS WHERE TO LOOK**
A targeted look at the men's and boy's industry.	*Daily News Record*, also published by Fairchild Publications (see previous entry) http://www.dailynewsrecord.com *MR Magazine* 185 Madison Avenue New York NY 10016 800-360-1700
An inside look at the shoe industry.	*Footwear News*, also published by Fairchild Publications (see previous entries)
A look at the west coast market/California fashion industry.	*California Apparel News* published by California Fashion Publications 110 East Ninth Street Los Angeles CA 90079 213-627-3737 800-360-1700 Also publish *Men's Apparel News*
Children's market news.	*Earnshaw's Review* 225 West 34th Street #1212 New York NY 212-563-2747 *Children's Business Magazine* published by Fairchild Publications (see *Women's Wear Daily* entry) http://www.childrensbusiness.com
Sportswear fashion news.	*Sportstyle Magazine* published by Fairchild Publications (see *Women's Wear Daily* entry) http://www.sportstyle.com
Specific textile/industry trends.	*Bobbin Magazine* 1110 Old Shop Road P.O. Box 1986 Columbia SC 29202 803-771-7500 http://www.bobbin.com
Latest news on hot licensing properties.	*The Licensing Book*, published monthly by Adventure Publishing Group 1501 Broadway New York NY 10018 212-575-4510

WHAT DO YOU WANT TO KNOW?	SOME SUGGESTIONS WHERE TO LOOK
Associations providing in-depth coverage to help designers/product developers, manufacturers, and retailers review past trends and strategies and provide direction for projected merchandising trends.	American Apparel Manufacturers Association 2500 Wilson Boulevard Arlington VA 22201 800-520-2262 http://www.americanapparel.org Clothing Manufacturers Association of USA 730 Broadway New York NY 10010 212-529-0823 National Retail Federation 325 7th Street NW Washington DC 20004 http://www.nrf.com Also access http://www.ceoexpress.com and link to industry research to open hundreds of doors to manufacturers, designers, textile firms, associations, and even fashion organizations.
A list of major stores, chains, and resident buying offices throughout the United States, by state. This will be a source that you generally will find only in a library or large company.	*Sheldon's*, published by Phelon, Sheldon & Marsar in Fairview, New Jersey.
Corporate financial status, operational structure, and principal competition of leading companies.	*Hoover's* capsule version is available at http://www.ceoexpress.com/ and then link to Hoover's under Company Research. Or link directly through http://www.hoovers.com
Individual company information.	Company press kits and annual reports available for all public companies from the public relations department or often directly from their website. Again use http://www.ceoexpress.com/ and link through Company Research.

CONSUMER GROUPS

Why You Should Research—Consumer Groups

Yes, we already talked about demographics and psychographics in Chapter 4, but now we are going to give some more details about why this information is important along with some sources to help you research.

Most large-scale industries with products that have longevity (for example, detergents, foods, cars) perform statistically driven research to determine consumer likes and dislikes. The garment business, however, is one of very

THE INSIDE SCOOP

KIM ROY

The group president for special markets apparel and accessories at Liz Claiborne, Kim was introduced in Chapter 6 with her thoughts on fitting the right line to the right retailer. In addition, Liz Claiborne is one of the few apparel companies that conducts a great deal of original consumer research. The chairman of Liz Claiborne, Inc., Paul Charron, came from Procter & Gamble, a company known for its extensive research.

Liz Claiborne is currently working on "niche market" studies to investigate overlooked segments of the apparel-buying public. For each of the special market brands (Emma James, Crazy Horse, Russ, Villager, First Issue), focus groups have been launched. Other studies have been conducted in the handbag/accessory area and on Elizabeth (large sizes.) In 2000, Claiborne will again embark on a corporate-wide consumer research study.

We use our research to guide our strategic and tactical decisions in many different areas:

Internally

- To define our consumers and their needs;
- To design products that better address the lifestyles of our consumers in terms of versatility, care, quality, style, and pricing considerations;
- To position our various brands in terms of their value and end use to consumers, both emotionally and functionally.

Externally

- To partner with our retailers in presenting our product to best advantage in the shopping environment (for example, showing outfits that suggest versatility and enhance stylishness);
- To most effectively communicate with our consumers in various forms of advertising, promotion, and point-of-sale materials.

At Liz Claiborne Inc. we believe that, more than ever, knowledge is power and that a true understanding of the consumer gives us a strong competitive edge.

rapid change. Each item tends to have a rather short **selling life**. Therefore, it usually doesn't pay for garment companies to spend much money to determine if a specific style is going to be popular. By the time the research is finished, the fashion trend could be over.

More often, wholesalers and retailers will conduct general research of their customers' preferences. They will try to answer questions such as "What is the most someone will pay?" or "Why do customers prefer one brand over another?" As Bob Caplan, director of sales at Levi Strauss says: "In consumer research, gathering data is less critical than interpreting data."

Decisions about individual styles become much more a case of trial and error. Through experience, designers learn what has worked and what has not. Retailers learn what has sold and what has not. Here's the really tricky part: What sold yesterday in fashion is no guarantee that it will sell tomorrow!

What You Should Research—Consumer Groups

Statistical information is essential to support the general trend information. Yes, numbers will help product managers make sound decisions on product development. Consumer demographics focus on the population by:

- Age (number of people aged 0–10, 11–20, 21–30, 31–40, etc.);
- Race (Caucasian, African-American, Hispanic, Asian, Indian, other);
- Household (married, single, number of children);
- Education (technically trained, high school/college education levels);
- Housing (homes versus apartments—rent versus own, disposable income);
- Buying habits (leisure buying, home products, clothing, cars, electronics).

This information provides a base from which merchants can work. Just think about it. Now we all live in an environment that continues to find new medicines, healthier living conditions, and, generally, a population that is aging. Additionally, we are living in a growing multiracial environment in the United States. These life trends are the very foundation that support growth opportunities for manufacturers worldwide!

For example, we already made some generational distinctions in Chapter 4. Also note that the needs of each generation *change* as its members age. The same Baby Boomers who squeezed into hip-huggers and poor-boy knits in the early 1970s had put on enough weight by the late 1980s that they fueled the demand for oversized clothes. When you're in the industry, these graying Boomers will want comfortable and casual clothes for lounging in their new retirement condos.

Even ethnic heritage can influence clothing purchases. The influx of Asian immigrants into California, for example, has led stores to skew their size scales more toward the smaller sizes. As an illustration, in the Midwest (Ohio, Illinois, Indiana, Michigan, Minnesota, Wisconsin), a typical size-scale assortment breakdown on a dozen garments might run:

> **Selling Life**
> Length of time an item is desired by the public.

SMALL	MEDIUM	LARGE	EXTRA LARGE	
0	3	6	3	=12 pieces (1 dozen)

In California, a size scale might be

SMALL	MEDIUM	LARGE	EXTRA LARGE	
2	5	4	1	=12 pieces (1 dozen)

Where You Should Look—Consumer Groups

The sources you use to gather statistics for demographic research may be a bit dry, but we'll give a few that are easy to follow. Fortunately, you seldom have to dig into these numbers; instead keep your eyes open for articles, news programs, and documentaries that will give you a good view of demographic changes. Another insider's tip to know is that many major libraries enable you to call your local librarian who will gladly gather the information for you.

WHAT DO YOU WANT TO KNOW?	SOME SUGGESTIONS WHERE TO LOOK
Data on such topics as population, age distribution, median household income, spending potential indexes by category (travel, apparel, home repair, etc.), and changes in population by county. Also, top industries within each zip code area.	*Sourcebook of Zip Code Demographics*, published by CACI, Inc.
Demographic information including new housing units; crime rates; size of location being considered; percentage of population that is female and that is foreign-born; percentage of one-person households; percentage of professionals; number of employees in service industries, retail, and manufacturing; average wages for workers in those locations; and racial and age breakdowns for all places.	*Places, Towns and Townships* published by Bernan Press. http://www.bernan.com
Vital statistics (birth rates, death rates); new housing and value of that housing by state; household wealth by region; and household wealth and expenditures by state.	*Statistical Abstract of the United States*, published by U.S. Department of Commerce, Economics and Statistics Administration, Bureau of the Census. http://www.census.gov/statab
Projections of population for all states through the year 2025. Breakdowns by category including age, sex, and ethnicity.	Census Bureau—State Population Projections http://www.census.gov
Various statistical concerns in the United States, such as overcrowded classrooms, consumer buying habits, and health issues.	*American Demographics*, excellent, easy-to-read monthly magazine http://www.demographics.com

LIFESTYLE TRENDS

Why You Should Research—Lifestyle Trends

Marketers cannot use earning power as the *only* criterion for buying power. They must also look at customers' attitudes and characteristics. These can include interests, values, beliefs, activities, and opinions (see Chapter 4 under "Demographics and Psychographics").

For example:

- Does an individual buy strictly based on need?
- Will that person stretch himself or herself financially to indulge in a particular purchase?
- Does he or she find it important to keep up with the latest trends?
- How does this attitude change with age?

Several books have been written about changing lifestyles and attitudes as people reach different milestones in their lives.

What You Should Research—Lifestyle Trends

Merchants will often want to focus on the following:

- Consumer confidence. Are consumers spending money freely, are they saving (and how), or are they being cautious?
- Consumer needs versus wants. Just where are consumers spending their money? Is the income going to insurance policies, savings plans, computers, homes, cars? What is important to them?
- Consumer lifestyles. How are people living? Are their homes casually furnished? Do they work in a "dress-down" environment? Do they earn their living from home offices? Are they traveling and, if so, how often? Where are the hot tourist spots?

Where You Should Look—Lifestyle Trends

Lifestyle research is what we call "timely." In other words, you won't be digging through heavy reference materials and historical data. Attitudes are about living in the "now." That means you will find yourself relying on the Internet, consultants, and business publications that are up-to-the-minute.

There are many good books and articles written on lifestyle changes in the United States. These changes influence clothing like everything else. For example, the trend "guru" Faith Popcorn, author of the *The Popcorn Report* and *Clicking*, coined the term "cocooning" for the tendency of people to stay comfortably at home and pamper themselves. A whole industry of casual, comfortable loungewear emerged to play to that need, such as Calvin Klein's loungewear.

Even more obvious has been the change in corporate America toward casual dressing in the workplace. Both women's and men's sportswear firms have

cashed in on casual work clothes. Retail stores such as Dayton's, Hudson's, Marshall Fields, and Target have issued books and held customer seminars on how to dress casually (but appropriately) for those "dress down" Fridays.

WHAT DO YOU WANT TO KNOW?	SOME SUGGESTIONS WHERE TO LOOK
Predictions of lifestyle trends.	Books by Faith Popcorn such as *The Popcorn Report: Faith Popcorn on the Future of Your Company, Your World, Your Life* and *Clicking: 17 Trends That Drive Your Business—And Your Life*
Social trends.	*Megatrends 2000* by John Naisbitt, Patricia Aburdene, and Pat Aburdene.
Current trends.	Current newspapers and websites, such as http://www.yahoo.com/business.
Current trends/popular attitudes.	Consumer publications such as *People*, *Time*, *Forbes* and even your favorite TV shows!

FASHION TRENDS

Why to Research—Fashion Trends

Here is where you put it together to produce garments that will be successfully accepted by the consumer market. The key is to use all the information you gather. Some data will show you market strengths. Some will show you opportunities. And some information may indicate problems or even weaknesses in the marketplace. Do not discount that information. It may be just what you need to develop a new line of products for an untouched market niche.

What to Research—Fashion Trends

The list is endless, but here are some typical questions asked by product developers/designers each season:

- What are the newest styles and silhouettes?
- What are the important colors for upcoming seasons?
- What are the newest developments in the fiber and fabric markets?
- What is happening to materials and labor prices?
- Where are companies having garments made?
- Where can I get help for all of this?!

If your line is moderate in price, you would want to shop stores that are one or two steps higher in price (such as Bloomingdales), based on the trickle down theory of fashion leadership.

Inspiration from "Above"

You will also find yourself looking for "fashion clues" to inspire the styling of your line. Because fashion is a trend business, there is always some element of "copying" going on. Many fashion trends start at the top of the fashion pyramid—couture and designer. The ideas that originate in these lines tend to **trickle down** to lower priced lines through time.

Most designers and product developers generally have one or two lines that they watch closely each season. They look to brands that are one or two levels higher in price than their own line. For example, if you are producing a *better* line of women's private label sportswear, you would pay special attention to the designer level (which is one or two steps above your line). If you are producing a *moderate* line, you would probably look closely at the better and bridge lines above you. If you emulate a line that is too far above your price zone, you could end up looking too sophisticated. Conversely, if you emulate a line at your own price level, you will probably look outdated by the time your merchandise comes out.

This is a lot to keep track of! Fashion trends cover worldwide research, and you will often be using services of consultants and consulting firms to help you stay on the inside track. These services include:

- Fashion and color services;
- Fiber and fabric research;
- Print studios.

Trickle Down
Theory of fashion leadership (where fashion trends start) that explains that trends start with the highest levels of fashion (couture, designer) and then work their way to lower priced garments.

Fashion and Color Services

Fortunately, there are excellent services that designers can buy to help steer them in the right fashion direction. There are fashion design companies that will provide booklets of styling, fabric, and color ideas that are appropriate for an upcoming season. Among the largest are Promostyl (Figures 7-1 and 7-2), D3 Doneger, and Here and There. The merchandiser must remember, however, that these designs could in some cases be a bit too European or advanced for their market. By combining the past successes of their own line with the direction and feeling of the design service sketches, the designer or product manager can evolve the line in the right overall fashion direction. Full fashion services can cost $2,000 to $6,000 per year or more.

Often, designers will buy color services. These companies predict the important fashion colors by business (women's, men's, kids) *about 18 months in advance.* Color Box (Figure 7-3), Huepoint, Design Intelligence, D3

Dress from a designer line. If you were doing product development for a better private label line, what styling ideas might you get from this garment?

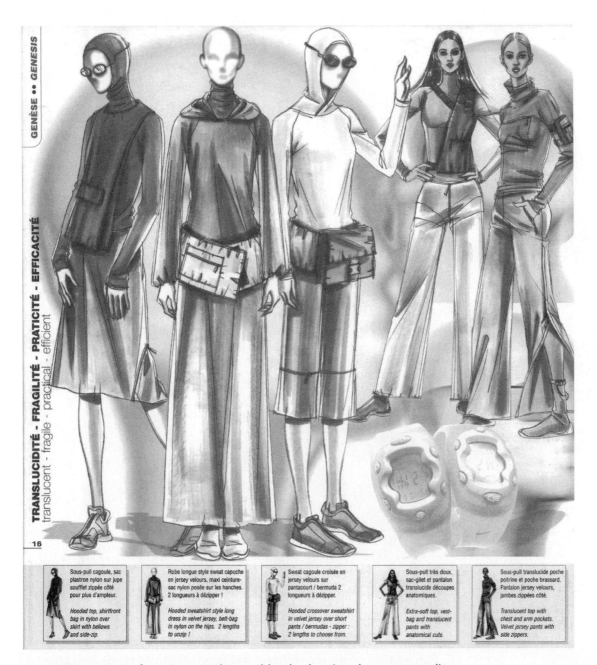

FIGURE 7-1 A page from Promostyl's trend book, showing the newest styling ideas for an upcoming season.

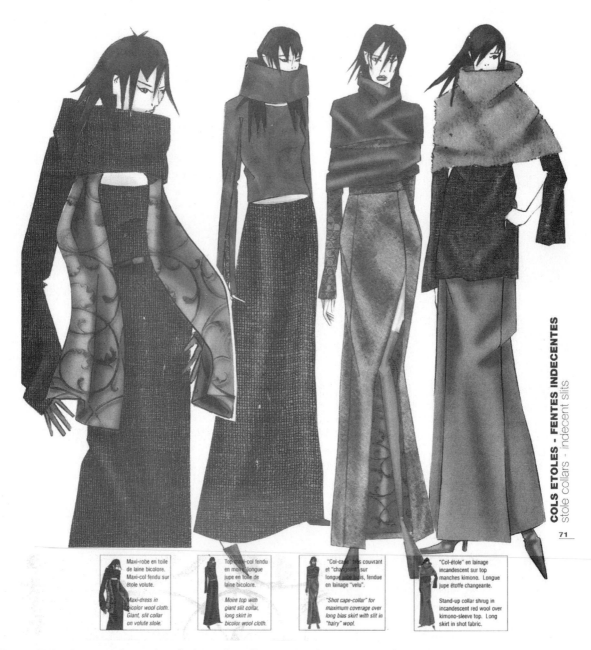

Maxi-robe en toile de laine bicolore. Maxi-col fendu sur étole volute.

Maxi-dress in bicolor wool cloth. Giant, slit collar on volute stole.

Top avec col fendu en moiré longue jupe en toile de laine bicolore.

Moire top with giant slit collar, long skirt in bicolor wool cloth.

"Col-cape" très couvrant et "changeant" sur longue jupe biais, fendue en lainage "velu".

"Shot cape-collar" for maximum coverage over long bias skirt with slit in "hairy" wool.

"Col-étole" en lainage incandescent sur top manches kimono. Longue jupe étoffe changeante.

Stand-up collar shrug in incandescent red wool over kimono-sleeve top. Long skirt in shot fabric.

FIGURE 7-2 Promostyl trend, called "stole collars and indecent slits." If you were doing a private label line for J.C. Penney, how might you interpret this trend?

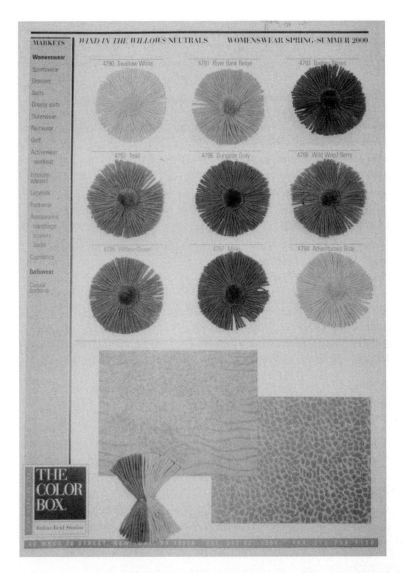

FIGURE 7-3 Forecasted color story from Color Box. You would receive this information about 18 months before the season.

Doneger, and Promostyl are several of many in New York. Designers will often buy two or three services each season ($600 to $1,500) and look for commonalties and specific shades that will work for their market. Again, the designer might not end up using the colors exactly as proposed but would modify some or most shades, depending on the customer. Still, the general direction has been identified by the service.

Fiber and Fabric Research

"There is no understanding of fashion without an understanding of fabric," says fashion journalist Clara Hancox. She's absolutely right! Fabric both *drives* trends and *follows* trends. In the early 1990s, for example, there was an explosion of new synthetic fiber and fabric development, the most famous be-

THE INSIDE SCOOP

SERGIO SANI

Sergio is the U.S. director for an Italian yarn mill, Nanni Filati. Before that, he worked for 30 years in international product design and development for U.S. stores. Based in Florence, Italy, Sergio is known worldwide for his design creativity, manufacturing know-how, and his "ice to Eskimos" sales ability.

On Competing in a Congested Market

Fine-Gauge Yarn
A thin yarn; yarn size is measured by many different (and confusing) systems.

Super 100's Merino
An exceptionally thin and fine woolen yarn.

Superwash Merino
A woolen yarn that can be laundered.

Our mill production has increased more than fourfold in the past five years. Italy now dominates the world market in fashion and fashion/volume **fine-gauge yarns** such as **super 100's merino**. This didn't happen by accident.

To approach a market like the United States you need a special niche; something to open the door; something that is different from the competition. Each time I go to American wholesalers like Dana Buchman and Ralph Lauren, I make sure I have something brand new: **Superwash merino** with a new formula to keep it very soft, for example. Or merino stretch yarns made without spandex.

You need to talk directly and often with the designers and manufacturers. Don't be vague, get specific. And don't just talk . . . feel the goods! Fashion evolution happens on a daily basis. Either a mill keeps up with this pace of innovation, or forget it!

Italian mills have constantly invested in new machinery to keep them competitive in spite of the high labor costs in Italy. But aside from cost, the number one goal has always been to keep or improve quality. The minute you let quality slip, you lose your business. Without quality, you jump into the *calderone* (big pot). And then you don't know where you will end up!

Microfiber
Fine yarns that are less than 1 denier thick (that's less than half the thickness of silk threads). "Denier" is a measure of yarn width.

ing **microfiber** fabrics. These new fabric developments stimulated drapey outerwear designs that showed the soft, flowing fabric to an advantage. In this case, the new fabric caused a change in styling. In the opposite direction, in the later 1990s, there was a movement toward tighter-fitting clothes. This renewed an interest in spandex, which had been around a long time. What became new was the blending of spandex with unusual fibers. In this case, the change in fit brought about changes in fabric.

The fiber and fabric mills that are considered the world fashion leaders are (not surprisingly) in France and Italy (Figures 7-4 and 7-5). Their fabrics are new, exciting, innovative—and expensive.

Most wholesalers, designers, and retailers contact these leading mills at the European fabric shows, such as Premier Vision (Paris), Interstoff (Frankfurt, Germany), and Ideacomo (Como, Italy). Some actually buy these beau-

FIGURE 7-4 Yarn-making in Italy. Last stage for bulk combed yarn, the "finisher."

FIGURE 7-5 Yarn-making in Italy. Turning semi-bulk yarn into single-ply yarn.

tiful fabrics and have them shipped to their garment factories. Private-label chains like Banana Republic and wholesalers like Liz Claiborne have done this extensively. Other wholesalers might buy 40 to 50 meters of European fabric to have their sample lines made up and then **knock off** the fabric in Asia for their bulk production. Still others just shop the show for direction

Knock Off
To make a direct copy.

THE INSIDE SCOOP

MAURICE ZUCKER

Maurice's career has been in the following New York buying offices: Consolidated Clothiers, Arkwright, and, since 1968, the Associated Merchandising Corporation. His areas of specialization have been boyswear and men's dress furnishings. He is widely acknowledged in the industry as perhaps the top authority on men's dress shirts and neckwear.

The most important fabric fair in the world is now Premier Vision in Paris. But don't expect to just wander in. You need prearranged appointments with fabric mills just to get in the door. Usually this means, at the beginning, that you should go with someone who has actually bought from these mills before. And if you want to come back, you'd better place some orders yourself!

At the appointment, they will ask you what category of fabric you are interested in (what quality, what general look, i.e., men's classic–dress shirts or casual–sport). For the next 45 minutes or so, they will flip hundreds and hundreds of swatches in front of you. At the end, you are expected to say "OK, I'll take fabrics numbered x, y, and z." **Clippings** for reference are very rare because these are usually trial looms woven by hand and because the mills fear getting knocked off.

References are sent after orders have been placed. Once a level of confidence has been established, they will send cards to you for additional review. The best approach is to come in knowing what you are looking for, but then having an open mind if something unexpected impresses you. And these innovative mills always come up with something new and exciting in textures, patterns, and colors! It's really an inspirational experience for the creative mind!

Clippings
Small fabric pieces clipped off a swatch.

(kiosks are set up with fabric and color stories swatched), and then with their eye educated, they travel to the lower-priced mills in the Far East to seek affordable "look-alikes."

An alternative to the European shows is the International Fashion and Fabric Exhibition (IFFE), held several times a year in New York. Although it tends to draw mostly secondary yarn and fabric suppliers, it still provides a good source of direction and inspiration. The trend kiosks, set up near the entrance, quickly communicate the most important new fabric trends.

Many big buyers who can order large quantities of fabric also have the alternative of working directly with the fabric mills to develop something exclusively for them. For European fabrics, a normal production run of one pattern (called a **full warp**) is about 900 to 1,200 meters (approximately 980 to 1,300 yards). In Asia, for standard fabrics, minimums typically range from 3,000 to 10,000 yards (yes, that's a lot).

Full Warp
Minimum quantity for a regular production run of a fabric. The exact quantity varies by fabric quality, price, and manufacturer.

MELISSA NIEDERMAN

Melissa is a graduate of the Fashion Institute of Technology (FIT), New York, where she studied buying and merchandising. She is now an account executive for Style Council, a large fashion service organization in New York.

On Discovering a Great Corner of the Industry

When I started out at FIT, I thought I would probably end up as a buyer. But I really wasn't sure what I wanted. Before graduation, I started working part-time for a textile **converter**, and they wouldn't let me go after graduation. I stayed there eight years!

But converter business is much harder today. Business is tough. While at the converter, I had worked with some textile and art design studios. I educated myself about this new end of the industry—by asking around and by grilling the people who interviewed me!

I didn't realize how important this service was. One part is original design (artwork for garments, prints). Manufacturers need to be original; they can no longer use **open market** goods because their competition could end up with the same prints. The second part of the service is redesign and recoloring of prints and patterns. We have 40 in-house artists.

This is a great section of the business to be in. You're a step ahead, directing designers and manufacturers on what themes, prints, and colors they should use. We work 18 months in advance of the season.

My advice to students would be to find out about textile design studios—this is the future! If I had known about this branch of the industry, I would have gone into it right away!

Converter
A fabric middle person who contracts with fabric mills to make specialized fabrics for individual customers.

Open Market
Fabric (in this case) that is available for purchase by any garment manufacturer. It is not exclusive to any one manufacturer.

Print Studios

In Chapter 2 you learned a little about the fashion and color services. Companies that are set up as print studios are typically run by one or two people who commission and/or collect original pieces of art from various artists, which they then sell to designers, merchandisers, or retailers (Figures 7-6 and 7-7). There are also studios that specialize in knit swatches or sweater **knitdowns** as well. Costs generally range from $75 to $400 per print or pattern. Print studios often meet their buyers at large print fairs held in New York's garment district several times a year.

Knitdown
A trial knitting piece knitted as a flat panel rather than as a full garment.

It is often necessary to adapt this original work so that it can be used technically. Most prints need to be put into a *repeat* so that they can be printed by a roller onto fabric. Knit swatches sometimes need adjusting to fit the knitting machinery available.

Student Menjeer Upadhya designing fabric prints.

FIGURE 7-6 Original print hand painted by student Ju Won Suk. What type of garment or accessory do you think would be best suited for this print?

Where You Should Look—Fashion Trends

Finding the exact sources of appropriate fashion information is a matter of trial and error. Each service has its own perspective that might or might not match your line and customer base. The best way to start is to sample a few sources in each of the following categories.

FIGURE 7-7 Companion (coordinating) print also by Ju Won Suk. Certain design motifs have been extracted from the more complicated print shown in figure 7-6. In some cases, both prints might be used in the same line.

What do you want to know?	**Some suggestions where to look**
Color trends, fashion trends, retailing trends.	Tobe 500 5th Avenue New York NY 10036 212-867-8677 Promostyl 80 West 40th Street New York NY 10018 http://www.promostyl.com 212-921-7930 Doneger Group 463 Seventh Avenue New York NY 10018 212-564-1266 e-mail: info@doneger.com Huepoint Color 39 West 37th Street, 18th Floor New York NY 10018 212-921-2025 Color Association of the United States 589 Eighth Avenue, 12th floor New York NY 10018 http://www.colorassociation.com Color Box 29 West 38th Street, 9th Floor New York NY 10018 212-921-1399 Here and There 104 West 40th Street, 11th Floor New York NY 10018 212-354-9014 http://www.hereandthere.net
Fabric services.	The Fashiondex, Inc. 153 West 27th Street New York NY 10001 212-647-0051 http://www.fashiondex.com a *great* comprehensive site
Large trade organization of circular knit and warp knit fabric manufacturers, which also provides information on fibers, yarns, machinery, dyers/finishers/printers and factories.	Knitted Textile Association 386 Park Avenue, Suite 901 New York NY 10016 212-689-3807 http://www.kta-usa.org/

WHAT DO YOU WANT TO KNOW?	**SOME SUGGESTIONS WHERE TO LOOK**
Specific fabric/textile information.	National Cotton Council, Washington Office 1521 New Hampshire Avenue, NW Washington DC 20036 202-745-7805 Fax: 202-483-4040 http://www.cotton.org/ncc Cotton Incorporated 488 Madison Avenue New York NY 10022 212-413-8300 http://www.cottoninc.com
World's leading wool textile marketing organization.	Originally founded as the Wool Bureau in 1937 Woolmark 330 Madison Avenue New York NY 10017 212-986-6222 http://www.wool.com.au/apparel/index.html
International fabric fairs.	Premier Vision, Paris: http://www.premierevision.fr Interstoff, Germany: http://www.interstoff.de IFFE, New York: http://www.fabricshow.com
Updates on the New York market.	New York's Fashion Center http://www.fashioncenter.com and Fashion Group International http://www.fgi.org
Latest fashion collections on-line.	firstVIEW 175 Fifth Avenue New York NY 10010 http://www.firstview.com
Good source of industry news, events, and other websites.	http://www.apparel.net/index.cgi http://www.fashionemarket.com
Tradeshow and business service information service.	http://dir.yahoo.com/business
A great one-stop shopping source for fashion info!	http://www.tsnn.com/bclass/tschannel
Trade show sources.	http://otexa.ita.doc.gov/
Excellent source for trade data, events and quotas.	Elsa Klentsch, E! Network
And don't forget TV!	
Fashion magazines!	*Vogue, Town and Country, Elle, Harper's Bazaar, GQ, Vogue Bambino* are just a few to pour over.

Now Let's Move to Some Really Enjoyable Research!

The research sources listed above will give you a good picture of the marketplace in general. You have another source much closer to home. If you are producing a wholesale or private label line, the best information comes from the past performance of your own merchandise.

Past Line's Successes and Failures

To know what to develop for the next season, the best place to start is with your most recent line. What booked big? What flopped? What was the feedback from the sales staff? The last line must be examined carefully for performance and profitability. What was the overall financial plan for the season—what was the actual result? Which items turned out to be profitable? Did we lose money on something that sold well that we had underpriced? If we raise the price next season, will the merchandise still sell?

Good wholesale designers and merchandisers sit with their showroom salespeople during appointments with their largest or most insightful buyers. The buyers' reaction to the line is the first feedback from outside the wholesale company. Wholesalers will probe the most savvy buyers to determine why the buyers like one style and dislike another.

Unfortunately there are fewer really in-touch buyers these days. Buyers are often far removed from the customers on the selling floor and can only guess why one thing has sold well. (Maybe knowing this, you can become a really great buyer?) As part of this probing, wholesalers often ask buyers how competitors (other wholesalers) look. Have they done anything that is especially good? How do prices compare? They also usually ask about current retail performance of their competitors' lines. Is anything selling really well? Is anything a **dog**?

Dog
A really bad seller.

Wholesalers must stay on top of their competition because everyone works hard in the garment business. "Well-priced" one season might be "too expensive" the next season because a competitor happened to move its garment production from North Carolina to Indonesia in the meantime. A line can also get too "unique" or "special" for retailers and customers to understand. Conversely, it can also get "tired" or "stale" so that buyers also pass on it.

Being a wholesaler means that you must stay on constant alert. There are still too many lines to sell to fewer and fewer retailers. Only the most appropriately designed, constructed, and well-priced lines get bought by retail buyers. These lines then have to sell well to the masses—and then you've got to repeat this "double success" three, four or five times a year!

If, however, you are developing a private label line as an employee of a retailer, the selling information that you receive will be much more accurate and complete than if you were a wholesaler. Everyone in the store wants the private label program to succeed, and stores have tremendous information systems available to all merchants. Once you have the selling information, the analysis becomes the same. You still must figure *why* one style sells while

If this dress is a bestseller, you can be sure a version of it will be on next season's line.

Shop for inspiration at large stores and small, exclusive specialty stores as well.

another sits there. The stakes are the same for a product developer as they are for a wholesaler's designer. If you can't create styles that sell consistently each season, they will find someone who can. It's harsh, but this is business.

Shopping Is One of the Best Parts of "Research"

Here's something that you probably like to do—that you can do in your new job—shop! One of the most important ways a wholesaler keeps in touch with the retail market and with competitors is to get into the stores and look closely at actual garments. Timing is an issue, because what the product developer must create is probably two seasons later than what is on the selling floor. Still, it is another reality check.

Samples are bought of garments that could be used as "inspiration" for styling, fit, fabric, color, trim, or print. Most fashion evolves as knock-offs or interpretations of someone else's good idea. These samples will be modified so that they will become appropriate for the wholesaler's target customer. (See "The Inside Scoop" for Bob Shultz on how to shop not as a customer but as a product developer.)

Visionary designers and merchandisers can see inspiration in the most unlikely places. An infant's designer might spot a great fabric in a men's knit shirt. A woman's outerwear maker might see a sensational fabric in a drapery department. Color trends could come from stationery or from cosmetic packaging. Home trends and even flower trends (for example, the popularity of sunflowers in the mid-1990s) can influence fashion. Don't get "tunnel vision" and look only at women's departments if you are designing womenswear.

Bernie Ozer, a fashion consultant to top department stores, was one of the great New York fashion **mavens**. For trend inspiration meetings with store buyers, he would bring foods that were just the right color, street dancers that were wearing some "extreme but directional" style of pants, or a snake

Mavens
Experts.

THE INSIDE SCOOP

BOB SHULTZ

In addition to being a full-time faculty member of New York's Fashion Institute of Technology, Bob also runs an international product development company called Fezbez, Inc. Fezbez combines trend analysis, fashion merchandising, and custom product development for clients, including many in Asia and South America.

On Shopping a Retail Store as a Product Development Professional

When I'm in a store, I listen to see which salesperson sounds smart, which is interested in fashion. Sometimes I ask for the store manager or assistant store manager. I will approach them with two or three garments over my arm, so they can see right away that I am serious about buying. I'll ask something like, "I have these tops. Is there anything else that is selling well that I am missing?" I don't want to hear what they like personally. I need to know what the customer is responding to. I want to buy garments for styling inspiration that customers are actually buying. If the salesperson doesn't understand what I am asking and shows me a style that I suspect she/he finds appealing, I'll say, "You mean to say that this is your *best* selling skirt?" Then they might say, "Well no, *this* one is the one we sell the most." That's the style that I buy. I need to tell my clients that not only did this style *look* interesting, it was confirmed as a *bestseller* as well. Obviously what I buy has to be in line with current trend forecasts as well as being a bestseller.

Another technique is to take two or three items to a salesperson and say, "I have a sister in California who has great taste. I need to send her a gift. Which of these three do you sell the most of?" If I find that the salesperson is knowledgeable and helpful, I will press on: "Why is this selling, do you think?" "Do customers like the color? The fit? The pattern?"

I continuously call the salesperson by name . . . I want to have a personal ongoing relationship with that person. When I leave the store, I enter their name in my shopping notebook.

If you become a regular you can develop a rapport with certain salespeople. I only go to Neiman's on certain days, because that is when Margie works. She never steers me wrong because I could end up buying 30 or 40 garments! And, of course, sometimes I buy nothing.

charmer to reinforce a reptile print message. It's always been a visual business, and that's how he made his point. As you can tell, his dramatic visual message stuck with those of us in the audience.

Within the United States, New York is the most directional shopping market, primarily because of the huge range of retail outlets. Bernie Ozer would say that you can't just shop Bloomingdale's, you've got to shop the barrio (local neighborhoods) as well! Influences from the street illustrate the **"trickle up"** theory of fashion leadership. California is also great for street fashion and sample shopping, especially for young, hip, surf looks. Montreal is a kind of "trade secret." Styling there is somewhere between the styling in

Trickle Up
Theory of fashion leadership that explains that trends can start with what regular people are wearing ("on the street") and that these looks can influence higher levels of fashion.

THE INSIDE SCOOP

CHERYL POLLARD

Cheryl got her start in this business at Bloomingdale's New York. Then she moved to G.H. Bass and Coach, where she added experience in distribution and specialty retailing. From there she moved to AMC, where her design/product development career blossomed as a product manager. She is now the vice president of merchandising and retail for a high-end plumbing fixture company called Waterworks. As Cheryl says, "As long as you know the product development process, plumbing and clothes are the same!"

On Design Inspiration

Where does inspiration come from? It's a matter of exposure: Reading, theater, opera, magazines, museums. I find myself constantly looking for design inspiration. A painting might inspire a color idea. Or it could come from graffiti spotted along the West Side Highway!

I look closely at people on the street. (I've learned to look someone up and down, discreetly.) I try out outfits on myself.

The toughest part is staying fresh. For that, you must be constantly looking. But you also need to trust your gut. You can't do any of this until you have a comfort level with your own personal style. That style becomes one ingredient in the recipe. Then you must incorporate that into your client's needs. You put all this into a pot, stir it, and see what comes out. Hopefully, it will be a fabulous mix!

the United States and that in Europe. It's especially good for outerwear styling and tailored women's apparel.

Now, as much fun as shopping New York, Los Angeles, and Montreal is, if you really want the most up-to-date fashion information and shop for the purest high-fashion styles, you must fly to Europe. (OK, we admit it. This part of the job is exactly as glamorous as it sounds! Sure, you have to spend long days traipsing in and out of shops—but oh, those shops! And oh, those restaurants!)

European customers are the most fashion-savvy in the world. They place a high priority on dressing stylishly and will pay a high price for beautiful clothes. Often, Americans are appalled by the prices and wonder, "How do these people afford such expensive clothes?" We have been told that they tend to buy fewer garments, but they are comfortable wearing them more frequently while they are at the peak of style. Then they buy another exquisite item or two the next season. The high-fashion runway shows in Europe represent the pinnacle of fashion. Influences from these lines will be felt for seasons.

Again it must be remembered that much of what is shown on these runways is exaggerated for shock value. "When fashion people look at collections on the runway, they look for creativity and newness. But the rest of the world is often turned off by anything that looks too different, finding it strange and even scary. Which is one reason that high fashion is worn by a

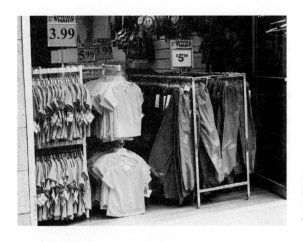

By seeing what people on the street are buying and wearing, designers are responding to the trickle up theory of fashion leadership.

microscopically small percentage of women, while the vast majority wait until new styles have been adapted and modified to look more familiar."[2]

Fashion usually filters down from its purest form in Europe to the United States within 6 to 18 months. Some say it is getting faster. In the process, however, it usually gets somewhat watered down. This is particularly true in menswear: European men are much more comfortable dressing "fashionably" than are U.S. men.

Certain cities in Europe tend to be the best for fashion shopping. Some seasons the clothes look great; some seasons they are not so good. In general, the most consistently strong fashion leaders follow:

Paris	All-around best. There is even a **cash-and-carry wholesale district** called "Le Sentier";
St. Tropez	French Riviera resort; for spring/summer casual wear;
London	For either very classic or very funky styling;
Milan	High-style, understated chic;
Florence	Menswear capital of the world;
Amsterdam	Strictly young and funky.

Cash-and-Carry Wholesale District Wholesale showrooms where small retailers can literally pick up their inventory to resell.

Other stops that are sometimes included: Munich, Barcelona, Brussels, and Rome.

Don't forget, good research doesn't stop here—it keeps you going. Watch TV, people watch, go to the movies. Yes, go to the movies! Watch the classics, see the elegance of designers like Edith Head, who created for stars such as Carole Lombard, Mae West, Grace Kelly, and Shirley MacLaine. Look at the styling, look at the flow.

Yes, it is OK to watch TV. Let's face it, every teenage girl has one character on the screen who wears all the looks that she would like to wear herself! Teenage boys won't admit it, but they too follow TV and (above all) sports shows, imitating this "look." In the 1990s, sports stars were setting more menswear fashion trends than anyone else! "Doug Levine, president of Crunch, a five-unit health club operation that markets activewear, suggests

THE INSIDE SCOOP

J. STAN TUCKER

A native of Charlotte, North Carolina, Stan was another of those famous trainees at Abraham & Straus. Afterward, he was with AMC for many years, including five years in San Francisco. In 1982, Stan became chief operating officer of Geoffrey Beene, Inc., which was followed by positions as managing director of Gieves & Hawkes and vice president and fashion director of Saks Fifth Avenue. He is now the senior vice president of menswear for Burberry.

On the Paris Fashion Show Scene

Fashion shows in Paris are glamorous, serious, and big business. If you want to observe fashion and its glitterati, lodging in the "glamour" hotel is a good start. It's where fashion is visible; where the press takes note.

Shows never start on time, which is unfortunate, as it becomes a domino effect. It only takes one to be late, and, you can be assured, the rest will follow suit. But everyone knows this, and it seems that 10:00 a.m. is always 11:00 a.m., and so on—it just becomes an accepted fact.

Getting into a Paris show is sometimes no easy feat. It is always a mob scene at the door, photographers rushing in early to establish their position—press, retailers, and, many times, the social set all arriving at the same time, and all wanting individual attention. Inside is what counts: Where you are seated, who is next to you, whether store X has as many front row seats as store Y, what celebrities are there, and so on. It is all about posturing. However, the seating is well planned by professional public relations firms overseen by the designer or VP of the company.

Nowadays, the fashion business is likened to Hollywood. It's closely related to TV, music, and movies. It's important to many to see famous people in the audience, as well as superstar models on the runway. All of this can cost hundreds of thousands of dollars.

Fashion shows give the audience the design concept or fashion statement the designer wishes to convey. It is how he or she sees the collection as a whole. I make copious notes during a show and try to spot a look that best exemplifies the collection. Many times this look will be chosen for advertising (therefore we would want it to be **exclusive**), so it is important to speak to the business partner immediately following the show to secure it. At the same time there is a frenzied rush by others, including the press, to get backstage and congratulate the designer, whether the collection was good or not. It is what I call "fashion protocol"; in other words, just fashion good manners.

In a single day I will attend six to eight shows with business meetings in between—and many times, no lunch. The day starts at 7:30 a.m. and usually ends at midnight; Saturdays and Sundays turn into Mondays and Wednesdays—in other words, every day is a workday in Paris. Everyone comes home exhausted.

Exclusive
Sales that are limited to one company.

that the street style of male athletes on the courts—from tattoos to earrings—is what appeals to urban markets".[3]

Other Options

If you happen to be lucky enough to live near a local art or costume museum, please visit! If not, maybe a vacation will find you near some of the following famous costume museums:

Museum at the Fashion Institute of Technology, New York, New York (Figures 7-8 to 7-10)

Costume Institute, Metropolitan Museum of Art, New York, New York

Costume Gallery, Los Angeles County Museum of Art, Los Angeles, California

Smithsonian Institution, Washington DC

Kent State University Museum, Kent, Ohio

Costume Institute, McCord Museum, Montreal, Quebec, Canada

Dugald Costume Museum of Canada, Dugald, Manitoba

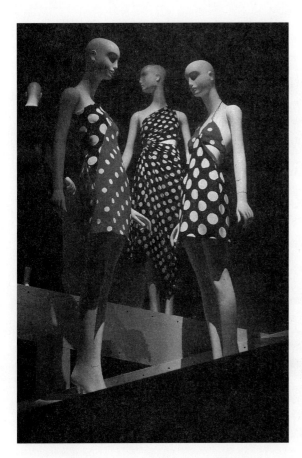

FIGURE 7-8 The Museum at the Fashion Institute of Technology in New York creates influential historical displays of past fashion designers and trends.

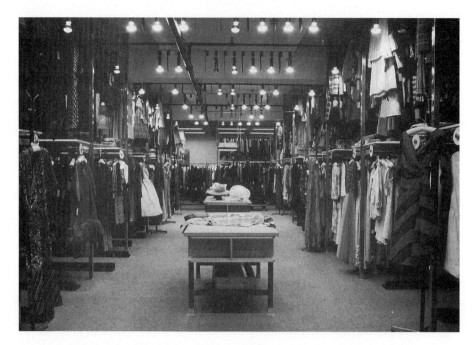

FIGURE 7-9 Design lab in the costume collection at the Museum at the Fashion Institute of Technology.

FIGURE 7-10 The Museum at the Fashion Institute of Technology also has an extensive collection of accessories.

Le Centre du Documentation de la Mode Parisienne, Paris, France
Victoria and Albert Museum, London, United Kingdom
Centro Internazionale Arti e dei Costume, Venice, Italy

The collections, which are magnificent, are referenced with detailed information about the creation of these garments. If you can't get to one of these museums, many have produced books about their historic costume collections.

NOW, THE FASHION FEELERS ARE OUT!

With all this information, you really are ready to move forward. Don't think that this is too much. You will remember it all. Using these sources and thinking in these patterns will become part of your daily working life. If you make research the foundation of your business, you will be successful because you will be meeting your (well-researched) customer's expectations. Next, we move to the fun stuff—the actual product development process.

Endnotes

1. Susan Caminiti, "Will Old Navy Fill the Gap?" Fortune, March 18, 1996.
2. Ann-Marie Schiro, "When Designers Hone Ideas for the Mainstream," *New York Times*, September 24, 1996.
3. Rosemary Feitelberg, "Taking It from the Streets," *Women's Wear Daily*, January 30, 1997.

HERE'S HOW TO BEGIN . . . CHAPTER 7

It's important for you to research trends, lifestyles, fabrics, stores, manufacturers, and designers. Each is important in the consumer buying habits of today. Here are a few suggestions that we think you might try.

To Find Out About the Philosophy of a Designer or Manufacturer

FIRST: ASK FOR INFORMATION
Using sources like *Women's Wear Daily Buyers' Guide*, website homepages, or even phone books at the public library, locate the corporate headquarters for key designers or manufacturers that you admire. Some fascinating companies include the following:

Ellen Tracy	Levi Strauss	Betsey Johnson
Oscar de la Renta	Oshkosh	Calvin Klein

Nautica	Tommy Hilfiger	Dana Buchman
Donna Karan	Olga	Carole Little
Timberland	Anne Klein	Chanel
Versace	Lagerfeld	St. John
Ike Behar	Ralph Lauren	Liz Claiborne
No Fear	Karen Kane	Mossimo
Hanes	Coach	Ferragamo

Most designers have offices in New York City, so if search time is tight, simply call information at 212-555-1212 and ask for the corporate phone number. Once you've made the phone call, ask for the public relations department. Ask the public relations director to send you a press kit and/or annual report.

SECOND: GO ON-LINE

Using the computer systems at the public and school libraries (if you don't have your own), find what the business and trade publications are reporting about the designers and manufacturers. Complete a search on the two designers or manufacturers from whom you have asked for press kits and see how they are being viewed in the marketplace.

THIRD: SEE WHAT THE CONSUMER THINKS

Gather consumer publications (*Vogue*, *Glamour*, *Elle*, and *Town and Country*), and don't forget to look for men's information in *GQ*! Find advertisements or articles about the designer or manufacturer that you are researching. Does the designer's vision coincide with what the industry is saying and what the consumer is seeing?

FINALLY: WHAT DO YOU THINK?

Were you surprised to learn how a designer or manufacturer started? If everyone in the classroom chooses two different firms, the amount of information to share will be wonderfully rich.

To Find Out About the Direction of the Textile Market

Calling or writing textile companies will provide you with a good outlook about how the textile market is changing. Follow the same procedure as you did when asking for press kits and annual reports for the designers or manufacturers. Once you have found the phone number, make the phone call and ask the public relations department to send a press kit and/or annual report.

Do not focus only on textile mills; it is important to review the information and reflect on the direction provided by the Cotton Council and by fiber companies such as Burlington, Monsanto, and DuPont. Don't forget the knitting mills and the fur industry. In fact, examine some of the research sources and websites noted under "Where You Should Look—Fashion Trends" and check what they have to say about industry trends. Don't limit your search to the tools we provided—start building your own library.

To Find Out About Stores: Their Consumer Philosophy and the Place They Hold in the Marketplace

By using Hoover's, Sheldon's, and even local store information, locate the corporate headquarters for major stores. Again, with just a phone call you will learn how stores were started, by whom, and even why. In addition, you can learn firsthand where stores are planning to expand under the current corporate structure. Again, simply call the corporate headquarters and ask!

There are dozens of fascinating companies. Learn how they started, where they are now, and their visions of the future. A few suggestions follow:

Bloomingdale's	Saks Fifth Avenue	Macy's
Gap	Limited (all divisions)	Coach
Abercrombie & Fitch	Brooks Brothers	Neiman-Marcus
County Seat	Episode	Spiegel
L.L. Bean	Nordstrom	Target
K-Mart	Wal-Mart	Marshall's
Burdine's	Dillard's	Jacobson's
Lord & Taylor	Robinson-May	Marshall Field
J.C. Penney	Sears	Wet Seal
Bergdorf Goodman	Victoria's Secret	Bebe

Also, don't forget to check with the National Retail Federation.

Remember, these are the stores for whom you will be working as designers on the design team, sellers of products to them, or product developers, making products for them. It is important to know where they are positioned with consumers in the marketplace, what categories of merchandise they sell, what brands they carry, and what private label programs they have.

CHAPTER EIGHT

FASHION'S TRIANGLE OF BALANCE: YOU CAN'T SELL GRANNY BLOOMERS TO BABY BOOMERS!

Sometimes when you exaggerate, as the chapter title does, the point seems obvious and maybe a little funny. But the point is real: Three elements must be in balance to produce fashion success. The right designer or product manager must provide the right clothes to the right store for the clothes to sell well. Every designer has his or her own vision, design philosophy, and personal sense of taste, and you do too! Here's a test to help you identify yours.

- Close your eyes for a few moments, and relax—really relax.
- Imagine that there are no barriers and no restrictions and that you are living in your dream home. Keep your eyes closed.
- Can you hear the noises? Can you smell the air? Describe your home and the area.
- Now describe how your home looks, feels, and smells.
- Now consider the furnishings: Touch, colors, look.
- At what types of stores did you shop for these furnishings?
- One last thing: Do you see yourself in your home? What are you wearing?

This exercise helps you picture yourself in the surroundings in which you are most comfortable. When comfortable, you can picture what clothes you naturally lean toward. If the setting was casual, chances are that you pictured yourself in casual, stylish clothes. If the setting was more formal, chances are that your clothes were as well. The most successful designers are clear not only about their own taste but can also actually visualize their customers, where those customers live, and where those customers shop. A triangle of balance must be achieved among the following:

- Designer or product manager;
- Style of clothes;
- Store.

They all must be in balance, like an equilateral triangle (Figure 8-1).

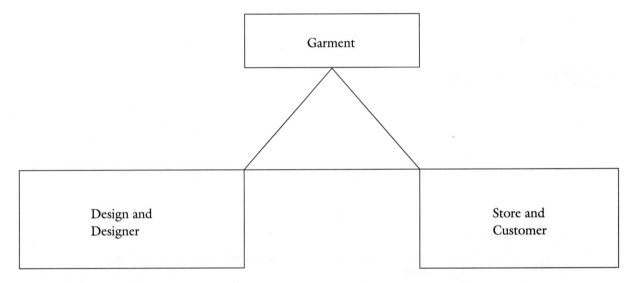

FIGURE 8-1 Balanced triangle. All three parts fit with each other.

Remember, this is not new! In Chapters 4, 5, and 6 you learned how customers buy according to their lifestyle, their perception of value, and their taste level. If one element is off, success cannot follow. Picture the following:

- A young, streetwise, urban designer;
- Showing fast street fashion clothes;
- Which are being sold in a promotional department store with mostly elderly customers.

These clothes will not sell.

Here's another example of the store being wrong: We've all seen expensive items, beautifully made but marked way down because everything else in the store was less expensive. This store's customers do not recognize the incredible value of the marked-down, better items. These items were in the wrong store; thus the triangle is out of balance. It can work the other way,

as well: An item that is cheap does not sell when surrounded by high-end, well-made garments; again, the triangle is out of balance.

A customer evaluates a garment to see if it is in balance by

- Eye appeal (color, pattern, texture): Do I like the overall look of the garment?
- Touch (**hand** of the garment): Does it feel appealing to me?
- Price and value: Is it affordable? Is it good value for my money?
- Fit and wearability: How does it look on me?

Although this next example might be obvious, it may make the point: Picture two customers, one a 65-year-old grandmother and the other a 17-year-old high school senior. Ask them the four questions posed in Figure 8-2.

Hand
Feel or touch of a fabric.

	Grandmother	High School Senior
What is the overall look of the garment that you want?	Not too flashy.	Attention getting.
How should it feel?	Soft, comfortable.	Fashionable—It doesn't matter how it feels!
Is it affordable?	As low a price as possible.	Price needs to be within reach; maybe a splurge for the right look or designer name.
How does it look on me?	Does it cover me up?	Does it show me off?

FIGURE 8-2 Two customers can feel very differently about their clothes.

Let's quickly look at two successfully balanced triangles: Figures 8-3 and 8-4.

FIGURE 8-3 Leslie Fay and Macy's fit together well.

PAMELA DENNIS

Pamela is president and designer of Pamela Dennis, a line that stands for glamour, taste, and sexy "wow" gowns. Winner of the Gold Coast Fashion Award, Pamela has shown her collection on the Oprah Winfrey Show, E! Entertainment, and HBO in Style. The line can be found in Bergdorf Goodman, Neiman-Marcus, Saks Fifth Avenue, Barney's NY, and Harvey Nichols, London. Her clientele includes Jamie Lee Curtis, Bette Midler, and Hillary Rodham Clinton.

On Knowing Your Customer and Store

I know my customer because I do lots of trunk shows and really like them! I'm a hands-on, roll-up-the-sleeves person. I work right in the dressing room with them. Without knowing what my customers' needs are, I couldn't do this.

In designing, fabrics are key. I also love antique shopping. At times we've duplicated antique fabrics for the collection. The fabric sometimes "says" what to make out of it.

How could I tell which stores would be best for my merchandise? I'm at the same price points as Armani and Chanel. That's an indicator. So I'm in Bergdorf's and Neiman's. Then it became word of mouth from customers. They told me which stores they shopped in!

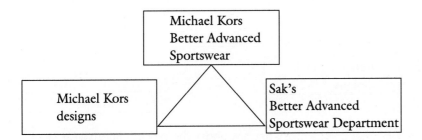

FIGURE 8-4 Michael Kors and Saks also fit together well.

Here's another interesting triangle-of-balance example: Halston was one of the classic designers of the 1960s (the late Jackie Kennedy was a fan). His merchandise was shown in better stores and sold successfully. In the 1980s, as J.C. Penney was pushing hard to get designer names represented in the store to enhance its fashion credibility, the Halston company agreed to design a Halston line for Penney's exclusively, which was then sourced by the Penney's staff or by licensees. It did not work because the triangle was out of balance (Figure 8-5).

The Penney's customer didn't "get" Halston, and as a result Halston was "tainted" by being in Penney's at that time.

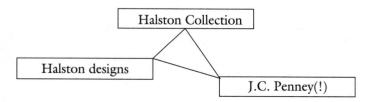

FIGURE 8-5 Halston designs were too sophisticated for J.C. Penney.

In 1997, TTI International launched two new Halston lines, both designed by cutting-edge designer Randolph Duke. Halston Sportswear was made for moderate department stores such as Macy's, and Halston Signature Collection was made for better stores such as Saks. The line for moderate department stores failed for many reasons, including a poor match between Randolph Duke's talents and the moderate merchandise in the sportswear line (Figure 8-6). However, the higher-priced line was much more successful, especially in the glamorous eveningwear that was Mr. Duke's specialty (Figure 8-7).

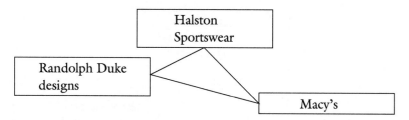

FIGURE 8-6 Randolph Duke's designs under the Halston Sportswear label were too sophisticated for Macy's.

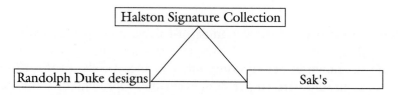

FIGURE 8-7 However, Randolph Duke's evening gowns under the Halston Signature Collection label were a good match with Sak's.

So here's the rather surprising ending of this story: TTI and Randolph Duke parted company, and TTI gave up the Halston license. Randolph Duke started producing eveningwear under his own label, and it has been a sell-out at Sak's. Once again the triangle is in balance, even though the Halston name is no longer in the equation (Figure 8-8)!

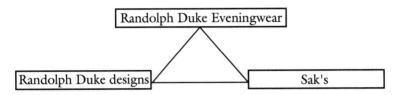

FIGURE 8-8 So Randolph Duke is now selling to Sak's under his own label. The triangle is balanced, and the gowns are sell-outs!

PRIVATE LABEL TRIANGLE OF BALANCE

The same triangle of balance test can also be applied to private label lines. This merchandise must also feature the right styling for the target store and customer. Banana Republic is a good example of a balanced triangle and a successful private brand (Figure 8-9). Everything is consistent: Merchandise, color, style, store environment, price, customer.

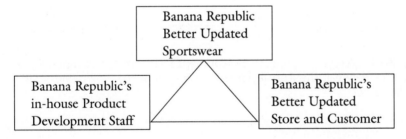

FIGURE 8-9 A balanced triangle at Banana Republic, resulting in ongoing success.

A private label store can also get out of balance. Ann Taylor's assortments got too trendy, almost kooky, in the mid 1990s. With the triangle out of balance, business plummeted (Figure 8-10). Finally in the late 1990s, the styling was refocused on the Ann Taylor core customer: Updated (not advanced), career/dressy (not overly casual). The triangle went back into balance, and success returned (Figure 8-11).

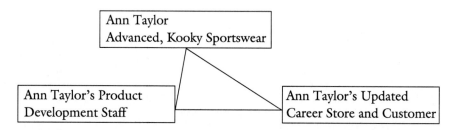

FIGURE 8-10 When the product developers got carried away with advanced styling at Ann Taylor, the merchandise did not match the customer base. Sales plummeted.

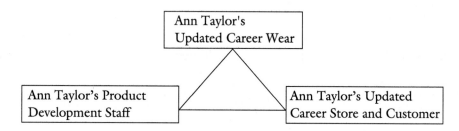

FIGURE 8-11 When the product development staff reverted to more classic updated careerwear, the Ann Taylor customer was happy again, and sales were fantastic!

Each customer has a different point of view and different needs. The designer or product manager who understands the particular customer, styles the right clothes for that customer, and places them in the right retail store will have achieved the triangle of balance necessary for success.

Building lines that are salable starts by being in balance because the object is to develop a profitable business. Where do you start? You start in Chapter 9 with concept and mood boards, which will be your first visual tools for building a successful line.

HERE'S HOW TO BEGIN . . . CHAPTER 8

You did a lot of research for Chapter 7. Take some time to analyze the information and forecast your own predictions about the designers and

MICHAEL MCKEITHAN

Michael is a textile CAD designer for Tommy Hilfiger. He studied at both Parsons and the Fashion Institute of Technology.

On the Difference Between School and Business

> In school I was still looking at clothes as an end-user (what did I like?), not as someone who has to manufacture these clothes. A design can be fabulous, but if the buyer doesn't like it, you might have to scrap that whole line and start over. That's where the real creativity comes in!

> On my first job, I was doing very expressive designs—until my boss came over and said "Simple sells!" I said, "Simple? Who wants to do simple?" When you're designing in business, you've got to start asking yourself such questions as, "What store is this going in?" "What fabrics can't we use?" "How much will it cost to make?"

manufacturers headed for continued growth and success in the twenty-first century.

Determining if a Designer or Manufacturer Is in Balance

First: Gather Information

Form a team of three or four students and list six manufacturers or designers that you feel are leading the industry right now, based on the information you have gathered on industry leaders, fashion trends, fabrics, stores, and consumer lifestyles.

Second: Analyze Facts and Build Your Own Triangle of Balance

Based on the information your team has gathered, answer the following questions:

a. What do you think is the designer's vision? What statement is the designer trying to make?

b. Who is the customer? Use Chapter 5 to help you find the niche.

c. Does the customer share the vision of the designer?

d. Where are the garments being sold? In what type of store? Again let the information in Chapter 6 guide you.

e. Now, shop the line. Yes, go shopping. Look at the garments. Do you think the eye appeal, wearability, and price are in line with the store, its customers, and the designer's philosophy? In other words, is the triangle balanced or is something missing?

Third: Form Your Opinion

Interestingly, you are providing opinions on two different levels: 1) As a member of the industry, analyzing and interpreting trends, and 2) as a consumer. It is OK to combine the two. Remember that focus groups are one vehicle used to determine consumer needs.

It is now time for your team to deliver your opinions as a focus group.

a. Which designer or manufacturer does the team feel is most successful and will continue to grow? Why?
b. Which designer or manufacturer does the group feel is struggling, and in what area? Is it in the product? Is it in the wrong store? Is it missing the target market?

Discussing a Designer or Manufacturer That Is Not in Balance

a. While you were shopping, did you see a well-made, creatively designed product that was priced right but in the wrong store? As a group, discuss where you feel these products should be shown to sell successfully.
b. Look through old fashion magazines and find designers or manufacturers that have faded. Find out why! A bit of research may be required, but many of the answers will be easy to see, such as

Good product–wrong store?
Good product–too expensive?
Great idea–great store–poor quality?

Designers and manufacturers can make mistakes. The key is to correct them and get back on track! How many companies did you see in advertisements that you no longer see in the marketplace? How many companies do you think have had to make significant changes to become successful in today's marketplace? Discuss these topics in your group, and then each team should share the information with the entire class.

CHAPTER NINE

BUILDING THE FIRST DESIGN IDEAS: DON'T LOSE THAT THOUGHT!

It's been a long wait, and you've paid your dues. You've spent much time and energy researching economic shifts, consumer and industry segmentation, and fashion trends. Now it's finally time for all that homework to pay off. The next step is designing or styling actual merchandise. To assemble a line, everyone (designers and private label product developers) follows the same sequence of steps. In this chapter we've made them as *visual* as possible.

The first step is to understand that these clothes go on actual bodies. Your styles must enhance those bodies and downplay any unflattering features. These general principles are employed at one time or another by almost everyone in the industry. For example, if you are on the cutting table and have to move a zipper, you must know the most flattering place to move it. So let's see what it takes to engineer a *pleasing* garment.

THE FIRST STEP IN ASSEMBLING STYLES FOR A "LINE"

First, let's consider the overall feeling of this season and line. Is the season going to be romantic and soft or active and hard? Is the general color sense muted and subtle or bright and bold? These ideas are often first conveyed

BASIC PRINCIPLES OF DESIGN

Proportion

Proportion is simply how the individual parts of a garment relate to the whole shape. The human body has many different contours, and a designer must modify parts of the garment to flatter the body. Sometimes this is achieved by emphasizing the natural body shape or sometimes by creating a new shape. A designer will look at the space, dividing it by height and width to create a pleasing look (proportion). The classic natural waist proportion is a ratio of 3 (top) to 5 (skirt) equals 8 (Figure 9-1).

However, other proportions also work. The junior market in the mid 1990s featured a "baby-doll" look for dresses. By making the bodice a shorter part of the design and the dress a longer part, the junior dress took on a younger, perhaps even a taller, look. The empire waist exaggerates a young girl's proportions (Figure 9-2).

Finally, broader shoulders creating a wedge proportion can help to play down a heavyset build (Figure 9-3).

FIGURE 9-1 Proportion: Natural waist.

FIGURE 9-2 Proportion: Empire waist.

FIGURE 9-3 Proportion: Wedge shape.

Continued on next page

BASIC PRINCIPLES OF DESIGN

Balance

A designer divides a garment both horizontally and vertically. For the garment to appear appealing, the right amount of detail and emphasis must be distributed to each horizontal and vertical part. Too much or too little in one area of the garment makes it appear unbalanced. Look at Figures 9-4 to 9-6.

FIGURE 9-4 Balance: Simple, equal left-to-right balance.

FIGURE 9-5 Balance: Vertical and horizontal balance. Note how cuffs balance bodice stripe.

FIGURE 9-6 Balance: Asymmetrical.

Continued on next page

BASIC PRINCIPLES OF DESIGN

Unity

Unity means that all elements included in the design work together and do not fight each other. For example, if a jacket has an off-center opening, the skirt underneath it should not have an on-center opening (Figures 9-7 and 9-8). Elements should look like they were planned, not a mistake. In Figures 9-9 and 9-10, notice how a slight shift in the seaming makes a huge difference in the unity of the garment.

FIGURE 9-7 Unity: Bad example—jacket and skirt seams do not line up.

FIGURE 9-8 Unity: Good example—jacket opening and skirt seams are both off-center.

FIGURE 9-9 Unity: Bad example—bodice and skirt fight each other.

FIGURE 9-10 Unity: Good example—vertical seams meet at the waist.

Continued on next page

BASIC PRINCIPLES OF DESIGN

Emphasis

Simply put, emphasis is the focal point, the center of interest of the garment, much as there is always a center of interest in a painting. It might be a fabric, a color, a detail, or trim, but it is the main reason your customers look at the garment! Look at Figures 9-11 and 9-12 and decide what makes each of these samples eye-catching.

FIGURE 9-11 Emphasis: What is the center of interest of this dress?

FIGURE 9-12 Emphasis: Why is the yoke on this dress white?

Continued on next page

BASIC PRINCIPLES OF DESIGN

Silhouette

Silhouette is the overall outside shape of a garment, and it is the most common element among all garments at a given point in time. When you see the padded shoulders and severe military suit silhouettes in a movie, you know that it was made in the 1940s.

The tight-waisted full skirt, paired with a clinging knit top, is pure 1950s. Silhouette tends to change slowly, and it is one of the few features that will probably be alike among designers. When the silhouette trend is oversized, for example, almost everyone will be doing oversized. The 1990s, for example, will probably be remembered for a return to tighter fits. Figures 9-13 and 9-14 illustrate the two different silhouettes.

FIGURE 9-13 Silhouette: Oversized.

FIGURE 9-14 Silhouette: Slim.

Continued on next page

BASIC PRINCIPLES OF DESIGN

Line

The lines of a garment include the seams and edges of the garment that divide it (Figure 9-15). Lines usually create a kind of "visual illusion": Longer, taller, or maybe slimmer. For example, princess seams create a slimming effect.

However sometimes, lines are used to create the illusion of weight. For example, a strapless look can be especially good for a thin woman because the shoulders appear wider (Figure 9-16). Strong asymmetrical lines tend to make a bold statement (Figure 9-17).

FIGURE 9-15 Line: Seams and edges of a garment create the "line."

FIGURE 9-16 Line: Strapless.

FIGURE 9-17 Line: Asymmetrical.

Continued on next page

BASIC PRINCIPLES OF DESIGN

Color

It has been found that the first element to grab the customer's eye is the color of a garment. Color is the most fundamental fashion element; it is usually the first decision a designer makes each season. Color is a study all by itself. Most schools have full courses on color theory. For our purposes it is most important for you to remember the three ways color is measured:

- **Hue.** The difference between one color (red, blue) and another (yellow).
- **Chroma.** Saturation or intensity of a particular color—the difference between brightness and dullness. Stated another way, it is the amount of gray in the color. For example, a dusty blue and a very dusty gray-blue can have the same hue and the same value but differ only in the amount of gray (chroma) in each color.
- **Value.** The difference between a light color (for example, light green) and a dark color (for example, dark green) of the same hue and chroma. This is the amount of pure white (tint) or pure black (shade) that has been added to the hue.

This may seem abstract now, but when you're sweating over a light box trying to judge whether a proposed sweater yarn is going to be a "close enough" match to a "matching" wool skirt, you will need to instruct the Hong Kong sweater maker in technical terms: For example, the color should be 10% brighter (chroma) and 20% lighter (value). This specific direction is the only way to achieve the appropriate match. There are machines that analyze these colors

FIGURE 9-18 Print: This original artwork by student Bo Young Noh would serve as the basis for a fabric *print*. Dyes will be applied to the surface of the fabric to create this design.

Continued on page 163

FIGURE 9-20 Mood board in July. The first items to go up are color services and early yarn cards. Swipes could be just for a color feeling, such as the landscape picture.

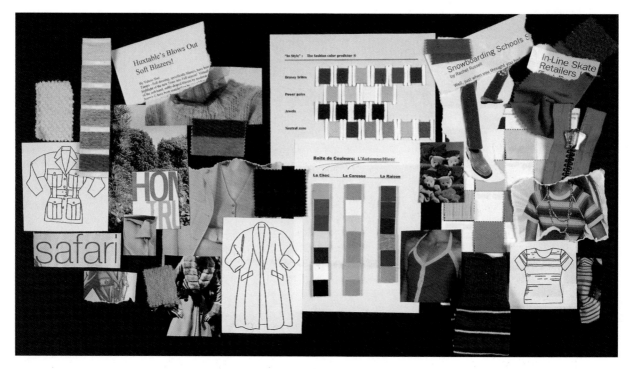

FIGURE 9-21 Mood board in August. More specifics are added: Fabrics, trims, zippers. Trade newspaper headlines about retail successes; contrasting green colors in a magazine typeface; perhaps a few line drawings of silhouettes spotted at retail. Teddy bear swipe captures the bright color feeling of one of the color services. Green sock and long gold dress swipe are for stripe ideas.

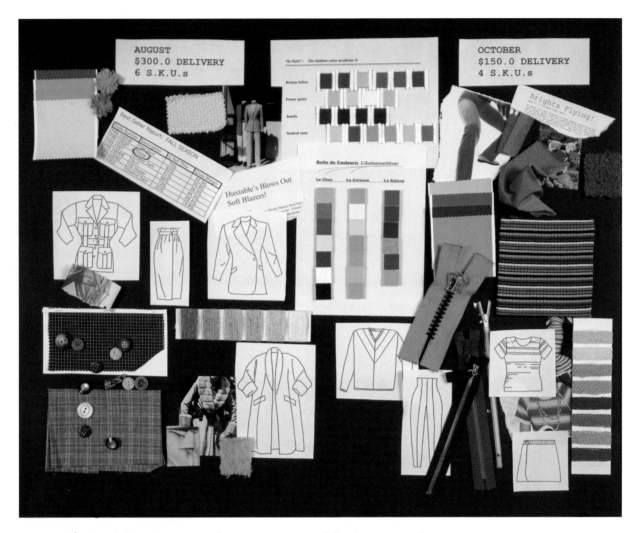

FIGURE 9-22 Work board in September. Two separate deliveries are starting to take shape: One for next August and one for next October. Right now the August "buy plan" is budgeted at $300,000 (written $300.0) with six stock keeping units (SKUs) or styles. October will be a smaller delivery, at $150.0 and four SKUs.

For the August delivery. A neutral-plus-blue/green color story has been extracted from the two color services. The soft blazer has become the key style based on two different retail selling successes. A picture of a soft blazer in a store window captures the perfect proportion. More fabric swatches and trims are added. The fisherman sweater swipe disappears because it is too casual for this delivery.

For the October delivery. Four bright colors have been selected—influenced by the French color service direction. Brights are selling! A great multicolored bright striped swatch is found, perfect for the T-shirt body. A slim pant and ski-inspired sweater are added. A novelty yarn card in brights is found—is it maybe too expensive? Check the price.

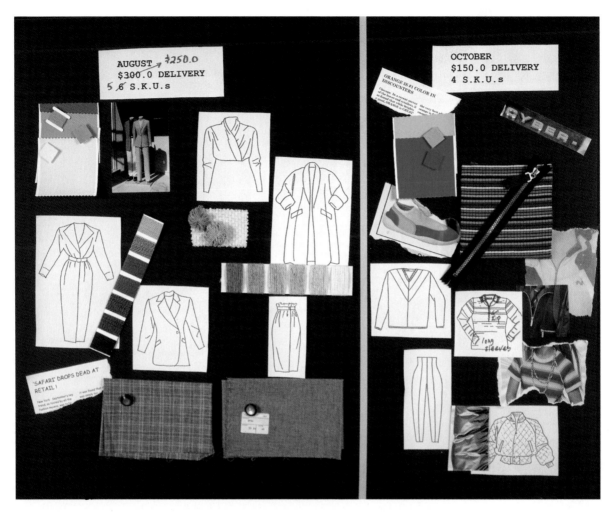

FIGURE 9-23 Work board in October. Two distinct deliveries are firming up. Actual bodies are being matched with actual fabrics.

For the August delivery. The budget has been cut, so one SKU is dropped. The color story is becoming dominantly neutral (gray with cream). However, the knitted top in two color combinations will keep a trace of the blue/green story. Smoky pearl buttons are selected to complement the heather gray fabrics. "Safari drops dead at retail." Drop the safari jacket, quick!

For the October delivery. Another shock! "Orange is #1 color in discounters." Downplay the orange—use only as an accent. You don't want to look like the low end of the market. This shifts the brights into a blue/green/black story, as exemplified by the sneaker. Zip collars suddenly take off, so the striped T-shirt is converted to a zip collar with long sleeves (October is still too early for short sleeves). A shiny quilted jacket is added (in small quantities) as a showstopper.

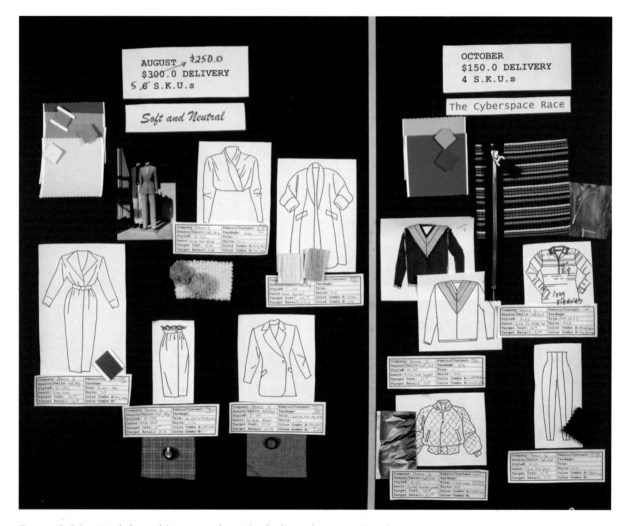

FIGURE 9-24 Work board in November. Final "line planner." Line is now set, item by item, with target prices, fabrics, colors, and color combinations per item as well as projected units and dollars for each delivery.

For the August delivery. Now called "soft and neutral," August stays with five SKUs. Ratios are two tops (blouse, jacket) to one skirt, plus the dress and topper coat. At the last minute, a small styling change: The paperbag waist on the skirt does not work with the blouse, so a regular waist is substituted.

For the October delivery. "The Cyberspace Race" is a fun, active group that actually looks better now that the colors have been narrowed. Ski sweater is shown in two color combinations. An appropriate and affordable spandex-blend fabric is (finally) found for the slim pant.

BASIC PRINCIPLES OF DESIGN

(Macbeth), but it almost always requires the human eye as well. (By the way, there is no such thing as a perfect match, especially between two different fabrics. The question becomes "How close is close enough?") To keep the job interesting, there are some colors like khaki that can match under daylight but not under store (fluorescent) light, and vice versa! Colors like these are called *metameric* and they can cause you to start to have nightmares in (metameric) color!

Print, Pattern, and Texture

In the industry a distinction is made between prints and patterns. Prints are applied to the surface of the fabric (Figure 9-18); patterns are woven or knitted into the fabric itself (Figure 9-19). Yarn-dyed woven plaids and jacquard knits are thus classified as patterns as opposed to prints. Prints and patterns follow fashion trends (for example, animal prints are in for a while, then they're out). Even more basic is the designer's knowledge of what size patterns work (or don't work) on a given garment. It is tricky to find a large pattern that can be used effectively, for example.

Texture is almost always referred to as the *hand* of a fabric. Does it feel soft, harsh, smooth, rough? Again the challenge is to pair a fabric of a particular hand with the right color in the right silhouette. This skill usually comes after making a few mistakes.

FIGURE 9-19 Pattern: Hand-woven swatch by student Ju Won Suk is an example of a fabric *pattern*. The design is woven in as the fabric is created.

through the development of **mood boards**, also called inspiration boards. (In these early stages, just collecting stimulating images is more important than organizing them. First you must find the overall mood of your collection. A product developer specifically will want to focus on styles and ideas that are prevalent in lines that are one or two steps higher in price.) Because fashion is a visual business, designers, product managers, and merchandisers often build their lines on corkboard walls or something similar. They start by pinning up anything that strikes their fancy. (This is the creative "right brain" process: If it pops into your head, pin it to the wall!) Gradually they edit, move, reconfigure, and refine the ideas until they join into a cohesive and practical line. (This is the organizing "left brain" part of the process.) It is helpful to be able to stare at the entire line often, if even for a minute or two at a time. Chances are that each time you will see something that could be improved.

The next questions are "What season are we working on?" and "What deliveries are we doing?" These mean, "When will this merchandise arrive in the retail store?" Usually several related deliveries within one season will be developed at the same time. For example, if fall is the season being considered, two "deliveries" might be planned: One to arrive in the store in August and one to follow in October. We must be on the lookout for some styles that might be shipped for both deliveries and some that might be shipped for one of the two deliveries.

In the fashion industry you are usually designing one year in advance. When the major European fabric shows are held in February, they are featuring fabrics to be used for spring and summer of the following year. When the fabric shows are held in October, they feature fabrics to be used for the following fall and holiday seasons. So when you are starting, you must think about what has just happened in the previous season and what you want to happen next year.

The best way to show the monthly progression is with photographs (Figures 9-20 to 9-24). Designers and product developers will start compiling pictures, **swipes**, words, fabric swatches, colors, trims—anything that might inspire them. They must also remember who their customer is. Into which square does this customer fit on the price/taste grid? A fall season plan, which covers shipping apparel from August through October, might go through a six-month planning phase before any samples are made.

To start in July, you will begin pinning up anything that you think could be directional or helpful in building *next* fall's line (Figure 9-20). In August, the board captures much of the inspiration but in greater detail (Figure 9-21). Designers want to be able to build on all good thoughts, not lose them. That's why they will pin up anything that hits them, when it hits them. Not all ideas may be used, but it is easier to eliminate ideas than to come up with them.

In September the boards start taking on a different slant and become real **work boards**. Everything before was from the creative right brain side, when you were collecting ideas and anything was possible. From September forward the business of design takes over, and the left brain starts editing and redefin-

ing ideas into a cohesive and salable line. This is when you must remember to stay in balance. Don't go off the deep end of design! These clothes must sell.

In September the business projections also start seeping in. Just what are the goals of your firm? How many pieces do you project to make and sell? What styles can you create from your ideas: What colors, what patterns? Details by style must be pinned down. The board will begin to reflect these decisions by looking at previous seasons' sales, projections, and assortments of mechandise.

Ratios

Ratios are an important measuring tool used by wholesalers and retailers alike to identify the best assortments of merchandise. Retail store buyers work to keep their inventories balanced to hit the correct proportion of basic merchandise, fashion merchandise, and promotional merchandise. They plan these ratios in a precise mathematical sense: For example, 60% basic merchandise, 25% fashion merchandise, and 15% promotional merchandise. These figures vary widely depending on the type of store, customer, and season. For example, trends and projections may indicate that the line should reflect:

60% basic merchandise

25% fashion merchandise

15% promotional merchandise

Take a closer look at what these terms mean.

Designer Christy Allen reviewing first prototype samples. Among other considerations, she is looking at the ratios of her line: How many jackets to tanks, long skirts to pants, and so forth.

Basic Merchandise

Basic merchandise, sometimes called staple merchandise, includes items that are wanted day in and day out. They tend to have a long selling life. Solid-color cotton turtlenecks (through fall and winter) and khaki shorts (in spring and summer) are two basics in which a moderate missy department would want to be fully stocked throughout the given season. Men's and kid's tend to have a relatively high proportion of basics; missy and especially juniors, have fewer.

Fashion Merchandise

Fashion merchandise includes styles that are current or are in demand for a limited period but then fall way off in popularity. Fashion merchandise is one of the trickiest parts of a buyer's job: How to know which fashion styles the customer will want, when he or she is ready to accept the look, and when he or she has moved past this look? When fashion items are new and hot, they can often command extra high markup. But when the look is over, they require an extra large markdown!

Promotional Merchandise

Actually, it was much more common in the past to bring in special groups of merchandise at reduced prices (perhaps a vendor's overstock, perhaps a closeout) and sell this special merchandise at reduced (promotional) prices. Today, it is more common for stores to promote their in-stock basic items

(even their fashion items) to drive sales volume. Customers will not tolerate second-best styling just to get something on sale. They want the regular merchandise (including brands and designers) to be on sale. This has taken a significant toll on overall profitability, but because all the competition is doing it, no store can avoid it.

There is one more small category of merchandise that you'll hear about: *Impulse items*. These are usually inexpensive items, often shown near the register, that a customer might pick up on a whim or "impulse." A cute novelty stuffed animal, a funny hat, a catchy printed T-shirt, or any number of eye-catching items are often stocked for this reason.

You, as a wholesaler or product manager, must understand that a buyer is going to evaluate your line by looking at ratios. You must examine (above all) the ratio of basic to fashion items as the line develops. In addition, you might think about the need to be involved in promotional items or impulse items. Each type of retail store will probably require different ratios of basics to fashion to promotional. Again, the wholesaler must know his or her customer (the retail buyer), and the buyer must know his or her customer (the consumer).

Still More Ratios

Other ratios must also be considered, usually measured against past selling history. These breakdowns provide choices for buyers. For instance, wholesalers and retailers want a line that reflects balance in:

- Ratio of number of tops styles to number of bottoms styles
- Ratio of hard pieces (tailored items such as jackets) to soft pieces (less constructed items such as sweaters and blouses)
- Ratios within bottoms: Skirts to shorts to slacks
- Ratio of knit tops to woven tops
- Ratio of long sleeves to short sleeves
- Ratio of solids to fancies (prints or patterns)

Determining these numbers is not as hard as you think. The first step, as we said, will be to work with the sales division to review past sales trends and identify what customers bought. The second step would focus on the styles and upcoming trends.

You can take this a step further by defining ratios for a season's line by looking at your own wardrobe. Take a look in your closet. How many tops do you own compared to the number of bottoms? Men often have 2-3 shirts for every pair of pants. Women usually can say the same about the number of tops for their skirts and trousers. Looking at the ratio of hard pieces to soft, again you probably have a jacket or blazer that works well with several soft pieces.

There are many more ratios, depending on your line. Each ratio takes on more or less importance based on season, store, and customer. (Doesn't this sound like the triangle of balance?) Just remember to look at all the items in a line and apply the same step-by-step breakdown, no matter what season you are working on.

Now, on to our work boards in September (Figure 9-22). You must create two groups, each of which has its own design theme for two separate deliveries. By October the two deliveries are becoming clearer (Figure 9-23). Then in November, you must make final decisions. The board in Figure 9-24 reflects the following:

- Work sketches of each item, incorporating the principles and elements of design (remember that some wholesalers' lines could be 200 to 300 styles per season)
- Color stories that project a fashion-forward image yet will be understood by the target customer
- Fabrics that will capture the fashion message yet are affordable
- Cost sheets that will project the cost of each style

This was just for two deliveries! Some lines can have as many as 10 or 20 deliveries per year.

How "Practical" Must Wholesale Designers Be?

In most design and garment-manufacturing books, one concept seems to be universal. The manufacturing process in the fashion industry is viewed in three parts:

- Design
- Production
- Sales

Hearing this, your first impression might be that sales sounds like the only part that is really "business." Surely designers are, above all, expected to be fashion visionaries. And production is run by engineering types who care about neither the design nor the salability of the garments. Wrong!

Each of the three areas must be run as a business. Each must search for efficiencies and savings. Each must think about the requirements and challenges of the other two areas:

- Design should be sure that its concepts can be produced efficiently and sold easily (designers are often accused of wanting the impossible!);
- Production must preserve the design integrity of each garment but in the most cost-efficient manner;
- Sales must understand the designer's vision plus the technical quality features that the production team has been able to build in. Salespeople are also the link to the retail buyer. They must be able to communicate the buyer's needs back to both design and production personnel.

The goal of any business is to produce a product or service that sells well and thus earns profits for that company. Each of the three parts of our business (design, production, and sales) must share this goal, and each must make its own businesslike contribution toward it. Communication among the three

segments is key throughout. Midstream changes that are not clearly communicated to everyone are a frequent source of production problems.

In the following exercises, you will be able to assemble your own line. Many students find this the most exciting part of the process. Although as we have just learned, it is one thing to create styles and another to create styles that *will sell*. In Chapter 10 we are going to learn about the number one factor that might limit your creativity: Cost.

HERE'S HOW TO BEGIN . . . CHAPTER 9

It's time to start putting together a line, so let's take some time and get the on-the-job training that we talked about before!

First: Gathering Information

We're going to ask you to start thinking about what you might be developing one year from now for a particular consumer group of your choice. Working with a team of three or four students, decide what category of merchandise you would like to develop. Some suggestions follow:

Men's casual sportswear or activewear;
Women's casual sportswear or activewear;
Contemporary women's sportswear;
Women's bridge/better sportswear;
Children's, boys 4–7 or 8–20, girls 4–14;
Juniors.

If you cannot decide, refer to Chapter 5 for some ideas.

Based on the information you have gathered on industry leaders, fashion trends, fabrics, stores, and consumer lifestyles, identify the category, look, price points, fabrics, and colors that you would like to present to your consumer.

Second: Gathering and Analyzing Information to Build Your Own Line

As a team, you are all staring at a blank board! Using photos from magazines, industry publications, press kits, or newspapers, pin (or tape) pictures of garments on a class bulletin board or corkboard that were top sellers for this past season. Add swipes reflecting trends that you like, along with color swatches or fabric samples. Add words that capture the feeling of the line you are developing. Words can often create a mood—and that mood can help you get started. Continue to add anything that you feel interprets the ideas you are looking to create. Trims, buttons, zippers, or even a paint swatch from a hardware store might be important to your line.

Third: Start Creating Individual Styles

As you look over the information you have collected, some practical reasoning must apply, and it is time to start developing styles that you feel will sell, along with color and fabric stories that reflect the vision of your design team and will appeal to your target market. Now, have someone on your team sketch samples that reflect the principles of design and will appeal to your consumer market. Don't forget: Stay in balance!

Fourth: Time to Fine Tune

It is time for everyone to stand back and look at the styles that are developing, along with the color and fabric stories, and identify specific groups. You may decide if you are working on spring/summer to have two major deliveries: One in January and one in March. If you are looking at fall/holiday, you may decide to have three deliveries: One in August, one in October, and then a small group for holiday delivery in November. Start to eliminate the excess: Pull the pictures that don't work, remove color stories that don't reflect the moods, and begin fine tuning your boards so they don't become overpowering. You may have two lines with 10 to 20 pieces in each for two different deliveries. Make sure to narrow the work field and keep the items that are strongest for your consumers based on your research!

Fifth: Time to Decide

At this point your board should reflect work sketches of each piece in your line, the color stories that you want to project, and the fabric stories. It is also time to decide how many pieces you think you would need to manufacture based on the number of stores that will be carrying the line. In your case you don't have actual numbers, but from your research on stores, you can determine how many branch operations a company has and how many pieces you would need in each store. The numbers can get staggering, so it is important to be focused on what your customers want!

The next step is crucial, because it is time for you to develop cost sheets and determine if the line is affordable. In Chapter 10 we provide ways to do that, so you might want to leave the boards in your classroom so you can go back and prepare an item-by-item cost analysis, just as you would do on the job!

A Final Note

It may take your team a few classes to complete these work boards, each week bringing in more pictures, ideas, and sketches. Remember that it takes a designer or product developer about six months to put boards together! Keep pinning items on the board; look at them for awhile; go back and see if they still interest you—take items off; put them back. Trust us, this is the same thing you will be doing on the job! Don't forget to have some fun and let your creativity take over. This is the time, so go for it!

CHAPTER TEN 10

GOING FROM PLANNING TO COSTING: SQUEEZING OUT THOSE PENNIES

No one will argue that building the fall line in Chapter 9 was a team effort. The focus for design, production and sales was to develop a commercially successful product. Logically you may think once the design was approved by everyone, the next step would be producing the garments. However, before you can lay out the patterns and start the first cut, you must also consider your customer, again. Now you have to specifically target what your customer will be willing to pay. This means each item on your work board will have to be analyzed financially, in two different ways. First you will have to determine how much it will cost to make each piece in the line, and then you must also figure out how much it will sell for in the retail marketplace.

THE KEY IS ALWAYS "COST"

Now that we have our designs, we need to be sure that they can be made at a workable cost. There are three major components of cost in a garment:

- Material (fabrics),
- Trims and findings,
- Labor and shipping.

Those who have gone before you in the fashion industry have already squeezed and shaved each of these components to save money. As a new-comer, you will need to squeeze and shave with the best of them! Otherwise you're going to be too expensive. According to retail veteran Ted Shapiro, "If you sold 500 dozen at $5.00 retail, ask yourself how many more you could sell at $3.00."

The best values are produced with close attention to every detail. For example, you might ask yourself:

- I love this fancy button, but is it absolutely critical or is there a cheaper version that will do?
- The imported fabric is gorgeous, but the shipping costs are high. Is there a domestic alternative?
- Factory X in Pennsylvania charges more for labor (**cut-make-and-trim**) but is much closer than the one in North Carolina, and we need these goods fast! Is the faster turnaround more important than the higher cost?
- Can I negotiate more favorable payment terms so that my money will stretch until I am paid by my customers for the completed garments?

Cut-Make-and-Trim
Production part of the garment-making process. Does not include fabric buying or pattern-making at the beginning or shipping at the end.

Each component and process must be efficient and cost-effective. To achieve this, you must start with the foundation of every deal in the fashion business: Negotiating.

NEGOTIATING

On her very first trip to the Orient when she had to stand in at the last minute for her boss, Hope Cohen realized at the airport that there were things she should have discussed before leaving. So she called her boss and said, "I'm not supposed to just take the price the vendor offers, am I? I'm supposed to negotiate or something, right?"

Right. Negotiating is the old push-pull. As the designer, merchandiser, or product manager, you must get your items made with the best possible fabrics and trims, constructed in the best possible way, for the lowest price and earliest delivery. The manufacturer or contractor on the other side of the table wants to use the cheapest possible fabrics and trims, constructed in the fastest (cheapest) possible way, for the highest price and (probably) the longest delivery. Somehow the two of you have to find a workable compromise. It's often possible, but not always. You may have to walk out because you simply cannot reach a middle ground that works for both parties. Both must be able to make a profit; neither is working for charity.

Negotiating techniques could fill another book. However, in our years of experience, one overall approach has always worked: Be firm but polite. Ted Shapiro reminds us, "If you don't ask, you don't get!" Tough but cordial negotiations allow everyone to keep their dignity. As you win some points, find a way for the other person to win some, too. Don't scream and rave. You'd be shocked to know how many people take this approach. It's almost always a mistake.

Here are two words of caution as you are outlining your requirements with the manufacturer: *Specification buying.* It is the buyer's responsibility to specify the quality required in fabric, trim, construction, and performance. As long as these standards are articulated in writing by the buyer to the manufacturer, he or she will be obliged to meet these standards (or to make good if something falls short). But *caveat emptor* (buyer, beware)! If a buyer fails to specify a single detail, the manufacturer can view the omission as something that can be skimped on later, if necessary, to protect his or her own **profit margin**.

Profit Margin
Percentage of sales that is profit.

How Do You Negotiate the Best Terms of Sale?

First: Discounts

You must start by negotiating the best price on the raw materials. This is done by working for the best discount, a deduction from the original price. Let's look at a few of the most common discounts that might be available on materials, trims, and findings.

- *Trade discount.* A discount expressed as percentage off the retail list price. It is a discount given for being a re-seller.

- *Quantity discount.* A discount given for large quantities purchased.

- *Seasonal discount.* A discount given for merchandise purchased before a normal buying season or well after the traditional selling season. (In both cases, when the demand is low and the vendor has plenty of available production.)

Second: Shipping Charges

After you negotiate the lowest possible price on the materials, the next step is to discuss who pays the shipping charges. Don't forget, you've learned that fabric mills and manufacturing centers are located everywhere on the globe. Moving materials around the world costs money. Manufacturers, designers, and retailers all identify the shipping expenses with specific terms. Take a moment to learn what they are.

FOB means *freight on board* or *free on board.* This designation determines when the change of ownership of goods takes place. Once that exchange occurs, it must be determined which party is responsible for the shipping charges up to that point and from that point.

Third: Dating and Payment Terms

Although dating and payment terms are not usually calculated at the time that cost sheets are developed, you should know that when you pay your bill is very important. You can lower the final cost if you keep a sharp eye on due dates and thus earn extra discounts for prompt payment. Let's look at cash discounts and dating terms.

SHIPPING TERMS

FOB store or destination. The manufacturer owns the merchandise and pays all freight charges until the merchandise reaches its destination.

FOB factory or shipping point. Buyer pays all freight charges, and transportation charges are added to the invoice.

FOB (city name) or FOB 50/50 (or some other split). With foreign goods the transportation charges are often split. Sometimes the manufacturer or mill will pay from their shipping point to a designated city, and then the importer or store will pick up the shipping expense from that point to the final destination. For example, if the terms agreed on were FOB New York, the manufacturer has agreed to pay the shipping charges from their location to New York and the store picks up the shipping charges from New York to the next destination. Another way to negotiate high shipping charges is to agree to split the charges.

Prepaid. Shipping charges are paid when the shipping company picks up the merchandise, and the seller is billed accordingly.

Cash discounts. Cash discounts are incentives to pay bills promptly. They usually involve an additional percentage that is deducted from the net amount of the invoice if the bill is paid within a specified period. Some important features about cash discounts follow:

1. Cash discounts are calculated after all other discounts have been deducted;
2. Cash discounts are given only if the bill is paid within the specified number of days;
3. If the letter "n" or the word "net" is written next to the terms, it means no discount;
4. Cash discount terms never stand alone but are combined with specific dating terms;
5. When written out, cash discounts look like fractions with each number or letter representing one aspect of how much the discount amount is and how many days the buyer has to earn that discount;
6. Cash discounts are an important way to earn more profit!

Dating. Dating is the practice of setting a specific time for paying the bill. There are several types of dating, and they work hand-in-hand with the cash discounts. Sometimes bills must be paid all at once; sometimes a mill or manufacturer will allow payment at a future date. The most important thing you have to negotiate is exactly what day the invoice must be paid.

Now, with this overview of terms and conditions with which you might negotiate when purchasing materials and supplies, let's look at an important work tool that you will be using: The cost sheet.

DATING TERMS

COD, collect on delivery. This is often used with new accounts.

Example: $300.00 COD. $300.00 is to be paid when the goods are delivered.

DOI (regular), ordinary dating. Payment window begins by identifying the date of the invoice (DOI) and calculating the payment days allowed from that date. This is frequently used for supplies.

Example: 2/10, n/30. A company will earn a 2% discount if the bill is paid within 10 days of the date of the invoice. If the payment is made between 11 and 30 days, the company must pay the amount in full.

ROG dating, receipt of goods. When using ROG dating you do not calculate the days to pay until the merchandise has been received. This is used primarily for merchandise bought overseas. It is too difficult to calculate when merchandise will be received, owing to duties and customs in the worldwide ports.

Example: An invoice is dated May 5; the terms read 8/20, n/30 ROG. The merchandise was received on July 3. To receive the extra 8% cash discount, payment must be made by July 23.

EOM dating, end of the month. The invoice will be paid within a specified number of days from the end of the month. This is the most popular type of payment terms used in the fashion industry.

Example: An invoice is dated August 15. The terms read 8/10 n/30 EOM. Merchandise was shipped on August 22. To receive the eight percent cash discount, payment must be made on September 10.

But what is really the end of a month? Some months have 30 days, some have 31, and then we are always faced with the 28- or 29-day

Cutoff date for EOM terms.

dilemma of February. Companies must have a common cutoff date, and in the fashion industry, businesses have assigned the twenty-fifth of each month as the standard cutoff date for the end of the month (Figure 10-1). So if an invoice is dated from the first to the twenty-fifth of the month, payment is made from the end of that month.

Example: An invoice is dated January 18, terms are 8/10 EOM. Payment is due February 10.

If an invoice is dated from the twenty-sixth to the thirty-first of the month, payment is made from the end of the next month.

Example: An invoice is dated January 28, terms are 8/10 EOM. Payment is due on March 10. These are often the terms for which many manufacturers and buyers strive because a business can have a six-week period (float) before the invoice must be paid. They will still earn the extra eight percent discount. (Does this sound a little like your own checking account?)

STEP-BY-STEP GUIDE TO COST SHEETS

How do you know if it is affordable to produce a particular garment? Wholesalers and product managers use a tool called a cost sheet to help make this decision. Each ingredient and its cost are itemized. Each cost is the result of negotiating for the best price. The cost sheet not only adds these individual costs to project the actual total cost of goods, but it also helps pinpoint if one or two ingredients are inflating the price inappropriately. After all, the lower the cost of the garment, the sharper the wholesale and retail prices.

Let's see what a cost sheet looks like. (Don't panic: It looks a bit overwhelming, but we will explain it, line by line.)

Note that a cost sheet determines the price of only *one* garment, so let us review how the components work together.

A. *Date*. Signifies that the prices are firm for an order placed as of this date. Negotiation and terms of sale have been determined with the textile mills and the findings companies. Generally these prices are good for about 30 days.

B. *Style number*. Numerical identifier of this garment.

C. *Sketch and material swatch*. Actual look and feel of the garment.

D. *Description*. Written description of the garment.

E. *Fabric mill*. Where the fabric is being purchased. Mill location is important for shipping, timing, duties, import/export quotas, and fees.

F. *Manufacturer*. Where the garment is being produced (contractor/country). Factory location is important because of duties, import/export fees, and quotas.

G. *Size range/size scale*. Size range is the range of sizes to be cut (for example, small, medium, large); size scale is the number (proportion) of each size (for example, three smalls, six mediums, three larges).

H. *Fabric width*. Used by the marker makers to calculate the minimum yardage use.

I. *Estimated marker yardage*. Fabric needed for most effective placement of pattern pieces for a full size run. This is a *critical* number: When all pattern pieces have been laid out for a complete size run, this is the amount of fabric that is required. The less fabric used, the lower the cost.

J. *Actual marker yardage*. Companies often go back and review cost sheets and spec sheets to determine the actual yardage used to see if their calculations were accurate or if something has changed, such as fabric width, which altered the amount of yardage used.

K. *Material/yardage*. Specific yardage for one garment. This is determined by dividing the total marker yardage by the number of sizes being made. For example, S, M, L, XL—21 yards for our size scale, which is 12 pieces; we're doubling on mediums and larges (two smalls, four mediums, four larges, two extra larges). Although a small size will certainly take less fabric than an XL, 21 yards ÷ 12 = 1.75 yards; 1.75 would be the average yardage identified on the cost sheet.

L. *Price per yard of material*. Price that was negotiated after all the trade discounts were discussed and shipping terms and payment arrangements made.

Continued on next page

STEP-BY-STEP GUIDE TO COST SHEETS

COST SHEET

Sketch and Materials Swatch

C

Date _____ A _____ Style Number _____ B _____

Description _____ D _____

Fabric Mill _____ E _____

Manufacturer _____ F _____

Size Range _____ G _____

Size Scale _____ G _____

Fabric Width _____ H _____

Estimated Marker Yardage _____ I _____

Actual Marker Yardage _____ J _____

MATERIALS	Yardage	Price per Yard	Total Amount
Fabric	K	L	M
Fabric			
Lining			
		Total Cost of Materials	N

TRIMS	Amounts	Cost Each	Total Amount
Buttons	O	P	Q
Zippers			
Belts			
Other			
		Total Cost of Trims/Findings	R

LABOR

Marking Costs _____ S _____ Grading Costs _____ T _____ Cutting Costs _____ U _____

Construction _____ V _____ **Total Labor Costs** _____ W _____

SHIPPING AND DUTY EXPENSES

Import Duties _____ X _____ Shipping Expenses _____ Y _____

Total Shipping and Duty Costs _____ Z _____

Total Cost of Goods to be Sold _____ AA _____

Suggested Wholesale Price _____ BB _____

Suggested Retail Price _____ CC _____

Continued on next page

STEP-BY-STEP GUIDE TO COST SHEETS

M. Total amount of material. Total cost of material (yardage x price per yard).

N. Total cost of all materials. For one garment.

O. Number of trim pieces. For one garment.

P. Cost of each trim. For one garment.

Q. Total cost of trims. For one garment, number of trims x cost.

R. Total cost of all trims and findings. For one garment.

S. Marking costs. Marking is laying out all the pattern pieces necessary to make a full size range of a garment or group of garments. Due to advances in technology, much of this work is done on CAD/CAM systems (computer-aided design systems are discussed in Chapter 15). Generally a total price is quoted, and the designer or manufacturer will divide the cost by the number of pieces being produced to determine the price for *one* garment. This expense is generally incurred once and will not show on a reorder.

T. Grading costs. Cost incurred for developing a full size range of products. Often this cost is combined with marking costs.

U. Cutting costs. Manufacturer's price based on a minimum cut to determine cost per unit. For example, a $100 fee for a 200-piece minimum cut = 50 cents per garment.

V. Construction. Labor costs, including bundling, sewing, pressing, trimming, and inspection. Generally determined as piecework (per piece) costs. Construction is discussed further in Unit 3.

W. Total labor costs. For one garment.

X. Import duties (see Y).

Y. Shipping expenses. Both import duties and shipping expenses are based on fiber content, weight of shipment, and location of manufacturer and shipping. Freight companies and brokers calculate the cost of freight and advise on import duties and taxes. These figures are given as a total and must be divided per piece.

Z. Total shipping and duty costs. For one garment.

AA. Total cost of goods to be sold. Materials (N) + trims (R) + labor (W) + shipping/duty (Z).

BB. Suggested wholesale price. Price the buyer would pay, determined as cost of goods to be sold + markup = wholesale price. *Markup* is the amount of money added on, which must be high enough for the designer or manufacturer to cover expenses and make a profit but low enough to keep the price competitive.

CC. Suggested retail price. Price the retail consumer will pay, determined as wholesale price + store markup = retail price.

STEP-BY-STEP GUIDE TO COST SHEETS

COST SHEET

Date ___June 12, 20xx___ Style Number ___510___

Description ___Women's two-piece knit___

Fabric Mill ___North Carolina___

Manufacturer ___U.S.A.___

Size Range ___6, 8, 10, 12___

Size Scale ___2–4–4–2___

Fabric Width ___60 inches___

Estimated Marker Yardage ___21 yds.___

Actual Marker Yardage _____

MATERIALS	Yardage	Price per Yard	Total Amount
Fabric	1.75 yds.	$6.40	$11.20
Fabric	0.25 yds.	$1.25	$0.31
Lining			
		Total Cost of Materials	$11.51

TRIMS	Amounts	Cost Each	Total Amount
Buttons	1 button	$0.04	$0.04
Zippers	none		
Belts	none		
Other	0.50 yd.	$1.50/yd.	$0.75
		Total Cost of Trims/Findings	$0.79

LABOR

Marking Costs ___$0.50___ Grading Costs ___$0.50___ Cutting Costs ___$0.72___

Construction ___$4.48___ **Total Labor Costs** ___$6.20___

SHIPPING AND DUTY EXPENSES

Import Duties ___none___ Shipping Expenses ___none___

Total Shipping and Duty Costs ___none___

Total Cost of Goods to be Sold ___$18.50___

Suggested Wholesale Price ___$33.75___

Suggested Retail Price ___$75.00___

Continued on next page

STEP-BY-STEP GUIDE TO COST SHEETS

Now look at a cost sheet that is filled in, and see how the values were determined. The information on this cost sheet on page 179 tells the design team the following:

1. On June 12, 20xx, these were the prices negotiated.

2. A women's two-piece knit style no. 510 is to be manufactured in the United States, with the fabric coming from a mill in North Carolina.

3. Four sizes are being made; out of every 12 pieces, there will be two sixes, four eights, four tens, and two twelves.

4. Fabric runs 60 inches wide. Markers have determined that 21 yards are needed for one full-scale run to be made. Therefore $21 \div 12 = 1.75$ yards per average piece, based on the size scale.

5. The material costs $6.40 per yard. This is the amount per yard that was determined after all the trade, quantity, and seasonal discounts were deducted. Sometimes even the shipping charges are calculated into this figure if the shipping charges are high. Therefore 1.75 yards x $6.40 = $11.20.

6. 0.25 yard of collar fabric (costing $1.25 per yard) is needed for a collar trim: 0.25 x $1.25 = $0.31.

7. Total cost of materials: $11.51.

8. The trims include one button at $0.04 each, for a total of $0.04, and 0.5 yard of elastic tape at $1.50 per yard, for a total of $0.75. Total cost of the trims is $0.79.

9. Labor expenses are determined as follows:

Marking costs (usually quoted for minimum cuts—in this case we are saying that the minimum is a 100-piece cut). For every 100 pieces the marking charge is $50.00; therefore the marking expense would be $0.50 ($50.00 ÷ 100 pieces = $0.50).

Grading costs. For every 100 pieces the grading charge is $50.00 ($50.00 ÷ 100 pieces = $0.50).

Cutting costs. For every 100 pieces the cutting charge is $72.00 ($72.00 ÷ 100 pieces = $0.72).

Construction costs. Designer or manufacturer has negotiated a construction cost of $4.48 per garment. The manufacturing company has presented this offer based on the amount of work in each garment. Again, this is an area that can be competitive, which we review in Unit 3.

10. Total labor costs are $6.20. This was determined by adding

$0.50
$0.50
$0.72
+ $4.48
$6.20

Now, let's take a step further. The total cost of goods to be sold is

$11.51 (materials) + $0.79 (trims) + $6.20 (labor) = $18.50

This is what you, the designer/wholesaler, will actually pay for each garment.

CALCULATING MARKUPS

The designer/wholesaler then must calculate the selling price: What the wholesale price will be when this garment is sold to a store buyer. Remember that the selling price will be a combination of two parts:

1. Actual cost of goods to be sold, in this case $18.50,
2. **Markup**.

In the wholesale industry the markup is generally 30% to 55% of the total selling price. Let's see how to calculate.

The selling price (which is always the total price) is equal to 100%. If the desired markup is 45%, the cost of goods to be sold would be 55%. This means that the final selling price (100%) is a combination of 45% and 55%. If you put this information in T-chart format, it is easy to see.

	Dollars	Percent
Selling price		100%
Markup	–	–45.%
Cost of goods to be sold	$18.50	55%

Now what do you do? Simple: Always remember that you are looking at the parts in relationship to the whole, and you know that $18.50 = 55%. If you divide those two amounts, it will give you the selling price. Try it!

$18.50 ÷ 55% = $33.64

That's right, $33.64. Typically, a designer or manufacturer would round that amount off to the closest quarter, so let's round up to $33.75. Take note of the amounts filled in the charts below.

	Dollars	Percents
Selling price	$33.75	100%
Markup	–	–45.2%
Cost of goods to be sold	$18.50	54.8%

	Dollars	Percents
Selling Price	$33.75	100%
Markup	–$15.25	–45.2%
Cost of goods to be sold	$18.50	54.8%

Check your work:

1. $\$33.75 - \$18.50 = \$15.25$

2. $\$33.75 \times 0.452 = \15.25

3. $\$33.75 \times 0.548 = \18.50

The $15.25 the designer/wholesaler earns must be enough to pay the salaries and expenses of the design team and the rest of the operation. In addition, each company is in business to make a profit, and there must be money left after all expenses have been paid. As you can see, the price is now inching up, because the wholesale price is just the price at which the designer/wholesaler will sell the merchandise to the store. Now the wholesaler must determine the suggested retail price to the consumer. (It is the store buyer's job to make the final determination of the retail price, but a good wholesaler will have a pretty clear idea of what that price will have to be.)

When the designer looks at the work board, filled with sketches, fabrics, and colors, and then at the cost sheet, the most important thing to ask is: "How much will the customer pay for this garment?" Alan Glist, president of Alan Stuart (a men's wholesale line), says about "merchandising" prices: "Pricing a garment must also be done by eye appeal. If (using our normal markup) a shirt prices out at $20.00, but it looks like more, we might mark it $22.00. The opposite also happens: A $20.00 top might only look like $17.75." Stanley Kreinik, president of the Sockyard (a hosiery wholesaler), puts it this way: "Picture the profitable items in your line as bricks. Picture the 'loss leaders' in your line (items sold slightly below cost) as mortar. If you build a house of all bricks, it falls down. If you build a house of all mortar, it cracks and falls. You need a good mixture of both bricks and mortar. The key is the profitable proportion of bricks to mortar."

THE STORE MUST GET ITS MARKUP, TOO

Initial Markup
First amount that a buyer adds to the cost price of a garment. If the cost price is $4 and the retail price is $10, the initial markup is $6, or 60% of the retail price. Later, the price (and thus the markup) may be reduced to clear the goods. That's why 60% in our example is called the initial markup. "Maintained" markup is lower.

In the retailing industry it is expensive to run a company, and sellers are competing for everyone's business. The garment must be quite exciting to command enough markup. There are markup standards in the industry that can be researched in the financial operating reports filed by the National Retailing Federation. The rule of thumb is that retailers must earn between 45% and 60% **initial markup** to be profitable. The same rules apply: Retail markup must be enough to cover the store's expenses and make a profit (yet the item must be competitively priced so that the consumer will buy it).

Mathematically, the same concept applies when calculating retail prices. Wholesale or cost price plus a markup will determine the actual retail price, the total price that is always equal to 100%. Let's look at the T-chart below, which shows the cost at $33.75, because that is what the store paid.

	Dollars	Percents
Retail selling price		100%
Markup	–	–
Wholesale cost price	$33.75	

In this case the designer has decided that the sales team will propose a $75.00 suggested retail price to buyers. Let's see what kind of markup can be earned.

	Dollars	Percents
Retail selling price	$75.00	100%
Markup	–	–
Wholesale cost price	$33.75	

Again, you are only going to be working with parts of the total and looking for the relationship, but this time you are going to work with the numbers. Let's determine what the markup percentage really is.

1. $75.00 – $33.75 = $41.25

2. $41.25 ÷ $75.00 = 55.0% (markup the store will get)

3. $33.75 ÷ $75.00 = 45.0%

Once again, check your work. You have two parts, markup and cost, that must equal the total amount, which is always equal to 100%.

$41.25 + $33.75 = $75.00
55.0% + 45.0% = 100%

The math formulas for all markup problems are the same:

Selling price always	=	100%
Cost dollars ÷ cost %	=	selling price
Markup dollars ÷ markup %	=	selling price
Selling price x markup %	=	markup dollars
Selling price x cost %	=	cost dollars

Once you have made the calculations, you finally know if the profits will support the illustrations, colors, fabrics, and shipping plans.

COSTING AND PRICING: WHOLESALE VERSUS PRIVATE LABEL

You just costed a two-piece knit for $18.50 that will sell in a department store for $75.00. The reason for the large difference in price goes back to what you learned in Chapter 3. Designers must sell their products to stores, and the stores in turn sell the products to the consumer. There are many middle people in that process: Fashion shows are held; major publicity and public relations events are staged; and there are dozens of people along the selling/customer service ladder who must be paid. The wholesaler still is only going to make $15.25 in markup, and that must be enough to cover the company expenses and make a profit.

But what if you are a product development specialist for a major department store? You would go to the same fabric shows and probably visit the same factories to make your products. But the difference now is that you don't have to sell to a store. You are making it for your own store. Sure, you will incur some advertising expenses to promote the product, but let's look at this:

	Dollars	Percents
Retail selling price	$75.00	100%
Markup	–	–
Cost of goods to be sold	$18.50	

If you marked the two-piece knit at the same price as the designer prices, look at how much margin/markup you could make:

$75.00 – $18.50 = $56.50

That's a lot more profit than the designer would earn!
If you fill in the numbers and percentages on the T-chart, it will look like this:

	Dollars	Percents
Retail selling price	$75.00	100.0%
Markup	– $56.50	–75.3%
Cost/wholesale	$18.50	24.7%

Remember, you did not change the cost of the goods to be sold. However, you must also realize that customers will usually pay more for a well-recognized national brand. Private labels tend not to command as much loyalty. So, what would happen if you reduced your selling price? You would still be giving the consumer the same product but now at a sharper price. That might get the customer to buy!

Let's see what your profit will look like if you mark the two-piece knit at $60.00:

	Dollars	Percents
Retail selling price	$60.00	100.0%
Markup	– $41.50	–69.2%
Cost/wholesale	$18.50	30.8%

$60.00 – 18.50 = $41.50 and then $41.50 ÷ $60.00 = 69.2%.

Just follow the math process you just reviewed.

At $60.00 you are still providing a high markup for your company (69.2%) to cover expenses and make a profit, yet suddenly you are cutting into the designer's business and giving the consumer a much better price! The challenge a product development/private label buyer faces is to build strong and consistent name recognition. Private label stores such as Banana Republic, Express, Structure, and Gap have reached this goal, and now department stores are joining them. Consumers are seeking Charter Club, INC, Field Gear, and Arizona Jeans brands, and department store organizations are pleased.

How Critical Are Cost Sheets?

In the chapter exercises, we will calculate some garment costs and then determine the wholesale and retail selling prices. Trust us when we tell you that many products never get past this point. They just don't work because the cost is too high and/or the profits are too low. All designers will tell you that it is much better to be disappointed now than to proceed further and invest money in products that won't sell.

As you can see, calculating a cost sheet enables you to make *go or no-go* merchandising decisions. But what a job! Imagine calculating a cost sheet for every item you consider for the line, but it must be done! Cost sheet analysis is essential in the product development process. Needless to say, finding short cuts has been a top goal for the apparel industry. Fortunately the computer has helped.

First, it is important to tell you that all the elements and methods to calculate cost sheets are the same no matter where you work. However, the style of the printed forms and how the forms are completed, either manually or by computer, vary among companies. For example:

- *Some firms still complete cost sheets manually.* Cost sheets are calculated using the same steps you just took with your calculator. Before you can move on to calculate cost sheets with computerized programs, you must learn the basic steps. Knowing what the numbers represent as well as how they were calculated will enable you to make the best decision for your firm.

- *Some firms complete cost sheets using commercially sold spreadsheet programs.* Microsoft Excel is the most commonly used. Excel enables you to create cost sheets with ease. The computer calculates the totals. First you enter the formulas into the software program and then the specific numbers for the materials, labor, and trims. The nice part is that each time you want to change something, or try another choice, the totals are instantly changed by the program.
- *Some firms complete cost sheets using industry-driven software programs that have been developed by the large apparel technology firms, such as Gerber Garment Technology or Lectra.*

In Chapter 15 we will explain in a bit more depth the difference between commercial and industry-driven programs, but for now we want to introduce you to a term that you will hear frequently in product development, and give you a quick overview of how it relates to cost sheet preparation....

PRODUCT DATA MANAGEMENT

If you are working with an industry-designed software program such as Gerber or Lectra you will hear about product data management (PDM), which is a fully integrated system that offers sophisticated computer tools for designing on-screen. The uniqueness of a PDM system is that it is like a built-in calculator connected to a telephone. First, all designs are generated on screen. If you change a design (for example, the length of a skirt), the amount of the fabric and the cost of the fabric also change. If you are using a PDM system, which is integrated with the other design and manufacturing computer programs, the change would be made automatically on the cost sheets and throughout the design/manufacturing and production systems, all of which are linked. The information is automatically updated, enabling all staff members to view the entire design/production cycle and control the quality of the product development process. In the long term, designs are improved, costs are reduced (because the trial and error steps are reduced), and communications are improved. The bottom line is value to the customer. A better product is delivered at the sharpest cost.

Once we have made preliminary decisions on the styles in the line and run the cost sheet calculations to see if they will all be affordable, is it time to produce the line? No, not yet. First you need some friendly free advice.

TALK OUT

At this stage, most wholesalers bring everyone (sales, design, merchandising, production) together to talk through the line as it is. Some call it a line review. Each area brings a different perspective, and each is important if the line is to be successful. Questions such as the following will be raised:

Sales. What will the major store buyers love? Hate? Will the prices fly, compared with those of the competition? Does anything look too conservative or too advanced?

Design. Does the line look cohesive? Is it consistent with the brand? Can we live with designs that have been altered for price reasons?

Merchandising. Are there one or two items where we will have to take a shorter (lower) markup as loss leaders? If so, where can we make up that lost markup on other items?

Production. Can these garments be made? Are there any potential pitfalls? Are they planned for the appropriate sewing plants?

From the back-and-forth friction of this process, the compromise that is reached usually produces a line that will get placed by buyers, be easily handled in production, and be profitable for the wholesaler. (Not always! We said "usually.")

Sometimes a trusted key retail store buyer is brought in for his or her opinion. Again, here's that key concept: The wholesaler is making sure that his or her customer (store buyer) is going to be satisfied. The wholesaler knows his or her customer and wants to make sure that which is produced will be met with approval. Each item in a group is approached in the same way. (Yes, just like we said before, this is work.)

So, one season is planned and thought through. Now we move into the next phase of the process: Going from size specs to samples.

HERE'S HOW TO BEGIN . . . CHAPTER 10

Now that you have gone through the process of costing out garments, let's look at three different problems. Relax, it's a lot easier than you realize. Let's go through the steps.

First: Determine the Cost of Goods to Be Sold

Using the cost sheets, fill in the information that is given to you. Make sure that all numbers are in decimal forms. Often the cost sheets are completed through computer programs, and a computer cannot read $\frac{1}{2}$; it reads 0.50. Once the information is entered on the cost sheet, extend the values. Add the materials, trims, labor, and shipping costs and find out just how much it costs to make a garment.

Second: Determine the Wholesale Selling Price

The next step is important. Follow the formulas, and fill in the T-charts with the information given in the problems and determine the cost or wholesale price—that which a store buyer will pay for the merchandise.

Third: Determine the Retail Selling Price

Remember that the consumer pays retail price, so find out what that should be, using the information given in the problems. Just follow the formulas in the chapter and fill in the T-charts. The answers will be easy to find.

Fourth: Talk Out

With all the math out of the way, you are now facing the most important question. Will the consumer be willing to pay the price? Have everyone give his or her opinion—think of all the pros and cons. Remember, a designer cannot afford to make a product that the consumer does not want to buy! If the consensus is that the item is great but a little too pricey, return to the work sketch and cost sheet to see if you can figure out a way to lower the price. It might be something as simple as eliminating a belt or changing a zipper. Don't be afraid to change (that's where the "creativity within limitations" comes in). Design teams face these decisions daily, and it is important to know how to do this, too!

Problem 1

Determine the Cost of Goods to Be Sold

Description: Girl's full-skirted Victorian-style "party" dress with collar and sash trim

Date: April 23, 20xx

Style: 962

Size range: 7, 8, 10, 12, 14

Size scale: 1–2–3–3–3

Fabric mill: In Taiwan

Manufacturer: In Hong Kong

Fabric width: 36 inches

Estimated marker yardage: 24 yards

Material: Victorian print broadcloth, 2 yards, cost $1.48 per yard after shipping from Taiwan to Hong Kong. This yardage for one garment was determined by estimating the total yardage for a one-dozen run and then dividing by 12: 24 total yards ÷ 12 pieces = 2 yards for one garment, which is entered on the cost sheet.

Collar facing: .25 yard at $1.19 per yard

Trim: 2.5 yards at $0.54 per yard

Zipper: $0.12 each

Marking and grading costs: $285.00 based on a 500-piece minimum order (combined cost). Don't forget this means $285.00 ÷ 500 to determine the cost for one piece.

Cutting costs: $175.00 based on a 500-piece minimum order

Construction costs: $48.00 per dozen (this is for all 12; what is it for one?)

Duties/shipping costs: $1.05 each garment

Second: Determine the Wholesale Selling Price

Using a 50% markup, determine the wholesale selling price. Fill in the T-chart below.

	Dollars	Percents
Wholesale price		100%
Markup	–	–50%
Cost of goods to be sold		50%

Remember to go back and look at your formulas. The selling percentage will always be 100%, and in this case because you want the markup percentage to be 50%, the cost percentage will also be 50%. Simply divide the cost

COST SHEET

Date _____ Style Number _____

Description _____

Fabric Mill _____

Manufacturer _____

Size Range _____

Size Scale _____

Fabric Width _____

Estimated Marker Yardage _____

Actual Marker Yardage _____

MATERIALS	**Yardage**	**Price per Yard**	**Total Amount**
Fabric	_____	_____	_____
Fabric	_____	_____	_____
Lining	_____	_____	_____
		Total Cost of Materials	_____

TRIMS	**Amounts**	**Cost Each**	**Total Amount**
Buttons	_____	_____	_____
Zippers	_____	_____	_____
Belts	_____	_____	_____
Other	_____	_____	_____
		Total Cost of Trims/Findings	_____

LABOR

Marking Costs _____ Grading Costs _____ Cutting Costs _____

Construction _____ **Total Labor Costs** _____

SHIPPING AND DUTY EXPENSES

Import Duties _____ Shipping Expenses _____

Total Shipping and Duty Costs _____

Total Cost of Goods to be Sold _____

Suggested Wholesale Price _____

Suggested Retail Price _____

of goods sold by the cost percentage, and you will arrive at the wholesale selling price, after rounding the final dollar value to $0.00, $0.25, $0.50, or $0.75.

THIRD: DETERMINE THE RETAIL SELLING PRICE

Use the wholesale price you reached in the T-chart below. Then, applying a 50% retail markup, determine the retail selling price for this garment. Round this price to the nearest dollar.

	Dollars	Percents
Retail selling price		100%
Markup	–	–50%
Cost/wholesale price		50%

FOURTH: TALK OUT

Now it is time to discuss whether this will be a strong-selling item or whether a better price on some element of the cost sheet is needed.

NOW, THE PRIVATE LABEL VERSION

If you are working in a resident buying office in the product development division, or if you are working with a major chain designing garments that will carry a private label, you would calculate the retail selling price, earning exactly the same number of dollars in retail markup as you calculated in step 3. The cost of goods to be sold for problem 1 is $10.70. A designer/manufacturer will divide $10.70 by 50% to determine that the wholesale/cost price would be $21.40. The designer would round this up to $21.50 to show to the store buyers. At this point, when store buyers purchase the garment, they too will markup the dress by 50% and the retail selling price would be $43.00, which means that the retail markup price that you show in your T-chart is $21.50. Now let's look at what happens when we squeeze out the middle and have the product manufactured and shipped directly to the selling store, just as do the major department stores and private label companies.

	Dollars	Percents
Retail selling price		100%
Markup	– $21.50	–
Cost of goods to be sold	$10.70	

Calculate the retail price, rounding it off to the nearest $00.00. Also calculate the retail markup percentage. The designer label sells for $43.00 and the private label for $32.00. Same dress, same store profit! If you are a designer or manufacturer, what would you do with your product line to compete with this price point?

Problem 2

FIRST: DETERMINE THE COST OF GOODS TO BE SOLD

Description: Men's henley shirt, a collarless three-button placket-front cotton knit shirt

Date: May 14, 20xx

Style: 402

Size range: S, M, L, XL

Size scale: 1–4–5–2

Fabric mill: Located in North Carolina

Manufacturer: Located in Miami, Florida

Fabric width: 60 inches

Estimated marker yardage: 24 yards for 12 pieces

Material: Solid-colored cotton knit jersey at $1.60 per yard

Buttons: 3 buttons at $0.03 each

Marking and grading costs: $185.00 based on a 500-piece minimum (combined cost)

Cutting costs: $175.00 based on a 500-piece minimum

Construction costs: $42.00 per dozen

Shipping costs: FOB factory (shipping charges to the store will be paid by the store thus are not calculated in the manufacturer's cost)

COST SHEET

Date _____ Style Number _____

Description _____

Fabric Mill _____

Manufacturer _____

Size Range _____

Size Scale _____

Fabric Width _____

Estimated Marker Yardage _____

Actual Marker Yardage _____

MATERIALS	Yardage	Price per Yard	Total Amount
Fabric	_____	_____	_____
Fabric	_____	_____	_____
Lining	_____	_____	_____

Total Cost of Materials _____

TRIMS	Amounts	Cost Each	Total Amount
Buttons	_____	_____	_____
Zippers	_____	_____	_____
Belts	_____	_____	_____
Other	_____	_____	_____

Total Cost of Trims/Findings _____

LABOR

Marking Costs _____ Grading Costs _____ Cutting Costs _____

Construction _____ 　　　　**Total Labor Costs** _____

SHIPPING AND DUTY EXPENSES

Import Duties _____ 　　Shipping Expenses _____

Total Shipping and Duty Costs _____

Total Cost of Goods to be Sold _____

Suggested Wholesale Price _____

Suggested Retail Price _____

SECOND: DETERMINE THE WHOLESALE SELLING PRICE

Using a 40% markup, determine the wholesale selling price. Fill in the T-chart below.

	Dollars	Percents
Wholesale price		100%
Markup	–	–40%
Cost of goods to be sold		60%

Remember to go back and look at your formulas. The selling percentage will always be 100%, and in this case because you want the markup percentage to be 40%, the cost percentage will be 60%. Simply divide the cost of goods sold by the cost percentage and you will arrive at the wholesale selling price, after rounding the final dollar value to $0.00, $0.25, $0.50, or $0.75.

THIRD: DETERMINE THE RETAIL SELLING PRICE

Use the wholesale price you reached in the T-chart below. Then, applying a 55% retail markup, determine the retail selling price for this garment. Round this price to the nearest dollar.

	Dollars	Percents
Retail selling price		100%
Markup	–	–55%
Cost/wholesale price		45%

FOURTH: TALK OUT

Now it is time to discuss whether this will be a strong-selling item or whether a better price on some element of the cost sheet is needed.

Now, the Private Label Version

If you are working in a resident buying office in the product development division, or if you are working with a major chain designing garments that will carry a private label, you would calculate the retail selling price, earning exactly the same number of dollars in retail markup as you calculated in step 3.

Problem 3

FIRST: DETERMINE THE COST OF GOODS TO BE SOLD

Description: Women's better sportswear—walk shorts

Date: Feb. 25, 20xx

Style: 1605

Sizes: 6, 8, 10, 12, 14, 16

Size scale: 1–2–3–3–2–1

Fabric mill: Located in Honduras

Manufacturer: Located in Honduras

Fabric width: 45 inches

Estimated marker yardage: 18 yards

Material: Khaki twill at $2.45 per yard

Zipper: $0.15

Belt: $1.00

Buttons: 2 buttons at $0.04 each

Marking and grading costs: $50.00 based on a 200-piece minimum (combined cost)

Cutting costs: $90.00 based on a 200-piece minimum

Construction costs: $5.00 each

Duties/shipping costs: $0.82 each garment

SECOND: DETERMINE THE WHOLESALE SELLING PRICE

Using a 30% markup, determine the wholesale selling price. Fill in the T-chart that follows.

	Dollars	Percents
Wholesale price		100%
Markup	–	–30%
Cost of goods to be sold		70%

Remember to go back and look at your formulas. The selling percentage will always be 100%, and in this case because you want the markup percentage to be 30%, the cost percentage will be 70%. Divide the cost of goods sold by the cost percentage to arrive at the wholesale selling price, after rounding the final dollar value to $0.00, $0.25, $0.50, or $0.75.

COST SHEET

Date _____ Style Number _____

Description _____

Fabric Mill _____

Manufacturer _____

Size Range _____

Size Scale _____

Fabric Width _____

Estimated Marker Yardage _____

Actual Marker Yardage _____

MATERIALS	Yardage	Price per Yard	Total Amount
Fabric	_____	_____	_____
Fabric	_____	_____	_____
Lining	_____	_____	_____

Total Cost of Materials _____

TRIMS	Amounts	Cost Each	Total Amount
Buttons	_____	_____	_____
Zippers	_____	_____	_____
Belts	_____	_____	_____
Other	_____	_____	_____

Total Cost of Trims/Findings _____

LABOR

Marking Costs _____ Grading Costs _____ Cutting Costs _____

Construction _____ **Total Labor Costs** _____

SHIPPING AND DUTY EXPENSES

Import Duties _____ Shipping Expenses _____

Total Shipping and Duty Costs _____

Total Cost of Goods to be Sold _____

Suggested Wholesale Price _____

Suggested Retail Price _____

THIRD: DETERMINE THE RETAIL SELLING PRICE

Use the wholesale price you reached in the T-chart below. Then, applying a 55% retail markup, determine the retail selling price for this garment. Round this price to the nearest dollar.

	Dollars	Percents
Retail selling price		100%
Markup	–	–55%
Cost/wholesale price		45%

FOURTH: TALK OUT

Now it is time to discuss whether this will be a strong-selling item or whether a better price on some element of the cost sheet is needed.

NOW, THE PRIVATE LABEL VERSION

If you are working in a resident buying office in the product development division, or if you are working with a major chain designing garments that will carry a private label, you would calculate the retail selling price, earning exactly the same number of dollars in retail markup as you calculated in step 3. If you are a designer or manufacturer, what would you do with your product line to compete with this price point?

CHAPTER ELEVEN

LINE BUILDING: FROM SPECS TO SAMPLES

You've planned your line. The styles have been costed. You are almost in the production phase of the product development cycle. But first, you need to make changes that will enhance the product in terms of style, quality, and price by choosing the appropriate fabrics and eliminate mistakes and/or problems in the manufacturing cycle by detailing accurate measurements.

MAKING THOSE STYLES A REALITY

You now have a complete profile of each item that you want on the line:

Item, style number;
Sketch (silhouette);
Proposed (target) fabric;
Target cost;
Planned delivery.

Target Cost
Desired cost.

Wanting an item in your line, however, does not necessarily mean that you will produce it exactly as you planned. After reviewing the cost sheet, you might decide that it's just too expensive for the customer. That does not mean that you have to eliminate the item; it might mean that you must rethink how to produce it less expensively. Two major components determine cost: Fabric and manufacturing. Let's discuss fabric first.

Each item takes on a completely different character depending on the fabric that is selected. Changing the fabric often creates a totally new look. However, some basic items require very little guesswork on fabric. For example, a basic T-shirt would probably be made in 100% cotton jersey, 180 grams per square meter (180 grams per square meter means the weight is about 5.3 ounces per square yard, a typical light fabric weight).

Other styles might require a more unusual fabric. Textile shows such as Premier Vision (and others as listed in Chapter 7) often provide actual new fabrics. For some designers, these expensive mills can only provide the inspiration. Sometimes a designer will find a garment at retail or a swatch of a fabric that would be nice for a style being planned. The designer would then research various fabric mills to see what could capture this look at a workable price. There are many fabric mills that can develop a fabric that has a similar "look," but they change a few features to keep the price down. Let's look at a typical design problem.

Maybe the designer or product manager loves a complex, multicolored paisley print (Figure 11-1) but it costs $7.00 per yard. At $7.00 per yard, the garment would be too expensive for the customer. The designer's job is to find an alternative. In checking with various mills, it is found that other

FIGURE 11-1 Complex, multicolored paisley print at $7.00 per yard.

options (although not identical) exist at a more affordable price because they use fewer colors and are less complex (Figures 11-2 and 11-3).

FIGURE 11-2 With fewer colors in the print, this fabric might cost only $4.25 per yard.

FIGURE 11-3 This fabric is printed with just one color over white, so its cost might go down to $3.50 per yard.

The designer or product manager must be able to visualize how this fabric would work in the planned silhouette. (How soft/stiff? How drapey/rigid? How limp/crisp?) Even experienced designers get both pleasant and unpleasant surprises when the first sample is made up. If there is a problem, they then scramble and change the model to better suit the fabric, or they change the fabric to better suit the model. Once the right fabrics are found, most wholesalers order sample yardage (often about 15 to 60 yards) to be knitted or woven immediately so they can have sets of samples made in the correct fabrics in time for the opening of the line.

The technicalities of yarns, fabrics, and dyeing are other areas that fill (other) books. We're just going to give a few of the "big picture" definitions so that you can show off on your first job. Almost everyone else (like us) had to look totally blank when this came up the first time! All joking aside, this knowledge is critical.

YARNS AND FABRICS

Yarns and fabrics have become a key area of concentration for the fashion industry in the past 10 years. New fiber developments such as Tencel and microfiber and new, more complex weaving or knitting techniques are becoming commonplace at all price levels. Consumers have many choices. Garment makers must differentiate their products from the competition; fiber, yarn, and fabric are the most common differentiators. This is also the area in which retail buyers and other newcomers to product development tend to have the weakest background. Eventually you will need to learn much technical information, but we'll begin here with a comprehensive introduction.

Fibers

These are the building blocks of yarns. They are either natural or manufactured. You're familiar with most.

NATURAL	MANUFACTURED	
	CELLULOSIC (NATURAL FIBER THAT'S BEEN HEAVILY TREATED)	PETROLEUM-BASED
Cotton	Acetate	Polyester
Wool	Rayon	Nylon
Silk	Tencel	Acrylic
Linen		

These are either spun together or extruded (pulled) into yarns. Yarns are measured by thickness. It's far too complicated to explain in detail because different types of yarns use different measuring systems. In general, the higher the number, the thinner (finer) the yarn. For example, the yarns in a blouse could be "40s" or "50s," whereas the yarns in heavy denim jeans can be "7s."

Each type of yarn has its own positive and negative characteristics. Natural fibers have a certain status, but they can wrinkle easily (linen) or can be

fragile and difficult to wash (silk). Manufactured fibers have come far since the double-knit polyester of the 1970s with its stigma (but it never wrinkled!). Blends of manufactured and natural fibers are common because they can impart some of the good qualities of each. These fibers are also blended overseas to qualify them as *chief-weight natural fibers* (thus getting the lower natural-fiber duties) versus *chief-weight synthetic fibers* (thus getting higher duties).

There are three ways in which yarns are put together to become structured cloth: Weaving, knitting, and felting. Felting is a relatively uncommon process whereby fibers are simply pressed together to form fabric. We will concentrate on the two other techniques, which are much more common.

Woven Fabric Construction

Woven fabrics are produced on a loom which is set up with a row of yarns that will eventually run lengthwise in the fabric (along the **grain**). These yarns are called warp yarns. While on the loom, crosswise yarns (called weft or fill yarns) are interlaced horizontally across the warp yarns (Figure 11-4). These yarns run across the grain from one edge of the fabric to the other edge, also called the *selvage*. When they reach the opposite end, the same yarns are then carried back again across the warp yarns.

Grain
Lengthwise orientation of a fabric, as opposed to *crosswise*. Straight-grain runs exactly along the warp yarns of a woven fabric.

The following explains several more advanced points that few people know when they enter the industry. On their first trip to the Orient, their eyes pop from the technicality. From then on they're using this terminology daily.

A common blended broadcloth woven fabric (in a woman's blouse or a man's dress shirt) is quoted in construction terms as follows:

$$\frac{110 \quad \text{x} \quad 70}{45 \quad \text{x} \quad 45}$$

This means:

110 threads per inch in the warp (vertical direction);
70 threads per inch in the weft or fill (horizontal direction);
the size of each thread in the warp is "45";
the size of each thread in the weft or fill is "45."

FIGURE 11-4 Woven fabric construction: Yarns cross in a woven fabric.

This very accurately explains which thread and what density of threads are used in both directions of the woven cloth. It provides an exact fingerprint of the fabric.

Believe us, it can get complicated! Here, for fun, is the distinction between the oxford cloth used by one American designer in his status dress shirt and the oxford cloth used by another famous designer:

DESIGNER A	DESIGNER B
96 x 96	92 x 48
40 I I x 20/2	40 I I x 25/2

You need not remember this, but I I means parallel (two yarns are run next to each other as if they were one yarn, but they are not twisted together beforehand), and /2 means two-ply (two yarns twisted together first and then woven as one).

Knitted Fabric Construction

Knitting is the other major technique used to give structure to yarns so they become fabric. They are formed through a process of interlocking loops in successive rows (Figure 11-5). There are no warp or fill yarns. The same yarn catches itself as it passes back and forth across the rows (also called courses), which provides the structure.

The easiest way to spot the difference between a woven fabric and a knit is that in most instances (there are exceptions!) knits tend to be stretchy and wovens tend to be rigid.

Knitted cloth is measured by *gauge* (a measurement of the machinery that is used to knit it) and *weight* (the heaviness of the cloth). Yarn size is usually quoted as well. In sweaters, for example, 3 GG (gauge) is a heavy sweater knit (as in a fisherman's sweater), and 12 GG (gauge) is a fine sweater-shirt type of knit (as in a fine merino wool turtleneck). In knitted fabric the higher the gauge, the finer and lighter the fabric (18 GG, 20 GG, 32 GG, and so forth). Fabric weights were once expressed in many different terms, but thankfully most of the world is settling on grams per square meter. (Yes, we realize this is getting a bit overwhelming.)

FIGURE 11-5 Knitted fabric construction: Yarns interloop in a *knit* fabric.

A sample *knit-down* handmade by student Eun Ju Lee. This trial piece is made up to see how a knitted pattern will actually look when it is mass produced.

FABRIC DYEING

Three main dyeing techniques are used in the garment business: Yarn dyeing, piece dyeing, and garment dyeing.

Yarn Dyeing (Figure 11-6)

Yarns are dyed first and then either knitted or woven into a fabric. An example is a striped T-shirt, where one color yarn is knitted into cloth until the vertical height of that stripe is achieved; then the machine picks up the second color yarn and knits that, and so on. In woven fabrics, the colored yarns are set up on the loom (in the warp), and then colored yarns are woven across them (in the weft, or fill). When alternating colors are used in both directions, the result is a plaid fabric.

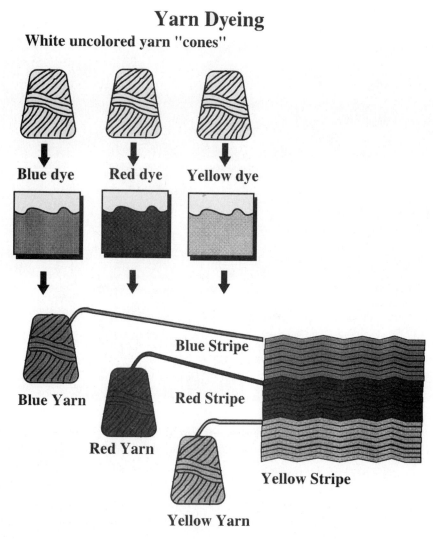

FIGURE 11-6 Yarn dyeing process.

Piece Dyeing (Figure 11-7)

Yarns are woven or knitted into fabric in their natural state (called *greige*). Then the already completed fabrics are bathed in dyes. This is the most common type of dyeing and is usually the most economical. This would be used for a solid-color T-shirt or a solid-color dress, for example.

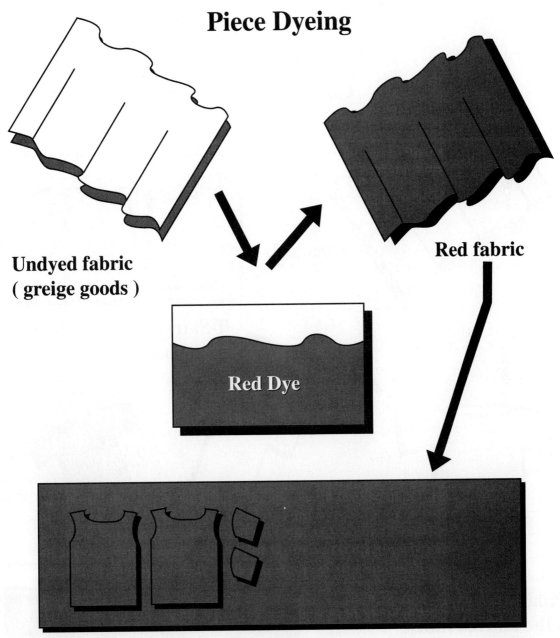

Piece Dyeing

**Undyed fabric
(greige goods)**

Red fabric

Red Dye

T-Shirt pieces are cut out of the red fabric and sewn together

FIGURE 11-7 Piece dyeing process.

Garment Dyeing (Figure 11-8)

Garment dyeing is a more uncommon technique, and it has its pros and cons. Garments are actually sewn or knitted together out of the undyed fabric or yarn. Then, as full garments, they are dyed together in a big vat. This technique allows color selection to be made very late in the process (close to selling time). It generally works only on casually constructed items, such as T-shirts, casual pants and shorts, and casual sweaters. The color effect is sometimes uneven; the garments tend to look a little "funky"; and they are likely to fade in sunlight.

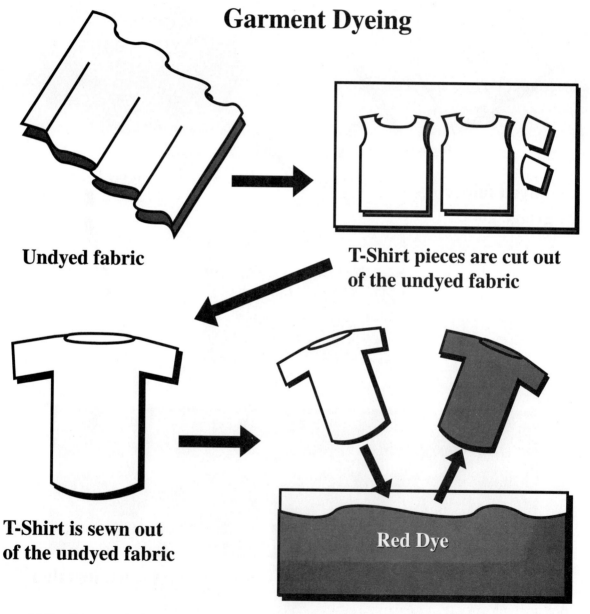

Garment Dyeing

Undyed fabric

T-Shirt pieces are cut out of the undyed fabric

T-Shirt is sewn out of the undyed fabric

Red Dye

FIGURE 11-8 Garment dyeing process.

PRINTING TECHNIQUES

Prints come and go in fashion, but they're never gone for long. They can transform an ordinary piece of white fabric into a masterpiece (especially if you're talking about white silk and the printing is being done in Como, Italy). The two main printing techniques are screen printing and roller printing.

Screen Printing

Screen printing is similar to what you might have done in art class, only it is on a larger scale (Figure 11-9). Thick dye is "squeegeed" through a partially porous, partially solid screen in a pattern onto the fabric below. Each different screen adds only one color to the garment until the total number of colors in the print is reached ("three-color print" means three screens; "12-color print" means 12 screens). It can be done by hand or by automation (rotary screen). Screen printing is quick and not too expensive, but the design cannot be too intricate.

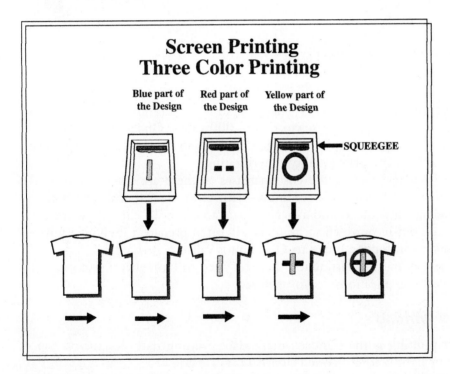

FIGURE 11-9 Screen printing process.

Roller Printing

The roller printing technique uses large metal rollers with designs engraved on them, one roller per color in the print (Figure 11-10). Fabric is run under these rollers very quickly, and the pattern is applied continuously.

Roller Printing

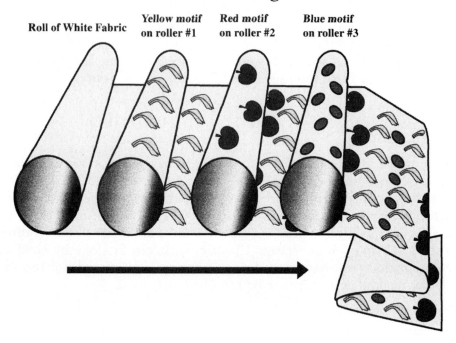

Roll of White Fabric **Yellow motif on roller #1** **Red motif on roller #2** **Blue motif on roller #3**

FIGURE **11-10** Roller printing process.

Rollers are quite expensive to make up, so most printers will not offer this service if you are printing fewer than 5,000 yards. Once set, however, this technique is rapid, accurate (fine detail), and can keep printing large quantities without the print quality deteriorating.

In both techniques, the cost increases as there are more colors in the print. Two to six colors is common—with more than that it gets both expensive and difficult to find a factory that can do it. To check how the print will come out in production, printers will often prepare a preliminary hand-screen version for the buyer to OK. This is called a *strike off*.

There is another distinction that you need to know because it can cause some real complications, as you will see.

Direct Printing

Direct printing is the standard method of printing dark designs on top of white or light colored fabric (Figure 11-11).

Dye and Discharge

Dye and discharge is a much more expensive technique that starts with a dark solid-color fabric (Figure 11-12). Then to have lighter-colored designs show on top, the dark color must be *discharged out* (removed) in places. Then the lighter-colored design can be printed onto those places that are now white again. Picture yellow polka dots on a navy background.

FIGURE 11-11 A direct print. Dark dye is applied to a light colored fabric.

FIGURE 11-12 Dye and discharge print, turned back on itself. The fabric started out dark, and then the dye was removed to produce the flowers and stems. The back side of the fabric (on the left) shows that the discharging is less strong on the back than on the front. Also, the edge of the fabric (dark diagonal area) shows the original solid dark color.

S.Y. KIM

A native of Korea, S.Y. graduated from Seoul National University with a major in fabrics and textiles. She then worked with several U.S. importers in their Korean offices. In 1982, S.Y. joined AMC-Seoul, where she rose through the ranks to divisional manager. After two years in New York she moved to the AMC-Minneapolis office to service the Dayton's, Hudson's, Marshall Field's men's account as global sourcer. She then moved to Sears and is now director of production for Liz Claiborne Infants.

On Being Brave Enough to Admit You Don't Know

On his first trip to Korea, a product manager (PM) from New York negotiated a printed shirt program with our key Korean vendor. A 50-50 averaged price was struck for the two different kinds of printing—50% should be direct prints and 50% should be discharge prints. The product manager actually didn't know the difference between the two prints but was afraid to appear ignorant, so he didn't ask.

When the PM booked the program with the buyers in New York, he sent the patterns back to Korea. The vendor complained bitterly that of the 10 patterns, nine had to be done by the expensive discharge process. Only one was a regular (direct) print. The price quoted was based on five and five. The problem was that the product manager couldn't tell which patterns needed which process.

The faxes flew back and forth, and tempers flared. The vendor and the office thought the PM was trying to cheat. The PM thought the vendor was just trying to raise the price after the orders were in. Finally, I figured out that the product manager probably had not understood the distinction between the two prints. We carefully explained and gave him options to change color combinations to solve the problem.

The product manager faxed back the next day and said, "I feel like my eyes have finally opened." So I think rather than looking "smart" now and "not so smart" later, it's always better to admit you don't know something, and ask!

Now that you know how important these distinctions can be, here is one last printing distinction.

PRINT "REPEATS"

For continuous printed fabrics that are technically feasible to print, the design must repeat itself. Think of a roller printer. When the roller has revolved one full turn, it must begin again to print the exact same pattern (Figure 11-13).

However, most original fabric design artwork is not sold in this format (Figure 11-14). The design must be altered so that it will repeat itself ex-

FIGURE 11-13 When the roller has revolved one full turn, the pattern will start to repeat itself.

actly in both vertical and horizontal directions. Often a specialized artist will be commissioned to convert an original print into a repeat. The repeat can be identified by looking for the point at which an individual motif within the print recurs for the first time on an exact horizontal line (horizontal repeat) and on an exact vertical line (vertical repeat.) Product managers must be able to recognize where a pattern starts to repeat in both directions because this has an effect on the price. (Generally the bigger the repeat, the higher the price.) There are many points within a print where the repeat can be located, but in all cases, the size of the measurements (horizontally and vertically) will be exactly the same (Figure 11-15).

All-over prints cover the fabric in a consistent repeat both vertically and horizontally. But there are actually two types of all-overs:

Figure 11-14 Original fabric design hand-painted by student Ju Won Suk. Like most print paintings, this one does not show a full *repeat*. More of the design will need to be painted to create a repeat both horizontally and vertically. This step is usually performed by a different artist.

FIGURE 11-15 Corners of both boxes show points where the fabric repeats itself in both horizontal and vertical directions. When comparing the thin box with the thick box, you can see that the repeat is found in many different places in the design. However, the *size* of the repeat will be the same no matter where you find it.

One-Way Print

In one-way printing the pattern on the fabric has a definite top and bottom (Figures 11-16 and 11-17). All motifs in the print point in one direction. It is more expensive to cut a one-way print because all the motifs must "point up" the same way on each piece of the garment.

FIGURE 11-16 One-way print. Each fabric panel must be cut in the same direction.

FIGURE 11-17 One-way print fabric. If you turn this fabric upside down, all arrows will point down. One side of the front of a shirt cannot point up, and the other side point down.

Two-Way Print

Many prints have motifs that point both up and down, so the fabric can be cut in either direction (Figures 11-18 and 11-19). This allows for a more efficient layout of the marker because the pattern pieces can go in either direction, thus saving money.

FIGURE 11-18 Two-way print. Each fabric panel can be cut in either direction.

FIGURE 11-19 Two-way print fabric. If you turn this fabric upside down, it will look just the same. Therefore, it can be cut in either direction.

Border Print

A border print is not an all-over; it has a different design on different parts of the fabric (Figure 11-20). Border prints have a special motif that runs lengthwise along an edge of the fabric. The remainder of the fabric could be solid or it could have a different, related print. A print such as this could be used for a skirt, with the special motif running along the hemline.

FIGURE 11-20 Border print. Figures run only along the edge of the fabric; leaf patterns would continue up the fabric to the top. Original artwork painted by student Shirley Yu.

Placement Print

A placement print (also called an engineered print) is intended to fall on each garment in exactly the same way. The print and print position on each garment look exactly alike. For example, a printed stripe might be planned so that it runs only across the chest of a shirt. Each shirt that is produced will have the chest stripe in the same place.

The swimsuit placement print in Figure 11-21 is designed to fall on each swimsuit in precisely the same way. The curving lines with the triangles would always be on the left hip. The lines with the circles would always be on the right chest. Such prints are also sometimes called panel prints. Placement prints require careful pattern placement, often causing significant fabric wastage (and, thus, increased cost).

FIGURE 11-21 Swimwear placement print. Also painted by Shirley Yu, the design does not repeat anywhere on the garment, so the pattern pieces must be carefully placed on the fabric before cutting.

RECOLORING PRINTS

Often it is necessary to change some or all of the individual colors in a print that are going to be used. Sometimes the design motif is perfect but the colors don't match rest of the colors intended, say, for a sportswear group. The recoloring process starts with a listing of each individual color in the original print. Let's say it is a flower and leaf print on a colored background.

Print Motif	Original print colors
flower	yellow
leaf	green
background	blue

But if our planned line uses pink, green, and purple, the print will need to be recolored. The product manager would indicate which new color replaces each original color.

Print Motif	Original print colors	New print colors
flower	yellow	purple (replaces yellow)
leaf	green	green (replaces same)
background	blue	pink (replaces blue)

This process is trickier than it looks. It is easy to "lose" the whole look and feeling of the original print if the colors (hues, values, and chromas) are significantly different in the recolor.

With all the choices of fabrics available you can see how important the choice of fabric is not just for design, but also for pricing. Once the fabric is chosen the garment manufacturer must next determine exactly how much will be used for a garment. Only then will the manufacturer be able to calculate an actual price quote based on which fabric, and how much fabric, will be used for a garment.

SIZE SPECIFICATIONS/PATTERNS

A garment manufacturer cannot give an accurate price quote without knowing exactly how much fabric will be used for a garment. It is in the product manager's best interest to be able to provide exact measurements to the manufacturer to get the most accurate quote. If you remember, on the cost sheet there were actually two notations about marker yardage: One estimated and one actual. By having an accurate measurement from the start, designers can make more reliable business decisions regarding whether a garment will be made.

Taking a hip measurement on a boxer short.

How do you do this? It is done in one of two ways:

- Providing size specifications (specs) on standardized forms that show the measurements of each dimension of the garment;
- Providing a **contract cutter** with a copy of your **marker** with the pattern pieces already drawn for all sizes to be cut.

In either case, the manufacturer must also know the total number of sizes required and the measurements of the sizes.

Let's look at the information with which a product manager would work. For example, four sizes might be required on a T-shirt: Small, medium, large, and extra large. The manufacturer also must know the **grade** or measurement increment between each size. An example of this would be

	SMALL	MEDIUM	LARGE	EXTRA LARGE
Chest measurement	18 inches	19 inches	20 inches	21 inches

Note this is the half-circumference chest measurement (Figures 11-22 to 11-25 are technical work drawings of each size). Either half-circumference or full circumference can be used.

The above would be considered a 1-inch grade, because there is a 1-inch difference between each size. Grades vary by customer type and by brand, and they do not necessarily have to be even between all the sizes!

Contract Cutter
A subcontractor who cuts the pieces of fabric (only).

Marker
Paper pattern that is placed on top of the stacked fabrics; the pattern lines on the paper provide the cutting lines.

Grade
Difference in measurement between sizes.

FIGURE 11-22 Half-circumference chest measurement, size small.

FIGURE 11-23 Half-circumference chest measurement, size medium.

FIGURE 11-24 Half-circumference chest measurement, size large.

FIGURE 11-25 Half-circumference chest measurement, size extra large.

The manufacturer must also know the size scale or the number of pieces of each size that will be ordered. (Remember, the bigger the size, the more fabric it takes.) Size scales are often (but not always) expressed as the breakdown within one dozen. Here are some typical size scales:

	SMALL	MEDIUM	LARGE	EXTRA LARGE	
	1	3	5	3	= 12 pieces
or	0	3	6	3	= 12 pieces
or	1	5	4	2	= 12 pieces

SPEC SHEETS

To compile the information to determine the accurate yardage, critical measurements are needed for each size. A design team works this out on a specification (spec) sheet. A spec sheet is a technical rendering of a garment, with the measurements and tolerance levels identified for each step. Often, companies have technical designers and/or patternmakers to make up the size specs or patterns. This is increasingly being done on computers. But remember that essentially every garment requires a new set of specs because there will probably be something unique on that garment that is different from a generic body.

In smaller companies, the designer, merchandiser, or product manager might be required to develop the specs themselves. This takes considerable training and/or experience. It doesn't matter whether the sheet is computer driven or calculated manually; what matters is that everyone in the design industry must be able to read and use one.

Let's look at this spec sheet from Alan Stuart Menswear (Figure 11-26) and review what it means.

- *Style*. Numerical code used to identify each style.
- *Season*. Most wholesalers track their styles first by season, then by style number. Silhouettes and styling can be similar, with slight design modifications from season to season.
- *Codes*. If you look at the sketch on the right side of the spec sheet, you will notice that there are the same letter

| PRODUCTION SPEC ☐ |
| PRE-PRODUCTION SPEC ☐ |

Alan Stuart INC.

STYLE

SEASON

GARMENT SPECIFICATIONS - MEN

MEASUREMENTS: PLEASE MEASURE ACCORDING TO INDICATED GUIDELINES IF MEASUREMENT ARE IN CENTIMETERS OR INCHES. CIRCUMFERENCE MEASUREMENTS ARE GIVEN ON THE HALF.

CODE	TOP SPECIFICATIONS-MEN	TOLERANCE	SIZES					
K	"CHEST" MEASURE 1' BELOW ARMHOLE FROM SEAM TO SEAM	+ / − 1/2"						
J	"SLEEVE LENGTH" MEASURED 2" FROM CENTER BACK NECK TO BOTTOM OF SLEEVE	+ / − 1/2"						
P	"SLEEVE AT OPENING" MEASURED FROM FOLD TO FOLD	+ / − 1/4"						
P2	"SLEEVE WIDTH" MEASURED 1" DOWN FROM UNDERARM SEAM FROM FOLD TO FOLD	+ / − 1/4"						
I	"NECK OPENING" MEASURED FROM SEAM TO SEAM	+ / − 1/4"						
L	"SHOULDER WIDTH" MEASURED FROM SEAM TO SEAM	+ / − 1/2"						
M	"BOTTOM WIDTH" MEASURED FROM INSIDE TO INSIDE	+ / − 1/2"						
N	"BODY LENGTH" MEASURED FROM CENTER BACK NECK TO BOTTOM	+ / − 1/2"						
N2	"FRONT LENGTH" MEASURED FROM HIGH SHOULDER TO BOTTOM	+ / − 1/2"						

DATE:

PREPARED BY:

Figure 11-26 Garment spec sheet.

Continued

SPEC SHEETS

codes as in the code column. These codes are important because they match measurements with instructions (as to exactly how the measurements must be taken). For example, code K represents the chest measurement. On the sketch you will see that the line running horizontally across the shirt is identified as K.

- *Method of measurement.* (Listed on the Alan Stuart spec sheet under "Top Specifications—Men.") Now it is time to match the measurement method to the codes and the drawing. For code K, it is noted that the chest measurement is measured 1 inch below the armhole from seam to seam. You cannot assume that everyone measures the same way because there is no single standard in the industry. If you told someone to measure the width of the chest, where would he or she lay the tape? Would he or she place it at the armhole? One inch below? Two inches below? It's done different ways by different companies, so the method of measurement must be stated clearly on the spec sheet to guarantee that everyone involved will measure the same way on this garment. It is also important, as you can see on this spec sheet, to identify if you are measuring in centimeters or inches and to note whether a circumference measurement is given "on the half." That means that if a chest measurement shows 20 inches, it would only be the front half—the circumference would be 40 inches.

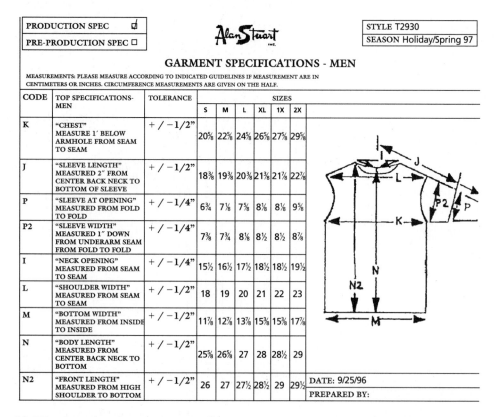

PRODUCTION SPEC ☑									
PRE-PRODUCTION SPEC ☐							STYLE T2930		
							SEASON Holiday/Spring 97		

GARMENT SPECIFICATIONS - MEN

MEASUREMENTS: PLEASE MEASURE ACCORDING TO INDICATED GUIDELINES IF MEASUREMENT ARE IN CENTIMETERS OR INCHES. CIRCUMFERENCE MEASUREMENTS ARE GIVEN ON THE HALF.

CODE	TOP SPECIFICATIONS-MEN	TOLERANCE	SIZES					
			S	M	L	XL	1X	2X
K	"CHEST" MEASURE 1' BELOW ARMHOLE FROM SEAM TO SEAM	+ / −1/2"	20⅝	22⅝	24⅝	26⅝	27⅝	29⅝
J	"SLEEVE LENGTH" MEASURED 2" FROM CENTER BACK NECK TO BOTTOM OF SLEEVE	+ / −1/2"	18¾	19¾	20¾	21¾	21⅞	22⅞
P	"SLEEVE AT OPENING" MEASURED FROM FOLD TO FOLD	+ / −1/4"	6¾	7⅛	7⅞	8⅛	8⅛	9⅝
P2	"SLEEVE WIDTH" MEASURED 1" DOWN FROM UNDERARM SEAM FROM FOLD TO FOLD	+ / −1/4"	7⅜	7¾	8⅛	8½	8½	8⅞
I	"NECK OPENING" MEASURED FROM SEAM TO SEAM	+ / −1/4"	15½	16½	17½	18½	18½	19½
L	"SHOULDER WIDTH" MEASURED FROM SEAM TO SEAM	+ / −1/2"	18	19	20	21	22	23
M	"BOTTOM WIDTH" MEASURED FROM INSIDE TO INSIDE	+ / −1/2"	11⅞	12⅞	13⅞	15⅜	15⅜	17⅞
N	"BODY LENGTH" MEASURED FROM CENTER BACK NECK TO BOTTOM	+ / −1/2"	25⅝	26⅝	27	28	28½	29
N2	"FRONT LENGTH" MEASURED FROM HIGH SHOULDER TO BOTTOM	+ / −1/2"	26	27	27½	28½	29	29½

DATE: 9/25/96

PREPARED BY:

FIGURE 11-27 Completed garment spec sheet.

Continued

SPEC SHEETS

- *Tolerance.* Garment sewing is not like stamping out metal. No two garments are exactly alike. Tolerance measurement is given to indicate how much of a measurement deviation (plus or minus) will still be acceptable.

- *Sizes.* Each size to be cut has its own measurements. You learned in Chapter 8 that a well-balanced product must have a good fit. That good fit starts here, with each successively larger size getting larger in all proportions. Different garments might be cut in different ranges of sizes. (Small, medium, large is one range. Small, medium, large, extra large, extra extra large is a different range, for example.) Only the sizes that will be used for this particular garment will be listed across the top.

Then the exact measurements for each code (under each size) will be filled in.

- *Sketch.* This is the technical sketch of the garment being produced. With manufacturing happening all over the world, it is always good to have a visual reference to support the statistics! If someone is reading this information overseas, the numbers and sketch alone would provide substantial information. (Please note that this particular Alan Stuart spec sheet does *not* show a sketch of the exact garment. You will see technical work sketches in the exercises at end of this chapter.)

Now let's look at a completed Alan Stuart spec sheet (Figure 11-27).

The designer has coded this style T2930. It is for the Holiday/Spring 1997 season. In the small size, the measurements are

Chest	20 5/8 inch	with a 1/2-inch tolerance
Sleeve length	18 3/8 inch	with a 1/2-inch tolerance
Sleeve at opening	6 3/4 inch	with a 1/4-inch tolerance
Sleeve width	7 3/8 inch	with a 1/4-inch tolerance
Neck opening	15 1/2 inch	with a 1/4-inch tolerance
Shoulder width	18 inch	with a 1/2-inch tolerance
Bottom width	11 7/8 inch	with a 1/2-inch tolerance
Body length	25 5/8 inch	with a 1/2-inch tolerance
Front length	26 inch	with a 1/2-inch tolerance

Now you know the number of sizes, approximate measurements, and how many sizes will be cut per dozen. Each of the factors has a significant impact on the amount of fabric needed, called fabric consumption. This, in turn, has a significant impact on the price. By the way, which size scale do you think will cost most?

It has become commonplace for size specs to be entered onto a computerized spec sheet. Complete designing and manufacturing programs such as product data management allow for this and integrate this information with cost sheets and production. (More on product data management in Chapter 15.) With this tool, the technical designer or patternmaker can call up an old spec that might be similar. Then he or she can simply adjust a few measurements to accommodate the new style. Once this has been done, the system can automatically grade the other sizes and note the tolerance for each measurement.

Alternatively, a patternmaker can construct the actual pattern pieces for the new style by adjusting similar old pattern pieces. Once all the pattern pieces are set, the system automatically grades them for the other sizes and lays out an initial marker as well. It just takes one click to print the full-sized marker, ready for sample making. If the sample looks good, the marker is approved for use on the production line. In integrated systems, the marker can be transmitted electronically to the production factory anywhere in the world!

Looking at the size medium specs, you can see how these measurements increase as the size of the garment increases. Once the specs and then the patterns are set, they form the basis for garment production. Written specs ensure consistency of styling and fit from the sample to the production and, within production, from garment to garment. They are also used during production for the quality control department to ensure that everything is coming out correctly.

FIRST SAMPLES

After all this work, who knows what the line even looks like? So far, we just have lots of paper! *First samples* are made of each item and evaluated for look, fit, construction, and value. Major adjustments to the line are often made at this time. Whole segments might be dropped and others added. Samples are usually made in the manufacturer's or wholesaler's sample room or perhaps by an outside sample-making service. But remember that every style that is dropped now means that the time and money already spent on that style has been wasted. Often, the exact zippers, buttons, and/or other trims might not yet be available. The color of the fabric is usually whatever is immediately available. It takes a fair amount of imagination and experience to picture a great product in this sorry state—these samples usually look pretty rough.

Mannequin
A wood-and-cloth form constructed exactly to the body measurements of a company's ideal customer.

To check if the proposed size specs or patterns are correct, this sample will be tried on either a **mannequin** (Figure 11-28) or on a live *fit model*, someone who is the perfect sample size in the perfect proportions for a particular kind of fit. A fit model that's right for a missy line, for example, will not be right for a junior line. Yes, even if you are a 3X, you might be just right as a big-sized fit model, as long as everything is in the proportions specified. Reviewing the garments on either the mannequin or fit model, the technical designer will then adjust the size specs to provide the best possible fit.

Now we have a line of sample garments that have passed all the challenges to this point. It's finally time to start up the production line.

Here's How to Begin . . . Chapter 11

In Chapter 10 you worked with cost sheets, and now you have been introduced to spec sheets. We are sure that you can understand why these forms must be so accurate: One wrong number and you could lose a lot of profit! If everyone measured in his or her own way, the design industry would be a mess. What we want to show you is not only how to measure but also how to complete a spec sheet correctly.

FIGURE 11-28 Mannequins for boy's and men's.

We're going to walk you through this step by step so that you'll get a clear picture. Before you start, you're going to get the retail industry involved, in addition to using your negotiating skills. Because you all understand the importance of networking, two or three students must volunteer to go to a local Gap or Old Navy store and ask for some project help. Ask to borrow a small, medium, and large basic women's T-shirt and a small, medium, large, and extra large men's T-shirt. It might take a little time in the store because they will have to prepare a *goods sign-out sheet*. This is a form used to check merchandise out of a store without selling it (for example, when placing merchandise in fashion shows). Because paperwork can get tedious, it might be wise to call and arrange with the store manager ahead of time. Remember that if these garments cannot be returned in exactly the same condition, the store will require full payment. (This means leaving the tags on, too.) If all else fails, perhaps the school could pay to purchase the seven samples.

With the women's basic T-shirts in hand, let's get to work.

First: Draw a Technical Work Sketch and Identify the Key Measuring Points

Draw a technical sketch of the T-shirt and, using codes, identify each of the two front measurements you will be making (refer to Figures 11-29 and 11-31). Put both coded arrows on the same figure.

CODE	MEASUREMENT
A	Chest
B	Sweep

Now draw the back of the T-shirt (refer to Figures 11-32 and 11-34) and draw the coded arrows for the two back measurements. Again, both back coded arrows should be on the same drawing.

CODE	MEASUREMENT
C	Center back length
D	Sleeve length

FIGURE 11-29 Chest measurement.

FIGURE 11-30 Chest measurement point, close up.

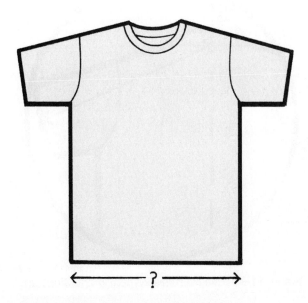

FIGURE 11-31 Sweep measurement.

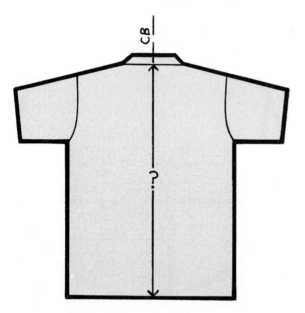

Figure 11-32 Center back length measurement.

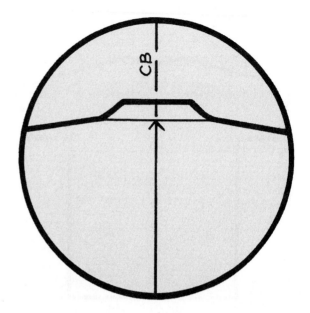

Figure 11-33 Center back length measurement point, close up.

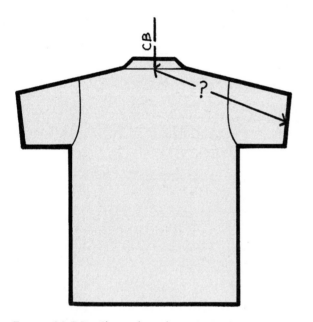

Figure 11-34 Sleeve length measurement.

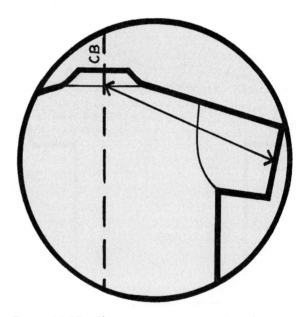

Figure 11-35 Sleeve measurement point, close up.

Second: Measure the Garments to Identify the Spec Measurements

- Working with just the small, measure the width of the chest from 1" below the armhole (yes, this is the standard place where chest measurements are taken) (Figures 11-29 and 11-30).
- Measure the bottom of the T-shirt from side seam to side seam across the bottom. This is called the "sweep" (Figure 11-31). Often sweep and chest measurements will be the same. Can you think of a top where they would not be?
- Place your tape measure at the center of the back at the bottom of the neck trim, and measure the length of the back (Figures 11-32 and 11-33).
- Measure the sleeve length from the center of the back neck (same point that you used for the center back length measurement above) to the bottom of the sleeve (Figures 11-34 and 11-35). Include any ribbed trim at the cuff of the sleeve. Put your measurements on this chart:

CODE	MEASUREMENT	SIZE SMALL	
A	Chest	_____	inches
B	Sweep	_____	inches
C	Center back length	_____	inches
D	Sleeve length	_____	inches

Obviously there are many other points of measurement that would be taken for actual product development. Chest, sweep, body length, and sleeve length are usually the most important for tops.

Third: Complete the Spec Measurements for Sizes Medium and Large

Once you have finished with the size small, measure the medium and large, following the same steps outlined above. Fill in the measurements for those sizes.

CODE	MEASUREMENT	SMALL	MEDIUM	LARGE	
A	Chest	_____	_____	_____	inches
B	Sweep	_____	_____	_____	inches
C	Center back length	_____	_____	_____	inches
D	Sleeve length	_____	_____	_____	inches

Are both your sketches (front and back) clearly identified with the codes? Are measurements noted for each size on the chart? Now exchange spec sheets with another student, and see if his or her spec sheet looks like yours.

- How many had identical measurements?
- Were all measurements taken at the right place(s)?
- Can you figure what the grade is from size to size? Remember, grade is the difference between the sizes. For example, what is the difference in the chest measurement between sizes small and medium, between sizes medium and large, and so on?

Repeat Steps One to Three Using the Men's T-shirt in Four Sizes

For these exercises, the class is divided into four groups. Each group should measure and spec one of the four men's sizes. Then by writing each group's findings on a large size spec sheet on the board, the class can "discover" the grade between the garments.

CODE	MEASUREMENT	SMALL	MEDIUM	LARGE	X LARGE	
A	Chest	_____	_____	_____	_____	inches
B	Sweep	_____	_____	_____	_____	inches
C	Center back length	_____	_____	_____	_____	inches
D	Sleeve length	_____	_____	_____	_____	inches

We have told you that sewing garments is an imperfect science. We think you are going to discover this by looking at the grades. The group might come up with slightly irregular (but accurate) measurements. That is because each garment is not sewn exactly to spec; it is sewn within a specified tolerance or deviation from the spec. As a group, you might have to do a little creative rounding up or down to figure what the intended grade is between sizes. (Actually, in the industry, you never rely on the measurements of just one retail sample to determine a competitor's spec. It is usually best to measure four to six garments of each size and then round off using all the measurements.) Note also that there might be different grades among sizes: Between sizes small to medium, the grade could be 4 inches; from medium to large, it could be 4 inches; and from large to extra large, it might be only 2 inches.

CHAPTER TWELVE

PRODUCTION: GO, TEAM, GO!

You've researched, analyzed, compiled, planned, costed, spec'ed, and sampled. The line is now ready to be produced. We consider acquaintance with the specifics of factory production to be a must for everyone in the fashion business. Product developers and designers need a thorough working knowledge. Grab the first chance you have to tour a garment factory. In the meantime, here's an overview.

IN THE FACTORY

The actual production of garments is a little like a football game. The quarterback (production manager) leads a team of people, each with different skills, whose job is to complete production within the allotted time. There is no overtime; the retailer can legitimately cancel an order if it isn't delivered on time. This means that the whole team loses. Each team member makes a critical contribution.

Felix Garcia and Lawrence Behar discuss production issues on the Ike Behar factory floor.

Production Manager

Generally, production managers are either gray-haired or bald! Ultimate responsibility rests on his or her shoulders. If everything runs smoothly, he or she is just doing the job. If anything goes wrong, it is always the production manager's fault! The production manager tries to schedule just the right flow of work through the factory. If there is too much, mistakes will be made in the rush. If there is too little, time (money) will be wasted. Some trained employees might even leave to find work elsewhere if they don't have steady work. The production manager must have seasoned managerial skills—all the rest of the functions outlined below fall under his or her jurisdiction. This responsibility can be pictured as an umbrella over everything and everyone in this chapter.

Quality Control

Making sure that every garment produced is of the appropriate and agreed-upon size specs and quality level is a bigger challenge than you might realize! There are numerous components and operations required for even the simplest garments. With so much pressure on keeping prices low, everyone in the process is trying to use the least expensive, but still acceptable, materials put together in the shortest possible time. It is a fine line between acceptable and unacceptable quality. Of course, in high-quality lines, only the best materials are used. But even there, quality control (QC) personnel must stay alert.

CLEO RYAN MONJOY

Cleo has spent many years in quality control and management, including 14 months running AMC's Hong Kong/China office. After that, she became vice president of quality assurance for Donna Karan. She is now the director of western hemisphere production for Charming Shoppes, Inc.

On the Repercussions of Quality

While quality control is expected to have some immediate visible impact on product or service, the real return on investment may take several years. As QC policies and procedures are implemented consistently over time, the QC pendulum picks up momentum, having an ever-increasing positive impact on supplier and customer perception. Concurrently, the initial organizational "pains" suffered in setting a quality approach are usually "cured" with employee education and the time it takes for the process to become a routine way of business.

Conversely, inconsistent implementation of a quality control philosophy, or override of quality standards in favor of other short-term financial goals, can produce a slow, sometimes subtle erosion in quality of product and service. Unfortunately, by the time this erosion has the company's attention, the negative momentum of the pendulum may have swung so far already as to have caused irreparable damage to the organization's reputation for quality. The short-term goals for which quality was sacrificed are often a faint memory. Recapturing credibility with the customer becomes, at best, an arduous task; at worst, a lost cause.

Most manufacturers and wholesalers entrust this responsibility only to very experienced, technically trained pros. Don't expect a startup job here! Chances are that a quality control professional will have an engineering degree plus significant experience on the production line. They would be entrusted to

- Evaluate yarn and fabric mills for suitability;
- Evaluate garment production plants to see if the required quality level can be achieved. They can also tell (after just a few minutes) how efficiently the plant is working;
- Know the capabilities of spinning, knitting, dyeing, cutting, and sewing machinery;
- Inspect piece goods before they are cut (Figure 12-1) and monitor garment production to be sure that all measurements and other requirements are being met. Most importers require that their own QC agent issue a *certificate of inspection* before the goods can be shipped;
- Test for **shrinkage**, **seam strength**, **colorfastness**, and other points of performance.

Shrinkage
Change in length and width after washing and drying.

Seam Strength
Measure of how much pressure a seam will withstand.

Colorfastness
Ability of dyes to remain on the intended fabric (usually during washing) and not to run onto other fabrics.

Findings Buyer

The findings buyer is responsible for ordering findings (zippers, thread, linings) (Figure 12-2) and trimmings (buttons, appliqués, and so forth). If a zipper ordered by the findings buyers is too short or if a button is late, the entire production must be held. Problems or delays with findings are the

FIGURE 12-1 Piecegoods waiting for inspection.

FIGURE 12-2 Even the thread color is critical.

most frequent reason for delivery delays. So it might not seem that ordering buttons is a big job until you grind the entire production line to a halt.

Patternmaker

A patternmaker works closely with the designer and is sometimes called *assistant designer*. This person takes the designer's original sample pattern and modifies it so that the garment will be practical and easy to sew. The pattern will be drawn in the standard sample size (Figure 12-3). The itemized listing of all the pattern pieces and components for each style is called the *cutter's must* (Figure 12-4) and is used to make sure that every fabric, lace, button, or zipper that is needed will be anticipated and accounted for.

FIGURE 12-3 Pattern pieces.

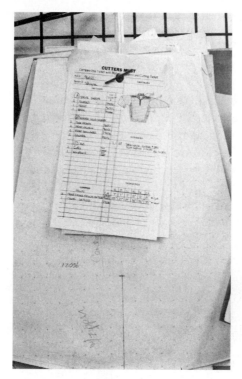

Figure 12-4 The *cutter's must* lists every component that the garment requires.

Grader

The grader takes the pattern generated by the patternmaker and makes the patterns for the other sizes. Each pattern piece must be made larger or smaller (graded) for the rest of the sizes (for example, small, large, extra large if the patternmaker made the first pattern in size medium) (Figure 12-5).

Figure 12-5 Components for differently sized garments are cut together. At this corner of the marker, you can see two XL pattern pieces.

Marker Maker

The marker maker arranges all the pattern pieces on a paper of the same width as the fabric (Figure 12-6). He or she will arrange and rearrange the pieces until they fit together tightly, wasting the least amount of fabric. To give you an idea of how tricky this is, an experienced marker maker might lay out only one or two styles per day. If the pieces don't fit together as tightly as possible, profit will be lost. Pattern pieces are then traced in place on the paper, which then becomes the marker. (In Chapter 15 you will see how many of these operations have been automated with computers.)

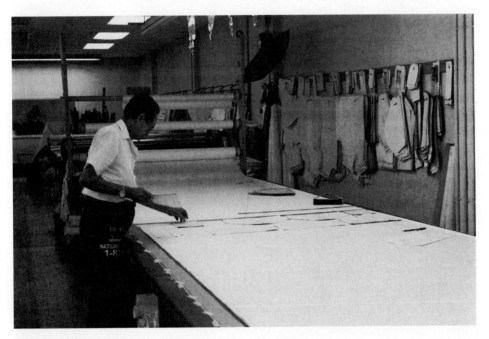

FIGURE 12-6 Marker maker carefully arranges pattern pieces to use the least possible fabric.

Spreader

The spreader rolls out layer upon layer of fabric on the cutting table (Figure 12-7). If the fabric is patterned (requiring matching at the garment seams), each piece must be carefully lined up on top of the last one. Also, the spreader watches closely for **fabric shading** within or between bolts of fabric. Finally, the paper marker is laid on top of these layered fabrics (Figure 12-8).

Fabric Shading
Slight irregularities in color from one part of a bolt to another or among different bolts.

FIGURE 12-7 Fabric spreader.

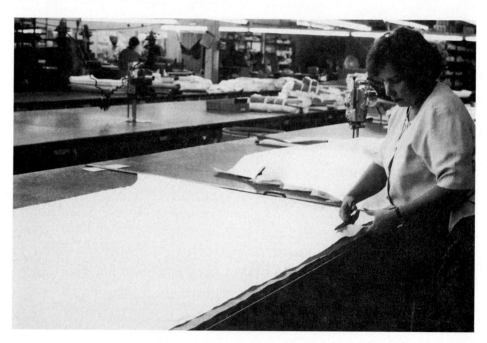

FIGURE 12-8 A paper marker is laid on top of the stacked fabrics.

WENDELL WATKINS

Wendell is vice president of manufacturing for Harwood Companies, Inc. Harwood produces private label boxer shorts (2.5 million dozen a year) for customers such as L.L. Bean, Hanes/Michael Jordan, J. Crew, Polo, and J.C. Penney.

On the Importance of Marking Correctly

Fabric is the most important thing. It represents so much of the cost of the garment. It can be 40 to 60% of the total cost, depending on where you produce. If you throw even 10% of that fabric away, that's a lot of money! You can make or break yourself by saving fabric.

Cutter

The cutter uses a cutting "knife" (Figure 12-9), which is like a hand-held electric jigsaw, to cut pattern pieces from the whole layered stack of fabric at one time (Figure 12-10). The paper marker provides the cutting lines. If a mistake has been made earlier by the patternmaker or grader, it is almost impossible to reverse the error once the fabric has been cut.

FIGURE 12-9 A cutting knife is used to cut multiple layers of fabric.

FIGURE 12-10 After cutting, there is a stack of identical pattern pieces.

Bundler

The bundler ties together the various cutout pattern pieces (Figure 12-11). Then the production ticket is attached (for organization). Findings, trimmings, and care and main labels are bagged with the bundled pieces that will receive them.

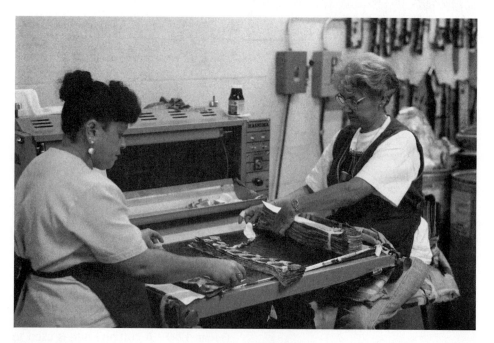

FIGURE 12-11 Cut-out pieces are bundled together.

Operator

The operator is the person who actually sews (Figure 12-12). Each person along a sewing line generally performs one operation (buttonholes, closing seams, or attaching the collar, for example). Afterward, they pass that bundle to the next operator, who conducts the next sewing step. Even for simple garments, a sewing line is often 15 to 20 people long, some of whom use very specialized machines (Figure 12-13).

(Note: A new concept has emerged that is called *production pods* or *modules*. Fewer people do more operations each. As in the auto industry, it is being tried to counteract the carelessness that can come from assembly-line production.)

Operators have a difficult job. They must sew at lightning speed with total accuracy. Half an inch off will be out of tolerance, and the garment becomes a reject. Just as they have gotten used to sewing one tricky style, it is finished, and the next, different (tricky) style comes down the line.

FIGURE 12-12 The operator sews the pieces together.

FIGURE 12-13 Specialized multineedle chain stitch machine.

Final Quality Control

Final QC people check for errors and decide if a garment is OK or whether it must be returned to the line for repairs or be discarded (Figure 12-14). Every garment that reaches this point but cannot be shipped represents a big loss (think how much time and material has already been invested). QC people might also snip loose threads and attach paper tags.

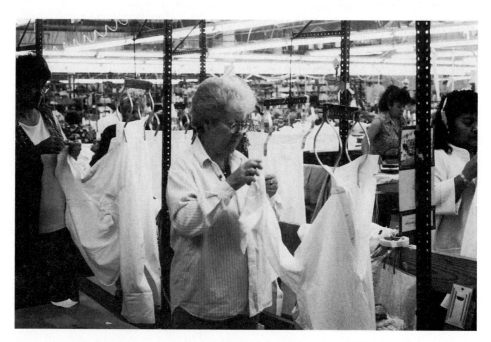

FIGURE 12-14 Each shirt is meticulously inspected at the Ike Behar plant in Miami.

THE INSIDE SCOOP

S. MILLER HARRIS

Miller joined Eagle Shirtmakers in 1946, almost 80 years after it was founded by his great-grandfather, and headed it for most of the ensuing 37 years. After a brief retirement he was called back by Smart Shirts Ltd. (Hong Kong) to head their stateside office. His mission: To build an organization focused on design and merchandising to make an offshore contractor user friendly. His final assignment was the launch of Kellwood's (Smart's parent company) first men's branded venture, the Nautica dress shirt collection.

On Squeezing Out Those Pennies

By the middle '50s at Eagle we were designing all our own patterned shirtings. We soon realized that since these fabrics were being woven to our specifications, we could engineer the design for maximum yield. It was also our custom to select the most aesthetically pleasing centerline for each pattern—the line on which the front buttons and buttonholes are sewn—so that every shirt of that pattern, no matter what size, had the identical repeat. If the repeat of the stripe was close to 1 $\frac{1}{2}$ inches (the width of the top center), there was danger that the stripe on the placket edge would overlap the same stripe on the shirt and that, since the placket was constructed with a folder, there was a chance that the placket edge would look wavy.

We devised a clear plastic template which we laid on top of the painting or handwoven sample of the proposed pattern. It had one stripe for the centerline flanked by two others to indicate the width of the placket. We could see immediately if the pattern as it then existed met our parameters. If it did not, we would adjust the repeat—either wider or narrower—a fraction of an inch on each side.

We then instructed the mill to weave every pattern with that center stripe precisely $\frac{7}{8}$ inch (a figure developed by our cutting room staff for maximum yield) from one selvage (edge of the fabric). The results: Perfectly matched fronts and plackets; no wavy edges to the plackets; every shirt identical; and—most important to our controller—no wastage on the floor!

Finishers

Finishers are the final pressers who make the garment presentable for sale. Folding is sometimes partially mechanized (Figures 12-15 to 12-17).

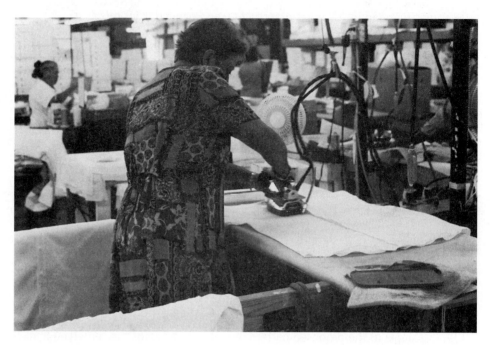

FIGURE 12-15 Final pressing.

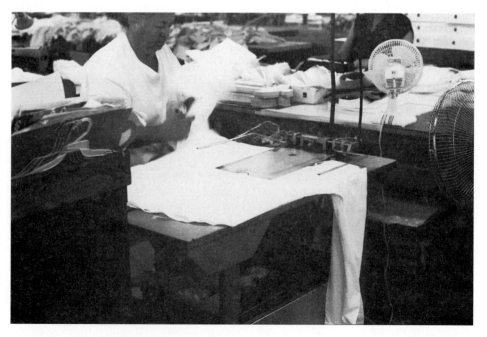

FIGURE 12-16 A folding machine…

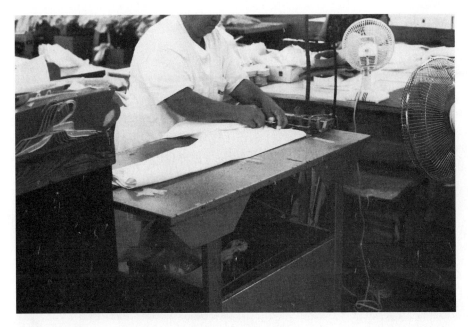

Figure 12-17 …ensures a crisp, consistent fold.

Packing/Shipping

Packers and shippers put the garments in bags (Figure 12-18) or in boxes or on hangers. They must pull and pack accurately because the packing slip and invoice (bill to the customer) must match exactly (Figure 12-19). If there is a discrepancy, bills don't get paid. The packing/shipping department also arranges transportation of garments from the factory.

Figure 12-18 Each shirt is carefully pinned and bagged.

FIGURE 12-19 Pulling and packing the correct assortment per order.

Delivery

After solving dozens of little problems along the way, the precious shipment is ready to be delivered. In some cases, this could be as simple as carting it across the street to the wholesaler's warehouse. More likely it means shipping halfway around the world from the contractor's sewing plant in Bangkok to a branch store in Boston. Sea freight delivery from some of the more remote locations (Pakistan, Mauritius, Zimbabwe) can take as long as 60 days to reach port, clear **customs**, and be delivered to the warehouse.

Customs
Government agency that monitors imports and collects duty (tax).

Cartons and Freight

Glamorous it's not, but important it is, that your merchandise get from factory to selling floor in good condition. Most garments shipped from overseas are folded and put into poly bags. Usually 12 to 48 pieces will then be packed into a sturdy cardboard carton for shipping (Figure 12-20). Alternatively, some garments will have hangers already inserted and then laid flat in a carton. This saves time when they are received—the stores' receiving room employees don't have to put each garment on a hanger. It's already done by someone earning less!

There are even shipments on hangers hung on a rod in a wardrobe-type carton. This technique, called "GOH" (garments on hangers), allows each garment to hang for the entire journey. Garments hung on a rod and those on a hanger in a box cost more in packaging, and in the case of the wardrobe hanging boxes, a lot more in freight cost. However, if the garments are expensive, and if shipped hanging they won't wrinkle, it might be worth the cost because they won't have to be repressed (expensive, again!) when they reach the United States (Figure 12-21).

Figure 12-20 Shipping folded garments in boxes.

Figure 12-21 Shipping garments on hangers (called "g.o.h." in the trade).

Most cartons that are shipped by sea get packed into huge steel boxes (containers) that are 20 or 40 feet long. One container can hold as much as 20,000 adult turtlenecks or 44,000 kids' turtlenecks. That's a lot! Imagine getting this fax (which we actually did in 1997): "Your container of turtlenecks suffered water damage crossing the Pacific. Will have to unpack in Long Beach to see extent of damage. Thanks and best regards!"

If a store or importer orders enough to fill an entire container (FCL means full container load), the order can travel intact all the way to the warehouse without being unpacked or repacked. This saves a considerable amount of money.

Knowing that almost anything can happen to delay production or shipping, most wholesalers allow a 30-day cushion from the planned arrival time in the warehouse to the required ship date to the stores. This cushion is doubly important if different components of a collection are being made by different contractors and/or in different countries. Even with the best planning it is impossible to have all shipments arrive at precisely the same time. With the 30-day cushion, they can stagger in and still all get shipped together as a package to the retail stores. Also during this time, a spot QC inspection might be conducted in the wholesaler's warehouse to ensure that there are no problems with the completed merchandise (Figure 12-22).

Figure 12-22 Spot quality control log: Checking a selected number of garments to make sure they measure "to spec."

More and more, retail stores are requiring smaller but more frequent deliveries of merchandise. In the past, they might have "loaded up" with a whole season's inventory at the start of the season. Today stores want to receive some new merchandise every month: This is better for their **cash flow**, and it gives their customers something new and exciting to see every time they come into the store.

Cash Flow
One measure of corporate wealth based on the company's ability to access its funds.

Oops!

Sometimes garments with problems slip through the system and arrive at a wholesaler's warehouse or a retailer's distribution facility. Perhaps labels were put in upside down, holes were discovered in the fabric, or seams were not sewn closed. A whole mini-industry has formed to solve these problems that have multiplied as more garments are made in unsophisticated and remote locations. Specialized companies take the shipment, fix the problems in creative ways, and then return it in the desired condition. These services can be relatively expensive, but they can also turn a million-dollar disaster into salable merchandise. One company is actually called Whoops!

ONE'S EASY, NOW TRY 1,000 DOZEN!

It's at this point that we like to take our students to see a real garment factory in operation. Standing in the middle of a building bigger than a football field, with the steady bustle of hundreds of workers, one student always says, "Yikes, how do you get from sewing one garment to this?" He or she is right: Sewing one garment and sewing 1,000 dozen nearly identical and perfect garments are two totally different undertakings. The "football team" usually means hundreds of people, not just a few dozen. And these team members depend on each other for their livelihood.

When you are a student, either your parents are supporting you or you are working outside the classroom to put yourself through school. But let's say that you have graduated and have now become the designer at a good-sized manufacturer. You walk the factory floor on your first day and see the hard-working and dedicated sewing operators, packers, pressers, and cutters busily filling a large order. At this moment you realize that your obligation to do a good job is not just to yourself, to your boss, or even to your customer. It is also to these people who don't make much money, and what they make often supports entire families. They count on you to design a successful line so that they can keep their jobs. Their jobs are in your hands.

Ouch! What responsibility! But that's teamwork. You must count on them to cut, sew, and press the garments correctly so that your efforts will be successful too. When dealing in large-scale manufacturing, everyone must understand clearly what he or she must do, and then that person must do it well. If not, the result is not an F on a report card—it can be a financial disaster.

HERE'S HOW TO BEGIN . . . CHAPTER 12

The cost sheets have been prepared, the spec sheets are complete, and now it is important to get that information communicated correctly to the production team. You've probably already surmised that production teams are usually not next door to the designer studio. They could be miles away or even in another country. Clear and professional communication skills are the foundation of success in any field. This becomes doubly important if you are working with people long distance (in the mills, in the factories, and so forth). It becomes triply important when some of those people are in foreign countries, where English is not the first language.

There are a few "tricks" to specific and clear communication in the garment world!

First: Gather All the Information Before You Start

Have everything related to this issue in front of you. It is so easy to skip a few specifics (such as style number or spec measurement) if the information is in a file someplace. Skipped specifics lead to misunderstandings every time!

Second: Assume Almost Nothing!

Don't assume that the reader "knows what you mean." Your job is to provide specific and crystal-clear details. Remember, you do not know to whom this message might be passed. Your primary recipient might "get" what you are saying but how about the production manager or shipping clerk whom you've never met? Avoid slang: "This fabric looks cheesy!" will not be understood.

Third: Ask Your Questions

Be certain to include any questions that you need answered. People often do not reply if they are not asked to respond to specific questions. To make questions very specific, number each question and ask that each question be answered by number.

Fourth: Establish a Time Line

If time is an important part of your correspondence, set checkpoint dates, which will help you know what is going to happen when. When you promise something, always specify when you will deliver it. When you request something, specify when you need it.

Fifth: Always Sound Reasonable!

Strong emotions expressed in writing, such as faxes and e-mails, somehow end up sounding very emotional and severe. Keep your tone reasonable—firm if necessary, but not negative or accusatory.

First, let's give you some examples of unclear and clear phrases that were intended to say the same thing…Then afterward, let's see if you can "clear up" some fuzzy phrases.

UNCLEAR PHRASE	CLEAR PHRASE
T-shirt style	T-shirt, style 123.
Scheduled for February delivery	Scheduled for February 28 delivery.
Shorts are too long.	Shorts, style 456: Inseam measurement of sample is 5 inches. Our spec calls for 3 inches.
Will shipment be on time?	Please advise: 1. Vessel name 2. Vessel number 3. Exact sailing date.
Blouse collar looks funny.	Blouse collar point spec (code F) calls for 2 inches. Sample has been made to our spec; collar point measures 2 inches. However, now that we see the sample, the 2-inch collar looks too short. Please change collar point spec (code F) to 3 inches, remake sample with new collar, and resend. Please advise when you can resend.
Have sent skirt sample to you. Please advise your price.	Have sent skirt sample to you. Based on specs of the sample itself, please advise your price. Please also advise exact fabric construction on which this price is based. Sorry for the rush, but I need this answer no later than June 25. Can you get me the information by then?
Have sent toddler short sample and size specs to be used for this style. Please advise your price.	Have sent toddler short sample. Have sent size specs to be used for this style. Plan to use a S–M–L size scale of 2–6–4. Please advise your price.
Your lab dip looks too dark.	Lap dip is not approved. It must be 10 percent brighter (chroma) and 20 percent lighter (value).

Rush this shipment, or I'll never do business with you again!

Garments must leave factory no later than November 2.

[No reply to a fax because you don't know the answer.]

Sorry, I still do not have an answer. Will be able to give you complete explanation tomorrow.

Will send you orders in April.

Orders will be in your hands no later than April 10.

Will be visiting Hong Kong in September. See you then!

Will be working in Hong Kong September 15–17. In advance of our appointment, please cost out objectives 31, 32, and 37. Specs are attached. Please bring to the appointment a swatch of each fabric on which the prices are based.

Do you have a jazzier fabric for this style?

Must upgrade this style with a better fabric. Would prefer a softer, brushed hand. Can only increase garment cost by $0.50, however. Please advise exact fabric (and fabric construction) you propose.

Dress is too expensive.

Sorry, price is too high on ladies dress style 567. Must come down at least $1.00 on first cost. Fabric cannot be changed! Can you suggest any other changes that might save $1.00?

We need this jacket to ship from Hong Kong no later than September 15. What do we have to do?

We need this jacket to ship from Hong Kong no later than September 15. To achieve that ship date, please advise the trigger dates when you will need the following decisions:

1. Date you must have exact quantity
2. Date you must have exact fabric; construction
3. Date you must have exact colors and the quantity for each color
4. Date you must have finalized styling.

Now it's your turn to try this. See if you can be more specific than the given phrases. When you're finished, why not compare several in the class and decide which are the most clearly communicated?

UNCLEAR PHRASE	CLEAR PHRASE
Our blouse.	_____
When will it ship?	_____

Color is "off."	_____

Sleeves look too long.	_____

Sweater is priced too high.	_____

Orders are coming soon.	_____

This fabric is sleazy!	_____

Need goods by January 10, or else!	_____

Where's my order?	_____

I want this T-shirt in October.	_____
What's it going to cost me?	_____

CHAPTER THIRTEEN

SELLING THE LINE:
HOW FINAL IS THE SALE?

Salesperson Samples
Sets of samples for salespeople to use when showing the line to their retail accounts (buyers).

Production Fabric
Portion of the actual fabric, as opposed to a sample, that will be used to make the entire run of this style.

Swatch Card
A card with small pieces of fabric attached to show alternative patterns or colors that are available.

Sample Line
A full collection of sample garments that will be shown to retail buyers.

Once the kinks get worked out on the first samples, most wholesalers have several **salesperson samples** made up. The exact **production fabric** is ordered (but in a smaller quantity of 15 to 200 yards, depending on the size of the sample line). This is so that garments and swatches can be assembled for selling purposes. Retail buyers are under tremendous pressure to perform. They must see what they will be shipped. These samples really must be exact representations (color, fabric, make, styling) of what will be shipped if the buyer places an order. To save money (samples can cost up to five times as much as the same garment will cost in production), wholesalers will often show just one color or pattern in full garment form and have the other colors or patterns represented on a **swatch card**. CAD printouts are also widely used to represent secondary colors or patterns.

With a full **sample line** completed, the sales staff starts calling on retail store buyers, often as production is just beginning. The wholesaler is anxious to start getting a reaction to the line and to start getting firm orders for the merchandise that is already being made.

Note that in private label production never starts until the orders are confirmed. After all, these goods are being custom-made for the retailer. A

1411 Broadway, one of New York's premier garment showroom buildings.

New York's Fashion Center Information Kiosk outside 1411 Broadway.

retail product developer is not going to gamble on styles that might not be confirmed by the buyer, if the buyer is someone other than the product developer. Remember, in private label there is no one else to sell these styles to....

OPPORTUNITIES FOR WHOLESALE SELLING

New York Showrooms

The New York garment district is the "capital" of U.S. fashion. Along 7th Avenue and Broadway from 35th to 39th street are thousands of **wholesalers' showrooms**. Retail store buyers from all over the country come to New York to visit these showrooms and **to shop** the wholesale lines. Some showrooms are owned by one manufacturer or designer. Others could be multiline showrooms where the salesperson represents several different lines.

There are specified *market weeks* during which the new season's lines are unveiled. Most buyers come at these times to see the lines as they open. The women's ready-to-wear market generally has five such weeks during the year:

Wholesalers' Showrooms
Offices where wholesalers have their sample lines and where they show these lines to buyers.

To Shop
To visit, to look.

1407 Broadway, another key garment center building.

MARKET WEEK	SEASON BEING SHOWN
Mid-January	Summer/transitional
End February	Fall 1
End April	Fall 2
Early August	Resort/holiday
Early November	Spring

Men's, kids, and accessories are similar, if a little less frequent.

What is an appointment "to shop" a line like? Let's say that you're the buyer of moderate missy sportswear for Huxtable's department store in Tampa, Florida. You've flown in on Sunday afternoon so that you could start promptly at 9:00 a.m. on Monday of market week. Your first appointment is at 1407 Broadway with Mar-Lee Casuals, a small but up-and-coming missy separates line. Over coffee the salesperson will ask how your current group from Mar-Lee is selling in the store. What's been good? What hasn't? He or she will also probably ask what other vendors or items in your department are selling well. How is business overall? Are you planning increases or decreases for the upcoming season?

Before getting into the individual styles on the new line, your salesperson might point out that the showroom has been set up ("trimmed") to capture the mood of the new line. Perhaps there are props and backdrops to evoke a rustic feeling or maybe a sleek, sophisticated tone, depending on the look of that season's line. Mannequins might be dressed in the most striking combinations of styles from the line.

The salesperson will start with a description of the designer's concept for this delivery, based on international fashion direction merged with the knowledge of what the Mar-Lee customer has purchased (or not purchased) in the past. Presentation boards showing the overall mood or inspiration for the line can be used to illustrate the concept. With this done, he or she will proceed to show the line style by style. Cost prices are quoted on most, if not all, styles.

Here's where we go back to the concept of knowing your customer. Our salesperson has probably worked with you and maybe even with the Huxtable buyers before you. From that experience, he or she knows that specifically at Huxtable's the best-performing parts of past lines have been, say, the brighter

knitted canvas

N407
Demitasse
jacket
100%
cotton
s-m-l
$32

N405
Long
jacket
100%
cotton
s-m-l
$37

N402
Nehru
jacket
100%
cotton
s-m-l
$34

N316
Pull on
skirt
100%
cotton
s-m-l
$24

N284
Pull on
taper leg
pant
s-m-l
$24

N283
Flood
pant
100%
cotton
s-m-l
$24

Some wholesalers such as Christy Allen make the buyer's job much easier by providing pictures and prices of the entire line during the presentation in the showroom. The buyer simply circles the styles he or she likes, making it easy to remember them later on.

and less expensive styles. In addition, from other Florida accounts, he or she knows to steer you away from all long-sleeved garments. With this knowledge, our salesperson directs you toward certain styles and away from others. The salesperson might even opt to skip a portion of the line that he or she knows won't sell at Huxtable's. After all, the salesperson wants you to be successful so that you will return next season! He or she also knows that your time is limited.

After the overview, you might double-check that you have noted all the important styles for your purchase. You could have the salesperson hang up just your proposed selection from the line for your final review. With these notes by style/cost, you can either write your orders on the spot or when you get back to the store. Chances are that you will want to see more of the competing lines this week before making the final decision.

THE INSIDE SCOOP

ZACHARY SOLOMON

Zach trained at Abraham & Straus and then followed the important back-and-forth merchandising line/store line career path: Assistant buyer, department manager, buyer, branch divisional, DMM, branch store manager. After that he was GMM of ready-to-wear at May Company-Los Angeles, president of the Emporium in San Francisco, vice-chairman of May Company-Los Angeles. At that point he switched from retail to wholesale, becoming president of Perry Ellis and then of Ellen Tracy. After serving as the chief executive officer of AMC in New York, he again returned to wholesale to head Adrienne Vittadini, then Baby Togs.

On Selling

1. *Don't oversell*. If you push a buyer to overbuy, he or she will always come out with a bad season, and this always comes back to haunt you.

2. *Be honest and realistic*. A buyer has to have confidence in what you're saying. She can't have the feeling that you're just trying to get the order. Don't let her buy what you know she won't be able to sell. She needs to know that you are getting the best assortment for her.

3. *Tailor each buy to the customer who will be coming into that particular store*. Your taste level is not always the same as the customer's. In fact, different parts of the country have different taste levels. When I was at Ellen Tracy, we found that the customers who bought Ellen Tracy in Texas, Oklahoma, Arkansas, and Louisiana were very conservative. So every season I would fight to be sure that we included a couple of 25-inch skirts that would cover the knee. Short skirts were great in New York, Los Angeles, or Chicago—but not in the southwest!

4. *Know when the sale is complete*. Don't keep selling when the sale has been made. Know when to stop!

Other Ways to Shop

There are shows all over the country featuring specialized market segments. Most of these shows are sponsored either by the regional marketing centers, such as the Miami Merchandise Mart (Figure 13-1) in conjunction with exhibition groups, or by corporate firms who specialize in coordinating, marketing, and producing the shows. Another show in south Florida is the Southern Apparel Exhibitors who feature the "Premiere Women's Apparel and Accessories" show. You can gather first-hand information about the show by linking to www.mimm.com

Other shows include the following:

Hawaii Market/Pacific Rim Trade Show	email: dtsm@hawaii.rr.com
Surf Expo	www.surfexpo.com

THE INSIDE SCOOP

CHRISTY ALLEN

Christy was practically born in the fashion business. Summers and weekends from the age of 12 she worked in her mother's upscale women's boutique in Bucks County, Pennsylvania. She then went to the Philadelphia College of Art and then Parson's in New York, with the dream of owning her own fashion business.

Her first venture was a successful retail store in Philadelphia called "No Saint." For eight years, Christy ran the store by seeking styles that were new and different from the competition. After a while, she realized that the looks she really wanted were unavailable in the wholesale market. So Christy designed a group of separates, sweaters, and coordinating tops and bottoms and made the plunge into wholesale manufacturing.

I researched the local manufacturers and found that there were lots of them. I wanted something made locally so I could oversee production. Finally, with a small collection, I got together the funding to rent part of a booth at the New York Boutique Show, a wholesale trade show. My samples were in the back of the booth, so practically no one saw them. I walked away with very few orders.

However, I decided that if I was going to give this a fair chance, I would have to invest some money, commit to fabric, and rent a whole booth for myself. It's important to invest some money in your dreams: There is no turning back then because you don't want to lose your investment.

The second show, I paid for my own booth. The show opened at 10:00 and I was still decorating the booth at that point. Well…by 10:10 there was such a crush of people I had to stop decorating and start taking orders. I wrote $50,000 worth of orders at that show, and I'm still here 13 years later, wholesaling two entire collections of sportswear (Christy Allen and Liv) each season!

FIGURE 13-1 Miami International Merchandise Mart.

A corporate firm you will often read about that specializes in show co-ordination is the Larkin Group (contact information below). Larkin, noted as a leader for fashion trade shows, sponsors many annual shows such as the following at the Javits Convention Center in New York City:

International Fashion Boutique Show
International Kids Fashion Show
International Fabric Fashion Exposition
Private Label-Product Development Expo
The Style Industrie
Pret America

The Larkin Group
100 Wells Avenue
Newton MA 02159
617-964-5100
Fax: 617-964-0657
http://www.larkingroup.com

If you don't really know what specific types of shows you want to attend, here are a couple of printed sources you might want to note. These sources will open many opportunities that will help you not only for trade shows where you can sell your products but also as you source out materials and suppliers to develop the merchandise.

- *National Trade and Professional Associations of the United States.* A wide array of professional and trade associations are listed alphabetically with contact information, a brief description of the group, names and frequency of publications generated by the association, as well as information about yearly meetings. This book is indexed

by subject, geographic location, acronyms of associations, and names of firms that manage associations. It is published by Columbia Books, Inc.

- *Tradeshows Worldwide: An International Directory of Events, Facilities, and Suppliers.* This was once titled *Trade Shows and Professional Exhibits Directory.* This resource contains an alphabetical listing by name of convention or exhibit. Information provided includes names of sponsors, contact information for the organization overseeing the exhibition, frequency of shows, location of shows with details concerning the exhibit hall (space rental rates, number of attendees, number of exhibits and exhibitors, and amount of exhibit space), and the date of the show. Also included are contact information for hotel and motel chains, visitors' bureaus, world trade centers, companies dealing with trade shows (for example, vendors signage) and lists of trade and professional associations, publications, and trade show consultants. This is published annually by the Gale Group.

Along the same lines, keep a few of the following virtual addresses handy to gather up-to-date information on trade shows. Don't forget! You can use this information as you source products, materials, and makers, too.

http://www.tsnn.com	Trade Show News Network
http://www.expoguide.com/shows/shows.htm	EXPOguide
http://www.tschannel.com	Trade Show Channel
http://www.tscentral.com	Trade Show Central

The final area of sales is one that has seen better times: *Road salespeople.* Not too many years ago, most purchases (even by major department stores) were handled by a local salesperson. They traveled from store to store with the line in the trunk of their car. As we have learned, with the nationalization of retail, there is just a handful of mega-retailers left. They tend to negotiate directly with the heads of the wholesale companies (called *corporate selling*) rather than with a local road salesperson. Those remaining salespeople tend to service the small independently owned specialty stores in small markets across the country.

"SELLING" PRIVATE LABEL PRODUCT DEVELOPMENT

As noted, when a retailer develops its own product, the middle person wholesaler is eliminated. Thus the need "to sell" the line to the retail store buyer is also eliminated.

Well, almost. Many large retailers have two separate staffs: One group develops the product from start to finish, and another does the actual buying. This is especially true in department stores where buyers are responsible for buying both wholesale lines and the store's private label line.

As a result, product managers must learn to develop a kind of selling skill as well. They will always confer with the buyer in the initial planning stages. There is no point in developing styles, price points, or fabrics that will be of no interest to the buyer. Product managers also generally confer with their counterpart buyer *during* the process as decisions are made.

When the line of private label styles is more or less set, often a professional-looking presentation board is created with CAD representations of all styles in all planned colorways. This allows the buyer to see a visual representation of the entire buy and allows the store DMMs and GMMs to review the planned purchase before final commitments are made. Usually the product manager will have to present this line to a large group including the managers. The presentation must be made with enthusiasm and conviction if it is going to receive the buy-in from all concerned.

After Selling, Adjusting the Initial Buy

Like any other business, the more inventory you have invested in what your customers want and the less you have of what they don't want, the more successful you will be. Unfortunately, however, the wholesaler must commit to most of the line before any retail buyers come and place their orders. Something in the line might "take off" and book in much greater quantities than expected. Conversely, an item could have been projected to be a big booker, only to fall on its face. (These styles are called "dogs.")

Here is where that scrambling comes in that Dianne Ige told us about in Chapter 2! How can existing orders be adjusted so there will be just the right amount of inventory for each style? There are quite a few tricks, and we will discuss some of the most common.

Swing

When the wholesaler makes advance commitments for fabrics and/or garment production space, the mill and/or cutter might be willing to take the order with a clause that at a specified future date, this quantity could be altered up or down by 10% or even 25%. This adjustment is referred to as the **swing** quantity. It acts as an easy cushion if demand turns out to be greater or less than anticipated.

Switch

If a yarn commitment is firm and cannot be changed, sometimes that yarn may be knitted or woven into something slightly different. For example, the same cotton yarn would be used to knit **flat interlock** as would be used to knit **drop-needle (ribbed) interlock**. If the flat interlock styles in the line underbook and the drop-needles overbook, you can switch the same (committed) yarn from one knitting technique to the other. An even more

obvious example would be a gingham check fabric, which is shown in the line as a jumper and as a dress. The jumper's great, but the dress is a dog. So switch all the piece goods to jumpers. ("Kill the dress, cut the jumper!")

Mill Goods

Mill goods are basic, running fabrics that are readily available and used extensively. These include woven fabrics such as **twill**, cotton **denim**, and **canvas** and knitted fabrics such as **jersey** or interlock. If you must back out of a commitment on one of these, chances are that the mill will be able to sell it quite easily to another customer (and thus might not hold you responsible). Novelty, specially woven, or specially knitted fabrics or even mill goods dyed in unusual colors become much more difficult to back away from. These fabrics will probably have to be **jobbed out** at a loss, with the loss being absorbed by the wholesaler who made the unfortunate commitment. However, beware saying, "OK—for safety's sake I think I'll stick to mill goods in basic colors for my first line." Just picture how boring and "unspecial" a line like that would look! You've got to take some risks to be successful!

Twill
Fabric woven is such a way that small, raised diagonal lines are produced on the cloth.

Denim
Twill fabric made with white and indigo-dyed yarns.

Canvas
A heavy plain-weave cotton-type fabric.

Jersey
Plain-stitch single-knit fabric: All stitches on the face are knit stitches; all on the reverse side are purl stitches.

Jobbed Out
Sold off; usually implies sold at a loss.

Shared Fabrics

One trick that many designers use is to repeat a fabric several places in the line, so adjustments can be made like in the gingham example above. They can also be used as trims: For example, using a shirt fabric also as the lining in a jacket. If the jacket is a dog, you can shift the lining fabric back to shirts.

Sample Looms

With some woven mills it is possible to place just a limited order of, say, 500 to 1,000 yards of a pattern (a "sample loom"). A designer might put five patterns into work and have the fabric woven and this limited number of shirts made (250 to 500 shirts, approximately). When the line is sold, it could be that only three of the patterns book well, so the designer or product manager would return to the mill and place the **bulk** piece goods orders on just the three patterns. With the preliminary set up and color matching already done, the mill can now produce more quickly the needed 5,000 or 10,000 yards, for example.

Bulk
Same as production fabric.

Staggered Trigger Dates

No, this is not a drunken brawl in a cowboy bar! Trigger dates are drop-dead due dates that are agreed upon by all partners. The point is to wait until the last possible moment to make the irrevocable decisions. Each decision is probably required at its own specific time. The later that each decision is made, the more booking or selling information you will have on which to base your decision. See Chapter 14 for more details on trigger dates.

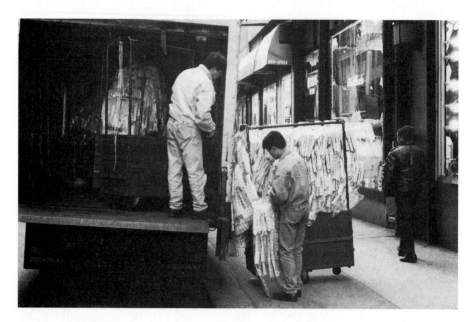

Moving merchandise as quickly as possible in New York's garment district.

Reorders

When you're hot, you're hot! Sometimes based on the strong initial orders received from buyers or sometimes based on fast sales at retail (**check-outs**), a wholesaler might want to get more of a particular item. The trick is to produce it much more quickly than the original production so that it can be made available as soon as possible. At times, available trims or fabrics might have to be substituted rather than waiting for customized materials all over again. There is a real art to making subtle substitutions that won't be noticed by either buyer or customer. It is common on reorders from overseas to pay the **surcharge** for **air freight** (extra charge over the regular, less expensive **sea freight**) to gain 15 to as much as 45 days.

THE STUFF THAT DOESN'T SELL

This is not a perfect world! With every wholesale line release, there are going to be items that do not sell up to the level of already committed **inventory**. A good wholesaler minimizes this problem by taking the steps outlined under "After Selling, Adjusting the Initial Buy," but it never works exactly right. So what happens to the merchandise that you can't sell? The best solution is to try to recoup as much of the cost as possible, toward which there are several different routes.

Your Current Customers

The first choice is always to make a reduced-price ("off-price") special offer to your current retail store accounts. This will allow them to run a special

Check-Out
Merchandise that has sold quickly.

Surcharge
An extra charge.

Air Freight
Merchandise shipped via airplanes (expensive).

Sea Freight
Merchandise shipped via ships (less expensive).

Inventory
Merchandise owned by a wholesaler or retailer at any given time.

sale and encourage traffic in their stores. With this route, the existing relationship between wholesaler and retailer is actually enhanced. Conversely, this keeps the wholesaler from having **to dump** the goods in different stores, which might compete with the regular client stores. Keeping off-price goods in the regular client stores and not in off-pricers or other less desirable outlets is called keeping your distribution clean.

Outlets

The next most desirable place to sell problems is a relatively newer phenomenon: The wholesaler's own clearance or off-price store. Outlet malls filled with brand-name stores have become such huge business that these stores cannot rely just on overruns and mistakes. These stores also buy and develop merchandise especially for themselves. Still, they will often absorb the wholesaler's overages, even though they have become more independent and can no longer be forced to take something they feel they cannot sell.

Off-Price Chains

Next are the national or regional off-price store chains, such as Marshall's and TJ Maxx. These large organizations can absorb much merchandise, but they will negotiate for sharply reduced prices on the wholesaler's overruns. To get this branded merchandise however, most of these chains will agree not to use the brand names in advertisements. This is to help the wholesalers preserve their relationships with the stores that buy from them at full wholesale price.

Special Situation: Overages Overseas

If merchandise is produced overseas and there is an overage, or even if there are seconds, sometimes the wholesaler/importer will buy this merchandise back from that overseas contractor. This is especially true for high-end status brands. They don't want this merchandise to be **diverted** and sold to unauthorized outlets. Some importers whose merchandise features highly recognized trademark logos or embroideries might insist that any merchandise that gets canceled (for example, if the manufacturer couldn't complete it on time) be destroyed! (We know of one importer who required videotapes of the burning of the garments.) Again, this is to protect their highly valuable and recognizable trademarks from ending up in the wrong places!

Diverted
To have sold or transferred merchandise to an unauthorized customer.

DIRTY LITTLE SECRETS

Here's what really goes on between wholesalers and retailers. As you have learned, there are fewer stores to whom wholesalers can sell. The biggest chains of department stores tend to have a **vendor matrix** set by top management. Buyers are only allowed to buy from resources that have been pre-

Vendor Matrix
A listing, set by management, of wholesalers from whom buyers must buy (an unapproved vendor is "off the matrix").

approved by management. If you're not on the matrix, you might not even get a buyer to look at your line!

The result of all this is a certain level of desperation on the wholesaler's part. They are desperate to get on the matrix, and they are desperate to stay on it. To ensure that their line will be profitable for the store, they might give that store some up-front guarantees:

- *Goods returned*. There might be an agreement that if the store has merchandise left at the end of the season, it can simply be returned to the wholesaler for a full refund.
- *Markdown money*. If the store must take more markdowns than planned to clear the inventory, some wholesalers will reimburse them with a check to make up the difference.
- *Guaranteed gross margins*. These are similar to markdown money. Store and wholesaler agree at the start of the season what the store's percentage of profit would be on the line ("gross margin"). If at the end of the season, the gross margin falls below the agreed-upon figure, the wholesaler reimburses the difference.

The sad truth is that these games are an illusion. The only way that a wholesaler can afford to offer these guarantees is to inflate the original offering price. So the value of the merchandise is suspect from the beginning.

Our editorial on the subject of these dirty little secrets is this: An unhealthy trap has been created by these practices. Store buyers now often seek the best deal, the best protection, rather than the best merchandise for their customer. The buyer comes out all right as far as profitability is concerned, but there are disappointed customers who don't find what they are looking for. In addition, the overinflated initial prices just encourage shoppers to wait for the sales. It's a vicious circle. It's our opinion that this practice has been one of the major factors contributing to the accelerating demise of department store chains in the 1980s and 1990s.

HERE'S HOW TO BEGIN . . . CHAPTER 13

Fashion Trends and Brands Project

It is now time to start compiling all the information you have been researching in your journals with what you have learned in this course. This project is designed for you to look at the garments being produced in the industry and compare their value, based on design, construction, and consumer acceptance. Note that this project will reflect your opinion, based on your research, so there is no "right" answer. Ultimately your opinion will be a key factor projecting the success of a product or group line. Good fashion forecasters must always ask themselves, "Will the customer be willing to pay the price I am asking for this garment?" Your research, knowing if your product is at the right

place with the right value, will provide you with the foundation to make qualified decisions. Suggested research tools are identified in Chapter 7.

PART ONE: IDENTIFY THE BALANCE OF A LEADING DESIGNER

Identify an item or group line produced by a leading designer and discuss:

a. Philosophy of the products created by this designer;
b. Consumer market being targeted;
c. Store type (with examples) of where the product is sold;
d. Characteristics of the product itself (look, price, fit, and durability and, if possible, where it was manufactured).

PART TWO: IDENTIFY THE BALANCE OF A LEADING PRIVATE LABEL PRODUCT

Identify an item or group line produced as a store's private label and discuss:

a. Philosophy of the products created and how these products relate to the store for which they are designed (for example, Arizona Jean Co. for J.C. Penney—how does the product reflect the store image?);
b. Consumer market being targeted;
c. Promotional approach and customer service presented in the private label store;
d. Characteristics of the product itself (look, price, fit, and durability and, if possible, where it was manufactured).

PART THREE: IDENTIFY THE BALANCE OF A LEADING NATIONAL BRAND PRODUCT

Identify an item or group line produced as a national brand label and discuss:

a. Philosophy of the products created;
b. Consumer market being targeted;
c. Promotional approach and customer service presented in the store for these product labels;
d. Characteristics of the product itself (look, the price, the fit, and durability and, if possible, where it was manufactured).

PART FOUR: COMPARE AND CONTRAST

a. Are each of these products meeting their consumers' needs?
b. Which product do you feel is more on track with the consumer market and why?
c. Based on your research of the consumer, economic, fashion, and lifestyle trends, which product do you feel is the one most likely to generate the strongest sales? Why?
d. Based on your product knowledge, which product do you feel is the strongest value? Discuss why!

CHAPTER FOURTEEN

THREE SEASONS AT ONCE: SPINNING PLATES ON POLES

So far in Unit 2, we have been working our way step-by-step through the product development process, from the first ideas through shipping and selling. In our example (fall season) we started with those first ideas in July (of the year before) and kept building for 13 months. At the end, we were finally ready to ship the completed merchandise to the stores. In graphic form, it would look like Figure 14-1.

Fall Line Development

	
July	→ START HERE FOR FALL (F) First brainstorming, first ideas.
August	(F) Brainstorming continues.
September	(F) Dollars, SKUs and deliveries broken down.
October	(F) Colors decided.
November	(F) Final line planner set; price and color information sent overseas.
December	(F) Manufacturers work on samples; price bids are submitted.
January	(F) Overseas trip; finalize vendors, prices, deliveries.
February	(F) Vendor orders piece goods and trims.
March	(F) Countersamples are sent from the manufacturer; patterns and specs are final.
April	(F) Piece goods and trims arrive; production begins. Line goes on sale.
May	(F) Production completed; shipped to warehouse.
June	(F) Goods arrive at warehouse.
July	(F) Merchandise is finally shipped to the stores.

14-1 Fall line development: Timing and action calendar.

OVERLAPPING SEASONS

Whew! It took a long time and a lot of thought and effort, but you did it—you shipped fall! But don't stop to congratulate yourself yet! The next season, holiday, doesn't start now. It started already! It actually overlaps with fall! Holiday goes through exactly the same sequence, but it starts just a few months after fall started (because you will ship holiday to stores just a few months later than fall).

Thus, the first holiday brainstorming starts in October (rather than in July for fall). Then it follows the same sequence month by month. Also remember that in October, when you are starting your first thoughts about next holiday, you are actually also shipping the current year's holiday line. So in the thirteenth month, the same season actually overlaps itself! Here is the same calendar again, but with the holiday time and action sequence added (Figure 14-2).

Fall Line Development
Holiday Line Development

July	(F) First Brainstorming, first ideas. (H) *Piece goods and trims arrive; production begins. Line goes on sale.*
August	(F) Brainstorming continues. (H) *Production completed; shipped to warehouse.*
September	(F) Dollars, SKUs and deliveries broken down. (H) *Goods arrive at warehouse.*
October	(F) Colors decided. (H) *Merchandise is finally shipped to the stores.* → **START HERE FOR HOLIDAY** (H) *Brainstorming next Holiday.*
November	(F) Final line planner set; price and color information sent overseas. (H) *Brainstorming continues.*
December	(F) Manufacturers work on samples; price bids are submitted. (H) *Dollars, SKUs and deliveries broken down.*
January	(F) Overseas trip; finalize vendors, prices, deliveries. (H) *Colors decided.*
February	(F) Vendor orders piece goods and trims. (H) *Final line planner set; price and color information sent overseas.*
March	(F) Countersamples are sent from the manufacturer; patterns and specs are final. (H) *Manufacturers work on samples; price bids are submitted.*
April	(F) Piece goods and trims arrive; production begins. Line goes on sale. (H) *Overseas trip; finalize vendors, prices, deliveries.*
May	(F) Production completed; shipped to warehouse. (H) *Vendor orders piece goods and trims.*
June	(F) Goods arrive at warehouse. (H) *Countersamples are sent from the manufacturer; patterns and specs are final.*
July	(F) Merchandise is finally shipped to the stores. (H) *See July above.*

14-2 Fall line development calendar with holiday line development slotted in.

Hey, this is getting complicated! But we are not done yet! The spring line is going to overlap both fall and holiday. They keep overlapping all year (Figure 14-3).

Fall Line Development
Holiday Line Development
Spring Line Development

July	(F) First brainstorming, first ideas.
	(H) *Piece goods and trims arrive; production begins. Line goes on sale.*
	(S) *Overseas trip; finalize vendors, prices, deliveries.*
August	(F) Brainstorming continues.
	(H) *Production completed; shipped to warehouse.*
	(S) *Vendor orders piece goods and trims.*
September	(F) Dollars, SKUs and deliveries broken down.
	(H) *Goods arrive at warehouse.*
	(S) *Countersamples are sent from the manufacturer; patterns and specs are final.*
October	(F) Colors decided.
	(H) *Merchandise is finally shipped to the stores. Brainstorming next Holiday.*
	(S) *Piece goods and trims arrive; production begins. Line goes on sale.*
November	(F) Final line planner set; price and color information sent overseas.
	(H) *Brainstorming continues.*
	(S) *Production completed; shipped to warehouse.*
December	(F) Manufacturers work on samples; price bids are submitted.
	(H) *Dollars, SKUs and deliveries broken down.*
	(S) *Goods arrive at warehouse.*
January	(F) Overseas trip; finalize vendors, prices, deliveries.
	(H) *Colors decided.*
	(S) *Merchandise is finally shipped to the stores.*
→	**START HERE FOR SPRING** (S) *Brainstorming next Spring.*
February	(F) Vendor orders piece goods and trims.
	(H) *Final line planner set; price and color information sent overseas.*
	(S) *Brainstorming continues.*
March	(F) Countersamples are sent from the manufacturer; patterns and specs are final.
	(H) *Manufacturers work on samples; price bids are submitted.*
	(S) *Dollars, SKUs and deliveries broken down.*
April	(F) Piece goods and trims arrive; production begins. Line goes on sale.
	(H) *Overseas trip; finalize vendors, prices, deliveries.*
	(S) *Colors decided.*
May	(F) Production completed; shipped to warehouse.
	(H) *Vendor orders piece goods and trims.*
	(S) *Final line planner set; price and color information sent overseas.*
June	(F) Goods arrive at warehouse.
	(H) *Countersamples are sent from the manufacturer; patterns and specs are final.*
	(S) *Manufacturers work on samples; price bids are submitted.*
July	(F) Merchandise is finally shipped to the stores.
	(H) *See July above.*
	(S) *See July above.*

14-3 Fall line development calendar with both holiday and spring line development slotted in.

Take, as an example, the month of December. In this month alone,

- For fall, you will be evaluating the price bids as they come back from the manufacturers on the new styles;
- For holiday, you will be taking your design ideas and breaking them into a line, by style, price, and so forth;
- For spring, you have this spring's line arriving at the warehouse, ready to be shipped to the stores. For next spring (to follow the holiday line above), you are just 30 days away from starting your first ideas!

You can't be serious! Yes, we are—and now you really know why they call it "work"! Every day you will find yourself addressing some issue on each of the three seasons. As you're planning a new season, you've got buyers in to buy the current line, and you've got a stack of faxes saying that the line under production has just run into some technical problem!

The best way to visualize what this job is like is to picture an old TV novelty act where a man kept a whole row of dishes spinning on top of a row of poles. He would race back and forth to re-spin each plate just before it was about to drop to the ground (Figure 14-4). That's what your job will be like—running back and forth from season to season snatching each line from some unexpected disaster! (By the way, this cartoon captures the situation so perfectly that we've found it displayed in the offices of several product managers!)

Oh, and just to make it even more vivid, remember that many ready-to-wear companies have five lines a year, not three. Picture how many plates you'll have to keep spinning for that!

14-4 Running back and forth from season to season snatching each line from some unexpected disaster!

SHORTENING LEAD TIMES

Doing this process in less time is everyone's goal. Great, let's just spin those plates even faster! In the calendar above it takes 13 months from idea to final sale. So you can imagine that finding a way to do all this in less time has become a hot topic!

Here's the ideal situation: On Thursday, a retailer sells one piece of a blue jumper size 10. On Friday the blue size 10 replacement jumper is shipped back into stock. If this were possible, it would be hard for a buyer to guess wrong when he or she was ordering!

Here's the opposite scenario: A complicated item in a complicated fabric is being custom-woven and custom-sewn for the store. A plaid jumper made from yarn-dyed cotton twill from China could take nine months or more from the time it is ordered by the buyer and the time it hits the selling floor. The further in advance you have to buy, the more likely customers might not want that item any more by the time you finally get it!

So everyone in the process is looking for a way to order and receive merchandise in as short a time as possible. It's quite tricky, but here are several successful techniques.

- *Trigger dates.* Making each individual styling decision at the last possible moment to allow for more selling information to be factored into that specific decision. For example, 180 days in advance of shipment, commit to fabric construction; 150 days in advance of shipment, commit to fabric color; 120 days in advance of shipment, commit to garment styling; and so forth.

- *Local production.* Cut the shipping times. Use of fabric from China that is shipped (30 days) to Sri Lanka, where garments are sewn and then shipped (60 more days) to the United States means that 90 days are spent just for transportation. Instead, you could use U.S. fabric and U.S. sewing and gain most of the 90 days back.

- *Quick response.* Technique of linking all parties by computer so that vital information is passed automatically, rather than waiting for someone to remember to send it. As a result, no party waits even one day.

When many of these techniques are joined and the process is clearly understood and agreed upon by all parties, the time frame can be shortened dramatically. We've even heard of start-to-finish in six weeks! This is called "speed sourcing," but just leave it to the seasoned pros right now—it is difficult. (The Limited is famous for being able to produce and ship merchandise out of the Orient in a matter of days! The advantage for them? To replenish inventories as soon as they discover what customers are starting to buy.)

In Unit 1 we learned that fashion is founded on an understanding of the customer, customer segmentation, and the spectrum of stores. In Unit 2 we saw what it takes to actually make a garment. Now, in Unit 3, we're going to look at the rest of the business tools that you will need to find success.

UNIT THREE

3

TECHNOLOGY, POLITICS, AND GEOGRAPHY: WHERE IN THE WORLD IS ALL THIS GOING?

CHAPTER FIFTEEN

APPAREL GOES ON-LINE

In Unit 2 you learned the step-by-step process used to produce a garment. Surely this is enough to know, right? Well, not exactly. To make this work on a commercial scale and at appropriate pricing, you need a few more skills.

In Unit 1 we learned that fashion is founded on an understanding of the customer, customer segmentation, and the spectrum of stores. In Unit 2 we saw what it takes to actually make a garment. Now in Unit 3, we're going to look at the rest of the business tools that you will need to find success:

- How technological innovations are making radical (good!) changes in the industry
- How government rules and regulations continue to influence what you can make and where you can have things made
- Where you'll need to travel to produce affordable clothing
- Whether you can still have some garments made here in the United States

Yes, there's lots more to this business than just design! Beautiful designs don't make you successful. Well-executed and well-priced garments that sell, do.

There's No Getting Around It: Computer Skills Are Critical

Today's fashion world has become an extension of the computer world, like just about every other business. If you are pursuing a career in retail, all your budgets and open-to-buy calculations will be computerized. Even the wholesale world is wired today. Most communication in the industry is via e-mail, and, increasingly, more production processes are computer controlled, as we will see in this chapter.

One of the most exciting developments has been the computerization of design and product development. These areas have exploded in technological improvement in just the past couple of years. Students who are serious about careers in these areas should learn computer skills now. They will mean the difference between getting and not getting a job.

The computer is the tool in the global marketplace that connects two competitive worlds—design and business. The computer has the capacity to relate, exchange, and agree on answers in design, manufacturing, and pricing faster and more economically than ever before. Technology now manages all three areas in wholesale (and the equivalent areas in private label):

- Design
- Production/manufacturing
- Marketing and sales

and it is becoming an affordable tool for companies of all sizes.

It is true that for years many designers resisted the move to computer designing and sketching. That is, until they got the hang of it. Systems makers

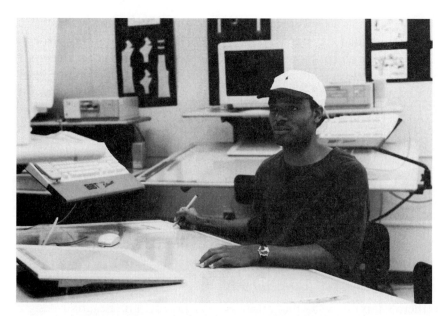

Student Jonathan Grimes working with the Gerber system.

were sensitive to this resistance and have created programs to be more "designer friendly." Now designing might remind you of the hassles encountered when learning to drive a car. Once you mastered it, you couldn't imagine *not* driving. Today, well-honed computer skills are a must for product developers and designers.

It is also true that, for many years, only the most financially sound companies could afford using the systems. Not only did companies have to buy the equipment but they had to train their staff on how to use the systems and change all the support procedures/systems because of these system changes.

Moving into the 21st century, the system makers and technology companies have made significant strides. Now apparel companies of all sizes can benefit from the advantages of computer aided design (CAD) and manufacturing.

This chapter will first discuss what the computer does, and then it will address some of the types of systems and programs available for product development. The computer handles many of the following tasks: Design, Sourcing, Production/manufacturing, Marketing and sales, which are linked and tracked by what is called **connectivity**.

At times it can get quite technical, but some of the downright amazing things that these systems can accomplish are described in the next three sections.

Connectivity
Electronic communication among computers, machinery, business operations, and people.

Technology for Design

- A huge library of prints, patterns, trims, buttons, and styles is stored in the computer. Do you need to see how your tunic sweater would look if it was done in a jacquard instead of a solid color? Push a button! (Figure 15-1).

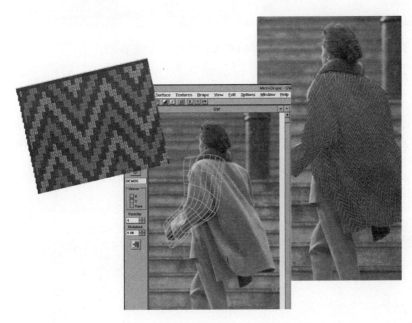

Figure 15-1 Jacquard pattern is "placed" on the solid sweater so that the designer can see what it will look like.

- Do you want to see how a patterned fabric will "drape" on a gathered skirt silhouette? The computer will make a three-dimensional image for you.
- Do you want to select different colors for your range of T-shirts? Some of these machines store 16 *million* individual colors! (Figure 15-2).

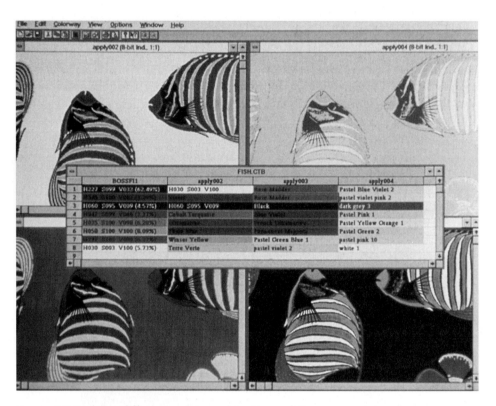

FIGURE 15-2 Four different color combinations of the same print.

Sweater Graph
A drawing on graph paper using each box to represent the color and style of *each stitch* of a knitted item such as a sweater.

- Do you want to design a new fabric for your collection? You can simulate different weaves, knits, and jacquards. You can automatically **sweater graph** patterns. You can print your newly created print design right on a sample fabric and then have a sample made up (Figure 15-3). You can also transmit your new print design directly to the fabric mill for bulk production.

FIGURE 15-3 Scanning and printing fabrics.

- You can "draw" right on the computer screen with a cordless light pen.
- You can cost out each item with a built-in cost sheet calculator, using the product data management programs we talked about in Chapter 10. You can do a "what if" check to see what a change in the design will do to the price. (Change the buttons? Change the length? Change the fabric? The computer recalculates the cost for you!) (Figure 15-4).

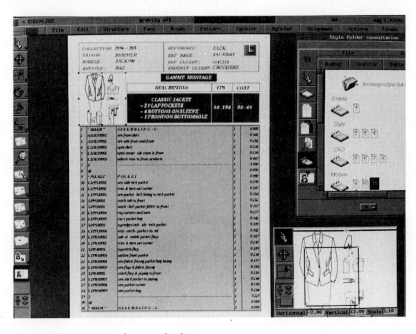

FIGURE 15-4 Cost sheet calculator.

- Arrange all your sketches into work boards without resketching. You can also make final presentation boards, send them by modem to the sales force, who can preview them with key customers, and send back their reaction! You can send the completed collection on CD-ROM for customers to view in their own offices (Figures 15-5, 15-6).

FIGURE 15-5 Work boards can be assembled automatically.

Figure 15-6 Presentation boards showing alternative color combinations.

IN GREATER DEPTH

COMPUTER AIDED DESIGN

Here's a brief background on computer aided design (CAD) and how these powerful systems control a paperless world in textile and garment design and manufacturing.

In the 1970s CAD emerged with a focus on drafting and technical functions emphasizing the following:

- Patternmaking
- Grading
- Marker making

The initial goal was to support manufacturing. Often you will also hear the phrase CAM systems, which is the acronym for computer aided manufacturing. Sometimes this term is substituted or used interchangeably with CAD, but CAD is to design what CAM is to manufacturing.

Today product developers and designers can conceptualize, create, and modify with the click of a button. This means the design team can change a collection in many ways without wasting paints, paper, or other materials. With fewer expenses, the costs of the products are less, and this lower cost is then passed on to the retail consumer.

Today's CAD software is available as either "industrial," which means it is software that focuses on a specific industry, or "commercial." Commercial programs, also known as "off the shelf" applications, are designed for multiple industries to use and are marketed to both business and retail consumers.

MICHAEL McKEITHAN

We met Michael, the CAD designer for Tommy Hilfiger, in Chapter 8....

On Maximizing CAD

It's not about just simply "working" the CAD machine. You can learn the functions in a week. No, it's what you *bring* to the machine, what else you know. You need an understanding of knitting, weaving, and printing techniques. If you don't know how cloth gets printed in a factory, you won't be able to get the most out of CAD.

It's also a matter of trial and error. When I first started working with "repeats," some designs were not always apparent. It took a month to figure it out but then one day the lights went on and "Boom!" I was flying!

I love the challenge of CAD. It's like accomplishing the impossible: To take something really difficult and render it so it looks like an *actual knitdown*. And then to color it and make it look, not just fashionable, but *salable*! That takes longer, but it's always worth it!

TECHNOLOGY FOR SOURCING

In Chapter 7 you learned the importance of research. Here you can see how those research skills are applied. Product development specialists rely heavily on the computer to source the following:

- Fabrics
- Findings
- Manufacturers
- Trade shows

The Internet will probably be one of your best tools for sourcing information. Using many websites identified in Chapter 7 you will be able to gather competitive data about the services, materials, suppliers, and manufacturers in the marketplace.

In addition, e-mail will let you communicate effectively with these sources around the global market to discuss your product needs. Travelling sourcers can keep on-line logs of their factory evaluations that then can be accessed back home by the merchandising and production teams.

TECHNOLOGY FOR PRODUCTION/MANUFACTURING

Here are a few highlights of the current technology for the highly technical areas of production and manufacturing. Enormous benefits can be seen as the computer

- Makes patterns, grades patterns, and makes markers;
- Makes modifications, including updating lines from season to season;
- Assists the production staff to monitor budget requirements and deadlines.

Patternmaking and Grading

Previously used patterns can form a quick basis for new patterns. These can be easily stored, retrieved, and modified on the screen. Or, for experienced patternmakers who are only comfortable working with full-sized patterns, there is a system that accommodates them (Figure 15-7).

Figure 15-7 Patternmaking on screen.

Some systems can call upon a database for the various body shapes of different population groups. Grading from size to size can be automatic, based on previously decided fit distinctions between sizes (Figure 15-8). Automatic adjustments for seam allowances and shrinkage can be made.

FIGURE 15-8 Grading on screen.

Marker Making

This is where it starts getting a little scary. The marker maker can be programmed to find a way to only allow x % of the fabric to be wasted, and it will work all night (by itself) until it finds the right layout of pattern pieces! (Figure 15-9).

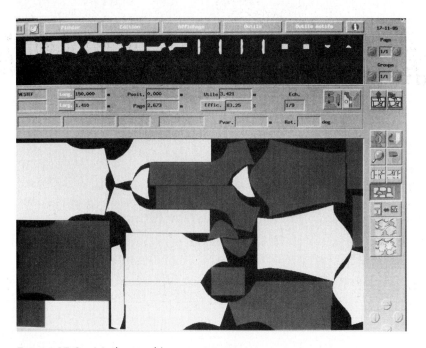

FIGURE 15-9 Marker making on screen.

Spreading

Remember, spreading is when layers of fabric are laid out on the cutting table. Not only do these automated machines lay out to the exactly right length (they receive the information on-line from the marker maker machine), they can also handle the really difficult fabrics like stretch knits and tubular knits in such a way that the fabrics don't get stretched during the process (Figure 15-10).

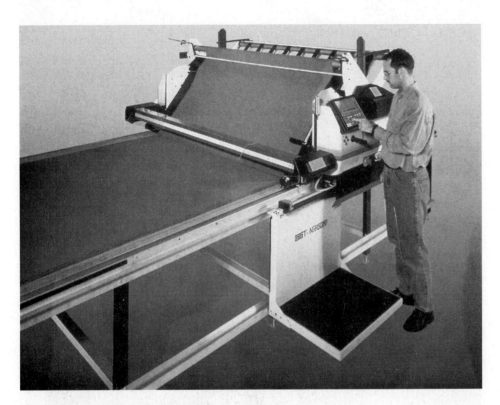

FIGURE **15-10** Computerized fabric spreading.

Cutting

In a nutshell, the fabric layers are held down with a vacuum system, and then the already-programmed cutter cuts them together (Figure 15-11). But how's this for amazing? The cutting knife knows when to sharpen itself, and some specialized machines use a camera to view a single layer of plaid-patterned fabric, sees the irregularities in that particular section of cloth, and adjusts the cut so that when the garment is sewn together, all the plaid pieces will match (Figure 15-12)!

These cutters can also be used on some plastics and leathers. Laser cutters can be used to seal the cut edges. To keep all the cut pieces straight, there is an automatic marking machine that puts an adhesive identifying stamp on each stack of pieces. The technology is so advanced in some systems that computerized cuts can be made on one custom piece or up to 200-ply at one time.

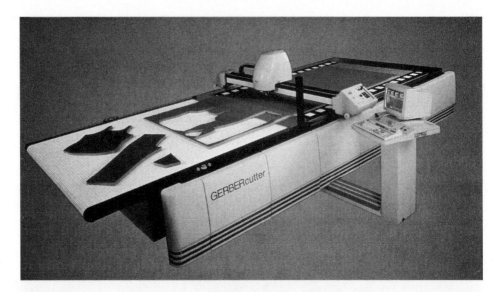

FIGURE 15-11 Cutting multiple fabric layers by computer.

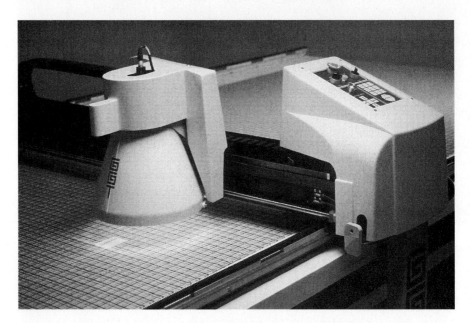

FIGURE 15-12 Specialized cutting machine "reads" irregularities in the plaid fabric and adjusts the cut so that the pattern pieces will match.

Sewing

Sewing is still the weakest link in the automation process, although technology is making significant strides. It still is difficult to handle the flimsy and floppy individual pieces of cloth in a machine. That is why, even with all the automation listed above, imports from markets with low labor costs continue to take more of the market. Yes, there are automatic pocket applicators and collar makers, but this is a drop in the bucket as you look at all the steps needed to construct a garment.

Factory Flow Systems

One of the few advances that has been made on the sewing floor is a system to *move* goods around the factory automatically. Hanging overhead, partially completed garments move from operator to operator to finisher with greater ease (Figure 15-13). But if markets with high labor costs such as the United States think this system will be enough to make them competitive . . . be forewarned: We have seen this technology in places as unlikely as Singapore and Egypt!

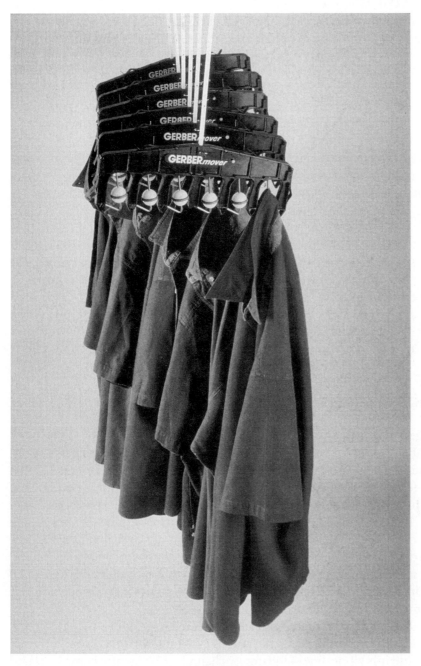

FIGURE 15-13 Garment moving system in the factory.

TECHNOLOGY FOR MARKETING AND SALES

Marketing and sales staffs can now work with top quality visual selling materials generated by the computer such as the following:

- Presentation boards
- On-line catalogs and websites
- Three-dimensional simulation of garments (which is an exciting 21st century selling tool!)
- Collateral materials including sales catalogs, press kits, annual reports, sales training materials and videos, and price tags and labels along with concepts of packaging design.

EDI and QR

In addition, information systems are also being used to link garment makers directly with their partners. Electronic data interchange (EDI) has connected wholesalers with retailers and fabric suppliers with wholesalers. This connectivity is among several companies, not just within one. Quite simply, electronic data interchange allows the partners in garment making and selling to get more complete and timely information directly from each other's computers. For example, wholesalers can get a steady stream of selling information from retailers. With this information they can quickly make up the needed replacement goods—for clothes that are *actually selling*. Orders can also be transmitted electronically, in some cases automatically, without having to wait for an overbusy buyer.

This entire setup has been dubbed "quick response" or QR. As all the players get bigger, this technology becomes critical to ensure that the supply lines keep the appropriate merchandise flowing into stores.

PUTTING IT ALL TOGETHER: CONNECTIVITY

As changes and decisions are made within a wholesale company or within a private label product development organization, the computer links or connects the design, production, and sales/marketing departments. Often changes to a line are made up until the time of production—or even the night before the season's sales launch. With so many different tasks being handled, the computer becomes the communication source. It serves as a clearinghouse where ideas, changes, and decisions are exchanged, reworked, and tested. With on-line access, out-of-date written inventory records are no longer a salesperson's nightmare. Financially, costs are contained because the changes in design, manufacturing, marketing, and sales can happen without wasting materials or incurring unnecessary labor costs.

Actually this technological thread of connectivity is the biggest breakthrough of all. Everyone along the way is working with the same information, because it is all on-line. Updates or changes are instantly communicated to everyone. The head office can check on a particular fashion group to see

where it is in the design and production cycle. (Does this mean no one will ever be late again? We doubt it....) These systems are also getting easier. They are personal computer-(PC) or Macintosh-(MAC) based and are often programmed with software that makes them e-mail compatible. Along the way, designers, patternmakers, or cutters can attach comments for someone down the production line. One of our favorite features is that a patternmaker in Los Angeles can attach a visual video explanation in Spanish for the production manager in Mexico!

This is only a *brief* overview of what computers can do for you. We hope this quick techno-snapshot has you excited! You probably realize now that the computer can make your job easier! But we are also realistic. Along with excitement, we assume you are probably feeling some frustration, wondering the following:

- How do I learn these skills?
- What specific computer program(s) should I be studying?

These are valid questions. First, let's look more closely at two specifics:

- Computer systems (called platforms)
- Computer software programs.

You will have multiple choices. Understand this at the outset: No one system or program is better than another. Generally each platform and program have features or benefits that contribute to the overall process. The platforms and programs chosen by a company will be the ones that best suit their corporate needs.

COMPUTER SYSTEMS/PLATFORMS

First, you probably wonder which computer system or **platform** you should learn. Simply put, the choices are PC and MAC. Rather than spend hours debating which is better, we are going to give you the only reliable answer. Learn how to use both! Most forward thinking firms utilize both systems along with many different software programs. Actually the *differences* between the systems are now minimal, and being cross-trained enhances your value in the job market!

> **Platform**
> One of the two different operating systems that are used by computers: PC or MAC.

Design. Drawing programs are used that are compatible with both PC and MAC systems.

Production/Manufacturing. Database or spreadsheet-style software is used to display vector-drawing images of garments and to maintain the accounting functions and production flow of a collection. These programs are compatible with both PC and MAC systems.

Marketing and sales. Software programs are used that are compatible with both PC and MAC systems to develop professional materials such as presentation boards, catalogs, or web pages.

Both computer platforms can effectively handle the tasks for product development. In the article "For Best Color, Designer Mixes Three Platforms," Erik Sherman states, "Like many corporations, Calvin Klein's choice of computer platforms is driven by its choice of applications software. Each department has selected the applications it needs and then picked the appropriate platform."[1] Sherman explains that the design department uses Adobe Photoshop, QuarkXpress, and Designer by Micrografx on the MAC platforms. The production staff works with the product data management program offered by Gerber Garment Technology on a PC platform.

COMPUTER SOFTWARE PROGRAMS

Software programs, also called applications, are the tools that run the computer systems. In the marketplace today, there are already many programs. We can only imagine that the number of choices will continue to grow. Software programs for design are generally divided into two categories:

- Industry-driven programs
- Commercial, "off the shelf," and "third party" software programs.

Industry-Driven Systems and Software Programs

The original CAD programs were only designed for specific hardware systems and were sold directly for specific industry needs. The first users were automotive, interior, industrial, and the largest textile and garment industry firms. Each industry had systems tailor-made to meet specific product design needs. These programs are called "turnkey" systems. Just as the word turnkey denotes, by simply turning on the system, the programs are ready to go. The computer hardware is already loaded with integrated software packages that are preprogrammed. These programs design, produce, and operate the "production end of designing." These are state-of-the-art systems with the latest and most highly defined hardware components and programs. Leading industry-driven companies are Gerber Garment Technology (GGT) and Lectra, and excellent package programs are also available from Monarch or Colorado.

Advantages:

- Many tasks can be accomplished more quickly
- Changes can be accommodated more easily, up to the last minute. And everyone who is on-line will be aware of these changes
- More uniform quality can be achieved, especially in an area like cutting
- Smaller, customized orders of many more styles can be handled more efficiently
- Time is saved all along the design and production process, resulting in cost savings
- Most remarkable of all, each step can be completed in a different location. Design can be in New York, patternmaking in Los Angeles, and cutting and sewing in Mexico! All participants are electronically

linked with the latest information. Designs, patterns, and markers can be transmitted by modem or a direct line among all locations

- Excellent training and customer service programs are offered.

Disadvantages:

- High costs
- Specific and highly defined training needed
- Skilled support representatives needed to troubleshoot problems.

Commercial "Off the Shelf" and "Third Party" Programs

Recognizing the growth of design on computers, many companies have developed programs that are easy to acquire and use.

Advantages:

- Purchase is easy nationwide
- Many key tools and design features needed by a fashion designer or product developer are incorporated
- Installation on a home computer is possible as long as it has adequate random access memory (RAM) and hardware capability
- Large industry system makers have linked with the commercial software companies and identified some programs as "third party," which means that although the industrial firm was not the original software design house, they selected a commercial program as one that fits best with their industry platforms and even enhances the industry software
- Program training is easy to get
- Cost is much lower. In fact, some clip art programs are royalty-free and are sold on CD.

Disadvantages:

- Firms don't have a "custom" design feature for corporate needs
- Programs are divided by category—drawing, image editing, clip art—and are rarely integrated
- Programs do not have manufacturing features, such as patternmaking
- Programs do not have the connectivity feature
- Strong support training programs specifically for fashion design tend not to be available.

Commercial, "Off the Shelf" Programs
Software programs that are easily bought in office supply stores or computer chain stores.

"Third Party" Programs
Software program that has been selected by another company for use with its own systems and programs.

Just as it is important for you to know both platforms, it is helpful to know the basic skills in *both* industry-driven software programs and commercial, "off the shelf," and "third party" software programs. Today many schools offer training on both industry and commercial programs. It simply makes sense to train with both. This way you can see the common ground between them as well as the finely tuned differences.

We must state, however, that these programs are changing daily! One way to keep up on the latest improvements is to use your research skills. Review trade publications and gather information from the local library on com-

puter updates. We recommend regular trips to the virtual library where you can get up-to-the-minute information. Often you can download demonstration disks from company websites. This is a great way to try different programs using your personal computer.

Some companies that we recommend you investigate follow.

These are a few of the top industry firms for garment design and manufacturing systems. Each has many common features, which designers and manufacturers choose based on the unique features needed for their own operation. Here are some of their *special* qualities:

INDUSTRY DESIGNED PROGRAMS

COMPANY / PROGRAM NAME	WEBSITE	GENERAL COMMENTS
Gerber Garment Technology Inc. (GGT)	http://www.GGT.com	Complete software package for product development for use with PC systems.
Lectra Systèmes	http://www.lectra.com	A firm based in France that customizes hardware and software based on individual company needs. Generally used with PC systems.
Monarch Design Systems	http://www.monarchcad.com/	Leading firm for knit and woven textile designs capable of working with PC and MAC platforms.
Colorado system for Color'In distributed in the United States by AVL Looms	http://www.colorado-int.com	Complete computerized textile industry programs including designing fabric, colorways, and weaving/knitting solutions. Primarily uses a MAC platform.
Image Info	http://www.imageinfo.com	Digital imaging studio that applies these images to proprietary applications for fashion manufacturers and retailers.

Gerber

The forerunner in factory automation and machinery for product development, Gerber was established in 1968 featuring systems and computer software programs that have set the standard for garment design.

The featured product for the apparel industry is an integrated program called GERBERsuite that provides an easy flow of information among applications. This program includes a key design software program called Artworks Studio. Artworks supports product development from its early stages with drawing, colors, and draping for textiles. Production and manufacturing are supported by the GERBERsuite system that packages AccuMark, MicroMark, and UltraMark for such tasks as patternmaking, grading, and marker making. Highly defined equipment such as the Gerber plotters, cutters, and labelers support the manufacturing process. Maintaining accurate records and coordinating the production and merchandising functions are handled by product data management, which was reviewed in Chapter 10. Marketing and sales functions are supported by Artworks, which is used to develop merchandising tools used by the marketing and sales staffs. This application effectively customizes sales support materials such as catalogs, tags, and presentation boards.

One of the most impressive aspects of Gerber systems happens behind the scenes of the hardware and software programs. This firm is committed to an extensive support network of training, problem-solving, and updating that is staffed in more than 100 countries globally.

Lectra

Established in 1973, Lectra Systèmes stands side-by-side with Gerber as leaders in CAD/CAM systems for the apparel industry.

Like its counterpart, Lectra also supports hardware and software programs for other product fields such as textiles, leather, footwear, and luggage, to name just a few. This international firm headquartered in France provides hardware systems, software packages, and computer networks for use with a PC, and they also will work with the Unix operating systems for patternmaking and Windows operating systems for product management. The programs, which can stand alone, are all interactive and feature a strong tracking and linkage program. Lectra also builds industry workstations and has designed their software programs to be used with personal computers.

Monarch

Monarch Design Systems, a division of the Monarch Knitting Machinery Corp. (established more than 70 years ago), features software programs addressing the niche market for the design, development, manufacturing, and production of specialty textiles. The products they offer, such as Plaids & Stripes, FashionFindings, and ColorCharter for textile designs and colors, are driven by off-the-shelf applications such as Adobe Photoshop, Adobe Illustrator, and Fractal Painter for textile and fashion design. Painter, for example, uses custom brushes and colors to develop traditional images. By using commercial programs such as Photoshop for designing textile prints and offering a supportive hot line system, users find Monarch systems a strong component for creating quality designs quickly and cost effectively.

Colorado

Colorado, a firm that is more than 20 years old, features a full range of software for textile printing, coloring, knitting, and weaving. The Colorado system assists product development teams with a complete software package from design concept through marketing and sales. Program applications include specialty weaving and knitting software, printing and coloring software, texture mapping software, along with the design software for styles. By using the style software, designs can be laid out in story board/work board format that is part of the user-friendly approach featured in Color'In. This software program features an application called Prism that enables a designer to create color ranges and prepare custom Pantone textile files. It also interfaces with ColorMode, which features draping techniques. Beyond the design software Colorado programs integrate with other leading software applications to facilitate manufacturing and production needs.

Image Info (Figures 15-14 and 15-15)

Image Info, based in New York, supplies their program to major wholesalers and is starting to work with retail product developers as well. In their program, pictures or CADs of styles are scanned and imported into the database. In fact, they have a whole digital photography studio on West 36th Street in New York's garment district. Images can then be manipulated and organized so that assortments can be planned, costing projected, and line sheets printed. For presentations to buyers, CD-ROM slide shows and interactive presentations are made. (Products can even be shown in three di-

FIGURE 15-14 Image Info screen showing a "look book" of various styles that were digitally photographed.

FIGURE 15-15 Image Info screen containing all the detailed information a product manager will need along with a scanned photograph of the garment being modeled.

mensions!) Buyers can then enter their orders into the program and check them against their open-to-buy budgets. Finally, after order entry, all the assembled statistics can be sorted and evaluated by management or used by the product development staff as a basis for the next season's development.

This overview should give you a sense of how the *industrial* firms have concentrated on design and product development. What you are going to review next is a list of *commercial* programs that not only satisfy needs for apparel designs but are also excellent vehicles for all industries incorporating aspects of graphic design and imaging.

Using both PC and MAC systems with multiple software programs is not unusual for many apparel firms. Even companies that say they favor one system platform tend to use both. From *MacWorld Italia:* "From textiles to garments, footwear and even furnishing fabrics, the Mac is being used for creative work that used to be strictly manual. The sketch, which is the very soul of a creative design, takes shape on a monitor. Standard programs such as Macromedia FreeHand and Adobe Illustrator and Photoshop make a fundamental contribution to the creation of the design; then dedicated software steps in for the next stage, the creation of the actual collection. Time means productivity, and economy is the primary consideration in choosing a given process."[2] The article continues to note other changes that computers are making in the garment industry. "Meanwhile, some big fashion firms remain reluctant to use computers of any kind, but observers say this attitude will not last. Yves Saint Laurent, for example, recently decided to computerize the entire company, with Macs for graphics and Windows for databases, on-line catalogs and business-to-business communication."[3]

COMPANY / PROGRAM NAME	WEBSITE	GENERAL COMMENTS
Microsoft Windows	http://www.microsoft.com	Application software that works with the computer operating systems to manage word processing, databases, and spreadsheet programs for use on both PC and MAC platforms.
CorelDRAW 8! Corel Corp.	http://www.corel.com	Drawing, illustration, vector graphics for use on both PC and MAC platforms.
Adobe Systems Inc.	http://www.adobe.com	Drawing and illustration programs such as Illustrator and PhotoShop for use on both PC and MAC platforms. *Note:* This is among the most user-friendly programs for fashion designers.
MetaCreations	http://www.Metacreations.com	Natural media texturing and looks are provided for use on both PC and MAC platforms.
QuarkXPress	http://www.quark.com	Desktop publishing and layout program for both PC and MAC platforms that is often used in marketing/sales.
Designer 7 by MicroGraphix	http://micrografx.com	Strong drawing, technical illustration, and graphic design tools for both PC and MAC platforms. *Note:* Extensive clip art and color selection for fashion designers!

IF THIS IS WHERE WE ARE, CAN THERE BE MORE IN THE FUTURE?

You bet! Many things that were deemed impossible are now commonplace. The sewing part of the process is the weakest link at present. But you can be sure that some clever individual will figure that out. Is that clever individual *you*? The trend among the industry systems leaders, Gerber and Lectra, seems to be toward more connectivity and more compatibility and user-friendliness with commercial "third party" systems. Yes, technological

improvements seem to arise daily. With all these improvements, each day it becomes easier for you to work on-line in the global marketplace.

This chapter has explained how you will be working in your office. However, if you are actually going to be developing garments for either a wholesaler or a private label retailer, you will also have to get out of the office occasionally. You will need to get onto that great big *global* playing field, as you will see in Chapter 16.

Endnotes

1. Erik Sherman, "For Best Color, Designer Mixes Three Platforms," *Macweek*, August 3, 1998.
2. Moreno Soppelsa, Tony Stanley, "Macs Lead Fashion Industry," *Macworld Italia*, March 9, 1999.
3. Ibid.

CHAPTER SIXTEEN

THE POLITICS OF APPAREL IMPORTING: REWARDS AND PUNISHMENTS

In Unit 2 you learned how an apparel wholesaler or private label product developer assembles a fashion line. There are many steps from the concept to the selling of the line. In Chapter 15 you saw that technological advances are helping to make design, styling, and even garment production easier processes.

There is still this question: Where is the best place to have the line manufactured? In Chapter 17, we will discuss some of the pros and cons of various regions in the world. However, before you can strike out and locate factories, there is much you must know about the U.S. government's role in this process. It is more important than you might think: If you happen to break the U.S. laws of importation, you could actually go to jail!

THE U.S. GOVERNMENT HAS SOMETHING TO SAY ABOUT YOUR CLOTHES!

Textiles and apparel-making are important to the United States, as they are to almost every country. Unlike a product such as an airplane, which is made

in only a few countries, apparel is made almost everywhere. There are many dollars and jobs at stake. In fact, it is estimated that 23.6 million people work in textile and garment factories worldwide.[1]

Consider how important apparel-making is to a developing country like Bangladesh (located east of India). Bangladesh has a population of 123 million people crowded into an area the size of Iowa. Its primary activity is food production for its own people, but it often suffers huge losses owing to typhoons that flood much of the low-lying land. The entire sum of all products and services (gross domestic product) produced in Bangladesh in 1998 was $167 billion. Of that amount almost 10% came from its apparel exports to the United States alone. To further clarify the importance of this business to Bangladesh, in the same period it was forced to import $1 billion worth of rice and wheat because of crop failure. In other words, if Bangladesh had not had the opportunity to sell garments to the United States, thousands of people would probably have starved!

Because of a long history of strong lobbies, the textile and apparel industries are among the most protected in the United States. U.S. makers want to limit the amount of imports, and they want to tax them so that they will be less competitive in price. Now, in fairness to all, let's quickly point out that other countries do exactly the same. Europe and Canada have similar setups, and some Third World countries have been so restrictive on all imports that their people can only buy locally made goods.

With all this hassle, why go to foreign countries to have garments made? There are still a few compelling reasons:

- Labor costs can be so much less in some countries that even with all the duties, their products are still cheaper

- Some machinery is available only overseas (for example, **full-fashioned** knitwear machinery). Also, **hand work** is prohibitive if done in a developed country, but it is still affordable in the Philippines, India, and China, among others

- Smaller quantities and more variations are easier to produce, perhaps because so much is not automated in other countries. Also, we have found a more flexible attitude in other countries, more willingness to try something new.

Full-Fashioned Knitwear
A knitted fabric that is shaped during the knitting process.

Hand Work
Knitwork or needlework, such as hand embroidery, done by one artisan on one garment at a time.

U.S. RULES AND REGULATIONS

To help the companies that still produce textiles and garments in the United States, the government wants to limit the amount of imports and put a tax (duty) on them to make them less competitive. We also reward some countries and penalize others, so it gets a bit complicated.

Duty

Also called a tariff, duty is the tax that the U.S. government applies to imported articles. It is collected by the Customs Service and goes to the U.S.

JULIA HUGHES

Julie is vice president of trade and government relations for the U.S. Association of Importers of Textiles and Apparel (USA ITA) based in Washington DC. She is a veteran of the government scene, having covered it for years at AMC.

On Moving from Protectionism to Globalization

When I started in Washington in the early 1980s, my job was pretty much "What's under quota and how much is left?" We were just reacting to a system that had been in place for over a decade. The mid-80s brought a "sea change." The domestic industry was pushing hard to limit imports, via legislation like the Jenkins bill. Lee Abraham, chairman of the AMC, had the vision to see that we needed a concerted counter-effort among retailers, overseas producers, and private label importers.

Up to this point, "our side" had never worked with Congress. One senator told us, "Where have you been? I have stacks of letters from unions and the domestic garment industry—where are your letters?" We lobbied, we initiated letter-writing campaigns. When we finally defeated the Jenkins bill, it was suddenly a whole different ballgame.

At a reception at the U.S. Embassy in Geneva during the GATT talks, the domestic industry representatives wouldn't talk to us or even shake our hands! They had never had to deal with someone who had another view! Now, we're substantively involved in all negotiations. We provided a lot of information for the NAFTA and Uruguay Round Talks, for example.

But I think the point is not "us versus them." We're a global industry that's linked. The same domestic manufacturers are now going offshore via NAFTA or 807 or they are trying to export U.S. goods. For the first time, they're running into protectionism in those other countries.

If we all work together globally, we can have the best opportunities. For example, the United States produces lots of cotton. What if there were some incentive given for anyone in the global industry to use U.S. cotton? Politics has kept us apart, but—exports, imports—they're really all becoming the same!

Ad Valorem
In proportion to the value; duties levied on imports according to their invoiced value.

First Cost
Actual cost paid to an overseas manufacturer before additional charges such as freight and duty.

government. Duties for apparel products are slowly decreasing; most items still fall between 14 and 20% **ad valorem**. If an importer paid his or her Hong Kong contractor $10.00 in Hong Kong for a cotton sweater, the duty on this item when it arrives in the United States would be 19% of the **first cost** ($10.00) or $1.90 (19% is the current duty rate for cotton sweaters). This is one more cost that must be calculated in the selling price.

DUTY RATES FOR POPULAR CATEGORIES OF APPAREL

Cotton knit tops, except T-shirts and tanks	20.5%
Cotton T-shirts and tanks	19.2%
Silk knit tops*	4.0%
Cotton slacks, trousers, shorts	14.8%
Cotton sweaters	19.0%
Ramie/cotton blend sweaters**	5.0%
Wool sweaters	16.6%
Cashmere sweaters	6.1%
Man-made fiber sweaters	33.3%
Cotton outerwear	16.5%
Cotton outerwear, coated with a water-resistant finish	6.1%
Leather outerwear	5.8%

*Because there is no domestic silk industry to protect, duties are low on silk items.

**Ramie is a low-quality linen fiber. The huge difference in duty rate for all-cotton sweaters explains why so many imported cotton sweaters are actually blends of ramie and cotton. In fact, the blended yarn is inferior to the 100% cotton yarn, but it brings the price down considerably.

Quota

Quota is a limit on a particular category of apparel that will be allowed to enter the United States from another country. These agreements are worked out country by country, so amounts vary widely. As of 1999, the United States has quota agreements with 58 countries.[2] A worldwide agreement on quotas was established in 1995 and is called the General Agreement on Tariffs and Trade (GATT). Countries that are members of the World Trade Organization (WTO) have agreed to eliminate all quota restraint levels by 2005. This will greatly benefit markets with low labor costs such as Pakistan and Bangladesh that have production capacity that is greater than the current quota levels allow in.

The wild card in this arrangement is China. China has still not been accepted as a member of the WTO. (To date, global politics are playing a deciding role in this ongoing negotiation.) Even if China is admitted to the WTO, many observers feel that there will be a separate slower phase-in period for China's exports to other nations. China's manufacturing capacity is so vast that it could overwhelm other producing countries if it were allowed

to export unrestricted quantities. Even with the current quotas, China exported $5.9 billion in textiles and apparel in one year to the United States.[3]

At times when there is too much demand for a particular category (for example, women's wool sweaters, men's cotton outerwear, and so forth), quota becomes "hot." In some countries it is legal for manufacturers who own quota (because they have shipped this category in the previous year) to sell the quota to another manufacturer who needs it to ship his or her orders. This price is purely what the market will bear, but we've seen it go as high as $4.00 to $5.00 per piece on superhot categories in Hong Kong. This cost is added to the cost of each garment, which means that eventually, the customer ends up paying it. (By the way, a $5.00 per piece quota charge in Hong Kong would mean that the customer has to pay as much as a $20.00 difference at retail, with absolutely no difference in the garment to show for it!)

When a quota category is filled from a particular country, all remaining shipments are **embargoed**. This is not a happy situation. It means that your precious jackets are sitting in a warehouse in Long Beach while you are paying the warehouse charge, the contractor has already gotten your money for the jackets, and Customs is telling you that even though today is September 15, you can't touch those jackets until January 1 of the next year when the new quota period opens ("But they're jackets! What do I do with jackets in spring?").

Country of Origin

Because of the quota allocations by country, manufacturers and importers have gotten creative in trying to find a way to have a garment come from one country (with lots of quota) even if it might be partially made somewhere else (where quota is tight). Fraudulent disregard for these laws gets you into jail, as we mentioned. For example, if garments are made in China, they will not be allowed to enter the United States if the quota category is already filled for that year. An unscrupulous importer might ship the completed garments to a country with quota still available, for example Panama. In Panama, the "Made in China" labels are replaced with "Made in Panama" labels. The importer then ships them to the United States, representing them as garments whose country of origin is Panama. This is called **transshipping**, and it is illegal and punishable.

Rules have become so complicated that it is often hard to pinpoint the official country of origin. Generally, in most cases the country where the garment is assembled is deemed to be the country of origin.

Normal Trade Relations, Formerly Called "Most Favored Nation"

Almost all countries charge each other their standard duty rates regardless of whether there is full agreement on all political points. In some instances this is not the case. Unlike other countries, China has to be recertified by the United States every year. It's always a nailbiter, because if certification is not renewed, the duties (and thus costs) skyrocket. There are also some coun-

Embargoed
Stopping of all remaining shipments at port and refusal of entry until the new quota period opens.

Transshipping
An illegal trade practice in which merchandise made in one country is represented by the importer as being made in a different country.

tries that do not have **normal trade relations** status at all, so their products are penalized with much higher duties. These include Afghanistan and Vietnam. Still other countries have total trade embargoes imposed by the United States. No trade is allowed, for example, with North Korea and Cuba.

Normal Trade Relations
A status conferred by the U.S. government on most nations, calling for standard duties; the few countries that do not have this status, such as Vietnam, pay significantly higher duties.

Special Programs

Here is where we get into some of the "rewards." There are special agreements with some of our neighbors and closest political allies to give them a trade boost. Some of these follow.

Israel Free Trade Agreement

The United States and Israel signed the first free trade agreement in 1985. Duties were phased out over a 10-year period, and quota is open.

9802, Formerly Called 807

To qualify, the fabric must be of U.S. origin, and part of the manufacturing (often cutting) must be done in the United States. However, assembly then can be performed in the Caribbean or Central America. Duty is paid only on the value added in the other country, and there are special quota considerations as well. As of 1998, apparel imports from the Caribbean were worth about $3 billion.[4] However, since the establishment of NAFTA (see below), Mexican imports have been rewarded with even greater benefits than those from the Caribbean. As a result, there has been a movement to allow the Caribbean countries to enjoy the same advantages. They are seeking **parity**, an equal set of benefits. Of all the Caribbean countries, Jamaica has seen the largest declines.

Parity
Equality. The condition of being treated the same as someone else.

North American Free Trade Agreement

Enacted in 1994, the North American Free Trade Agreement (NAFTA) effectively ties the United States, Canada, and Mexico together as three special trading partners. Eventually goods will be able to move across these borders as if the whole area were one country. This change is being phased in with completion planned for 2004. By that time, all duties among these countries will be eliminated. There is one qualification, however: Apparel goods must meet the NAFTA rules of origin, which means they must be totally or mostly manufactured in North America. For example, merchandise that is made in a different country and is only partially completed in Mexico will not be given duty-free status.

The most significant restriction applies to the fabrics used in garments. Mexican factories will not be able to use fabrics from a non-NAFTA country such as China or Indonesia and still get preferred duty and quota treatment. Fabrics must come from Mexico, the United States, or Canada.

Nevertheless NAFTA will stimulate much more trade among its three member countries. In fact, Mexico has surpassed China as the nation with the largest total dollar value of imported clothing into the United States.[5] The U.S. textile producers favored NAFTA because it encourages the use of U.S.

fabrics for sewing in Mexico. In fact, 80% of the apparel made in Mexico for export to the United States is currently made from U.S. yarns and fabrics.[6] The large U.S. textile mills such as Burlington, Cone, and Guilford are all investigating the establishment of wholly owned or joint-venture fabric and garment production in Mexico. As a reverse benefit, Canada and Mexico have become the two largest markets for U.S. exports as well.[7]

African Growth and Opportunity Act

Another special trading agreement under consideration by the U.S. government is the African Growth and Opportunity Act (AGOA). It could potentially eliminate quota restraints on certain African nations such as Kenya, Mauritius, Tanzania, and Uganda. Its prognosis is uncertain at this time.

European Union

The ongoing integration of most of the countries of Europe is altering the international landscape of trade. Fifteen European countries now share common policies and work in economic and political cooperation. From the perspective of international trade, their individual country borders no longer exist. This integration started in small steps in the 1950s and has accelerated greatly in the past few years. Its population of 300 million is greater than that of the United States, and it represents 20% of world trade and world gross domestic product.

A single shared currency, the Euro, was introduced on January 1, 1999. It is already used by the European Central Bank and all capital markets in the member countries. By 2002, the individual national currencies will be withdrawn in favor of the Euro.

The European Union is an economic powerhouse to rival the United States. It acts as a single entity in its dealings with the WTO and was instrumental in changing the U.S. policy of import quotas, for example.

Marking

All garments that come into the United States must have the following permanently attached:

- Fiber content
- Country of origin
- Legal identification (a trademarked brand, a store name, a registration number)
- Care labeling.

Marking
Labeling requirements on garments.

These **markings**, in some cases required by the Federal Trade Commission, are mostly to help consumers know how to care for what they have bought and how to trace the maker in case of a problem.

Since 1997 a new system of international care symbols (pictograms) has also been allowed to specify washing and care instructions. For example, a triangle means bleach, a circle means dry clean, and so forth (Figure 16-1).

Clothing Care Symbol Guide

FIGURE 16-1 Clothing care symbols established by the Federal Trade Commission.

With the globalization of fashion motivating retailers such as Gap and Wal-Mart to expand overseas, these universally understood pictograms will eliminate the need to print care instructions in different languages.

So How Big Is the Imported Apparel Business?

One statistic says it all. In 1998, the total sum of all apparel imports shipped into the United States from all foreign countries was $48.2 billion at first cost (cost paid directly to overseas manufacturers)! To show how rapidly this is increasing, 1998 showed a whopping 12.5% increase over the year before.[8]

Quota category	Merchandise category	Imports in dozens[9]
338/9	Cotton knit tops	155,633,102
352	Cotton underwear	148,684,000
347/8	Cotton slacks and shorts	98,409,743
638/9	Man-made fiber knit tops	64,534,174

Certain categories of apparel tend to be the most commonly imported.

OK, so now you've done all your homework on the legal requirements involved in importing. (By the way, you can just imagine the paperwork that comes along with all this!) This is also the homework that everyone in the industry (who imports from overseas) must do. As you can see, these regulations can have a tremendous effect on the specific countries and regions that you will select for your garment production. Let's take a look at that effect in Chapter 17.

Endnotes

1. International Labor Office, October 28, 1996 release.
2. http://otexa.ita.doc.gov, accessed May 19,1999.
3. Joanna Ramey, "China Embassy Bombing Seen Hitting WTO Plans," *Women's Wear Daily*, May 11, 1999.
4. http://otexa.ita.doc.gov, accessed May 19, 1999.
5. *Ibid.*
6. Standard and Poor's, "Apparel and Footwear," *Industry Surveys*, October 1, 1998.
7. *Ibid.*
8. http://otexa.ita.doc.gov, accessed May 19, 1999.
9. *Ibid.*

CHAPTER SEVENTEEN

THE GEOGRAPHY OF TOMORROW'S MANUFACTURING OR "I HAVE TO CHANGE PLANES IN KUALA LUMPUR?"

To get to Madras, India, we flew overnight from New York to Frankfurt. After a long and drowsy layover, we changed planes for yet another overnight flight to Bombay. From Bombay it was a couple more hours to Madras, which is situated in India's steamy south. We finally collapsed in the hotel.

BAD KARMA!

The next morning, after getting about two hours sleep, we set off on a 90-minute ride through blazingly colorful streets. The car crawled because the roads were impassable with carts and animals plus men and women dressed in brilliant colors and plaids (this is Madras, after all).

After creeping through, we finally arrived at the office of the famous Mr. Iyer. He is well-known in the industry for his stunning and original woven cloth. We were asked to wait in the hallway next to a pungent, smoking religious shrine for almost 30 minutes. Finally, we were escorted into Mr. Iyer's office, expecting to be greeted as the big buyers we (Johnson and a depart-

ment store buyer from Los Angeles) were. Instead, we found him glowering behind a huge desk. Suddenly, we felt like kids called into the principal's office.

After a long, dramatic pause, Mr. Iyer finally broke the silence: "Your company is the most disreputable company I have ever met. I refuse to do any further business with you, so you might as well just go back to New York right now!"

Yikes! This actually happened. It turned out (when we calmly, politely, and firmly pressed the issue further with Mr. Iyer) that someone else had knocked off patterns that he had designed exclusively for us last season. Mr. Iyer thought we had knocked him off. After a couple of hours, we were friends again; there were no hard feelings, and business continued.

There are a couple of international sourcing lessons to be learned from this experience.

1. *Don't panic.* Stay calm, reason things out, don't shout. People overseas are often embarrassed by strong emotions.
2. *Anything can happen!* Who knew after flying for $2\frac{1}{2}$ days that the whole point of the trip would be in jeopardy? Be ready to scramble at all times!
3. *All business is personal.* Transacting business among people from any two countries requires that these two people find a way to establish a level of rapport and trust, sometimes despite major cultural differences.

WHERE IN THE WORLD?

In Chapter 16 we learned that U.S. government policies are a significant determining factor when it comes to selecting overseas countries for garment making. In addition, each country has its specialties, strengths, and weaknesses. Through time, these change. Hong Kong, for instance, was a huge supplier to the United States through the 1970s and 1980s. But this is now declining, mostly because of ever-rising labor costs.

Most garment manufacturing, especially in your young careers, will be done in **developing countries**. Garment making is still quite labor intensive, which means that cheap labor is the only way to stay competitive. Wholesalers must keep shifting contractors and countries to keep costs low. As wages in a given country increase, garment manufacturing tends to become replaced with more sophisticated, higher-tech industries such as fabric weaving and electronics assembly.

Developing Countries
Nations that are less developed economically than the United States and Europe, such as Pakistan, Indonesia, and Sri Lanka.

Korea

Korea is a good example of a country that has gone through all the manufacturing stages within about 25 years. In the late 1960s, believe it or not, one of the biggest Korean exports was human hair! Wigs were in fashion then, and the only skill a hair-grower needed was "combing." After wigs came clothing exports in the early 1970s. Korean workers were low paid but disciplined and highly trainable. The industry boomed, the country bene-

fited, wages went up. Newer workers arrived with more education and higher expectations, so they no longer wanted to work in hot, cramped sewing lines. The electronics giants started luring these workers away with higher pay in air conditioned factories. (U.S. garment sourcers joke that when the hotels become nice in a country it is time to move to a poorer country with uncomfortable hotels. With envy they say that the electronics people don't arrive until nice hotels are built!)

By the 1980s, Korean factories were making cars and ships. Those companies that had developed expertise in garment production over the years had to find a creative solution to stay in business. Their own workers were just too expensive so along came the invention of triangle shipments.

Triangle Shipments

Triangle shipment is a term used to describe an increasingly common multi-country procedure. See the following example.

The manufacturer's company headquarters is in	Korea.
To put together a flannel shirt program at the sharpest possible price a U.S. wholesaler flies to	Korea.
The fabric is best and cheapest if it is woven in	Korea.
Because it is too expensive to sew the shirts there, the manufacturer ships the fabric to their own factory in	Nicaragua,
where the garments are assembled by Nicaraguan workers under Korean supervision.	
Completed garments are shipped directly from Nicaragua to	The United States.

The term "triangle" is used to signify that there are three different locations (countries) for the manufacturer's headquarters, garment construction, and customer. (Previously, construction was always handled in the same country as the manufacturer's headquarters.) Most of the original Far East garment countries (Korea, Taiwan, Hong Kong) are holding onto fabric production, but all have had to move to triangle arrangements to find low-cost garment assembly.

Currently there are some artificial situations caused by quotas (which were explained in Chapter 16). Some countries actually have a significant allowance of quota, but their own labor force is too small or too expensive for garment making. As a result, some garment companies establish factories in those countries and import the workers just as they would import the fabric! In

Saipan (a U.S. territory) there are dormitories full of Chinese workers. In the United Arab Emirates, workers might be from Pakistan; in Malaysia they might be from Sri Lanka. These workers, who are separated from their families, live in what we would consider Spartan conditions for two or three years. At the end, they return with much more money than they could have earned at home.

If all this sounds complicated, look at what "triangle" shipments are turning into.

Manufacturer's headquarters is in	Singapore.
Fabric is woven and dyed in	China.
Special fabric finishing is applied in	Hong Kong.
Fabric is sent to	southern Malaysia,
where the individual pattern pieces are cut and sent to	northern Malaysia,
where they are embroidered by Sri Lankan workers and then trucked back to	southern Malaysia,
where the pieces are assembled into garments and then are trucked to	another town in Malaysia,
where they are washed and then trucked back to	southern Malaysia,
where the washed garments are pressed and packed in the original factory and then finally shipped to	Taiwan,
where they move from the smaller ship (feeder vessel) to the larger ship (mother vessel) for shipment to	The United States.

This is more than a triangle. This is called "asking for trouble." It might come as a shock to you, but most of your clothes are better traveled than you are! A recent variation on this theme paints a clear picture of the economics involved. A Korean-owned garment maker, S.H. International, produces T-shirts in a factory in Vladivostok, Russia, where quota allowance is large. Local Russian seamstresses earn just 21 cents per hour, much less than the $2.69 per hour that S.H. International would have to pay in Korea. However, to reduce costs even further, the company temporarily imports Chinese

SARA BAVLY

Sara is the senior merchandise representative in AMC's office in Tel Aviv, Israel.

Doing business in Israel is a little different from other countries. It is a very small and friendly market. If a manufacturer is quoting a price, he might say that another Israeli manufacturer might be able to quote you a better price!

The textile business in Israel is mostly made up of generations of the same families. The first generation all know each other, and the second generation probably all went to technical school together. These manufacturers prefer to tell a buyer up front if he anticipates that there might be technical difficulties knitting or dying their requested style. But to do business with these manufacturers, buyers need to arrive fully prepared with designs, specs, colors, price targets.

workers who will work for 11 cents per hour.[1] (More on the moral issues under "Labor Conditions and Underage Workers Overseas.")

WHERE DO IMPORTED GARMENTS COME FROM?

The following table lists the top 20 countries that shipped apparel to the United States in 1998.

1998 U.S. Apparel Imports by Country of Origin in Billions of Dollars[2]

COUNTRY	1998 SHIPMENTS	CHANGE FROM 1997
1. Mexico	$6.7	+ 28.6%
2. China	$4.3	– 3.9%
3. Hong Kong	$4.3	+ 12.6%
4. Dominican Republic	$2.3	+ 5.7%
5. Taiwan	$2.1	+ 2.1%
6. Korea	$1.9	+ 24.6%
7. Honduras	$1.9	+ 12.9%
8. Philippines	$1.7	+ 9.3%
9. Indonesia	$1.7	+ 3.9%
10. Bangladesh	$1.6	+ 12.3%
11. India	$1.5	+ 12.6%
12. Canada	$1.4	+ 18.0%
13. Thailand	$1.4	+ 15.5%
14. Italy	$1.3	+ 10.0%

15.	Sri Lanka	$1.3	+ 8.7%
16.	El Salvador	$1.2	+ 11.3%
17.	Guatemala	$1.1	+ 18.1%
18.	Macau	$1.0	+ 9.5%
19.	Costa Rica	$0.8	− 2.3%
20.	Turkey	$0.8	+ 16.2%

As noted, the elimination of quotas in 2005 will shake this up considerably. Mexico will still be dominant because of NAFTA. If China is admitted to the World Trade Organization it will probably stay in second place. After that? Hong Kong and Macau will probably fall off the chart, and the lowest labor countries will rise (Bangladesh, Indonesia, Sri Lanka). Vietnam and central Africa remain wild card countries.

LABOR CONDITIONS AND UNDERAGE WORKERS OVERSEAS

Labor overseas is a highly complex subject, and we don't pretend to be legal or moral experts. Let us just state that we feel no one should be forced to work, no one should have to work in unsafe or unhealthy conditions, and no child should ever be exploited as a source of cheap labor. Having said all that, it is not a black-and-white issue.

There have clearly been abuses—Chinese forced labor in prisons, for example, or young children in **sweatshops** in places like Bangladesh. Most U.S. wholesalers and retailers have been trying hard to ensure that their merchandise does not end up in such shops. Not in anyone's defense, but sometimes it is hard to know where your garments are actually getting made. Contractors often subcontract to cheaper, less sophisticated operations. Like the layers of an onion, this can actually go down several levels, with no knowledge on the part of the buyer. We've seen garment components flying back and forth in taxis (going where?).

The issue of sweatshops in the apparel industry has become hotly debated. After the Kathy Lee Gifford/Wal-Mart factory controversies in 1996, the White House Apparel Industry Partnership was established. In 1998 a committee of business, labor, and human rights representatives was formed, the Fair Labor Organization. It published a comprehensive suggested code of conduct and a monitoring system to be used by foreign companies producing merchandise for U.S. consumers. In 1999 seventeen large U.S. universities (Harvard, Yale, Princeton, Duke, Notre Dame, and others) also joined.

The guidelines basically establish a maximum 60-hour work week, a ban on labor by children younger than 15 years unless the specific country's laws allow employment at age 14. The guidelines also demand that the country's minimum or prevailing wage be paid to garment workers. It also established standards for independent, external monitors.

Child labor continues to be a difficult issue worldwide. The legal minimum age for children is as low as 12 in Bangladesh, Peru, and Tanzania. In some countries, children support their families. In other situations, the only

Sweatshops
Factories where labor law(s) are being violated, such as minimum wage, underage workers, and unsafe conditions.

money-generating alternatives for children are even less desirable than garment sewing.

Still, child labor is not confined to the garment business. In fact, most child labor is in agriculture. The International Labor Organization (ILO) estimates that at least 250 million children between the ages of 5 and 14 are working in developing countries. Approximately 120 million of these children work full-time, and tens of millions work under exploitative and harmful conditions. According to the ILO, most of the world's working children (61%) are found in Asia, followed by Africa (32%) and Latin America and the Caribbean (7%).[3]

HOW IS THIS COMPLICATED BUSINESS MANAGED?

Most U.S. and European wholesalers and retailers work overseas via agents or with their own offices. As you can imagine, there are so many details to be attended to that several people are required on-site in each producing country. Agents are independent operators who provide these services for a fee (usually some percentage of the cost of the shipments). Two of the largest independent agents in the Orient are 1) Li and Fung and 2) Connors. Other U.S. companies are so large that they have their own network of offices (May Company, Macy/Federated), or they band together and share offices (Target Corp., Bloomingdale's, Saks at AMC).

Most jobs in these overseas offices are filled with people from that country. By the way, this would be an exceptional opportunity for foreign students who have studied in the United States and then returned home. They would be viewed as highly desirable employees because of their exposure to the U.S. wholesale and retail scene, their newly acquired technical skills, and their native language facility. From time to time, there are also opportunities for skilled and experienced Americans in some of these offices.

WHAT IS A SOURCING TRIP ACTUALLY LIKE?

We've already seen many reasons why a product developer must travel to several different countries to find the best factories for his or her program. Typically a product developer or sourcer has a core group of factories that have proved reliable and affordable over past seasons. One factory might be best for complicated styles; another might be extremely well-priced but best for simple styles. One factory might have a quota for full-zip-front knit styles (jacket quota), whereas another might only have a quota for pullover knit styles.

Usually you will evaluate your assortment already knowing the most probable factories for each style. You will also want to price out each style in a few competing factories so that you can be sure that you are getting the best price. Most sourcers will have their target factories quote prices on each style before the trip. If sent detailed specification sheets with fabrics, styling, and size specs, most manufacturers can quote approximate costs. This gives the sourcer a big head start. It could be that some factories won't even need to

be visited or that entire countries can be skipped. In addition, often these quotes will uncover design issues that have needlessly inflated prices. With a simple redesign, the style can be made within the target cost after all.

After all this preliminary work, a sourcer will plan the trip itinerary based on the locations of the factories that seem to be the most likely candidates for this particular group of styles. This itinerary could change based on market changes. Perhaps quota is suddenly hot (and thus too expensive) on a particular category for all makers in Hong Kong. But quota is still workable in Thailand, so you might visit only Thailand.

The sourcer or product manager will probably visit a manufacturer in the showroom of his or her factory. Your agent or office representative will accompany you to translate and help negotiate. On a typical appointment with a manufacturer overseas, it is often considered impolite to just jump into business. There will be introductions, perhaps each side will explain the company they represent. If this is a repeat visit, there will often be an exchange of personal greetings and expressions of interest. After that, if you are running a program in that factory, you will review its status. Is everything on time? Are there any questions or problems?

Finally you will focus on the new set of styles. For each you will explain the styling, fabric, details, and size specs to the manufacturer. He or she will probably ask for clarification on certain points ("What size zipper do you need?" "Must it be a YKK brand zipper or will you accept a cheaper substitute?").

After all the details are understood, the manufacturer is usually prepared to quote a price on the spot. This is especially true if you have sent the information in advance, allowing time for the supplier to study the styles, research current fabric prices, and spot any problems. If the price quoted is acceptable to you, great! Usually some back-and-forth negotiation is required. If the price is significantly higher than acceptable, it is often a good idea to "partner" with the manufacturer. ("What options do we have to bring this style down to the target cost?") The manufacturer might suggest a substitute fabric, a change in styling, a change in size specifications. Perhaps among these suggestions is one with which you can live.

It is a fluid process, and you must stay reasonable and flexible. The best styles and the best values are discovered mutually between the manufacturer who is a technical expert on production and the product developer who knows what the customer will accept.

Style by style this process is repeated. It could take a few minutes or many hours to work out one style. Then this process is repeated with the other factories you are considering, including those in other countries. By the end of the trip, you will know much more about the technical intricacies of each style, enabling you to avoid potential production pitfalls. You will also have comparative price quotes so that you know which factory has the best price. Importantly, you will also develop a "feeling" for which factory is going to do the best job on each style. Which will produce the best quality at an acceptable price?

Finally you want to balance the program so that you do not have all your eggs in one factory's basket. Nor do you want to have such a fragmented program that you are placing only bits of business with many manufacturers.

Each "bit" might turn out to be relatively unimportant to each supplier, and your goods will get pushed to the back of the production line when the crunch comes.

Yes, there are many considerations when choosing where you are going to place your styles. If you can travel with an experienced professional for your first few trips, you will learn many of these issues "the easy way." Otherwise you will probably have to experience some big difficulties to establish your own set of guidelines.

A FEW TIPS ON SOURCING OVERSEAS

As with anything else, skills develop in this arena through good and bad experience. Conducting business overseas is different from conducting business in the United States. As our friend S. Y. Kim (Director of Production, Liz Claiborne Infants) explains, "There is only one America. Don't expect other countries to be America also. Please respect that they have their own values."

The United States has been quite isolated throughout history, as well as linguistically spoiled. (Relax: Even though we shouldn't be so lucky, there probably is no place left on earth where we can't get by with English.) When we Americans set out in the international business world, we're often not really prepared to deal on someone else's terms and turf.

Next we'll look at some basic pointers to guide you on your international way.

Careful, Clear Communications

Always speak clearly and slowly—don't mumble. Don't talk baby talk! (You would not believe how many Americans start doing this when they get to the Orient! How embarrassing!) Words don't always mean the same things overseas. For example, did you know that "I'll try" is the polite way of saying "no" in much of the Orient? They don't want to insult you with "no," but then you go merrily along assuming that they are still working on your project, which they are not doing. Please also refer to the exercises at the end of Chapter 12, where we practiced clear written communication. Because of the vast distances involved, most communication will be written via e-mail or fax.

Setting Everyone Up to Succeed

Some wholesalers, designers, or sourcers fly overseas, ready to battle everyone! If they are tough on agents and contractors, their thinking goes, they will come out the winner. But this goes back to our section on negotiating. Everyone has to make his or her profit. You just need to make sure that no one's profit is overinflated and that everyone will earn their profit. Some negotiators feel that they should "dare" the contractors to do the "almost impossible." It's really much healthier to try to make things as "possible" as you can. Talk all the details through with the contractor; anticipate problems; and avoid them early, when it's easy. Don't load your partner with so many "challenges" that it will be a miracle if he or she succeeds. You might be forgetting that this also means that it will take a miracle for you to get your goods the way you want them when you want them. You can't succeed if he or she doesn't succeed!

Oy, the Problems!

When you're working all over the world, it's not a case of there "might" be problems. There will be problems! Lots of them, most totally unexpected. Our friend, Hope Cohen, tells about an AMC trip to Uruguay to design sweaters: "We were sitting in the vendor's showroom in downtown Montevideo when suddenly the lights went out. Time was tight, so we moved over to the window, lit some candles, and proceeded to pick colors for the sweater jacquards in semidarkness. It must have worked, because we had our most successful season ever! So what's the moral of the story? Always pick your colors in the dark?!"

This e-mail came to our friend May Cygan while she was also at AMC: "Your shipment mistakenly put into refrigerated container rather than regular garment container. Garments now frozen. Will advise status once they thaw out." The key is keeping your cool at all times and looking for solutions, not people, to blame. Now that you're in the big leagues, when the teacher passes out the construction paper and Popsicle sticks (Chapter 1), she might surprise you with a blindfold. You still must find some way to make that airplane!

Sticking with a Good Partner

Another common mistake for newcomers is to move their program from one contractor to another, or even from one country to another, for a small savings in cost. Going back to our football metaphor, that would be like tossing out your most experienced team members near the end of the season and bringing in a bunch of rookies who have never played together before. The old plays that everyone on the team understood suddenly run into new misunderstandings. Yes, there are times when it's right to make a change. But most inexperienced importers make the mistake of changing partners too often rather than not often enough.

There are many more pointers for overseas sourcing. For now, let's just tell you about one entry-level position that could start you in this international direction.

IMPORT PRODUCTION ASSISTANT FOLLOW-UP

After production orders have been placed with the manufacturers, and wholesale orders have started to come from store buyers, the follow-up begins. Or if you are doing product development for a retail store, the follow-up starts as soon as your buyers have decided their quantities. You've glimpsed how complex all this follow-up can be. It becomes the responsibility of the production assistant, a possible entry level position for someone starting in wholesale or product development. Entering with the following abilities is a must:

- Good oral and written communication skills
- Meticulous attention to detail
- Ability to remember the "big picture" even while immersed in hundreds of details.

Some duties of the production assistant include the following:

- Confirming exact quantities, styles, colors, and deliveries to the various manufacturers
- Proactively watching the calendar to make sure that all trigger date deadlines are anticipated and met
- Ensuring that all fabrics and trims have arrived on time
- Maintaining the merchandiser's cost sheets (usually on Lotus or Excel) as price changes or competitive bids come in
- For a wholesaler, tracking production of the salesperson samples and swatches so that everything is ready for the line opening; for a product development retailer, tracking ad samples

Lab Dips
Small pieces of fabric or yarn that have been dyed as a trial to see if the color will be acceptable to the buyer.

- Following-up on color approvals (**lab dips**), fit comments, and trim details
- Monitoring deliveries closely so that shipments will be on time.

It Is an Adventure!

So this gives you a bit of the "flavor" of international product sourcing. As you have seen, it always seems to come with "experiences," good and not-so-good. With all these adventures, it's easy to forget that there are still many garments made right here at home. In Chapter 18 we find out more about the garment manufacturing business in the United States.

Endnotes

1. Russell Working, "Russia's Patchwork Economy," *New York Times*, March 18, 1999.
2. http://otexa.ita.doc.gov, accessed June 2, 1999.
3. http://www.dol.gov/ilab/public/media/reports/iclp/sweat5/execsum.htm, accessed April 4, 1999.

CHAPTER EIGHTEEN

MANUFACTURING IN THE UNITED STATES: IS THERE A FUTURE?

In Chapter 17 we learned about regions in the world where garment manufacturing is growing and other areas where it is declining. But how about here? Is there a future in manufacturing apparel in the United States? Yes and no. It is becoming harder to price competitively if your labor costs are in the United States. However, there are new ways of doing business, and there are niches of business that can still work here.

TOUGH GLOBAL COMPETITION

The fall-off in both textile and apparel employment in the United States has continued if not accelerated. The average annual number of U.S. employees in textile mill products in 1990 was 691,000. By the end of 1998, that number had dropped to 579,000. In apparel-making, the drop was from 1,036,200 to 731,000 in the same period.[1] Even with these drops the Bureau of Labor Statistics expects that these two manufacturing fields will still provide eight percent of all projected U.S. jobs in manufacturing in 2005.[2]

Empty racks and "going out of business" sales in New York's garment district.

As we have seen in Chapters 12, 15, and 16 this industry continues to be dependent on a high amount of manual labor. All countries with highly paid workers are experiencing similar declines, especially in apparel production. Don't think that this is just happening here: Japan, Korea, Taiwan, and Hong Kong have also been going through the same scenario.

In dollars and cents, it becomes quite clear why manufacturers and importers have sought other countries to produce clothing.

AVERAGE HOURLY APPAREL WORKER WAGES IN SELECTED COUNTRIES[3]

Italy	$14.00
Canada	$9.88
United States	$9.56
France	$7.81
United Kingdom	$7.38
Hong Kong	$4.55
Costa Rica	$2.38
Dominican Republic	$1.62

Eastern Europe	$1.11
Mexico	$1.08
Colombia	$1.05
Thailand	$1.02
Philippines	94¢
Nicaragua	76¢
Haiti	49¢
Indonesia	34¢
Sri Lanka	31¢
India	26¢
Vietnam	26¢
Pakistan	21¢
China	20¢–68¢
Bangladesh	10¢–16¢

With such a huge difference, importers can add duties and freight to their overseas (first) costs and still come out at a lower price than if merchandise were made here. This has ballooned the annual apparel plus textile import volume into the United States to a staggering $60 billion.[4]

FIGHTING BACK

Well, domestic textile mills and apparel manufacturers weren't about to just let this happen.

First, cotton is still king in the United States. The United States is the world's largest exporter of raw cotton, with 22% to 25% of the share of world exports. (That's five to six million bales!)[5] Even if it is difficult for the United States to be competitive in textile and garment production, it appears that this country will maintain its dominance in raw cotton growing.

There are also some regions of the country that are bucking the overall decline. In California, the number of apparel industry employees actually grew by 14.5% between 1992 and 1997.[6] In Los Angeles County alone there were 160,000 people employed in garment production in 1997. According to the California Trade and Commerce Agency, the California apparel industry produces $13.7 billion in products each year and exports over $1 billion.

Across the country, there has been a huge push to remain competitive, including steps such as the following.

- *Modernizing equipment.* We've already learned about Gerber and Lectra (see Chapter 15). There are similar advances in textile technology.
- *Quick response.* By electronically linking all players (fiber and fabric producers, garment makers, and retailers), U.S. suppliers can offer quicker replenishment of bestselling merchandise.
- *Combination operations.* Most U.S. garment makers originally did all of the production steps with their own employees. This is called "in-house labor." This has been followed in recent years by several innovations:

Subcontractors. Manufacturers send partially completed items to subcontractors who can add the next operation more efficiently and thus less expensively because they specialize in certain operations (pleating, embroidering, or simply sewing).

Offshore and other combinations. Many manufacturers in the United States are now doing part of their production overseas. The 9802 (807) laws encouraged U.S. makers to do their cutting in-house and then send the pieces overseas (usually the Caribbean) for lower-cost sewing assembly. NAFTA has accelerated this trend to go offshore because both cutting and sewing may be performed in Mexico, as long as the fabric is from North America. Ironically, while the 9802, super 807, and NAFTA rules are all encouraging the use of U.S.-made fabrics, they are also speeding the movement of apparel-making jobs to other countries.

Joint ventures. At times manufacturers will share in the ownership of a subcontractor (either here or overseas) to tighten the relationship and reliability. NAFTA has encouraged more partnerships between firms in the United States and Mexico. Several U.S. textile mills have already established mills inside Mexico. Recently they have also entered some joint ventures with sewing plants in Mexico. Galey and Lord has already established its own sewing lines in Mexico. Burlington and Cone have entered joint ventures, and Glenoit is investigating. These textile makers can then offer a complete sourcing package to wholesalers and retailers.

SWEATSHOPS IN AMERICA

The squeeze on prices has also produced some abuses within the United States. There have been some highly publicized cases of "sweatshop" labor in the United States. Recent immigrants with few skills (business, language, or legal) fall prey to contractors who take advantage of their naiveté and force them to work unusually long hours, sometimes in unhealthy surroundings, for insufficient pay. "The Labor Department estimates that about half of the 23,000 contract shops in the country are sweatshops—places where inspectors uncover illegal practices, including violations of wage and hour laws, employment of illegal aliens, and unsafe working conditions."[7]

As a result, The Labor Department initiated a "No Sweat" campaign in 1996[8] to try to end such abuses. By singling out known abusers, by encouraging those known to comply, and by trying a "No Sweat" hangtag campaign (Figure 18-1), the Department of Labor hopes to change this situation. Former Secretary of Labor Robert Reich said: "We hope that the administration's emphasis on encouraging manufacturers not to do business with known unscrupulous contractors and to monitor formally their contractors for compliance with minimum wage and overtime laws can buy long-lasting positive changes in the working conditions for this country's workers."[9]

Three Clues for Consumers That Your Clothing is NO SWEAT.

 You can ask your retailers questions about where and how the garments are made. Garment workers are required to be paid at least the minimum wage and overtime.

 You can ask your retailers whether they independently monitor garment manufacturers to avoid buying from sweatshops. Many retailers have voluntarily agreed to conduct site visits of suppliers to monitor working conditions.

 You can ask your retailers whether they support "No Sweat" clothing. Commitments from retailers to avoid buying sweatshop-made clothing can go a long way toward eradicating sweatshops in America.

FIGURE 18-1 Consumer information provided by the "No Sweat" campaign.

The two former apparel unions, ILGWU and ACTWU, merged to form a combined union, UNITE (Figure 18-2). "The union label certifies that the garment came from the hands of U.S. workers who belong to UNITE, the Union of Needletrades, Industrial and Textile Employees. These workers are guaranteed at least minimum wage, health-care benefits, and worker's compensation for on-the-job injuries."[10]

FIGURE 18-2 Members of the Union of Needletrades, Industrial and Textile Employees (UNITE).

OPPORTUNITIES OTHER THAN SEWING

Even if the U.S. textile industry can continue to produce some price-competitive fabrics, the future doesn't look too rosy for most mills and garment manufacturers.

The U.S. Bureau of Statistics projects employment statistics in a publication called *Career Guide to Industries.* Their projections for changes in total number of jobs between 1996 and 2006 do not look promising for textile and apparel production.

	1996 EMPLOYMENT	**2006 EMPLOYMENT**	**CHANGE**
Textile mill products manufacturing	332,000	301,200	−9.3%
Apparel and other textile products manufacturing	642,900	475,100	−26.0%

Related to the shrinking number of jobs is the low pay that these jobs command. In 1996 the average pay for production workers in all indus-

LAWRENCE AND ALAN BEHAR

Lawrence, vice president of production, and Alan, vice president of marketing/finance/design, along with their brother Steven, are carrying on the legendary tradition of their famous father, Ike. Sold at Saks, Nieman-Marcus, and specialty stores, Ike Behar shirts are known as the best of the best. There is also a growing market for these shirts on stage and in films (*Carlito's Way*, *Cotton Club*, *Wall Street*). A Japanese study ranked the Ike Behar shirt as having the best quality in the world.

On the Importance of Maintaining Quality

Piecework
Work for which payment is made not by the hours worked but by the number of garments sewn.

We've always stood for just one thing: Quality. It just happens to be made in America. But quality is why we've been able to exist here. We don't have a QC department. Quality is instilled in everyone in the company. It's an attitude from beginning to end. Most of the rest of the industry's sewing operators get paid on **piecework**. This always turns into "How much can you make for me today?" We pay by the hour, instead.

Our father was trained in Cuba as a tailor. He still sits down at the sewing machine and shows the operators how it's done. They know that he can probably do it better than they can! We feel our shirt is an exceptional value, especially next to comparable shirts from Italy which can cost twice as much, or more. And our business grows purely by word of mouth.

and having management located in the factory building has accomplished that control for one of the most famous men's dress shirt makers (see "The Inside Scoop" for Lawrence and Alan Behar).

Niche Markets

There are some businesses that are so well targeted to their customer, and which dominate their niche of the market, that they can survive using domestic production. A great example, as well as a stirring story, is Malden Mills, in Lawrence, Massachusetts. On December 11, 1995, the mill burned to the ground. Its products, Polarfleece and Polartec, were in tremendous demand (Figure 18-3). Overseas competitors simply could not achieve the same silky softness of the fleecy fabric.

Mr. and Mrs. Feuerstein, the owners, vowed to rebuild in Massachusetts: "Others might have seized the opportunity to move their manufacturing to a developing country, where labor would be cheaper. But the couple were committed to the mill and to Lawrence."[14] On September 14, 1997, a gleaming new $130 million factory was dedicated in Lawrence. By that date, Mr.

tries in the United States was $530 per week. For textile mill workers, it was $390, and for sewing machine operators it was $250.[11]

That's not a pretty picture! But again we say, "Don't panic!" There are companies that have been able to buck this trend. Above all, they know what they can make competitively and what they shouldn't even try to make.

Note that this will actually have limited impact on students who are studying fashion. There will still be plenty of jobs in design, merchandising, production-supervision, product development, sourcing, wholesale selling, and retail. These functions will continue to remain in the United States even if the garments are made somewhere else. Here's Robert Reich again: "In a wired world, fewer Americans will directly manufacture products. But more of us will devise better methods for making products or will add value through designs, marketing or engineering. In all these endeavors....computers are essential partners."[12]

Specialized Items Such as Cotton Sweaters

The United States is a world leader in cotton fiber production and is also very competitive in cotton yarns. Heavy cotton sweaters (using lots of cotton) have tended to be more price-competitive in the United States than overseas. Simple sweaters are usually less **labor-intensive** than cut-sewn woven garments, so more of the cost of a cotton sweater comes from the yarn. With the advantage in yarn cost, U.S. suppliers continue to beat their overseas competition.

Labor-Intensive
Requiring lots of lab

Low-Labor Items

Some items are so standard that their production can be highly mechanized. T-shirts are a good example of this. Tubular T-shirts (those with no side seams) are almost always cheaper if made in the United States. Their production requires costly machinery (different garment sizes, or tubes, require different circular machines), but the labor for assembly is minimal. Then, via either piece dying (fabric is dyed, then cut) or garment dying (garment is completed, then dyed), U.S. makers can supply T-shirts quickly, sometimes within two to five weeks. "Wisconsin children's wear maker, Oshkosh B'Gosh Inc., has decided it can effectively produce knit garments like leggings and tops in the U.S."[13]

The entire hosiery industry has likewise been able to compete with imports because it is more dependent on sophisticated high-tech machinery (which we have in the United States) and less dependent on manual labor. The labor that is required is usually higher-skilled than many other traditional garment making jobs.

Top End of the Market

With production and marketing know-how, there are some companies that continue to thrive in the United States. They make the labor costs work by producing an especially high-end quality product. On-site control is the key,

FIGURE 18-3 Malden Mills producing its famous Polarfleece.

Feuerstein had rehired almost all of his 2,700 workers (Figure 18-4). "Sales are up 40 percent since the fire....productivity is up 25 percent."[15]

Massachusetts has recently produced other success stories in addition to Malden Mills. Quaker Mills of Fall River is now the world's largest producer of chenille yarn and one of the three top U.S. manufacturers of upholstery

FIGURE 18-4 Mr. Feuerstein and Malden Mills employees.

fabric for the furniture industry. As recently as 1989, Quaker Mills had only 800 workers and had lost $7.4 million on revenues of $80 million. Owner Larry Liebenow rebuilt the company as a vertically integrated yarn and upholstery maker with new high-speed looms and spinners. He expanded into new higher-priced items and marketed the product toward the fast-growing home furnishings market. He found a specific market niche, upgraded equipment to be more efficient, and created success despite his location in an area with high labor costs.[16]

This concludes Unit 3. We've now learned that the fashion business is truly a global business. Just about everyone involved in fashion must be up-to-date on the rules and regulations of importing, because more garments are being produced offshore. Together, Units 1 to 3 have painted a picture of today's fashion business: Who drives it, who designs it, who sources it, who makes it. Hopefully they have also shown you *how to do it*. In Unit 4 we move to the future: *Your* fashion industry. We're going predict where *your* job and business opportunities will come when you enter the industry.

Endnotes

1. Joanna Ramey, "Apparel, Textiles Left Out of Rosy Job Picture," *Women's Wear Daily*, January 11, 1999.

2. http://stats.bls.gov, accessed June 2, 1999.

3. Anonymous, "Labor Costs: Where and How Much?" Source: Werner International, *Women's Wear Daily*, December 31, 1996.

4. *Fairchild's Textile and Apparel Financial Directory*, Chain Store Guide 1999.

5. http://www.cottonusa.org, accessed June 8, 1999.

6. http://www.commerce.ca.gov/california/economy/profiles/apparel.htm, accessed June 8, 1999.

7. Anonymous, "Shaking the Sweatshop Stigma," *Women's Wear Daily*, January 7, 1997.

8. Garment Enforcement Report, April-June 1996, Wage and Hour Division, U.S. Department of Labor.

9. Anonymous, "Shaking the Sweatshop Stigma," *Women's Wear Daily*, January 7, 1997.

10. "Sweatshops: Fashion's Dirty Little Secret," *Glamour*, April 1996.

11. http://www.stats.bls.gov, accessed June 7, 1999.

12. "Hire Education," *Rolling Stone*, October 20, 1994.

13. Joanna Ramey, *Women's Wear Daily*, January 13, 1997.

14. Mitchell Owens, "A Mill Community Comes Back to Life," *New York Times*, December 26, 1996.

15. Carey Goldberg, "A Promise is Kept: Mill Reopens," *New York Times*, September 16, 1997.

16. Susan Diesenhouse, "A Fabric Maker's Tapestry for Success," *New York Times*, September 29, 1998.

UNIT FOUR

So, After All This, Is the Fashion Business for You?

CHAPTER NINETEEN

Apparel Business in the 21st Century: Where Will the Opportunities Lie?

In Units 1 to 3 we've tried to show you how this business has been done. In this final unit, we're going to ask, "Where are you going to take this fashion business in the future?" There are changes coming in the world of fashion and fashion retailing. We've looked into our crystal ball to make some predictions to help you select a *growing* part of the industry for your first job. The spots where the future is brightest follow.

Fashion Is Now a Global Business

Way back in Unit 1 we told you that the big are getting bigger. We think the biggest will get bigger still, especially among retailers. The giants like Wal-Mart (currently employing 825,000 people and growing over 20% per year), Sears, Penney's, and Target should continue to fill a large market niche. Their sophisticated computer systems will continue to give them a competitive advantage.

However, business is no longer confined by national borders. The next 10 years should see huge expansion *across* national borders. The largest com-

panies in the world, not just in individual countries, will become dominant. A fashion industry consulting company, Management Ventures, is projecting that by 2009 the 25 largest retail chains in the world will capture about 40%, or $3.6 trillion, of the world's retail sales, estimated to be $9.2 trillion by then.[1] Currently these stores control 15% of the market, up from 10% in 1994. According to the study, these top 25 chains will average $140 billion annually. Today, only Wal-Mart is of that size. These chains are expected to grow three times faster than the industry average. The study singled out the following U.S. retailers who will be members of the top 25 in descending order: Wal-Mart, K-Mart, Sears, J.C. Penney, Target, Kroger, Home Depot, Costco, and Safeway.

The largest specialty chains should also continue to dominate, provided they can stay in tune with their customers' wants and needs. The Gap did more than $9 billion in sales volume in 1998, up from $6.5 billion the year before. Annual growth for Gap has been over 20% per year, with a healthy income of 9% of sales. Intimate Brands (Victoria's Secret and Bath and Body Works) is at almost $4 billion, and it too is growing at over 20% per year. Abercrombie and Fitch grew an astonishing 56% between 1997 and 1998 with income of 12.5% of sales!

As noted earlier, many if not most of these retail giants are pushing their expansion into overseas markets as aggressively as they are throughout the United States. However, don't think running stores in a foreign country is the same as running them in your home market. Some European retailers have had disastrous results when they tried to enter the notoriously competitive North American market. Carrefour, a large French discounter, and Conran's, an English home furnishings chain, had to abandon their efforts in the United States even though they had been successful in other foreign markets. England's powerhouse department store chain, Marks and Spencer, announced a total pullout from the Canadian market. Laura Ashley is struggling badly in the United States. Only the most savvy companies who clearly understand the nuances of each national marketplace will succeed in global expansion.

On the branded wholesale front, designers are also going global. It is now business as usual for U.S. designers to establish their own stores overseas, especially in Europe. Calvin Klein has been there for years. The most recent additions are huge flagship stores for Ralph Lauren and Tommy Hilfiger in London and small boutiques for each on the French Riviera.

THE BRIGHT FUTURE OF LUXURY

As retailers and wholesalers go global, one of the fastest growing segments of the global brand business is the luxury end. High-profile designers and luxury-goods companies have touted their status worldwide for years. The payback comes as upper classes grow in most countries. Names such as Armani, Tiffany, Escada, Gucci, Dior, Ferragamo, and Burberry are in demand by those that can afford them, and they are aspired to by those that cannot. In good economic periods these high-end companies grow rapidly. Even in bad times, their clientele is often relatively immune to economic difficulties.

How big is this market? According to a study by Morgan Stanley Dean Witter, the luxury goods business is estimated at $60 billion worldwide, including such brands as Bulgari, Gucci, Louis Vuitton, Moet, Dior, Kenzo, Tag Heuer, Ittierre, and Hermes.[2] In this market segment too, the big are getting bigger. The same study indicates that 60% of the luxury market is controlled by just 35 companies. These well-financed giants ensure that their goods are always presented in an appropriate environment with a high degree of service. This perpetuates the luxury aura. And this aura translates around the world. Even with the economic difficulties of the late 1990s, it is felt that the largest long-term growth market for these purveyors of the good life will be in Asia.

Luxury conglomerates have formed, such as Moet Hennessey-Louis Vuitton (LVMH), which includes the Dior, Kenzo, LaCroix, Celine, and Givenchy fashion houses, Loewe leather goods, Guerlain perfumes, Duty-Free Stores, and the Sephora perfume/makeup chain. Prada, a small Italian accessory and shoe company just 10 years ago, expected a global sales volume of just under $1 billion in 1999.[3]

High-end department stores are also aggressively pursuing the affluent customer with enhanced presentations, enlarged assortments, and white glove service. Frequent-buyer loyalty programs have been instituted by Neiman Marcus, Saks, Bergdorf Goodman, Bloomingdale's, Marshall Field's, and Nordstrom. They offer perks such as shopping while the store is closed, personal fittings with designers such as Donna Karan (Saks New York), first-class airline tickets, hotel rooms, lavish dinners, and even discounts.

THE INSIDE SCOOP

HOPE COHEN

Hope has been the vice president of licensing for Polo Ralph Lauren. Before that she was their director of product development for knitwear. Before Polo, Hope worked in product development at Ann Taylor, Anne Klein, AMC, and Gap.

On Setting Up a License Agreement

A company to whom you are going to grant a license needs to be a good match-up. They must already have the correct quality, make, and details that will be right for the licensed product. Our company is design-driven, so we provide strong design direction to the licensee. They must be production experts in their field. But it is also critical to know that they will understand our sense of design. We ask that they identify a designer who will be able to work with our team—even before the contract is signed.

After the agreement is set and work starts, our job becomes one of "massaging" the relationship between the two different corporate cultures. We have to establish a good working relationship. We will constantly check up on them and give them suggestions. In effect, we play their conscience.

LICENSING IS THE NEW NAME OF THE GAME

Licensing is another booming segment of the fashion business. Companies that own successful names or trademarks can expand the number of products carrying this name by licensing it to companies that make specialized products. In fact, the trend for designers is to manufacture only a limited line, perhaps just their premier collection. Then, for all other categories, they enter into a licensing agreement with other companies to make most merchandise that carries that designer's name. The designer gets a royalty (fee) for this and doesn't have to worry about production. Donna Karan has been shifting away from production into more licensing agreements to make her company more profitable. Eleven percent of Polo Ralph Lauren's volume comes from licensing arrangements.[4] Companies that previously only manufactured garments with their own label now pursue such licensing arrangements. Liz Claiborne, for example, produces the DKNY Jeans line.

Some designers are going the other way: Calvin Klein has licensed his collection to designer manufacturer Selene based in Italy. Calvin will still design the collection, but Selene produces it globally and distributes it outside the United States.

Clever marketers are establishing their own "brand" status...and then going out and licensing the name that they have created. They build a customer following of people who want to live their lifestyle. "Martha Stewart—who may actually be the first human to embody a lifestyle—has this down pat. She has a weekly television program, a magazine and several lines of product—pricey ones sold through her catalogue and magazine, and a set of household items at much lower prices sold through K-Mart stores. The genius of Ms. Stewart's strategy is that her lifestyle is decidedly upscale, even as she makes it accessible to middle-class consumers, the nation's biggest group of purchasers."[5] Martha Stewart has built her name into a powerful marketing tool, one that companies will pay large sums to use on their products.

There is another clever way to build a name: Make it up! Two brothers, John and Bert Jacobs, started a business in the late 1980s selling T-shirts to college campuses in the Boston area. They kept trying different slogans and characters that could become their "brand." "We had been selling T-shirts, but we had no common thread," says Bert Jacobs. "It seemed the market was getting saturated with negative, loud, in-your-face sayings, so we wanted something that was clean and simple. We made a list of sayings, and 'Life is good' is the one everyone liked."[6] They coupled the slogan with a funny stick figure wearing shades and a huge smile. Then...it took them three years to get a trademark on it. In 1994 the T-shirts and caps were placed in 14 retail stores. By 1998 distribution had expanded to 500 stores nationwide, and volume was projected at $5 million for 1999.

Licensing is big business. It is estimated that $5.5 billion in royalties was paid to licensers based on sales of licensed products in the United States and Canada in 1998. This would mean that the retail volume of licensed products is about $110 billion.[7]

SMALL IS GOOD, TOO

As discussed before, as the big companies get bigger, they are bound to overlook the needs of certain groups of customers. A small company that services a small customer base can still be successful. Here's how Simon Graj (president of Graj+Gustavsen, the marketing company) explains it: "There are always small pockets of opportunity. For example, it's difficult to shop for clothes.... Therefore, people want clarity and ease when they shop. The number one reason to be a retailer is to be a guide. A small store with a distinct concept, thought through and executed consistently from product to packaging to selling environment, can go up against the big stores and succeed."

Alan Stuart, a small men's wholesaler in Miami, has found a narrow market niche and has made itself a market leader for that niche (see "The Inside Scoop" for Alan Glist). Michael Stern, vice president of manufacturing for Alan Stuart, explains: "You must identify your market niche. You can't be everything to everybody. Rather than make something that you know nothing about, you should try to enhance the product you know for the customer you know." This philosophy applies to both retail and wholesale. If you're

THE INSIDE SCOOP

ALAN GLIST

At age 21, Alan Glist started a business with his father. The line was named Alan Stuart, Inc. Today, Alan is the president and CEO of this manufacturer based in Miami.

On Staying Competitive by Knowing Your Customer Well

We created a niche for ourselves. We have our own look and target customer. We've never been inundated with a lot of competition in our niche. We sell to better specialty and department stores, where the special look is more important than the price. Of course, every business is price sensitive. But our end is not down-and-dirty sensitive. With this, we've been able to continue a significant amount of our production in the United States.

The key is getting to know your customer. In our case, it's a mature gentleman—40 to death. I actually walk up to these guys and ask them things like, "Why do you like a banded bottom on your shirt?" (It covers their midsection better.) We also learned that since many of our clothes are actually bought by women (for their husbands) rather than men, we have to appeal to women as well. We've used colors (like mauve) this way—or sometimes we use womenswear fabrics or prints and recolor them.

Our customer also cares a lot about washing. Ninety-eight percent of them prefer very washable, easy-care garments. We avoid "dry clean only." And our customer must have a pocket! We wouldn't produce a shirt without one!

going to start a new store, for example, don't try to take on Penney's or K-Mart. Find a little slice of the market that no one else is addressing, and your chances for success will be much greater.

THERE WILL BE LOTS OF OLD FOLKS!

Demographics can indicate new business opportunities. The age breakdown is changing in the United States. Just take a look at the expected growth of people aged 65 and older as a percent of the total population.[8]

2000	2005	2015	2025
12.6%	12.3%	14.5%	18.5%

It might not look so dramatic as a percentage, but this means that the total number of Americans 65 and older will grow from 35 million in 2000 to 62 million in 2025. In other words, while you are working in the fashion industry, the number of senior citizens will almost double. There is a tremendous opportunity for lines of apparel that will fit this older customer but will also be in synch with aging Baby Boomers' youthful self-perception.

Also within population shifts, one must factor the unfortunate trend that Americans of all ages are getting heavier. This will have a distinct impact on trends. It should inspire larger-sized clothes that are stylish but without a large-sized stigma. J.C. Penney's website has a section called "Just4me" that allows full-figured customers to build a "virtual model" of themselves to "try on" clothes. *Mode Magazine* continues to be successful featuring clothes for women sized 12, 14, and 16. By now, many major women's apparel companies also have profitable large-sized divisions. New to the large-sized business is girls/juniors. Sears has opened an in-store shop dedicated to plus-sized juniors called "Mainframe for You."[9]

Best of All: There Will Be Lots of Young, Fashion-Savvy Customers!

The census bureau expects the teenage population to grow faster than most other age groups over the next 10 years. By 2005 there will be 30 million teenagers in the United States with more growth after that. This is great news to newcomers in the fashion industry. It has been about 20 years since there has been such an upsurge of young customers. It seems that this group, having grown up in a plugged-in world, is sensitive to fashion trends and brands. The hottest segments at retail are already the juniors and young men's age groups. Department stores such as May Company, Dillard's, and Macy's are reopening departments for these customers. Retail specialty chains that are enjoying the largest increases are Abercrombie and Fitch, Buckle, Pacific Sunwear, Hot Topic, Claire's, Mr. Rags, Urban Outfitters, and Club Monaco.

Designer Todd Oldham closed his upscale design business and will now be concentrating on building a junior mega-brand. Jones New York is in charge of his trademark, and junior denim is the first priority.

This is an exciting time for young people in the industry. This is a chance to do lines of apparel that appeal to their own age group…and to have a sufficiently large audience to be successful.

OTHER CHANGES ARE COMING

As noted throughout this text, we are right at the beginning of a potential transformation of the fashion business. The role of the Internet will certainly become more clear over the next five years. Now it seems the impact is potentially the greatest in the *retail* arena: How people *buy* their clothes. However, surprises often surface!

Retailers with stores will have to fight back if they want to keep customers coming in their doors. They are already trying to make shopping an "experience." Oshman's SuperSports USA offers computerized 18-hole golf simulations of some of the world's leading courses, putting greens, basketball courts, batting cages, and in-line skating areas. REI has a 65-foot climbing pinnacle. Jordan's Furniture in Massachusetts pipes in agreeable scents such as pine or bubble gum! These efforts will probably become more dramatic and more bizarre as competition mounts.

FINALLY, PRIVATE LABEL IS A LABEL THAT IS HERE TO STAY

One reason this book has been slanted toward the private label end of the industry is because clearly it is a significant growth category in fashion's future. Private label allows retailers to sell merchandise at lower prices to consumers. It allows them to make more profit at the same time. In addition, private label means that this merchandise can only be found in one retailer. These three factors add to a tremendous push to increase not only the quantity of private label but also its quality. It is no longer acceptable for private label goods to look any less desirable than branded goods. This means that retailers must invest in the resources and in experienced and savvy staff to put these programs together. Our students are finding a great deal of satisfaction in private label jobs. It is our feeling that there will be many such rewarding private label jobs in the next few years.

These are some of the areas in fashion that will be seeing powerful growth in the next decade. It would be wise for fashion students to find their way into one of these specialties, because chances for success are always greatest in the strongest companies.

Before we send you off to find the job of your dreams, let's fill you in on some "inside information" first. In Chapter 20 we will teach you how to talk like a fashion veteran. In Chapter 21 we will hear advice from some of those veterans themselves.

Endnotes

1. Valerie Seckler, "Study: Giants Will Grow Fast," *Women's Wear Daily*, June 9, 1999.
2. Ira P. Schneiderman, "Competition on the Rise for Luxury Goods Marketeers," *Daily News Record*, March 26, 1999.
3. Constance C. R. White, "Once a Private Club, Prada Opens Its Doors," *New York Times*, September 15, 1998.
4. *Hoover's Handbook of American Business*, Hoover's Inc., 1999.
5. Jennifer Steinhauer, "That's Not a Skim Latte. It's a Way of Life," *New York Times*, March 21, 1999.
6. Melonee McKinney, "Everything's 'Jake' at Life Is Good," *Daily News Record*, September 4, 1998.
7. Anne D'Innocenzio, "Licensing: Spotting the Next Hit," *Women's Wear Daily*, June 9, 1999.
8. http://www.census.gov/population/projections, accessed February 8, 1997.
9. Cynthia Redecker, "A Big Push for Plus Sizes," *Women's Wear Daily*, July 1, 1999.

CHAPTER TWENTY

Garmento Lingo:
Talk Like an Insider

One industry veteran defined it this way: "Go into Harry's Deli at 1407 Broadway and see who is eating fast. The people gobbling their food and looking at their watches are 'garmentos.'"

What's a Garmento?

One of the pleasant surprises about the garment business is its humor! Things can get pretty tense, so it's a good thing that many people in the industry can stand back and laugh at themselves and at their predicament. "Garmento," for example, has a slightly negative connotation, reflective perhaps of the irony of having to perform miracles just to get a few dozen *schmattes* (clothes) shipped!

We thought we should give you a head start in the industry. No one taught us the inside terminology that gets used every day. When you're working in fashion, you won't hear people talking about the invention of the bustle in the nineteenth century. But you will hear something like this:

The color roll style blew out even though that vendor wasn't on the matrix. So my boss made me be a *schnorrer* and get an RTV. Turns out the style was on a rubber band already, so I didn't feel like such a *chazzer*. The margin came out great. So after all this, my boss let me put it back into four doors!

You're going to need to know what that means! Here's the translation:

The style that I bought in a wide range of colors sold extremely well. However, the manufacturer who made it was not on the corporate "approved list" of manufacturers. So my boss made me go to the manufacturer and beg to get his authorization to ship back whatever remained of that style. I didn't realize that this style was prearranged to be returned anyway, so I didn't feel so greedy (chazzer means pig). As it turns out, the profit on that item was great. So after all this, my boss let me put the style back into four branches!

INDUSTRY CLASSICS

Big pencil	Indicates that this buyer can buy large quantities ("She carries a big pencil").
Going to the market	When retailers visit the wholesale showrooms or when manufacturers visit their suppliers.
Rag trade	Garment business; sounds negative but is really affectionate.
Paper	When a buyer "leaves paper," he or she is leaving orders with a vendor.
SA	Seventh Avenue.
RTW	Ready-to-wear apparel for women.

RETAIL TRADE TERMINOLOGY

Selling Floor Terms

The Floor	Selling area in a store.
Face out	A fixture that allows merchandise to be hung so that the entire front of the garment shows.
Four way	A fixture that holds garments on four arms so that the end garment on each arm is facing out.
Rounder	A large, horizontal ring that holds lots of merchandise but shows only the shoulder of each item.
T-stand	A small fixture with just two arms used to highlight special merchandise.

| Jet rail | Horizontal bar along the wall that holds lots of merchandise but shows only the shoulder of each item. |
| Door | A separate store. A department store with one large downtown store plus 15 branches is said to have 16 doors. |

Retail Financial Terms

P.O.	Purchase order; the official paperwork a buyer presents to a wholesaler to order merchandise.
Keystone	Common practice of marking merchandise up 50%. Remember that this refers to 50% of the retail price. So if the cost is $10.00, the retail price would be $20.00 at keystone markup.
California keystone	Historically, retailers on the west coast had to add either an extra 2% markup or an extra $1.00 to cover the additional transportation cost to the West Coast.
OTB	Open to buy; an internal accounting dollar figure that represents the amount of open budget a buyer has to buy merchandise in any given month.
Bought up	Used to denote that a buyer has spent his or her allocated budget fully.
Out-the-door price	Promotional price at which most of the inventory of a particular style gets sold.
Sell-through	Percentage of inventory that has been sold within a specified period.
RTV	Return to vendor; merchandise that is faulty or does not sell can sometimes be returned to the supplier.
MIS	Merchandise information systems; in-store computer system that tracks inventories and sales.

Miscellaneous Retail Terms

Co-op	Advertising moneys contributed by wholesalers.
ROP	Run of paper; advertising that is printed at the same time as the rest of the newspaper.
Wear-now	Merchandise that can be bought by consumers and worn right away because it matches the season.

Style-out	Examination of all styles in a department to see if there are duplications or gaps.

FABRICS

Fancy	Any fabric that is not a solid color.
TC	Poly-cotton blend. (Don't ask, it's a long story!)
CVC	Chief value cotton. Still used even though the customs definitions have changed. It is used for fabrics that are more cotton than any other fiber (for example, cotton/polyester).
Yield	Amount of usable material and/or garments that come out of a set piece or length of fabric.
Head end	Beginning of a new piece or run of fabric in the loom, usually showing identification marks.
Confine a pattern	To have the mill sell a pattern only to you because you have bought a large enough quantity; also called an exclusive.
Pit loom	A small swatch, usually woven by hand, to test how the colors selected for the warp and fill (vertical and horizontal threads) will look when a pattern such as a plaid is woven; also called trial weave or hand loom.
Dye lot	Large quantities of fabric must be dyed in separate batches. There is usually a slight shade variation from one batch (lot) to another.
Recovery	Ability (or inability) of a fabric or garment to be stretched and then to revert naturally to its original shape.
Crocking	When the dye rubs off a dyed fabric.
Self-staining	When one colored panel of a garment runs onto another panel of the same garment. Just piece together bright red and white and then wash them!

LINGO

Checked out	Alternatively, "blew out" or "flew out"; used to describe anything that sells fast.
Dog	Alternatively, "had puppies" or "barks"; used to describe a style that does not sell.

On a rubber band	Alternatively, "on wheels"; merchandise that the wholesaler has agreed up-front to take back if it does not sell.
Flipped	We don't know why, but this is always the description for a positive reaction from a buyer.
Hashed together	Mixed, as in jumbled sizes or styles on a rounder fixture.
Who do you hang with?	No, this does not mean, "Who are your friends?" A buyer asks this of a wholesaler, meaning, "In other stores, which other brands are carried in the department where they also carry your line?"
Garanimals	Easy-to-match separates; term taken from the famous kidswear brand.
Stack 'em high, watch 'em fly!	What a wholesaler tells a retailer when he or she is sure of success.
Gorilla	An unsophisticated male customer, also known as "Joe six-pack."
Granny bait	Especially cute infantswear.
Tin cup	When buyers ask wholesalers for markdown money to help offset deficient retail profits.
Like buttah!	What your leather line feels like.
Like sandpapuh!	What your competitor's leather line feels like.

YIDDISH

There is a wonderfully rich Jewish history and tradition in the garment business. Many Yiddish words, or words derived from Yiddish, are used by everyone. Trust us on this—you will hear these terms and soon might be using them yourself!

Schmatte	"Rag"; used generically to denote a garment, especially a lower-quality garment.
Maven	An expert.
Pisher	Someone young and inexperienced.
Gontser Macher or big *Macher*	A real big shot.
Chutzpah	Nerve, arrogance.
Meshugge	Crazy.
Mishegoss	A situation that is so crazy it defies description.
Schmooze	A friendly chat.

Latke	"Potato pancake"; someone with no energy or spunk.
Mitzvah	A good work, a good deed.
Schmaltzy	Overdone, gaudy, too fancy.
Chazzer	A pig.
Schnorrer	A beggar.
Rachmones	Pity, compassion ("They were starting their own company, so I gave them a rachmones order.").
Schlep	To drag around ("You made me schlep these samples all the way from 34th Street?").
Schlepper	Salesperson.
Yenta	A gossip.

(Special acknowledgment to Leo Rosten's book, *The Joys of Yiddish*, Pocket Books, New York, 1968.)

CANTONESE

Don't think there haven't been linguistic influences from around the world! Every new country added to the sourcing list seems to bring in a couple of new words. Everyone in the business has been to Hong Kong at one time or another, and two Cantonese phrases (Cantonese is the dialect of Chinese that is spoken in Hong Kong) have become universal:

| Tai gui | Too expensive. |
| Mo mun tai | No problem. By the way, we've found that "no problem" in almost any language really means "Start worrying right now!" |

TRANSLATIONS

These are a bit of a "stretch," but they might give you a bit more "local color."

K-Mart with a candelabra	A store that thinks it's better than it really is.
Euro	"Euro" in front of any word means "more stylish than American."
Young men's bottoms	A departmental buying responsibility that a young woman on my staff refused to have printed on her business card.

I didn't get your message	Used to mean, "I got your message, I didn't answer it, and now you're going to pester me again, aren't you?"
Understands	Will put up with ("The better customer *understands* linen" means he or she knows it will be a mass of wrinkles five minutes after putting it on.)
Opportunity	Use in front of your boss instead of "problem."
Reach	A fashion stretch ("These two sweater styles are fine for my customers, but that Lycra-chenille-angora crop top is just too much of a reach.").
How's business?	Retailers never admit that their business might not be terrific. As a result, there has been the following "inflation" in the words used to describe retail selling performance.

DESCRIPTION	ACTUAL INCREASE
Tough	−10%
Flat	−3%
Up slightly	0%
Up high single digits	+2%
On fire!	+5%

CHAPTER TWENTY-ONE

WORDS OF WISDOM FROM INDUSTRY PROS

After you've been out in the business world for a while, you'll realize (as we all did) that good advice from experienced professionals is the best way to do things right, avoid mistakes, and get ahead. Dina Columbo of DKNY puts it best: "When you graduate, you think you know everything. You want to start at the top. You don't know everything! Be like a sponge. Listen to any idea. It could be a good idea, now or later. Listen to the ideas of successful people. They've gotten where they are by learning themselves!"

Dina Columbo

Words of Wisdom: Dale Nitschke, Target Corporation

"To succeed you have to be passionate about the industry, the product, the guest [customer]. It requires lots of time, energy, and focus. You don't appreciate that until you're in it. If you don't have that level of commitment, you won't succeed. Look for a mentor. Someone who is energized by the business. Find out what makes them that way!"

Dale Nitschke

Words of Wisdom: Diann Valentini

Diann (De De) is a professor in the fashion merchandising management department at the Fashion Institute of Technology in New York.

"What separates the students who end up being successful from those who don't? Drive! Some may not be the best academically, but students with drive, with a real hunger to succeed, do well. They seek out interesting new things, they experiment. Their open-minded attitude allows them to be more flexible and see opportunities.

Diann Valentini

"Of course, there will always be 'stars.' They shine with a special charisma. It's not coincidence that they often end up being in the right place at the right time. But the mainstay of the business will always be the 'troops.' The hard workers. They succeed because of determination and can be very successful. This is a very large business, needing so many different talents and abilities."

Words of Wisdom: Tommy Hilfiger

Tommy Hilfiger

"If you know what area you want to focus on—design, marketing, retail, graphics—you should study that in college. However, many young people are unsure of what area they would like to pursue. Therefore, internships are a good way to learn the business—fashion or otherwise. An internship gives you a chance to put what you are learning in school to practical use. It also gives you the flexibility to work within different departments to experience the diversity of the company. This will enable you to more easily decide what you find most interesting. There are many young people at Tommy Hilfiger who started out as interns and were hired in permanent positions after graduation."

Words of Wisdom: Pamela Dennis

Pamela Dennis

"I would tell design students, don't do only fads! They're great for one shot, maybe. But stick with timeless, class, good quality, and good fabrics. Women don't want fine tailoring to be a lost art. This business needs new blood. We want another generation to carry on."

WORDS OF WISDOM: BOB CAPLAN, VICE PRESIDENT OF SALES, LEVI STRAUSS & CO.

"Prospects are more encouraging now. We've gone through a 'flushing out' of a lot of peripheral areas in textiles, manufacturing, and retailing. We're hitting a point where we will see growth and a brighter future in our industry. In the global approach to apparel, there is still a constant mystique for Americana."

Bob Caplan

WORDS OF WISDOM: S. MILLER HARRIS, EAGLE/NAUTICA SHIRTMAKERS

"In putting together merchandising teams over the years, I've learned early on that the hardest person to find is one with both taste and business skills. You can find creative souls who are flakes—can't read a cost sheet or a line blueprint. Sometimes their talent is such that you hire them anyway. And since you can find good mechanics who don't know green from blue, the solution often is to pair one of each and then make sure they truly do complement one another and are compatible. But the real find—the true five-legged sheep—is someone who can do it all!"

S. Miller Harris

WORDS OF WISDOM: ED TORO, PRODUCT DEVELOPMENT MANAGER, HARWOOD COMPANIES, INC.

"Be accurate and precise in what you do. People are always rushing you, but take the time you need to get it right the first time. Don't rush for half an hour and do it wrong. Take the hour and do it right!"

Ed Toro

WORDS OF WISDOM: LAWRENCE BEHAR, IKE BEHAR INC.

"You can't be afraid to get your hands dirty. You've got to be willing to do anything and everything. Glamour is maybe 5% of your daily routine."

Lawrence Behar

WORDS OF WISDOM: ZACH SOLOMON, PRESIDENT, BABY TOGS

"Never talk down to anyone, no matter what their position. It doesn't matter if it's Louie in receiving. Louie became my bosom buddy. Ingratiate yourself with people, listen to them, ask questions. That's how you'll learn. You've got to be able to work alongside anyone."

Zach Solomon

Words of Wisdom: Mimi Platcow Lechter

Mimi is yet another of those graduates of Brooklyn's legendary retail training ground: Abraham & Straus. After becoming the buyer of women's sportswear, Mimi transferred to AMC-New York. In her 24 years at AMC, which culminated in being vice president, general merchandise manager, Mimi supervised all areas of soft goods. Those of us who worked for her credit Mimi for making us understand what it means to "be a pro."

Mimi Platcow Lechter

On being professionally correct: "It's all a matter of P's and C's."

Presentation

"You need to present yourself to the world in such a way that people will respect you, listen to you, and want to work with you. Remember that you are representing your company to the public. Even in dress, you should dress in accordance with the practice in your office—if the men are in suits and ties, you have to go with the flow."

Preparation

"If you are given an assignment or an activity that you are expected to carry out, you must be prepared to follow through. It's like being in school—you need to come to class prepared for discussions and exams. But in work, don't expect anyone to grant you an extension!"

Prepared for the Unexpected

"Work is fraught with surprises. You will need to deal with the unexpected often!"

Positive

"You must have a positive attitude in how you deal with the public and with your supervisor. If you are asked to do something that is over your head, approach it with a positive attitude and be open to it as a learning experience."

Pride

"You can't be a pro unless you take pride in your job and in doing it well!"

Commitment

"To do a job well, you have to be committed to do it to the very best of your ability."

Cooperative

"It's important not only to come across as cooperative to your boss—you've also got to be cooperative with your co-workers."

There are also some "no-no's" to be avoided if you want to be a professional.

Politics

"There are politics in every office. It's OK to be aware of the "intrigue," but it's very bad to get involved. It will almost always come back to haunt you."

Clock-Watching

"To get the job done, you have to spend as much time as necessary. If you have a 9-to-5 attitude, you won't be successful."

WORDS OF WISDOM: BARBARA DUGAN

Barbara Dugan

Barbara got her Bachelor of Science degree in clothing and textiles from Ohio University. This led to her first job, as assistant fashion director for a large fabric company. From there she went to Bagatelle and then to AMC. After being a merchant for 11 years, Barbara switched to the personnel department, which she now runs as the senior vice president.

"If you really want to do your best in an interview:

- Come into the interview already knowing something about the company. Do your homework;
- Bring along any projects, written materials, design portfolios—but less is more!
- Give a nice, firm handshake!

"This is the fashion industry, so presentation is key. I like to see someone who is confident, animated, excited about the interview. Someone who makes eye contact. Being a little nervous is perfectly natural. So don't worry about that. But within the first five minutes of the interview, you do need

to find a way to establish a rapport with the interviewer. You should steer the interview so that there is an exchange of information. Questions and responses on both sides. I don't want to feel that I'm selling the company to you. You have to think of yourself as one of perhaps ten candidates. How do you differentiate yourself?"

"And here's a pet peeve: Never, never say you want a job in this industry 'because you love clothes' or 'because you love to shop.' That comes across as terribly superficial. You'll sound much more professional if you say, 'I have always had an interest in the fashion business.' By the way, with the exception of department stores, there are very few "training programs" left. You're much wiser asking in your cover letter about opening-level positions rather than training programs."

WORDS OF WISDOM: AL DITTRICH

Al is the executive vice president of merchandising and marketing for Gander Mountain, LLC. Before that he had been a senior vice president at Dayton's, Hudson's, Marshall Field. We consider him one of the most insightful merchants in retailing today.

Al and Denise Dittrich and sons Blair, Neal, and Brett.

"Advice for someone starting in retail? I have two answers.

The short one: Always think like a customer, never compromise your integrity, roll up your sleeves and work hard, find a mentor and be a mentor, and make it fun every day!

The long one: I meet with every trainee who joins my team. I try to learn as much as I can about each as a person. I also impart upon them my six-point expectations speech. Having worked with trainees in every position I've been in over twenty years, they always ask what my expectations are. Thus, my speech, as if I were giving it to someone new to my team and new to retail.

First and foremost, I expect you to think! (I usually get a slight rise of the eyebrows as they think to themselves, "What does that mean? I'm thinking every day in everything I do.") My challenge is that I expect you to think like a customer in everything you do. You're at a point in your career where you can get sucked into the treacherous list of "To Do's." You're new, you're inexperienced, and you're at the "task level" of your job. Your team, and even you yourself, can start to evaluate your self-worth based on how many things you get scratched off your list of "To Do's." Let me give you an example. Once, many years ago (so many years, in fact, that cotton was just becoming a fabric for sweaters), I walked into an office, sat on the corner of

a trainee's desk, and said, "What do you think we should do about cotton sweaters?" He looked back at me with a blank stare. I was inquiring because I had just finished reviewing a recap that he had done. In the recap, cotton sweaters had an incredible sell-through and other sweaters had been weak. Our on-order was almost nonexistent in cotton. The person that I'd asked the question of gathered his composure and related that he didn't know anything about cotton sweaters but could do an analysis for me if I wanted. This was a classic case of "get it off the list of 'To Do's'." I was disappointed in what we were doing as trainers of new talent. His recap was everything we asked it to be: It was accurate, it was thorough, it was done quickly, etc. This trainee had given us what we asked for. He gave us an effective recap, but we hadn't set the expectation or the environment in which we expected our trainees to think. My expectation of every trainee is that you think. Think about everything you do and how it relates to the customer. If you're doing something that doesn't relate to the customer, challenge us as to why we asked you to do it. Think like a customer. We need your new fresh challenges and ideas.

My second expectation is that you participate. I've seen many talented people come into the business and hesitate to participate. They seem to be saying, "There's a lot going on here, some really bright people. I'll listen, absorb, and learn for a while." Not an option! The beauty of retail is that it is a business everyone knows something about—because everyone shops. This is not nuclear science; this is playing store. I expect everyone to participate, throw out your ideas, throw out your challenges, give your opinion. We need everyone's opinion; we need to know how everyone thinks as a customer. You'll learn easily in this business that a fragile ego will have a tough time succeeding. Retail is part art, part science. We have plenty of computers for the science/analysis part. We need the artists; we need opinions about what's the right color, what's the right button, what's the right price. Like art, the value lies in the eyes of the beholder. The value of the opinion is in the eyes of the customer. Many times you'll feel you are so right, but you're only right if the customer thinks so. Dare to try. If you're not wrong very often, you're not trying enough! The customers can make you very humble; they can also make you feel like a genius, and basically you'll get a little of both each day. Play the game rather than being a "student" of the game. Participate! It's fun!

My third expectation is ownership. Own the store! I remember my second day as a trainee. I went into my buyer's office and relayed a decision that needed to be made. I asked him what criteria one uses to decide something like this. His instant response was, "What would you do if it was your store?" I gave my answer, and he said, "Then go for it!" He followed with, "You'll never go wrong in this business if you make decisions as if you owned the store." Think about your area as if you owned the store. You want it to be the very best, you want customers to think of you first, you want your suppliers to know you're honest and fair, and you want to make money. This store is what provided for your family and you want to run this store as though it were the one thing you'd be able to pass on to your children. If you do that, you'll make the right decisions. If you do that, you'll lead as a

steward of the business rather than a manager of someone else's business. I look for people who take ownership, who show accountability, who aren't afraid to say, "I made that decision."

My fourth expectation deals with training. I've seen new trainees enter our teams with seemingly different views on training. One view seems to be "I wonder how well they'll train me?" The other view is, "I wonder how fast I can learn?" The latter sounds much better than the former in this business. It works not only when you're a trainee, but every day as well. I look for people who want to learn, people who want to be better today than they were yesterday. I expect everyone on my team to train. I expect everyone on my team to help each other. However, the primary responsibility of training lies with the individual who needs the training. I look for people who dive in and go the extra mile while the learning curve is steep. This is a competitive, fast-paced business. If everyone on the team isn't better today than they were yesterday, the competition will beat us.

My fifth expectation is to "have a little fun!" (I usually get a smile, a laugh, and full agreement to live up to that expectation!) My message is one of balance. This is the type of business that can reach out, pull you in, and absorb you. There is always more to do than you can do. There's one more analysis, one more recap, one more market preparation that you can do. Don't get caught up in "doing" and lose touch with life. In this business, when you lose touch with the customer, you're worthless to us. As I said earlier, we have computers to do the recaps and the analyses. We need merchants to merchandise. Some say retailers and retail hours aren't "normal." You need to be out in life, buying groceries when "normal" people buy groceries, going to movies when "normal" people go to movies, filling your car with gas when "normal" people fill up with gas. Merchandising is about knowing your customer, and you have to experience life to know your customer. Balance and work hard, but take time for family, for friends, for fun. You learn by living. "Lifestyle" is where all trends start. Have fun.

My final expectation is that you give your best. I believe that God gave everyone different talents and different levels of talent. All I want is the very best every day of what God gave you. You can't glide in this business. You can't take shortcuts. You have to work hard and give it your best! If you're doing that, there'll be a place in this business where you can contribute, where you can feel good, where you can work with some really great people, and where you can have fun.

I don't expect anyone coming into this business to have all the answers or to reinvent the wheel of retailing. I expect people to think, participate, take ownership, learn, enjoy, and give it their best. Everyone I know that has followed that formula has done well and enjoyed it. I've worked with some wonderful people in this industry and I hope that I have, in some way, helped some of them along. I have been asked many times if I would recommend retailing as a career for any of my three sons. My answer is that I hope I can help them match their talents to whatever is right for them. In whatever they do, however, they'll probably get my six-point expectations speech!"

WORDS OF WISDOM: EVELYN C. MOORE

Evelyn Moore

Throughout this book you might have noticed that we have stressed that you must know your customer to be successful in the fashion business. In fact, we took this same point to heart while writing: You are our "customer," and we sincerely hope that we have addressed your needs. We wanted to avoid writing a book that just talks "at" you. We hope we have been able to show you "how to" actually begin in the business.

As an instructor, my best advice is this: The other most important person for you to listen to is yourself! If you start by knowing yourself, it will be easier to understand that other people will share some of your opinions and not share others. Get to know yourself and discover what is special about you! This will help determine which path is best for you, which "niche" could be especially yours.

Take it slow and easy, and along the way, learn as much as you can from each opportunity and experience—good and bad. Remember the experiences that have given you satisfaction and enjoyment. They will help you identify where you best fit into this business. We hope that as you explore, you will find (as we did) that the most important measure of success is not necessarily a big commercial breakthrough. It is really a matter of finding day-to-day fulfillment throughout your career, throughout your journey!

WORDS OF WISDOM: MAURICE J. JOHNSON

Maurice Johnson

In writing this book, the most fascinating discovery was the consistency among industry members, regardless of location or rank! Either from their own experiences (Ken Master, May Cygan, Tonya Bott) or from their observations (Diann Valentini, Dale Nitschke), they said essentially the same thing: If you want to break into the fashion business and succeed, you're going to need push, gumption, and, as De De Valentini put it, drive. No one is going to hand you a career. In fact, it's probably going to be tough.

Some industry veterans, when asked what advice they would give to students just starting, said, "Tell them to run for their lives!" Invariably though,

a softer look would cross their faces, and the conversation would turn to the wonderful experiences and rewards that this career had given them. Many talked about a mentor who had given them extra special help along the way. If all the details in this book seem a bit overwhelming, take heart! You don't need to know everything on your first day—and there will no doubt be a mentor to help you, too.

The best advice I offer is that one secret of success is "caring." If you really, but really, care about your career, care about getting ahead, care about your reputation, care about the success of your work, care about seeing your customers and your staff become successful—everything else falls into place. Customers, clients, and even suppliers can always tell when someone sincerely cares. Conversely, they can see through false concern as if it were cellophane. True concern and caring, in my experience, have always made the difference between a job done well enough and a job done with great success.

AND NOW, HOW WILL YOU BEGIN?... CHAPTER 21

Unit 3 was a glimpse at fashion's future. Unit 4 has been a reflection of the experiences, drive, and passion of many industry leaders plus their guidance for you. In both Units 3 and 4 you were not given "So You Want to Work in the Fashion Business?" exercises. We wanted you to focus on your course-length notebook during that time. Now it is time to involve you in the "How to begin." Industry leaders worked hand-in-hand with us to bring you to this launching point. Now you need to join in this collaboration and think about where you will fit in this industry.

This last exercise is actually a lot of fun. Make a T-chart for each of the questions below. On the left side, write the answer; on the right side, discuss why.

First: What Surprised You?

List three things that you learned about the industry that surprised you. Then write why they were surprising and how this has changed your thinking about the fashion industry.

	SURPRISES	WHY
ONE:	_____	_____
	_____	_____
	_____	_____
	_____	_____
	_____	_____

Two: _____ _____

_____ _____

_____ _____

_____ _____

Three: _____ _____

_____ _____

_____ _____

_____ _____

Second: What Did You Like Best?

Something has probably grabbed your interest. List three things that you really liked and why you liked them. Are these the areas that fit best with your talents?

	LIKE BEST	WHY
One:	_____	_____
	_____	_____
	_____	_____
	_____	_____
	_____	_____
Two:	_____	_____
	_____	_____
	_____	_____
	_____	_____
Three:	_____	_____
	_____	_____
	_____	_____
	_____	_____

Third: What Do You Want to Learn More About?

Somewhere in this book we hope that something has sparked a brand-new interest. It could be a job, a company, the background of a leading designer, or even the role of politics in garment making. What would you like to learn more about?

	AREAS TO EXPLORE	WHY
ONE:	_____	_____
	_____	_____
	_____	_____
	_____	_____
	_____	_____
TWO:	_____	_____
	_____	_____
	_____	_____
	_____	_____
	_____	_____
THREE:	_____	_____
	_____	_____
	_____	_____
	_____	_____
	_____	_____

Fourth: What's Next?

List the first three steps that you will take to "break into" the fashion industry? What, in the book, brought these steps to your attention?

	PLAN OF ACTION	BECAUSE OF...
ONE:	_____	_____
	_____	_____
	_____	_____
	_____	_____
TWO:	_____	_____
	_____	_____

THREE: _____ _____

_____ _____

_____ _____

_____ _____

_____ _____

_____ _____

_____ _____

ABOUT THE AUTHOR

Maurice J. Johnson

A native of Appleton, Wisconsin, Maurice (Maury) Johnson received a B.A. degree in German language and literature from the University of Wisconsin-Madison, which included one year's study at the University of Freiburg, Germany. After receiving an M.A. degree from Cornell University in comparative/German literature and deciding to take a break in his studies, he consulted Cornell's career center for short-term work options. The center suggested entry-level training positions in banking, insurance, or retailing. Because retailing sounded more interesting than the other two, he interviewed with major New York department stores plus one New York-based international buying office, the Associated Merchandising Corporation. AMC's international connections sold him!

Maury capped a 23-year career at AMC as vice president and general merchandise manager. His responsibilities included product development, global sourcing, and marketing for department and specialty store clients in men's, children's, and women's private label apparel. In previous positions at AMC he was also involved in wholesale fashion and market coverage and reporting, research of consumer and market trends, and in-store consulting. Store clients included Dayton's, Hudson's, Marshall Field's; Bloomingdale's; Foley's; Filene's; Strawbridge and Clothier; Carson Pirie Scott; Parisian; Eaton's (Canada); Harrod's (London); de Bijenkorf (Netherlands); and Matsuzakaya (Japan), among others.

In recent years, however, AMC narrowed its services primarily to product development and sourcing. Maury's staff, ranging from 15 to 45 people, included many young people who had some department store background but no product development experience. It was his job to teach them this skill and to ensure their success. It was also his challenge to integrate these young people with the industry veterans, designers, and divisional managers already on staff. Together this group helped design, source, and market private label apparel for member stores. The group also organized exciting "buy meetings" with samples collected each season from their world travels. These meetings, attended by U.S. department store buyers, were held in New York, Los Angeles, Paris, Florence, and Hong Kong.

Maury has made more than 60 overseas trips, mainly to the far east, southeast Asia, Europe, Turkey, and Israel. He was included in one of the earliest groups of Americans to attend the Canton Fair, when China began to allow foreigners to visit. Special research trips were also made to locate new apparel makers in Portugal, Egypt, Uruguay, Argentina, Brazil, Malaysia, and the United Arab Emirates. The volume of shipments from overseas markets under his jurisdiction ranged from $200 to $400 million per year (retail dollar equivalents). Maury is now a full-time instructor at New York's Fashion Institute of Technology, a division of the State University of New York.

ABOUT THE AUTHOR

EVELYN C. MOORE

A graduate of Youngstown State University with a degree in business administration, Evelyn Moore worked as a sales associate, clerk, assistant buyer, and buyer at Ohio's Strouss Department Store, a division of the May Company. Her departments included children's, pre-teens, and intimate apparel. She found the opportunity to participate in the May Company executive training program classes exciting and rewarding. The classes, designed and presented by seasoned store leaders, were jammed with practical firsthand knowledge. She realized that her first love was training and development. Learning directly from the professionals made her realize the wide gap between on-the-job skills and college courses based on definitions and theory.

As a result, Evelyn returned to school for certification in grades K–12, secondary, and adult education programs. Upon entering the teaching arena,

she found there were many students like her, asking "OK, what do I do first?" "How do I start?" "What advice do you have?" But now they were asking her! Evelyn decided to look for a practical, step-by-step approach. On the job, she had found successful merchandisers, designers, and other business people who took the time to share this specific advice. She also treasured their encouragement, their words "Just try," "Don't worry about failure," "What do you have to lose?," "It will be a good experience," and "Just do the best you can!"

Evelyn found ways to make learning easier—to show students "how to." She has let her students "take over" the role of learning by giving them tools that are practical and relevant. In her first book, *Math for Merchandising: A Step-by-Step Approach, Second Edition*, she starts at the beginning: How to use a calculator. In *Apparel Product Development*, a wider-ranging book, she hopes students will find many helpful tools that will apply directly to their first jobs in the fashion industry.

Currently Evelyn, who has completed training as an online facilitator works as a specialized research consultant, and continues to teach as an adjunct instructor with Johnson & Wales University in North Miami, Florida. She was formerly an instructor in the Fashion Program with the Art Institute of Fort Lauderdale from 1987-1999 and earlier with Bauder College, a division of NEC.

Evelyn served as a member of the Broward County Schools Marketing and Diversified Advisory Board, from 1994-1999. This is a group of community business and college leaders throughout Broward County (Florida) seeking to address the curriculum needs of high school students who are planning to enter the business market upon graduation or who might consider postsecondary training and education. Evelyn was also a 1999 nominee for the National Achievement Awards, Distinguished Member of the Year, by the Art Institute of Fort Lauderdale, and was recognized in both 1996 and 1998 as an honoree in Who's Who among America's Teachers. She resides in Fort Lauderdale, Florida with husband Jesse and sons, Peter and Zachary.

INDEX

Fur Information Council of America, 102
Futurists, 254

G

GG, 206 (also known as Gauge)
G H Bass, 138
GQ, 133, 144
Galey and Lord, 328
Gander Mountain, LLC, 359
Gant, 27
Gap, 5, 10,17, 19, 33, 39, 47, 57, 92, 97, 100, 101, 109, 110, 185, 230, 312, 321, 338, 339
Garanimals, 349
Garment construction, 24, 27, 61
 definition, 24
Garment design, 15, 24
Garment dyeing, 207, 208
Garment spec sheet, 225
Garmcnto, 345
Garments on hangers (GOH), 250
Gary, Valerie, 24 (*See also* Alan Stuart Menswear)
GATT (General Agreement on Tariffs and Trade) 306, 307
Gauge (GG), 206
Gaultier, 72
Generation X, 63, 64, 92 (*See also* Generation X and X'ers)
Generation Y, 64, 65, 66, 75, 84, 86, 92 (*See also* Baby buster)
Generation Z, 65, 66
Generational Marketing, 59, 64
Generic name, 54
Generic trademark, 40, 42
Geoffrey Beene, 72
Geoffrey Beene, Inc., 140
Gerber, 186, 298, 328
Gerber Garment Technology (GGT), 186, 296, 298
GERBERsuite, 299
Gertz Department Stores, 100
Gianni Versace, 42 (*See also* Versace)
Gieves and Hawkes, 140
GI Generation, 61, 69
GI, 61, 96
GI's, 90
Gifford, Kathy Lee (*See also* Walmart), 318

Gilligan and O'Malley, 49, 54
Gillman Knitwear, 30
Givenchy, 71, 339
Glamour, 144
Glenoit, 328
Glist, Alan, 341 (*See also* AlanStuart, Inc.)
Global Sports, 97
Globalization, 306
GMM (General Merchandise Manager), 18, 64, 90, 262
 definition, 18
Going to the market, 346
Gold Coast Fashion Award, 149
Golden Gate Apparel Association, 263
GOH (Garments on hangers), 250
Gonster Macher, 349
Goods returned, 270
Goods sign-out sheet, 230
Gorilla, 349
Government Issue, 61
Grade, 223
 definition, 223
Graded, 240
Grader, 240
Grading, 287, 289
Grading costs, 178
Grain, 205
 definition, 205
Graj + Gustavsen, 10, 341
Graj, Simon, 10, 341
Granny bait, 349
Greige (greige goods), 209
Gross domestic product, 305
Gross margin, 45, 201 (*See also* Estimated gross margin, Guaranteed gross margin)
 definition, 45
Group product development, 31 (*See also* Product development)
Guaranteed gross margin, 270
Guerlain, 339
Guilford, 310
Gucci, 54, 72, 339
Guess, 63, 85, 86

H

Half-circumference, 223, 224
Halston, 149, 150, 151

Halston Signature Collection, 150
Halston Sportswear, 150
Hancox, Clara, 59, 125
Hand, 148, 163
 definition, 148
Handwork, 305
 definition, 305
Hanes, 43, 243
Hangtags, 30
 definition, 30
Hard goods, 89, 91
Harper's Bazaar, 133
Harris, S. Miller, 247, 355 (*See also* Eagle/Nautica Shirtmakers)
Harvey Nichols, London, 149
Harwood Companies, Inc., 5, 243, 356
Hashed together, 349
Hawaii Market/Pacific Rim Trade Show, 262
HBO, 149
Head end, 348
Hecht's, 91
Henry Grethel, 23
Here and There, 121, 132
Hermes, 339
Hickey Freeman, 10
Hilfiger, Tommy, 5, 38, (*See also* Tommy Hilfiger)
Home Depot, 338
Home Shopping Network, 96
Hong Kong, 314, 318, 320
Hoover's, 115, 145
Horizontal repeat, 215 (*See also* Repeat)
Horizontal direction(s), 205, 215 (also known as Weft)
Hot Topic, 342
http://dir.yahoo.com/business (Yahoo business directory), 133
http://interactive.wsj.com, (Wall Street Journal Interactive), 111
http://iserve.wtca.org (World Trade Center Association online), 111
http://micrografx.com (Designer by Microgrpahics), 302
http://otexa.ita.doc.gov/, 133
http://stats.bls.gov/ocohome.htm (Occupational Outlook Handbook), 113
http://www.adobe.com (Adobe Systems, Inc.), 302

I